82815

COLLIN COUNTY COMMUNITY COLLEGE

W9-BRQ-504

Learning Resources Center
Collin County Community College District
SPRING CREEK CAMPUS
Plano, Texas 75074

The Gothic Revival Chris Brooks

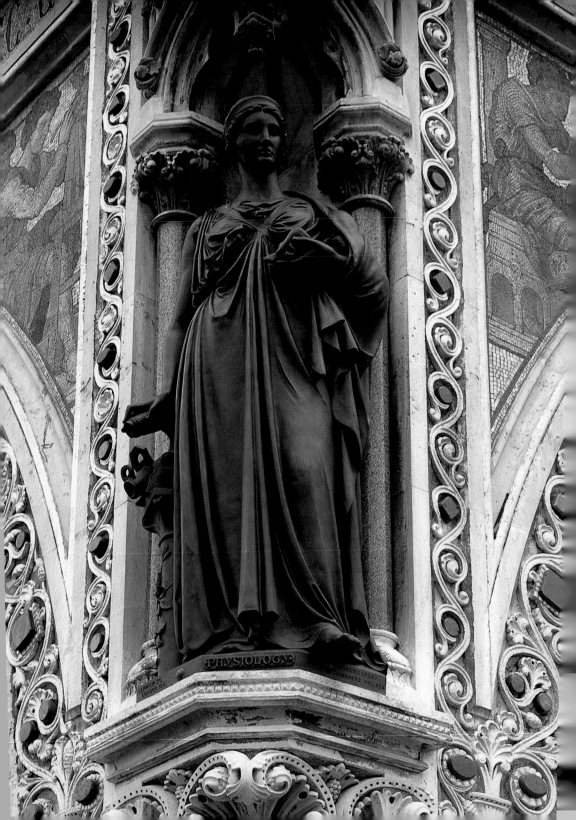

PHYSIOLOGY

Opposite
George Gilbert Scott, The Albert Memorial, London, 1862–72. Figure of Physiology by John Birnie Philip

Introduction

The Gothic Revival has been made from countless adventures in search of the lost world of the European Middle Ages. From the mid-twelfth century to the early sixteenth, the medieval world created its buildings, its sculptures and paintings in the style that came to be called Gothic – the name by which we still know it. This book looks at efforts to reclaim and recreate that style, and the accompanying gothic past, from their beginnings in the seventeenth century to the present. It surveys the extraordinary wealth of buildings designed, decorated and furnished in the gothic manner during the four centuries of the Revival – the churches and cathedrals, Romantic castles and suburban villas, schools and colleges, civic offices and centres of government. And it reaches beyond these, to the novels, poems, sculpture, paintings (1), movies and electronic images generated from innumerable acts of reinventing gothic.

1
Franz Pforr,
*Entry of
Rudolf von
Habsburg into
Basle in 1273*,
1808–10.
Oil on
canvas;
90·5 ×
118·9 cm,
35⅝ × 46¾ in.
Städelsches
Kunstinstitut,
Frankfurt
am Main

The creative adventures that inspired such works have always been seeking more than the revival of a past style. 'Gothic' has been inextricably linked to the myriad ways in which the present imagined its lost past – the social structure and working practices, political arrangements, worship and culture, tyranny, superstition and squalor of the medieval world. Because revived gothic has sprung from ways of constructing the past – sometimes physically, sometimes metaphorically – its revival has centred on how individuals and societies understood their own place in their own history. The Gothic Revival's towers and spires rise across the great territory that stretches between how we live now and how we lived once upon a time: or how, in our thoughts and fantasies, we may have done.

In that mental terrain reaching back into the medieval past, people have located the most transcendent marvels and the most

desolating fears. And because such intensities have been invested there, because such radiant angels and sooty demons lurk, it has always been contested ground. The past, it has been famously remarked, is a foreign country where things are done differently. But our sense of its foreignness, and of the differences or otherwise between then and now, is constantly shifting. Thus the maps we draw of that country constantly change as well, shifting as we do, as we choose to emphasize one feature and ignore another, to draw attention to the lushness of the valleys or the starkness of

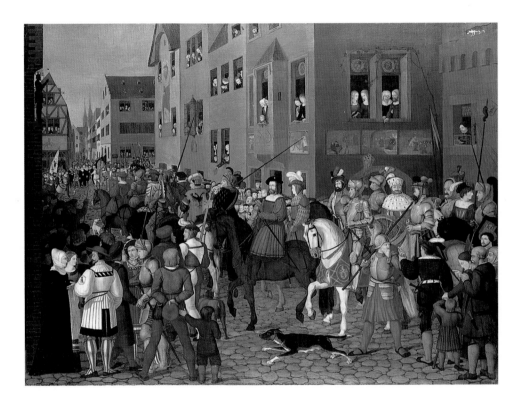

the mountains, as our moods or our current requirements dictate. Different needs demand different maps, and cultural or historical cartographers will dispute over whose version is the most accurate. 'Though God cannot alter the past,' the Victorian essayist Samuel Butler noted, 'historians can.'

The world the Gothic Revival built is both actual and imaginary. It exists not only in art and architecture, but in political discourse

and theories of government, in polemics about society and models of social organization. Like the historical terrain in and from which it was reared, gothic has always been a contentious concept – or, more accurately, a cluster of concepts. The gothic past has been claimed by radicals and conservatives. Gothic has been identified with parliamentary rebellion in the seventeenth century in England, the revolutionary politics of the American colonies and the Romantic Movement in Europe in the late eighteenth century. It has been adopted by wealthy landowners, the monarchy, the Church, utopian creative communities and, in recent times, the heritage industry and counter-cultural nihilism. Dynamic, cumulatively dense, certainly fraught and contradictory, the significances and associations gathered around gothic have made its revival culturally central to the centuries since the passing of the Middle Ages. Beginning in Britain, taken up across the rest of Europe, subsequently exported to North America, the Far East, Australasia, to parts of the earth unknown to the Middle Ages, the Gothic Revival has been a global phenomenon: indeed, broadly understood, it still is.

The styles we adopt always imply a way of understanding the world and our place within it – a way, that is, of making meaning out of things. This book, this history of the Gothic Revival, tells the tale of a style and its transformations. Because of that, it is also an essay in the history of meaning.

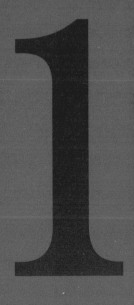

The architecture of the European Middle Ages had no style.
Rather, it had a way of building based upon the pointed arch, the
vault, the gable and the buttress. That way of building remained
constant through various historical phases from the twelfth
century to the sixteenth, and across numerous local, regional and
national differences. But it had no style in the sense that it was
not conscious of itself as style, and it had no name for itself. For
medieval master-masons, the construction and decoration (2–7)
that sprang from the pointed arch, however sophisticated, were
simply the way building was done. The concept of style, originat-
ing in discussions of rhetoric and the fine arts, was adopted
by fifteenth-century Renaissance architects already busily
engaged in recovering the principles of classical design from the
remains of Italy's ancient buildings and the writings of the first-
century BC Roman architect Vitruvius, particularly his carefully
specified proportions of the Five Orders of Greek and Roman
columns (8). Style itself was understood in classical terms. From
this point of view, it is true to say that medieval architecture
had no style. How could it have when its buildings predated the
aesthetic discourse which first made 'style' one of its terms?

To the Italian architect Donato Bramante (1444–1514), writing
in 1510, medieval architecture, set against Roman elegance and
proportion, was ugly and confused, and had a quite different
national identity:

The only sort of decoration employed by the Germans (whose manner
still persists in many places) consists of squat little figures, badly carved,
which are used as corbels to hold up the roof beams, along with bizarre
animals and figures and crude foliage, all unnatural and irrational.

For Bramante, and the Renaissance generally, medieval architec-
ture was architecture in 'the German manner'. Imposed by

2
Fan-vault,
Henry VII
Chapel,
Westminster
Abbey,
1503–c.1512

foreigners, its barbaric muddle constituted a kind of anti-style, wholly at odds with the classicism that was indigenous to Italy and was now being triumphantly rediscovered. In his hugely influential *Lives of the Most Eminent Architects, Painters and Sculptors* (1550), the painter and architect Giorgio Vasari (1511–74) gave the architecture of the Middle Ages both a myth of origin and the name that has attached to it ever since.

There is another sort of architectural work called German, which is very different in its proportions and its decorations from both the antique and the modern. Its characteristics are not adopted these days by any of the leading architects, who consider them monstrous and barbaric, wholly ignorant of any accepted ideas of sense and order. On the contrary, they are confused and disordered, for in these buildings, of which there are so many that they have contaminated the entire world, there are portals with flimsy columns twisted like corkscrews ... façades made up of one damned tabernacle on top of the other ... and lots of pinnacles, gables, and foliage ... This manner of building was invented by the Goths, who put up structures in this way after all the ancient buildings had been destroyed and all the architects killed in the wars. It was they who made vaults with pointed arches ... and then filled the whole of Italy with their accursed buildings.

There was an historical core to the architectural myth Vasari established. The Goths were a Teutonic people who originated from northeastern Germany and the shores of the Baltic, though the name 'Goths' was often used by Roman and later historians to label all the Germanic tribes on the northern margins of the Roman Empire – an extension of nomenclature that, as will be seen in later chapters, was to have some surprising results. In the great population migrations that began in the second century, the so-called folk-wanderings, the Goths moved gradually south and west. Despite various periods of accommodation with the Roman Empire, Goths under the leadership of Alaric invaded Italy in the first years of the fifth century, and in 410 sacked imperial Rome itself. Between the extinction of antique culture and its rediscovery in his own period, Vasari saw a millennium of darkness, more

3
Right
Amiens Cathedral, flying buttress, mid-13th century

4–6
Chartres Cathedral, later 12th century
Top far right
Gargoyle
Middle and bottom far right
Details of sculpture

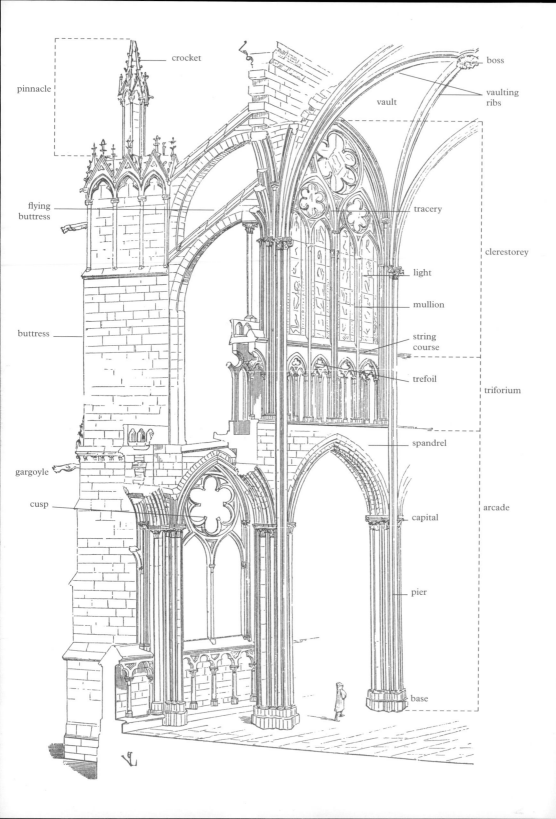

crocket

pinnacle

boss

vaulting
ribs

vault

flying
buttress

tracery

clerestorey

light

mullion

buttress

string
course

trefoil

triforium

spandrel

gargoyle

cusp

capital

arcade

pier

base

or less unrelieved and undifferentiated. The architecture that grew up in that gloom was the creation of savage tribes outside the pale of imperial civilization. It was the architecture of barbarism: it was gothic.

By the time Vasari came to write his *Lives*, the cultural, social and religious order that had created and sustained the 'gothic' architecture he denounced so roundly had disintegrated. Gothic belonged to a past world, that of medieval Europe. Modern Europe inherited the Middle Ages both as a material presence – as buildings, books and artefacts – and as a complex of ideas and feelings that travelled down through time gathering an

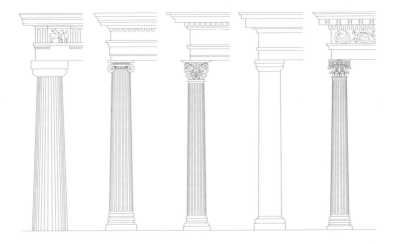

7
After Eugène-Emmanuel Viollet-le-Duc, Perspective section of the nave of the abbey church of St Denis, France, 1858, showing architectural terms

8
After Vitruvius, The Five Orders of Greek and Roman columns, l to r: Doric, Ionic, Corinthian, Tuscan, Composite

extraordinary variety of cultural meanings on its journey. Those meanings, at once real and imaginary, were inscribed on the objects and artefacts that remained, and formed the basis for acts of reinvention, for new buildings and new works of art founded on the medieval past. These evolving cultural patterns constitute the history of the Gothic Revival. It must begin by sketching the processes that ended the European Middle Ages, and that brought into being a modern world persistently haunted by the medieval world it had destroyed.

From the fourteenth century Renaissance Italy was casting off 'the German manner', but by the early sixteenth the Germans

themselves were taking the lead in a far greater repudiation of the medieval world in the revolutionary religious movement known as the Reformation. In 1517 Martin Luther fixed his ninety-five theses protesting at the sale of papal indulgences to the door of All Saints' Church in Wittenberg. The indulgences, certificates sold to the faithful in order to reduce a sinner's time in purgatory, were sold in order to raise funds for the building of St Peter's, Rome. Luther's objections to the power of the papacy in northern Europe were eventually to lead to the end of the medieval Catholic Church which, in theory at least, had acknowledged the pope in Rome as its spiritual sovereign, from Brittany to Bohemia, from Sweden to Sicily. Reformers dismantled the very doctrines of the late medieval Church such as the veneration of the Virgin and even the presence of the blood and body of Christ in the Mass. Around the teachings of Luther, Huldreich Zwingli and John Calvin, crystallized the theology of Protestantism. It chimed with the ambitions of princes quite as much as with the aspirations of ordinary people. By the 1560s, the German states of Brandenburg, Brunswick, Hesse and Saxony were Protestant, as were the kingdoms of Denmark and Sweden, Scotland and England, and many of the cantons of Switzerland.

In the late sixteenth century, the Church of Rome fought back through what came to be known as the Counter-Reformation, a latter-day crusade against Protestantism that sought to revitalize the Church, re-establish the pope's universal spiritual supremacy, and reassert the absolute power of the Catholic monarchs of Europe. The spiritual crusades of the Reformation and Counter-Reformation became indistinguishable from the political and dynastic goals of the rulers themselves. For example, Spain under the Habsburgs, champion of the Catholic cause, fought Protestant England, only for its mighty Armada to be annihilated in 1588 by storms and Elizabethan sea power. Starting the climb to maritime ascendancy and a world empire, England moved to consolidate the national position by trying to crush its Catholic neighbours in Ireland. In France, the Wars of Religion blazed fitfully for forty years after 1560; in the Low Countries, Calvinist

Dutch battled into the seventeenth century before throwing off
Spanish dominion; during the Thirty Years War (1618–48) the
armies of the Reformation and Counter-Reformation powers
laid waste large tracts of Germany and Bohemia.

Where the Reformation ended the religious system of the Middle
Ages, the Renaissance abolished the intellectual regime that
sustained it. In place of the supposedly timeless truths laid down
by the Catholic Church was set 'the new learning': rationalist,
humanist, derived from the rediscovery of the writers of classical
antiquity, but also the basis for the creation of empirical science
as an autonomous discipline. The very order of things was
remade: if the Reformation altered what it meant to be a
Christian, the Renaissance altered what it meant to be a human
being. Renaissance man – less often Renaissance woman – was
to be the measure of all things, arbiter of the knowledge of good
and evil, able to create the world in his own image. With the
precedents of classical civilization to draw on, the Renaissance
invented the individual: a being no longer tied to or by a preor-
dained supernatural order, a being equipped to dominate the
natural order by cunning and by conquest.

Underpinning the intellectual revolution of the Renaissance,
the theological revolution of the Reformation, and much of the
ensuing strife, were forces of profound economic change. The
medieval Church had claimed authority over economic behav-
iour, an authority transmitted, albeit unevenly, through the
hierarchical structure of feudalism. Feudal economic relations
were fixed and customary, based upon the holding and working
of the land: the peasant had a customary and moral obligation
to give so many days labour to his feudal lord; the lord had a
customary and moral duty to take responsibility for his social
inferiors. Monetary transactions were constrained not only
practically but theologically, for lending out money at interest
constituted the mortal sin of usury in the eyes of the Church.
By the time the Reformation broke, this economic order was
already tottering in many parts of Europe, and the impetus for

change carried religion and politics along with it. Where the Church, or the state with its backing, sought to maintain traditional regulation of the economic sphere, the desire for economic freedom was expressed through a demand for religious freedom, which became a demand for political freedom as well.

Inevitably, Renaissance notions of the free self were closely bound up with imperatives that were economic at root. In England in the sixteenth and seventeenth centuries, legal definitions of personal freedom were primarily economic: 'being free' meant being discharged from the customary dues and labour services that had characterized feudalism. And as Western ideas of individual being became increasingly identified with the notion of 'being free', individuality itself came to carry an intrinsic economic meaning. Among the Catholic constraints on economic freedom, one of the first to be removed by the Protestant reformers was the condemnation of usury as a mortal sin: lending money at interest, condoned by Calvin, was legally sanctioned in England after 1571. Over the same period, Protestant confiscation of monastic and ecclesiastical estates created an unprecedented property market that could not be contained by the traditional structures of feudal land-holding. The process was peculiarly rapacious in England where Henry VIII (r.1509–47) was created head of the Church of England following his divorce from Catherine of Aragon and excommunication from the Roman Catholic Church. He abolished all religious houses and seized their wealth in what became known as the Dissolution of the Monasteries (1536–9). The volume of cash transactions increased, supplemented further by the growing importance of mercantile sectors, particularly in the English and Dutch economies. Most dramatically of all, the new economic dynamics impelled the adventurous, the enterprising and the plain greedy to the West Indies and Americas, tracts of the globe effectively unknown to medieval Europe. It was the shape of things to come, the emergence of the economic order that would eventually be known as capitalism.

9
The ruins of Fountains Abbey, Yorkshire, 12th century and later

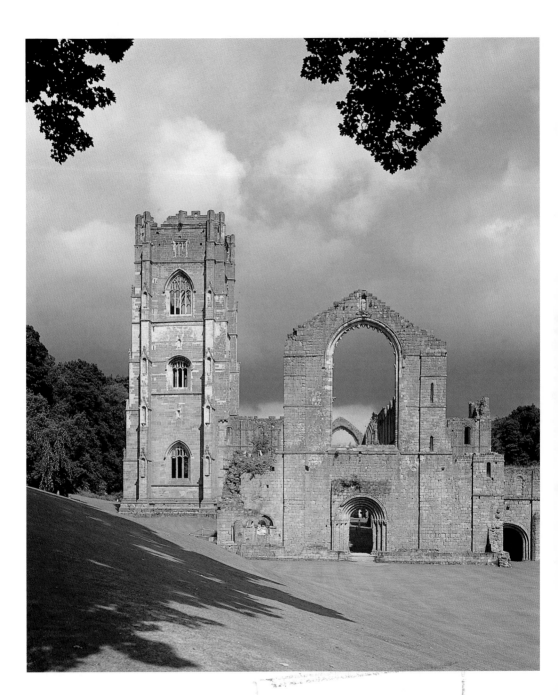

WITHDRAWN
SPRING CREEK CAMPUS

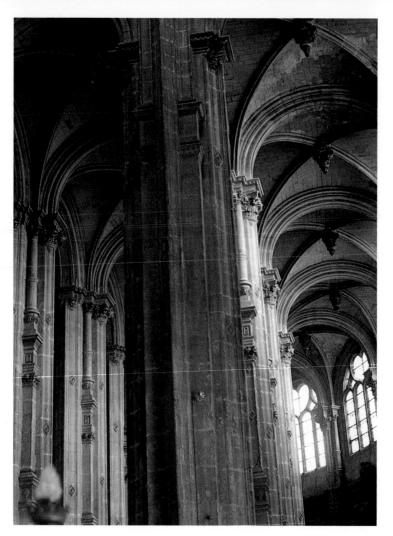

10
St Eustache,
Paris, begun
1532

The forces that brought about the disintegration of medieval
Europe called the modern world into being. Indeed, modernity
could only create itself by also creating a past from which the
present was different: by the early eighteenth century it would be
called 'The Middle Ages'. But that past was one whose remains
were everywhere present. Not least, of course, its buildings – the
churches and cathedrals, the monasteries, the manor houses and
town mansions, the castles, colleges and cottages that were the
material products and evidences of the culture of the Middle
Ages. In the Protestant north of Europe, great numbers of
medieval religious buildings were destroyed in the sixteenth

century (9). Although most non-monastic medieval churches in Protestant Europe survived, these buildings were reformed along with the faith they housed. Out went the stuff of Catholic worship – crucifixes, statuary, stained glass and wall-paintings, anything with images or ritual connotations that could be regarded as superstitious.

Protestant attacks upon medieval churches were frequently occasioned by little more than a desire for plunder, and looting offered an agreeably immediate way of securing a redistribution of wealth. Nevertheless, for committed reformers medieval religious buildings were the material expression of Catholic power and the system of belief it sustained; they embodied sets of meaning that had to be changed or erased. In other words, they were semantic structures – structures of meaning – as well as architectural structures. When reformers shattered images, razed monasteries and stripped cathedrals they were engaged in ideological warfare, battles about meaning. And if the meanings that medieval church buildings held were different for countries remaining within the Roman Catholic fold, they were not necessarily much more positive. Where the Reformation saw the Roman Catholic Church as an institution that was tyrannical and had to be removed, the Counter-Reformation saw it as one that was tired and had to be remade. Both, that is, were intent on changing the Church of the Middle Ages more or less radically, and for both the transformation had to be physical, enacted through the built fabric of the Church, as well as conceptual or spiritual.

Between them, the Reformation, Counter-Reformation and Renaissance brought about the repudiation and derogation of medieval architecture. As Europe settled, the new learning and the stylistic principles of classicism spread out from Italy to Catholic and Protestant countries alike, and by the later sixteenth century Vasari's mythological history of the Goths had become common currency among Italian architectural writers. As an adjective applied to specific medieval buildings, however, 'gothic'

first appeared in northern Europe when a Jesuit writer, Carolus Scribanius, in his book *Antverpia* (1610), described the Antwerp Bourse as an '*opus Gotico*', a gothic work. A Parisian cleric called Bergeron, writing in 1619, discerned elements in the Château of Beauvrages that were '*un peu gothique*', a little gothic. The painter Peter Paul Rubens (1577–1640), in the preface to his 1622 work on the palaces of Genoa, said that the buildings of the southern Netherlands were in the style '*chiama Barbara, ò Gotica*', called barbarous or gothic. By the 1640s the English diarist John Evelyn was using 'gothic' as a stylistic tag for medieval buildings that he noted on his travels.

Meanwhile, the long practice of constructing buildings in the gothic manner did not simply vanish with the coming of the Renaissance. Outside Italy, classicism appeared first as a new sculptural style and decorative repertoire, and was incorporated into formal and structural elements that were still medieval. For example, in the remarkable Parisian church of St Eustache (from 1532) all the structural elements remain gothic, but are translated into the forms of classical architecture (10). In Spain, Moorish details mingle with gothic and Italianate forms to produce the hybrid style known as Plateresque. In England, despite a premature outing in royal circles, the classical repertoire came largely as an ornamental import from the Low Countries, Italianate motifs sidling into otherwise gothic church fittings from around 1530. Not until the great houses of the Elizabethan court in the later sixteenth century did Renaissance forms overtake, or at any rate subsume, the native gothic tradition. Even as classicism eventually became the architectural language of the new Europe (despite the fact that its structural and organizational principles were not always, perhaps not often, fully grasped), the first signs of a conscious harking back could be discerned – not just the lingering of residual forms from an outmoded manner, but a creative resort to the medieval world that now lay in the richly imaginative country of the past. Around the start of the seventeenth century, and in England most importantly, the Gothic Revival began.

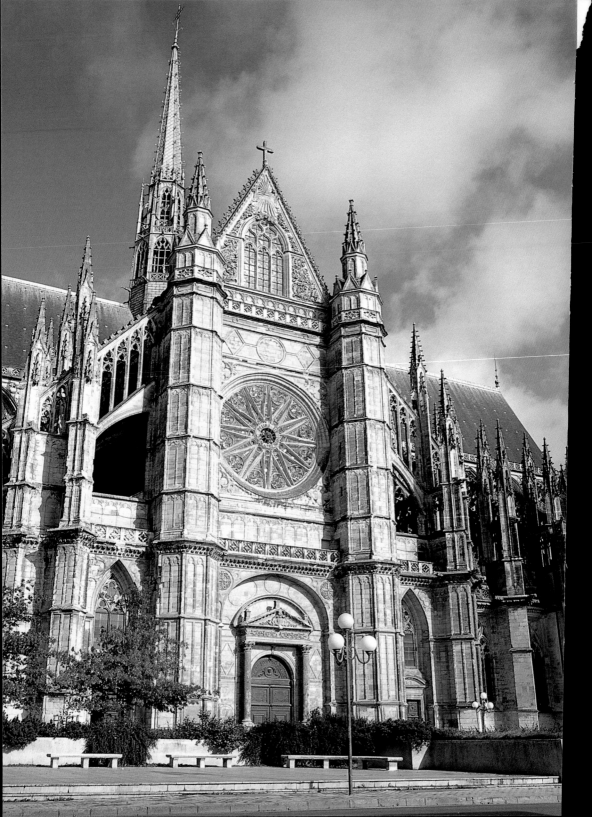

On 18 April 1601 Henri IV, King of France (r.1589–1610), laid the foundation stone for the rebuilding of the royal cathedral of Orléans, razed by the French Protestants, the Huguenots, in 1567. Formerly a Protestant, Henri had converted to Catholicism, and the rebuilding of Orléans Cathedral signalled the end of the French Wars of Religion, and the restitution alike of Catholic religion and Catholic monarchy. The architectural language the cathedral used to symbolize these events was gothic, its choice a conscious act of stylistic revival, a reclamation of the medieval lineage of Church and State that the Huguenots had sought to disrupt. What the Reformation had destroyed, the Counter-Reformation triumphantly could recreate, bigger and better. More than a century and a half in the building, Orléans was an ideological proclamation, its gothic style an essential vehicle of its meaning. It was intended to overawe, and succeeds, both by its visual richness – particularly the transepts (11) designed by Étienne Martellange (1569–1641) – and by its sheer size.

11
Étienne
Martellange,
South
transept,
Orléans
Cathedral,
c.1620

French gothic's royal connection, which was so firmly established – or re-established – at Orléans, persisted; when the church of Blois, a seat of the royal family, was destroyed by a storm in 1678, it was rebuilt as a gothic cathedral. Such acts of stylistic revival are striking, and their ideological significance resonated into the nineteenth century. But as yet they were isolated, relating to the peculiar circumstances of an individual building. More pervasive was gothic's association with religious architecture, unsurprisingly, for churches and cathedrals were the most familiar and among the most ambitious medieval structures to survive. Thus, the Jesuits, an order founded by Ignatius Loyola in 1534 to be the vanguard of the Counter-Reformation, incorporated pointed windows with simplified tracery (decorative pierced stonework in the head of a window) into the otherwise classical churches

they built in northern France, the Low Countries and Germany in the first half of the seventeenth century. Gothic's appropriateness for churches was felt even in the classicist heartland of Italy. For Milan Cathedral, built over three centuries, various gothic schemes for the west front were put forward, from that of Carlo Buzzi (c.1608–58) in the mid-seventeenth century to that of Bernardo Vittone (1702–70) in the eighteenth. Eventually, Giuseppe Brentano (1862–89) got the thing finished with an adaptation of Buzzi's design produced as late as 1888. Classicist Italy, it seems, could debate the propriety of reviving gothic, but found difficulty summoning the enthusiasm actually to do it.

Orléans and the designs for Milan Cathedral were certainly instances of revived gothic, but they were not expressions of a Gothic Revival, simply exceptions, in particular circumstances, to the hegemony of classicism. It was different in seventeenth-century England. Here, the connotations that gothic acquired, its political and religious resonances, and its associations with a medieval past that was both real and imaginary, gave the revival of gothic a cultural impetus it did not have elsewhere in Europe. This whole cumulative cluster of meanings, what we might call the gothic semantic, was at once dense and contradictory. At its core were questions of historical continuity, of the links that connected the brave new world of early seventeenth-century England with its past. 'Gothic' history and gothic style both played a central role in very different constructions of the past, depending on the religious and political affiliations of those involved. This chapter will trace several strands in the gothic semantic that contributed to the making of the Gothic Revival.

In the beginning was the religious past. While papal supremacy and its attendant errors had been cast off, the Church of England had retained many of the forms of worship of the medieval Church, as well as its buildings, institutional structure, geographical distribution of parishes and its hierarchy – the last traced all the way back to Christ and the Apostles. To the satisfaction of its adherents and the irritation of its opponents,

the Church of England maintained that it was both Reformed and Catholic, cleansed of popery (to use the Protestants' derogatory name for Roman Catholicism) but also the legitimate heir of the Universal Church. This was the *media via*, the middle way, the model – depending upon your viewpoint – of English moderate-mindedness, or English muddle-headedness. Its defence, against puritans on the Protestant wing and papists on the Catholic, rested upon a carefully constructed history of continuity and discontinuity. By showing that the English Christian Church, in its origins and traditions, had always had a separate identity, the break from Rome could be justified as a means of recovering independence. At the same time, the very existence of those origins and traditions allowed Anglicans to claim continuing membership of the Holy Catholic Church. Much of this work of historical construction was done at the universities of Oxford (12) and Cambridge, which provided all the Anglican clergy. Founded in the twelfth and thirteenth centuries, each had a core of original medieval architecture. Both were expanding rapidly, and it is not coincidental that the question of stylistic continuity was fundamental to the buildings this expansion produced.

Oxford built more extensively than Cambridge in the first half of the seventeenth century. Though there are classicizing features, almost all the seventeenth-century additions are unmistakably gothic, for example, the rebuilding of Oriel College (1620–42; 13, 14) and University College (from 1634). By and large their style is a development of that of the early sixteenth century, subsequently known – after the ruling English dynasty – as Tudor gothic: string courses or labels (projecting horizontal mouldings) over shallow-arched doors and windows for the ranges, open timbered roofs for the halls, pointed windows, cusped and traceried, for the chapels. Contemporary examples from Cambridge are fewer, the most important being St John's College Library (1623–5), though there is also the cavernous open timber hall of Trinity (1604–5).

The standard view of architectural historians that these seven-teenth-century collegiate buildings were instances of so-called

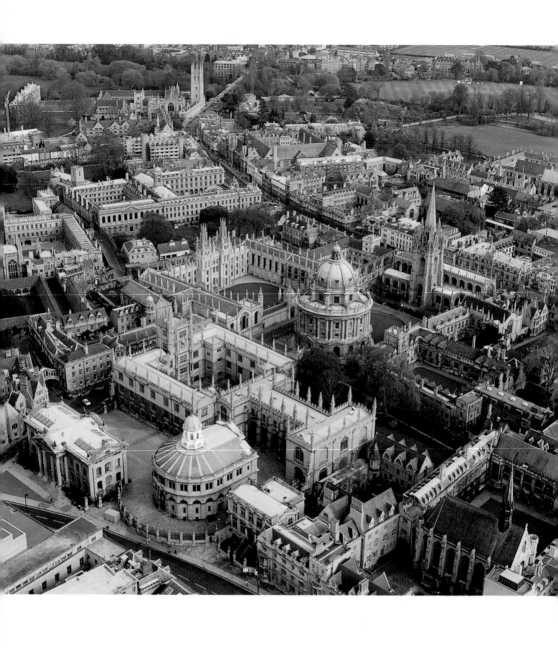

Gothic Survival does not really hold up. In this view, gothic hung on into an age that increasingly belonged to Renaissance aesthetics. It implies that the patrons and architects involved were using gothic unreflectively, building in the way of medieval masons because that was how building was done. But the universities were fully alive to the ideas of the Italian Renaissance, and by the early seventeenth century classical architecture itself had already appeared in the Gates of Virtue (1565–7) and Honour (1573–5) at Gonville and Caius College in Cambridge, and in any number of displays of the Vitruvian Orders in Oxford. Moreover, while so many of Oxford's buildings of this date are gothic, their fittings never are – they are in the peculiarly English style we know as Jacobean (from the Latin name of James I, r.1603–25), with its mix of Flemish and Italianate influences. In such a context, it seems scarcely conceivable that building in gothic lacked stylistic self-consciousness. Certainly, there was continuity, but it was a *conscious* continuity, a decision to retain a stylistic mode because it was understood as appropriate for specific contexts and specific purposes. In short, the early seventeenth-century gothic of the universities was not a residue but a revival.

12
Aerial view
of Oxford
University,
showing
the mixture
of medieval
and later
architecture

What was it that gave gothic its peculiar appropriateness? Contemporary testimony is scarce, but surviving correspondence about the new library of St John's, Cambridge (16), is particularly revealing. In 1623 Valentine Cary, Bishop of Exeter, wrote to the Master of his old college about the design, urging that 'the old fashion of church window' should be used because it was 'most meet for such a building'. The college authorities used exactly the same terms when writing to their patron, John Williams, Bishop of Lincoln. The 'old fashion' was, of course, gothic, and gothic the library duly became, the tracery of its tall, two-light windows (15) derived from that of the fourteenth century. In the correspondence the style is not called 'gothic', for the term was not yet current in England; but it is perceived as distinct, belonging to an earlier historical period, and specifically ecclesiastical – 'the old fashion of church window'. For bishops such as Cary and Williams it connoted the medieval religious

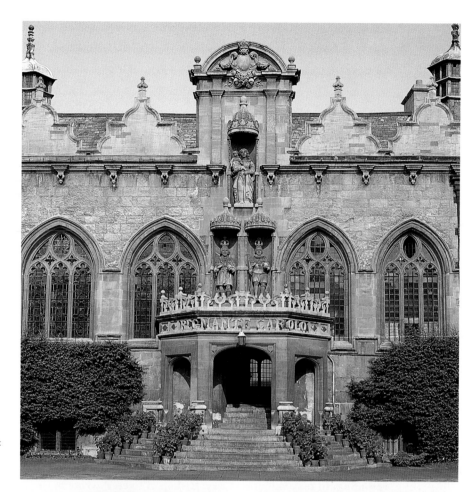

13–14
The Hall,
Oriel
College,
Oxford,
1620–42
Right
Entrance
Below left
Oriel
window

15–16
St John's
College
Library,
Cambridge,
1623–5
Below right
Pointed
windows
Opposite
View from
the River
Cam

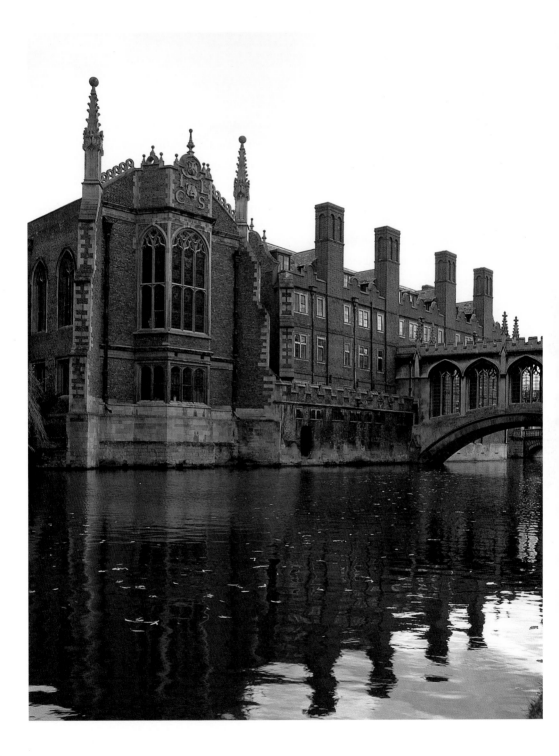

inheritance, 'most meet' for a library in which Anglican clergy would study. It was, in effect, a stylistic epitome of the Church of England's particular history of continuity and discontinuity. It also implicitly opposed the irreligious 'new learning' of the Renaissance, expressed architecturally in the secular logic of classicism. In the gothic semantic of St John's Library, learning belongs to the Church. Such stylistic meanings were even more pertinent to a place of worship: Williams also funded the most persuasively medieval of revived gothic buildings in Oxford, the chapel of Lincoln College (1629–31), designed with remarkable consistency in the manner of the late fifteenth century.

University gothic of the seventeenth century articulated what were felt to be vital elements of continuity in the institution, its society, scholarship, culture, above all its religion. Stylistic self-consciousness is apparent too in Oxford's enthusiastic adoption of fan-vaulting, that showy late gothic feature displayed most famously in Westminster Abbey's Henry VII Chapel (see 2). Though they hardly occur in Oxford's medieval architecture, fan-vaults are everywhere in the university's seventeenth-century gothic: in the gatehouses of Wadham (1610–13), Oriel (1620–2) and University (1635–7); in the Bodleian Library's Convocation House and Chancellor's Court (1634–7); in the great staircase (c.1640) of Christ Church (17). These vaults flaunt their gothicness, and work synecdochally – as parts that stand for the whole. The whole they stand for is the gothic style itself, with all its connotations of religious and cultural tradition, and the authority that tradition conferred on its possessors. The last of the series, the fan-vault of 1659 designed by John Jackson (c.1602–63) for the chapel of Brasenose College (18), is architecturally an illusion. For it is of plaster, mimicking a structural form but without structural function, not a vault at all but a ceiling that looks like a vault. In one of the defining acts of revivalism – to be repeated endlessly over the next two centuries – Jackson shifted categories in his handling of gothic, from the constructional to the visual. Abstracted in this way, the chapel's fan-vault reveals itself as cultural spectacle and cultural sign, its purpose to impress and evoke, to summon the

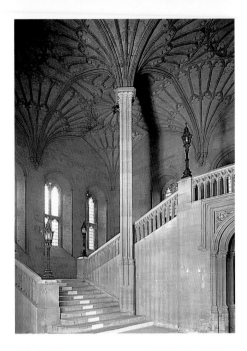

17
The Great
Staircase,
Christ
Church,
Oxford,
c.1640

18
**John
Jackson**,
Chapel
ceiling,
Brasenose
College,
Oxford,
1659

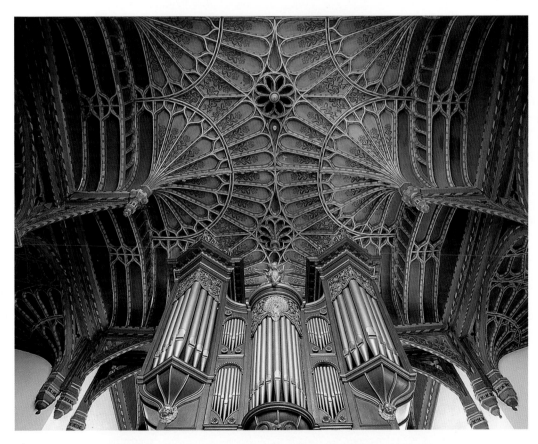

validating spirit of the medieval past into the present – and the presence – of seventeenth-century Anglican worship.

By the Reformation settlement, the Church of England had been established by law with the reigning monarch as its head: State and Church formed what came to be called the Establishment. In this context, an architectural style that connoted the medieval inheritance of the Church also connoted the medieval lineage of the crown. Medievalism, in fact, played a major role in the culture of the later Elizabethan court, and continued to do so throughout the reign of James I, the first king of the Stuart dynasty. Tournaments, fancifully imitating those of the Middle Ages, were revived as a royal and aristocratic entertainment, accompanied by a whole cult of chivalric behaviour. The primary focus was Elizabeth (r.1558–1603) herself, as she was of Edmund

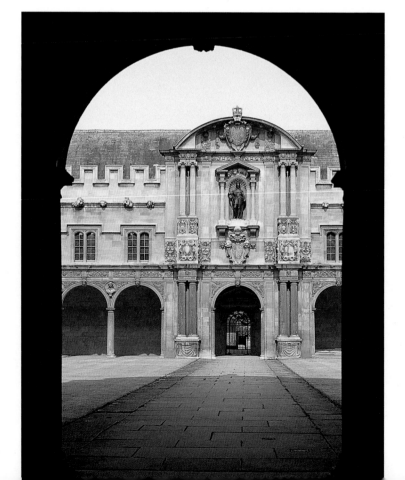

19–20
Canterbury
Quadrangle,
St John's
College,
Oxford,
1631–6
**Above
right**
Grotesque

Spenser's great poem *The Faerie Queene* (1589), with its intricate
machinery of knights, enchantresses and mock castles. At the
root of the cult was anxiety: the notoriously virginal Elizabeth
had no direct heir, and the realm was externally threatened by
the forces of Catholic Europe. Chivalry's stress on personal
loyalty unified the courtly élite around the throne – or, at least,
made a sufficient parade of so doing as to be ideologically useful
to the regime. Architecturally, medievalism was reflected in
many of the courtier houses of the period. In the work of Robert
Smythson (c.1535–1614) in particular, compact massing, towering
verticals and dramatic silhouettes summon up the castles of
feudal England, as at Wollaton Hall, Nottinghamshire (1580–8).
The Little Castle at Bolsover, Derbyshire, built in 1612 to designs
by John Smythson (d.1634), Robert's son, goes further, boasting
cross-shaped arrow slits and a whole suite of stone-vaulted
chambers. Fully, but wholly fancifully, fortified are Lulworth
Castle, Dorset (1607) and Ruperra Castle, Glamorgan (1626),
designed as hunting lodges complete with martial battlements
and corner towers.

The revival of gothic architecture in seventeenth-century
England was closely related to the turmoil of the Civil War
(1642–9), in which supporters of parliamentary government
opposed the power of the crown and rebelled successfully against
Charles I (r.1625–49). In its aftermath the republican Common-
wealth (1649–60) was set up under the leadership of Oliver
Cromwell, and the Anglican establishment was effectively

disbanded. The associations gothic could have for monarchists are evident in the buildings associated with William Laud, Chancellor of Oxford University from 1629, and Archbishop of Canterbury from 1633. Laud advocated the divine right of kings and the Catholic prerogatives of the Church of England with equally inflexible intensity. A particularly unwise counsellor of Charles I, Laud did not survive the Civil War: found guilty of high treason, he went to the block in 1645, preceding his royal master by a little over four years. Laud's beliefs spoke architecturally in Canterbury Quadrangle (19, 20) which he added to St John's College, Oxford, in 1631–6. Internally it has Italianate loggias, decked with episcopal heraldry and statues of Charles I and his queen. But this modish classicism is contextualized by a building that is otherwise wholly gothic – with crenellations and shallow-arched windows and doorways. Semantically, the historical authority connoted by past style validates the present alliance of crown and mitre announced in the iconography of the loggias. Similarly, the church of St Katharine Cree (1631), built in the City of London under Laud's patronage, hybridizes classical features redolent of the Stuart court and ecclesiastical gothic that speaks of Catholic continuity. This was an aggressive statement by Laud to the City, since it was a stronghold of support for parliament against the king.

Equally confrontational – to move from Laud to his circle – was the chapel of Peterhouse, Cambridge, completed in 1638 under the mastership of John Cosin (1594–1672). Here, the gothic display of the east end, with image niches flanking a five-light traceried window, faces the street and the world outside the college. The chapel's medievalism matched the ritualistic worship Cosin introduced; both these infuriated Cambridge's hard-line Protestants – as, in the atmosphere of the 1630s, Cosin must have known they would. In exile during most of the Civil War and Commonwealth, Cosin had his loyalty rewarded after the restoration of the monarchy in 1660 when he was made Bishop of Durham. With the Anglican establishment resurgent, he initiated a Gothic Revival all of his own, though he often mixed in elements

21
Font cover,
Durham
Cathedral,
*c.*1663

derived from Baroque, the richly decorative architectural style
that had developed across Europe out of the earlier and more
strictly disciplined classicism of the Renaissance. Thus, in
Durham Cathedral, Baroque forms and ornamental motifs are
embedded in fittings that are otherwise gothic, both in detail and
in overall character: the choir stall canopies, the screen work,
most of all the spectacular font cover, towering 12·2 m (40 ft) high
with classical columns and dense Baroque ornament in the lower
stages, but wholly gothic above (21). Combinations of gothic
and Baroque or classical forms appear in 1660s woodwork in
several Co. Durham churches. In St Edmund's, Sedgefield, a
parish connected directly with Cosin, the chancel screen (22) is

22
Detail of
the chancel
screen, St
Edmund's,
Sedgefield,
Co. Durham,
c.1670

23
Nave ceiling,
St John the
Baptist,
Axbridge,
Somerset,
1636. The
colouring is
modern

undilutedly gothic, a dense concoction of fourteenth-century motifs carrying real aesthetic conviction. Cosin's medievalist passion was born of religious and political commitment: his gothic was ideology enacted as style. So also in the case of Staunton Harold church, Leicestershire, built by Sir Robert Shirley in 1653 during the Commonwealth. In loving detail, it replicates the kind of late medieval parish church found throughout the eastern counties of the English Midlands, its gothic single-mindedness the material expression of uncompromising beliefs. Sir Robert openly opposed the Cromwellian regime and paid the price: he died in the Tower of London in 1656.

Shirley's Staunton Harold, Cosin's church fittings, Laudian architecture, the buildings of the universities, the medievalism of the Elizabethan and Jacobean court, were all products of high culture. They sprang from an awareness of the medieval past and a sense of gothic style that were both more widespread and more actively self-conscious than has generally been acknowledged. To return to an issue raised earlier, gothic in seventeenth-century England was far more a matter of revival than survival. Survival,

in the sense of an unreflexive tradition, there almost certainly was in remote parts of the country: the rebuilding of Arthuret Church, Cumbria (1609–10) and of the tower of St Teath, Cornwall (1630), both in simplified Tudor, are likely examples. But I doubt if this persisted much later than 1630. Moreover, the fact that, outside the universities, gothic was used almost exclusively for churches itself implies stylistic awareness, a recognition that gothic carried meanings peculiarly appropriate to Anglicanism. There are many examples, from the splendid traceried plaster ceiling (23) of St John the Baptist, Axbridge, Somerset (1636–7) or the elaborate gothic and Baroque mixture of the 1662 Burford Chapel, Oxfordshire, to the simple medieval-izing churches built by Anne, Countess of Pembroke on her Westmorland estates between 1649 and 1676.

Broadly, the revival of gothic architecture in seventeenth-century England, unparalleled elsewhere in Europe, served under the standard of Church and King. But in war, one party never has a monopoly on recruiting the past, and parliamentarians found a very different version of gothic to enlist on the side of rebellion. For them, as we shall see, the idea of gothic acquired a markedly Protestant, radical colouring, its ancient virtues linking it to con-temporary themes of constitutional liberty and nationhood. To trace the development of this alternative strand of seventeenth-century gothic, it is necessary to return for a moment to Giorgio Vasari's view of architectural history.

Writing from a distinctly Italian perspective, Vasari had blamed the barbarousness of medieval architecture on the gothic hordes who had shattered classical civilization. From northern Europe, however, the old imperial history looked quite different. Here, it was the Romans not the Goths who had been the invaders; medieval not classical architecture represented native traditions; and the few surviving Roman structures were foreign intrusions, remnants of a colonized past. In the turmoil of the Reformation, as new states and beliefs fought their way into being, re-exploring that past became imperative – especially those strange regions

which nations, and notions, can excavate for their origins. For history, of course, can be used to legitimize overthrowing as well as maintaining the status quo. Just as Vasari reached back to the period of ancient Rome, so also did sixteenth-century historians in northern Europe. What they found or, perhaps, invented – in the sense both of discovering something and of making something up – was an alternative gothic history.

This drew extensively on Jordanes, a shadowy figure from the Ostrogothic court of mid-sixth-century Italy, first unearthed by sixteenth-century Swedish scholars at the University of Uppsala. In 551 he wrote *De origine actibusque Getarum* (*The Origins and Actions of the Getes*), usually known as the *Getica*, a condensed version of a lost work. According to Jordanes, the gothic tribes, of which the Getes were part, originated in Scandza, identified by the geographers of Uppsala as Sweden. The *Getica* tells how the tribes, growing ever more populous, spread south and east from the third century, increasingly came into conflict with the forces of imperial Rome, eventually defeated them, and established supremacy in Italy itself. Jordanes represents the Goths not as barbarians, but as a young and vigorous people opposing an empire which was moribund and corrupt. Rough as it was, gothic energy had rightly swept aside Roman decadence. Writers outside Sweden, particularly in England, expanded the story on the basis, ironically, of the first-century work *Germania* by the Roman historian Tacitus. With first-hand experience of the Germanic peoples, he found much to admire, particularly in contrast to an over-sophisticated Rome. Like the Goths in the *Getica*, Tacitus's Germans were a warrior race. But they were also distinguished by an intense love of liberty, preferring death to the possibility of enslavement, living in open countryside on their own land, choosing their own kings, and making major decisions through tribal assemblies. A stalwart folk, with strict sexual morals, the Germans were also generous and open-hearted, incapable of the dissimulation which, Tacitus implies, the Romans had learned only too well.

Once Tacitus's account of the Germanic tribes had been fastened onto the Goths and manoeuvred in line with the *Getica*, historical cause and effect looked radically different. Imperial Rome had not been toppled by mere barbarian muscle, but by the Goths' love of personal and political liberty, their scorn of servitude, their purity – by all the noble simplicity of a fiercely free people. One link between Tacitus and Jordanes was particularly important: Tacitus warned that 'the freedom of Germany', capable of 'more vigorous action', was a primary threat to the Empire. By the fifth century that threat had been realized, bringing about, in Jordanes's phrase, 'the transfer of empire to the Teutonic peoples'. This meant not just Teutonic hegemony in the wake of Roman rule, but the establishment across Europe of those gothic polities, the polities of a free folk, that could be traced back across the reaches of Germania to the distant homeland of Scandza. For Scandza, to quote Jordanes again, was 'the womb of nations', the source from which Europe, freed from Roman oppression, had been renewed and replenished. Here was a myth of origin indeed.

For the German Reformation, the alternative gothic history afforded a compelling analogy and precedent, notwithstanding the fact that its Swedi⸱h inventors were fervent Catholics. As the liberty-loving Goths had thrown off the tyranny of imperial Rome, so their descendants, the German Protestants, battled against the dominion of papal Rome. And as the Goths had rejuvenated Europe, so, surely, would the German reformers inaugurate a spiritual rebirth – and another transfer of empire to the Teutonic peoples. With a little ingenuity, and an enthusiasm for the Protestant cause, other nationalities could demonstrate gothic ancestry too. In France, the Huguenot lawyer François Hotman produced *Franco-Gallia* (1573), tracing Gauls and Franks – the two peoples who historically made up the French population – back to Germanic roots. A similar job for the English was done by Richard Verstegen's *Restitution of Decayed Intelligence* (1605; 24): according to Verstegen the Jutes, Angles and Saxons, who drove out the native British and settled England

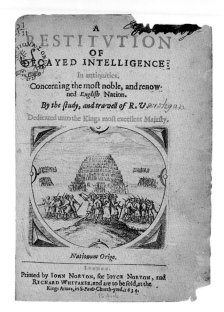

24
Title page
of Richard
Verstegen's
*Restitution
of Decayed
Intelligence,*
1634 edition

after the Romans, were all from Germanic stock. So the English,
like the French, joined Germans and Swedes as the children
of Scandza. The extraordinary hotchpotch of myth, history,
idealism, religious polemic and nationalist aspiration that
started life at Uppsala had spawned a gothic brood. It was to
be in England that the offspring would grow most vigorously.

The political possibilities of gothic history, first explored in
Franco-Gallia, were seized upon by English parliamentarians
in their growing conflict with the crown. The issue, put at its
simplest, was whether parliament, particularly the House of
Commons, had the right to limit the power of the king, and thus
whether sovereignty lay ultimately with parliament – the people's
representatives – or with the crown. Rights in such matters rested
not upon abstract theory but upon precedent, upon history. As
seen earlier, seventeenth-century buildings in medieval style
connoted a continuity that validated the established authority of
the Church and monarchy. Parliamentarians advanced a rival
version of how political authority in the present connected with
the past. They founded their case upon gothic history, using it in
a way that eventually reflected back upon gothic architecture and
was to affect the whole course of its subsequent revival.

25
Ernest Normand, *King John Granting Magna Carta*, from *Cassell's History of England*, 1901–2. An early 20th-century interpretation of gothic political history

As Verstegen had shown, the English were a Germanic people: therefore, the original Saxon settlers brought with them not only an innate love of liberty, but also the specific political features Tacitus attributed to all the Germanic tribes. Accordingly, in the golden age of Saxon liberty kings were elected to limited powers by an assembly of the people, and that assembly, which decided all matters of moment and was the ultimate court of law, was sovereign. To parliamentarians the historical record was quite clear: the English constitution originated in a free gothic polity. With this starting point, subsequent history could be constructed to demonstrate continuity. In the Anglo-Saxon council, the witenagemot or witan, gothicists saw the successor to *Germania*'s tribal assemblies. Though the Norman Conquest in 1066 yoked Saxon liberty, its tradition of free political institutions was merely suppressed, not extinguished – an interpretation that became known as Denying the Conquest. Thus later constitutional developments, particularly those of the thirteenth century, were seen as testimony to the persistence of pre-Conquest liberties.

In 1215 the Magna Carta – the famous charter of rights forced on King John by his barons (25) – was a recognition of rights already long-standing; a tradition of national councils allowed Simon de Montfort to convene a parliament in 1265; and the first parliaments called under that name by royal summons, those of Edward I (r.1272–1307), were thus effectively the assemblies of old England with a French title. And so on through to the Commons of the seventeenth century. Royalists read history quite differently. For them all the witans in the Anglo-Saxon world did not matter, because William of Normandy (r.1066–87) had assumed absolute power by right of conquest. Consequently, Edward I's parliaments were a new departure, ultimately a creation of the feudalism that came into England with the Normans. Parliament thus originated as a king's concession to his realm. Constitutionally, it remained a royal favour, and what a thirteenth-century king had granted his seventeenth-century successor had an absolute right to withdraw. On the one side, then, parliaments were gothic, and the inheritance of the people; on the other, they were feudal, and the gift of the crown.

The argument was carried on through pamphlets and treatises, with antiquaries crucially involved disinterring and interpreting the historical documents that were part of both sides' weaponry. So much so indeed, that James I and Charles I both tried to suppress antiquarian findings favourable to the gothic camp. In 1642, on the battlefield of Edgehill, the issue between crown and parliament moved beyond a paper conflict, and the eventual triumph of parliament in the ensuing Civil War was accompanied by an ideological victory for the cause of the gothic constitution. In one of the most thorough-going of all the gothic treatises, Nathaniel Bacon's *Historical and Political Discourse of the Laws and Government of England* (1647), there is a note of triumphalism: 'Nor can any nations upon Earth shew so much of the ancient Gothique law as this Island hath.' Two years later the sovereign Court of Parliament, under 'the ancient Gothique law' which its supporters traced back to Tacitus's tribal assemblies, sent King Charles I to the scaffold.

Gothic theory went through many further refinements in the second half of the seventeenth century, called forth particularly, after the Restoration, by the crown's periodic flirtations with ideas of absolute power. In the foolish person of James II (r.1685–8) flirtation hardened into fervour, made all the more alarming by his open avowal of Roman Catholicism. The menace of a reversion to royal dictatorship combined with the threat of a return to papal domination was intolerable. In the Glorious Revolution of 1688–9, parliament effectively deposed James in a bloodless coup and gave the crown jointly to his daughter Mary (r.1689–94) and her husband, William of Orange (r.1689–1702). With its accompanying Bill of Rights and Act of Succession, the Revolution secured parliamentary authority, a constitutionally limited monarchy and a Protestant throne. To gothicists, parliament had exercised the ancient tribal right of electing the king. In the aftermath, a profusion of political, legal and constitutional treatises sprung from the gothic position, such as James Tyrrell's *Bibliotheca Politica* (1692–1702), Algernon Sidney's *Discourses Concerning Government* (1698) and Robert Molesworth's 1711 translation of Hotman's *Franco-Gallia*. Almost ritually insistent, historians rehearsed the gothic origins of English liberty, brought to fruition – final and perfect as many of them thought – in the constitutional settlement of 1689. And when, after a century of domestic broils, Englishmen looked abroad, they often did so with undisguised self-congratulation. 'Gothick Governments were all free', wrote John Oldmixon in his *Critical History of England* (1724–6), and 'no Nation has preserv'd their Gothick Constitution better than the English.'

Smug as this judgement most certainly is, it contains a core of truth. In the seventeenth century, gothicism was a dynamic force for political change in Britain as nowhere else in Europe. In Sweden, without adequate political institutions, gothic foundered; Germany was fragmented; France subject to an increasingly rigid autocracy. Only in Britain were the constitutional and broader ethical values of gothic theory matched to practical political objectives in the context of a unified nation

state. There was, however, a further reason: from about 1650, gothic began to change its position in the political spectrum to align with the rights and privileges of landed property. Here was to be the vital link between the ideological realms of gothic theory and the people who had the wherewithal to erect gothic buildings, and who owned the land on which to do it. Decapitating the king, one might say, was heady work: the power of land brought gothic, quite literally, down to earth.

During the Civil War period parliamentary leaders had had to defend the principle of landed property against the communistic demands of more radical political groups. Their defence drew support from gothic history itself. Antiquaries, including Verstegen, had demonstrated that the Saxon English had held land in their own right rather than as tenants of the crown – the latter system, which was feudal tenure, being introduced by the Normans. Land ownership could thus be defended as an essential part of a free gothic polity – and in any case, the parliamentarian leaders were themselves landowners. In *The Commonwealth of Oceana* (1656), the republican James Harrington, while maintaining the gothic origin of free parliaments, argued that enough change was enough. Though the gains of gothic liberty had to be defended, further aspirations had to be tempered by the stability of a landowning class – that élite social group whose common cause came to be known as 'the landed interest'. This was the key shift in gothic's place in the political spectrum. By the time the Glorious Revolution tumbled James from the throne, gothic's dangerously democratic impulses were checked and balanced by the landed interest's rooted concerns. So moderated, gothic theory was assimilated into the core beliefs of the Whigs – the name given to the loose but powerful alliance of forces that had promoted the Glorious Revolution and that dominated British politics until the 1760s.

Despite some heart-searching over the replacement of one anointed king by another, most Anglicans accepted the 1689 settlement and the new look Establishment. John Inett's

Origines Anglicanae (1704) claimed the national Church's independence under the crown went back to Saxon times and that the Reformation, in cutting away the accretions of popery, had reaffirmed ancient rights and freedoms that were both religious and political. Here was 'the gothic theory in a surplice'. Reforming the medieval Church while retaining catholicity went hand-in-hand with creating free political institutions while retaining monarchy. In effect, 1689 turned gothic theory into part of the ideology of the political and religious status quo. Nevertheless, like many a radical come to walk in the ways of orthodoxy, gothic never wholly forgot its rebellious past – as we will see.

Architectural historians of the Gothic Revival have consistently underestimated, sometimes ignored, the profound political significances that accrued to the notion of gothic during the seventeenth century. This cumulative process transformed what I have called the gothic semantic: without it the Revival's trajectory, particularly in its broader cultural relations, loses a major part of its meaning. By the early eighteenth century the cluster of associations whereby medieval style connoted continuity with the Church and State of the Middle Ages, met and mingled with the set of ideas in which gothic expressed continuity with the free polities of the Saxon past; and both were directly related to landed power. The crucial national role played in all this by antiquarian researches was re-enacted at a local level. Social upheaval and economic change, not least the changes in land ownership as a result of the Dissolution of the Monasteries, gave an unprecedented importance to genealogy and heraldry. For between them they established or supported legal privileges, and helped provide the record of marriages, alliances, births and deaths, upon which the possession and inheritance of property depended. Heralds, led by William Dugdale, who became Garter King-of-Arms in 1677, tirelessly quarried medieval documents, from individual wills to monastic records, and medieval churches, with their memorial inscriptions and coats of arms. As well as being politically vital, the results of

26
Roger
Jenyns,
*The Palmer
Pedigree,*
1672.
Illuminated
manuscript
on vellum,
bound in
red morocco;
38·7 ×
25·6 cm,
15¼ × 10 in.
Private
collection

the heralds' researches could be artistically sumptuous; as with the medievalizing *Palmer Pedigree* (26) produced in 1672 by the herald Roger Jenyns for Lady Anne Palmer, to demonstrate the legitimacy of her descent from the Earl of Castlemaine.

Whether national or local, the record of the medieval past assembled by the antiquaries was predominantly literary. For most scholars in the seventeenth century, what we think of today as antiquities – old houses, old churches, old tombs – were secondary to written records and notation systems, namely old

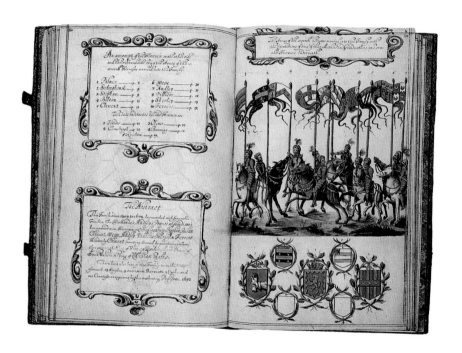

documents and old heraldry. Thus what is probably the greatest antiquarian achievement of the century, Dugdale's *Monasticon Anglicanum* (1655–73), is largely a documentary compilation relating to the history of the monasteries. Similarly, the histories of the English counties that began to appear after Dugdale's *Antiquities of Warwickshire* (1656) concentrated on written sources and emphasized genealogy and heraldry. Antiquity, and the authority antiquity bestows, resided in the word. Nevertheless, visual interest in medieval buildings was growing, both reflected and fostered by the engravings that accompanied

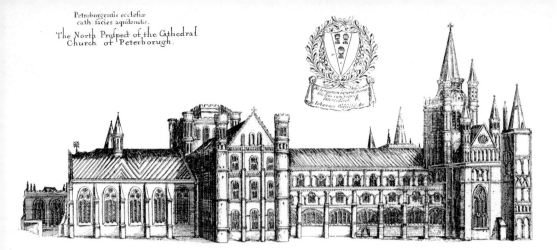

Petroburgensis ecclesiæ
cath. facies aquilonalis.

The North Prospect of the Cathedral
Church of Peterborough.

the antiquaries' learned texts: the illustrations of Wenceslaus
Hollar (1607–77) to Dugdale's *History of St Paul's Cathedral*
(1658), for example, or the engravings of Daniel King (d.c.1664)
in *Monasticon*. It is indicative that King's plates were republished
as a separate volume, *The Cathedrall and Conventuall Churches
of England and Wales*, in 1656, with an enlarged edition in 1672,
the first time architectural images of Britain's medieval past
achieved independence from the literary construction of that past
(27). Crude as they often are, these early engravings inaugurated
the Gothic Revival's visual archive.

The antiquaries were busy assembling their histories of land
ownership as landowning itself was being aligned ideologically
with gothic liberty. Dugdale's *Warwickshire* and Harrington's
Oceana came out in the same year; Dugdale the royalist and
Harrington the republican met on the common ground – literal
and metaphorical – of the landed interest. Rising from that
ground were the gothic edifices, again both literal and metaphor-
ical, of the Middle Ages. The rich complexity of what those
edifices had come to signify in mid-seventeenth-century England
imparted to gothic a creative impetus that propelled its revival
into a national, and then international movement. The site
of departure, appropriately, was to be that definitive cultural
product of eighteenth-century landowning, the landscape park.

27
Daniel King,
Engraving
of the north
prospect of
Peterborough
Cathedral,
from *The
Cathedrall and
Conventuall
Churches
of England and
Wales*, 2nd
edition, 1672

The first gothic garden building in Britain, indeed in Europe, was erected in 1716–17 at Shotover Park, near Oxford. A thoroughly assured little structure known as the Gothic Temple (28), it was built for James Tyrrell, the gothic constitutional propagandist who wrote *Bibliotheca Politica*. The Temple's style connotes gothic theory and history, the whole epic of unfolding liberties, from *Germania* to the Glorious Revolution. Indeed further, for in 1714, following the death of the childless Queen Anne (r.1702–14), the crown passed to George I (r.1714–27), the first king of the House of Hanover. With his arrival a Protestant succession and a constitutional monarchy were secured, though not without difficulty. Plots by the so-called Tories, opposed to the Whigs and the 1689 settlement, had to be defeated. So too did an armed rising in Scotland by supporters of the son of the deposed James II, known as Jacobites. By the end of 1715, however, George was safe on his throne. For Whigs, gothic's political purposes were fulfilled. It was the moment for Tyrrell, one of the architects of gothic's ideological triumph, actually to build in gothic.

The Shotover Temple was genuinely innovatory. Though common in political discourse, 'gothic' was not in general use as an architectural term until the later seventeenth century. Without that currency, the meanings generated by gothic theory could not migrate from the political page to the three-dimensional stuff of pinnacles and pointed arches. Moreover medievalizing buildings had previously connoted continuity with feudal and Catholic authority. So, for gothic architecture to signify gothic liberty, Tyrrell had to wrest the meaning of medieval style from the control of his ideological opponents. Culturally, too, it was a bold move. By the early eighteenth century the dominant cultural tone was set by the Enlightenment – the intellectual movement, inheriting the ideals of the Renaissance and committed to

28
The Gothic
Temple,
Shotover
Park,
Oxfordshire,
1716–17

advancing the cause of rationalist and scientific inquiry in every field of human activity. Its official aesthetic was classicism, led in British architecture by Palladianism, the severe classical style, symmetrical and strictly proportioned, derived from Vitruvius via the work of Andrea Palladio (1508–80). In such a context artistic and architectural refinement, the whole concept of 'taste', was aligned with intellectual advance, with enlightenment itself. Gothic, freighted with all its derogatory Renaissance connotations, was inevitably disparaged. When architects adopted gothic it was to harmonize with existing buildings: at Oxford Christopher Wren (1632–1723) used it for Christ Church's Tom Tower (1681–2), 'to agree with the Founder's work'; and Nicholas Hawksmoor (1661–1736) seems to have changed to gothic in rebuilding All Souls' (from 1716) in response to the college's medieval setting. In other contexts, 'gothic' signified lack of civilization, even social boorishness. In William Congreve's *The Way of the World* (1700), the sophisticated Mistress Millamant rejects her country cousin: 'Ah, rustic, ruder than Gothick.'

The building of the Shotover Temple was, then, a defining moment in the development of the Gothic Revival. It initiated an eighteenth-century fashion for erecting gothic buildings in the grounds of country houses: a fashion, but not superficial – despite the label 'follies' familiarly tagged on to many of its products. Although often whimsical, garden gothic engaged issues of great social, political and cultural moment. It did so in ways architecturally new, crucially distinct from seventeenth-century revivalism which, because of its ideological imperatives, always had reference to established medieval building types, principally churches and university colleges. Garden buildings had no medieval tradition to imitate and evoke. Shotover's gothic thus liberated medieval style from the contexts prescribed by medieval buildings. Abstracted in this way, gothic became a repertoire of formal elements – pinnacles, tracery, pointed arches – that could be endlessly recontextualized, never wholly losing their evocative reference to the past, but capable of semantic adventure, of assuming a new range of identities for the present.

29
Roger
Morris,
Gothic tower,
Whitton
Park,
Middlesex,
1734–5.
Engraving by
William
Woollett,
1757

The meanings Tyrrell put into his Gothic Temple recur in the extraordinary walls and bastion towers erected around the park of Castle Howard, Yorkshire (from c.1726). Like the house itself, designed by Sir John Vanbrugh (1664–1726), they are Baroque in handling, but their details are taken directly from gothic castles and may have been designed by the eccentrically gifted Hawksmoor. The seat of the Howards was one of the principal Whig strongholds in northern England, and its medievalizing bastions trumpet the fact. Where the Shotover Temple, its owner a scholar and antiquarian, invites us to contemplate the origins of gothic freedom, Castle Howard's ramparts evoke gothic in its military aspect, implying both a history of struggle and the need to defend hard-won constitutional liberties. The meditative and the martial were also combined in the long-demolished gothic tower built in 1734–5 at Whitton Park, Middlesex, for Archibald Campbell, the third Duke of Argyll – one of the grandest of Whig grandees. Sited at the end of a formal canal, the tower, built by Roger Morris (1695–1749), was triangular in plan with circular turrets and gothic windows (29). Like the Shotover Temple, the tower was the garden's compositional and contemplative

30
James Gibbs, The Temple of Liberty, Stowe, Buckinghamshire, 1741

focus – an object of reflection mirrored in water so that it becomes a reflected object, and a structure in which reflection can occur. Its military associations were inseparable from the constitutional history its gothic connoted. Giving views over all the surroundings, Whitton was the first free-standing Gothic Revival tower in Britain: a gothic structure offering a panorama of the countryside. The builders of that other gothic construction, the epic story of British political liberty, surveyed the historical panorama of the nation in much the same way.

Gothic meanings become fully explicit in the Temple of Liberty (1741), designed by James Gibbs (1682–1754) for the grounds of Stowe, the great house of Richard Temple, Viscount Cobham, in Buckinghamshire. Triangular like Whitton, but intricately showy in its varied towers and elaborate elevations (30), the Temple's gothic semantic, announced in its very name, had a sharply contemporary political focus. In the 1730s the Whigs split over the

policies of the prime minister, Sir Robert Walpole, whose closeness to the court was seen by his opponents as a threat to the free institution of parliament itself. Cobham led the Whig opposition. The Temple of Liberty was a combative restatement of the gothic inheritance Walpole had jeopardized, and its hilltop was originally shared by statues of the seven deities of Saxon England. 'Ador'd Protectors once of England's weal', enthused the versifier Gilbert White, 'Gods of a nation, valiant, wise, and free, / Who conquered to establish Liberty!' The site's composite meaning was amplified by an inscription in the Temple: 'I thank God that I am not a Roman'. Ostensibly an affirmation of Protestant independence against Roman Catholic absolutism, it also celebrates the happy Saxon inheritance of being a freedom-loving goth, not a subject of imperial Rome. And who is the 'I' that is 'not a Roman'? In part the building itself, the gothic edifice – material and metaphorical – that is so defiantly unRoman; in part the inferred visitor, the Briton who can congratulate himself on his Saxon birthright; and, uniting both, it is Richard Temple, Viscount Cobham, who both built and *was* the Temple of Liberty.

Versions of gothic Britishness, such as that promoted by the Temple of Liberty, constituted a Whig claim on national history, an ideological appropriation of the medieval past. It did not go unchallenged. In the 1720s, at Cirencester Park, Gloucestershire, the Tory Lord Bathurst erected a battlemented lodge known variously as Alfred's Hall and King Arthur's Castle. Whigs and Tories alike were fond of Alfred the Great, a model patriot king who served a free Saxon polity: he appears, for example, in the classical Temple of British Worthies at Stowe, and is also commemorated in the gothic Alfred's Tower (1762) built at Stourhead by the Tory banker Henry Hoare. For good goths, however, Arthur was much more problematic, for his kingship was sanctioned by divine authority rather than parliamentary credentials. Which is why Arthurian references abounded in one of the oddest garden buildings, Merlin's Cave (31), a rustic gothic pavilion at Richmond designed in 1733 by William Kent (c.1685–1748) – of whom more later – for Queen Caroline, the

consort of George II (r.1727–60), with her protégés, the poet Stephen Duck and his wife, installed as caretakers. Visitors to the Cave were treated to a tableau of wax figures, from Merlin to Queen Elizabeth, duly explicated by the attentive Mr and Mrs Duck. The symbolism of this bizarre anticipation of Disneyland claimed that the Hanoverian line descended from King Arthur, thus giving a strongly royalist slant to Britain's gothic history.

The detailed political meanings of these garden buildings reveal both the vital role of ideology in gothic's eighteenth-century revival, and the style's flexibility as a vehicle for association and symbolism. However, political competition over the gothic inheritance increasingly occurred within a broader consensus that to build in gothic was to say something about being British; that gothic, redolent of the country's history and thought of as indigenous, was a national style. It was also, thanks to the creation of the naturalistic landscaped park in the 1730s, increasingly recruited into the world of Nature.

Before this time, seventeenth- and eighteenth-century English gardens, such as those at Shotover and Whitton, were formal in their planning, their layouts derived from precedents set by Italian and French classicism. A geometry of straight lines demarcated the grounds of the country house from the countryside in which it sat. From the 1730s, however, all this began to change. The invention of the ha-ha, a concealed ditch that served to keep livestock out of parks and gardens, made it possible to dispense with enclosing walls and fences so that the immediate grounds of the house appeared to open out to the rural setting. Inside the park, the high formality of the classical garden was abolished: serpentine paths replaced straight walks; trees were planted in clumps or dotted about singly, rather than marshalled into avenues; meandering streams were introduced instead of fountains and cascades; irregular lakes and pools replaced canals. In short, the landscaped park was created.

Naturalistic landscaping engineered a visual and conceptual interplay between the house, its park and the larger rural setting.

31
William Kent, Merlin's Cave, Richmond, 1733. Engraving by T Bonles from *Merlin or The British Inchanter and King Arthur, The British Worthy*, 1736

32
William Kent, *View from the Vale of Venus, Rousham, Oxfordshire, c.*1740, showing the gothic eyecatchers. Pen and wash on paper; 31·7 × 43·2 cm, 12½ × 17 in. Private collection

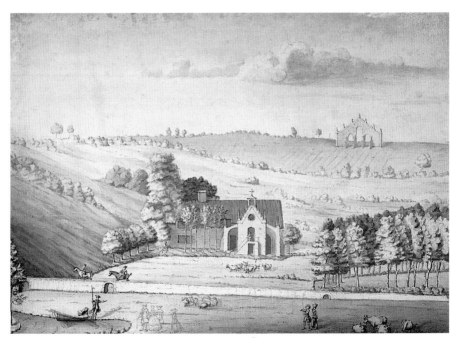

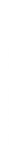

In the famous phrase of Horace Walpole – to whom we will return – it was William Kent who first 'leaped the fence, and saw that all Nature was a Garden'. In landscaping Rousham, Oxfordshire (1737–40), probably his most comprehensive scheme, Kent included two so-called eyecatchers in the gothic style: the Chapel of the Mill, with quatrefoil (four-lobed) windows and a pinnacled gable, and, on a hill beyond, a free-standing triple arcade (32). Compositional focal points, located beyond the garden proper, they take the eye out of the landscaped grounds and into the surrounding countryside. Though without the overt political significance of the gothic at Shotover or Stowe, the Rousham eyecatchers also work ideologically.

The landscaping aesthetic Kent initiated disposed the country house park with ever greater 'naturalness', while shaping and planting the surroundings to create scenic vistas, so the whole became a seamless composition of apparently natural features. The necessary precondition for any of this was that the land, the eighteenth century's primary source of wealth and political power, should be owned. But where classically-inspired formal design had stressed proprietorship by sharply distinguishing between aristocratic park and agrarian setting, landscape design disguised the fact. Ideologically, it made the park and the big house appear natural, and thus inevitable, parts of the British countryside. At Rousham, and many later gardens, the gothic structures mediated between the physical domain of ownership and the terrain outside. Appropriately so, for landowning was integral to gothic theory, and the style's supposedly uncivilized origins aligned it with rusticity. So gothic's identity as a national style, its connotations of Britishness, fused with its identity as a natural style. It thus belonged to 'the country' in two senses: to the historical entity that was the state, the country of Great Britain; and to the rural terrain that made up the British countryside. In gothic, history and nature became one. And that fusion served the dominant class, the landed interest that owned 'the country', for it fostered the myth that their power, the outcome of human agency working through history, was

simultaneously the creation of nature. In short, that they were the country's natural governors.

Developments in political discourse helped the myth along. In particular, the opposition between gothic and feudal polities, so important in the previous century, started to dissolve. Works such as Thomas Madox's *Baronia Anglica* (1736) saw constitutional progress as a continuum reflecting changes in land ownership, with councils and parliaments, whether gothic or feudal, as the means for representing the interests of property. So the tribal gatherings of Saxon England and far-off Germania turned out to have had no taint of democracy after all, but to have been assemblies of a primitive landowning nobility. The product of liberty, the product of property, national and natural, what better style than gothic to grace the grounds of a country seat? A number of other changes in the 1730s and 1740s helped consolidate and develop the emerging elements of the gothic semantic. Palladianism was losing its first force, subverted by the naughty curves of the rococo style. Nature cried out against the confines of Palladio's austere geometry, and patriotism similarly protested against coercion by a foreign code of conduct: the revival of gothic, natural and national, benefited on both counts.

As we saw earlier, the defeat of the Jacobite rebellion in Scotland in 1715 had helped occasion the first gothic garden structure, Shotover Temple. In 1745–6, in a final attempt to put the Stuarts back on the throne, Scottish Jacobites rebelled again, eventually to be crushed at the Battle of Culloden. Once more, gothic celebrated Stuart defeat. On his estate at Richmond, Yorkshire, the local MP John Yorke built an octagonal gothic tower, probably designed by Daniel Garrett (d.1753), and called it the Culloden Tower (33) to celebrate that decisive and bloodily one-sided battle. Around the same time at nearby Aske Hall, one of Yorke's relations, Sir Conyers D'Arcy, employed Garrett as architect of a gothic temple, a martial affair impressively defended by circular bastions. In 1751 at Gibside, Co. Durham, owned by the arch-Whig George Bowes, it was Garrett again who designed a gothic

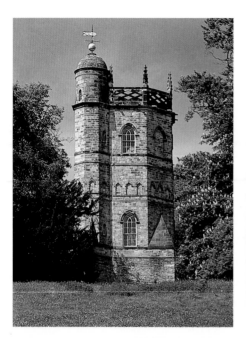

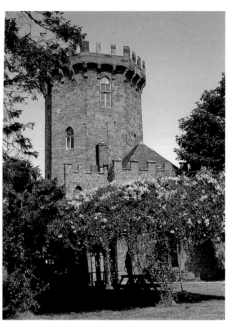

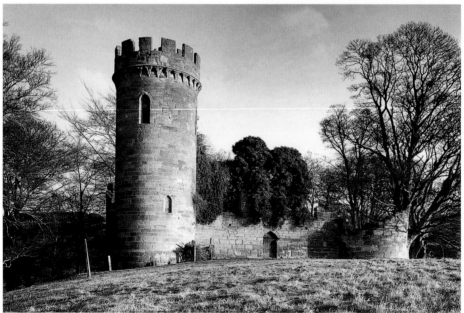

banqueting house, set in a naturalistic landscape and purposively aligned with a giant column, rising to 42·6 m (140 ft), surmounted by a gilded statue of British Liberty. Similarly, on the Hanoverian home turf of the Great Park of the royal castle at Windsor, the younger son of George II, the Duke of Cumberland himself, the victor of Culloden whom the Scots rightly called 'Butcher', built a triangular gothic tower, and gave Cumberland Lodge a gothic front facing an obelisk erected to commemorate his victory.

These were exercises in Hanoverian triumphalism, but the rebellion of 1745 may also have triggered a very different development in garden gothic. In 1746–7, a Warwickshire squire with a taste for literary antiquarianism and medieval architecture, Sanderson Miller (1716–80), built a large octagonal tower on his Radway estate (34), overlooking the battlefield of Edgehill. The design clearly derived from the fourteenth-century Guy's Tower of Warwick Castle – the first gothic garden structure to be based on a specific medieval source. The tower, the site and the date link disparate times and places in a dramatic narrative. As Culloden determined the issue between Hanoverian constitutional liberty and Stuart absolutism, Miller built a gothic tower marking the site of the first English Civil War battle, taking its design from a medieval castle whose most famous lord had been Richard Neville, Earl of Warwick – whose control of the throne during the Wars of the Roses (1455–85) earned him the title 'Kingmaker'. The Radway tower invites us to contemplate the drama of the making and unmaking of kings and constitutions, played out within the terms of gothic and feudal principles, from the Wars of the Roses, to the Civil War, to the tragedy of Culloden. And the mode of historical engagement it offers is reflective, not triumphalist: it takes no sides.

Miller reinforced the contemplative character of the Radway tower by adding a smaller square tower and a run of broken wall, creating a group that looked like a ruin, a fragment from some long-abandoned medieval building. The evocative power of ruins was familiar from the classicist landscape paintings of Claude

33
Daniel
Garrett,
The
Culloden
Tower,
Richmond,
Yorkshire,
c.1746

34
Sanderson
Miller,
The Tower
and
associated
group
of ruins,
Radway,
Warwick-
shire, 1746–7

35
Sanderson
Miller,
Hagley
Castle,
Hagley Hall,
Worcester-
shire, 1748

Lorrain (*c*.1604–82) and Nicolas Poussin (1594–1665), and Miller injected this into gothic's growing identity as a national style. The result was a new class of landscape structure which, as Miller's neighbour, the poet and landscape gardener William Shenstone remarked, could 'turn every bank and hillock … into historical ground'. Ruins enabled landowners to invent English history – both discover it and make it up – on their own estates. Miller designed another ruin, started in 1748, for Sir George Lyttelton, at Hagley Hall, already celebrated as a landscaped garden. With one turreted tower and the shattered stumps of others, Hagley Castle (35) was conceived with considerable dramatic flair, drawing from Horace Walpole the famous remark, 'it has the true rust of the Barons' Wars.' The comment is not as casual as has usually been thought. The Lytteltons had links back to the constitutional struggles of the thirteenth century, of which the Barons' Wars (1263–7) – a key episode in gothic history – were a part. And Sir George himself was associated with Viscount Cobham, who built the Temple of Liberty, as a defender of parliamentary rights. By virtue of its associations, Hagley Castle connected Lyttelton's current championship of liberty with the family's claim on gothic history, and in the process turned Hagley Hall 'into historical ground'.

In the third quarter of the century, gothic ruins of every ramshackle variety rose in landscaped parks and gardens across the country. The tottering fragment of wall and traceried window built in 1747 in Mount Edgcumbe Park, high above Plymouth Sound, is one of the earliest and most elegant; and one of the biggest is the 1768 castle at Wimpole, Cambridgeshire, by James Essex (1722–84) – a round tower peppered with windows, surrounded by a riot of broken walls. There are many more. The passion for artificial dereliction also encouraged an appreciation of the actual ruins of medieval buildings, particularly monastic remains (36). Between the 1750s and 1770s, the skeletons of Rievaulx, Fountains and Roche, once great Yorkshire abbeys, were all preserved as thrilling exhibits in newly landscaped parks.

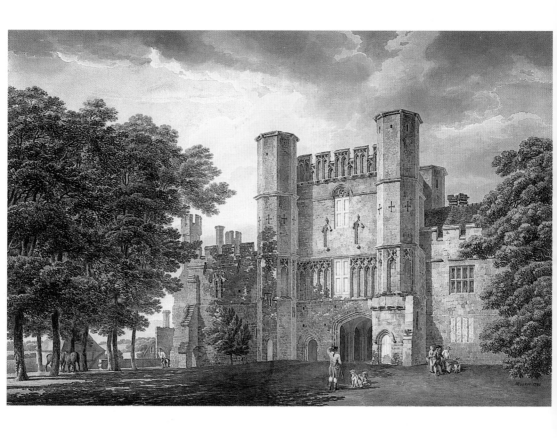

**36
Michael
'Angelo'
Rooker,**
*The Gatehouse
of Battle Abbey,
Sussex,* 1792.
Pencil and
watercolour
on paper;
41·8 × 59·7 cm,
16$\frac{1}{2}$ × 23$\frac{1}{2}$ in.
Royal
Academy of
Arts, London

The ground that could be made historical by ruins potentially covered the whole of Britain. Freed from dependency on a particular spot, history became transferable, a cultural liquid asset circulating throughout the country. Moreover, because gothic fused history and nature, and ruins were evidence for the natural workings of time, Britain itself became a product not just of history but also of nature. But ruins also turned history into an aspect of property, which was the precondition for its circulation as a cultural asset: 'historical ground' could be anywhere or everywhere, but always had to be owned by somebody. And as landscaping naturalized the possession of land, so ruins natural-ized the possession of history by landowners. Literally and metaphorically, the past could become part of their property, for property extended in time as well as space.

The great decades of gothic ruin-building brought a major expansion in other types of garden gothic. In many, perhaps most, gothic connotes a blend of history, nature and Britishness, which was certainly imprecise but culturally and ideologically potent. Imprecision, indeed, made it easier for estate owners to put the style to new associative uses. For example, a number of gothic garden buildings near Bristol – the prettily fenestrated pavilion at Frampton Court (1752), the prospect rotunda at Goldney House (1757), at Henbury the triangular tower known as Blaise Castle (1766) – were built with money that came from commerce. In part their gothic style associated new wealth – or wealth not initially derived from land – with a past the landed class claimed as its own. But more important was gothic's iden-tification as a national, and thus patriotic style. For commerce, by the mid-century, was being promoted as a patriotic activity. The widely-read James Thomson was its bard, as also, in his poem *Liberty* (1735–6), he was a vigorous exponent of English freedom's gothic pedigree: the Saxons, 'Untamed to the refining subtleties of slaves', had 'brought a happy government … Formed by that freedom which … Impartial nature teaches all her sons.' The national genius, he said, particularly suited commerce, whose benefits Britain had generously bestowed on the world.

From such a viewpoint, the port of Bristol's overseas trade was a national enterprise of the first magnitude, and its mercantile men, building their garden gothic, were justified in using the style to demonstrate the patriotism of profit. With its basis in foreign trade, the British Empire was also a candidate for gothic celebration, particularly after the unprecedented success of the Seven Years' War (1756–63), a conflict involving all the major European states in which Britain, at France's expense, became the dominant colonial power in Canada, India and the Caribbean. The colossal and much-turreted Racton Tower, Sussex (1771), was designed by Theodosius Keene for the second Earl of Halifax, whose success in expanding commerce with America earned him the title 'Father of the Colonies'. And the Haldon Belvedere at Dunchideock, Devon (1788) was built to commemorate another imperial patriarch, General Stringer Lawrence, called the 'Father of the Indian Army'. Standing high on the Haldon Hills, its panoramic views over the country exemplify the conflation of rural terrain and the nation described earlier, and imply an extension into the illimitable prospects – both vistas and opportunities – of the Empire that beckons beyond the horizon.

37
Tearoom,
Pitchford
Hall,
Shropshire,
*c.*1760

Balancing such literal and metaphorical expansiveness are the gothic seats and shelters, summer houses, gates and gazebos, built in the grounds of so many country houses. Out of hundreds, a few examples will indicate the variety. Painshill, Surrey has a Gothic Tent – an octagonal canopy pierced with ogee (double curved, bending one way and then the other) arches and quatre-foils – dating from the 1740s; Princess Amelia, daughter of George III (r.1760–1820), embellished Gunnersbury Park from 1765 with structures that included a gothic bath-house and dairy; variously dated between the 1750s and 1770s is the extravagant collection of gothic allsorts – bridges, gateways, pinnacles, arches, a barn like a toy church – that Viscount Limerick scattered round Tollymore Park, the centre of his Irish estates; and returning down the scale from ostentation to modesty, there is the daintily decorated tearoom of about 1760 at Pitchford Hall, Shropshire, remarkable only because it perches in the branches of a tree (37). For people building, using, or just looking at garden structures like these, gothic probably carried only the most general associations: a graceful historical reference here, a touch of natural style there. A far more explicit sense of historical and stylistic continuity accounts for gothic's adoption in the grounds of actual medieval buildings, particularly castles. This category includes the gothic seat designed by Garrett in 1752 for Raby Castle, Co. Durham; the battlemented hunting-lodge (1764–6) at Warwick Castle; and the strikingly exuberant Brizlee Tower (1781) that Robert Adam (1728–92) designed for the grounds of Alnwick Castle, Northumberland (38).

38
Robert Adam, Brizlee Tower, Alnwick Castle, Northumberland, 1781

Meanwhile, as garden gothic assumed its many different shapes, there were buildings that sustained those explicitly political meanings first announced at Shotover. At Uppark in Sussex, the staunchly Whig Sir Matthew Fetherstonhaugh employed Henry Keene (1726–76) to design the Vandalian Tower, commemorating his involvement in a utopian scheme to establish a new American settlement, Vandalia. The name carries a prodigious political freight, for gothic history credited the Vandals next to the Goths themselves with overturning the Roman Empire; as free

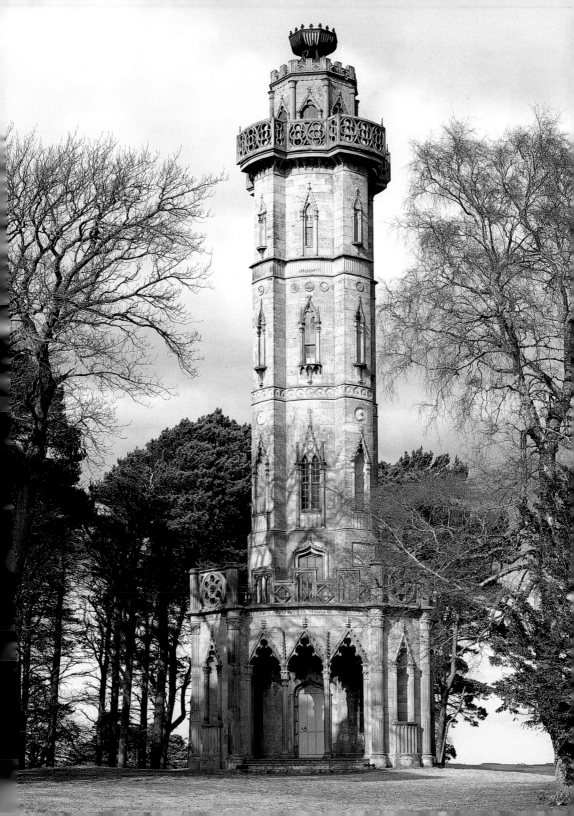

Germanic tribes had repeopled the Old World, so Vandalia would people the New. Ironically, the scheme collapsed when Americans took a more direct route to a rosy future by seeing off the British Empire in the American War of Independence (1775–81). The American cause found an unlikely supporter in Charles Howard, eleventh Duke of Norfolk, a radical with a passion for gothic political theory. On the family's Lake District estates in 1780 he built a gothic hunting-box called Lyulph's Tower after a local Saxon hero. He followed it up, around 1785, with two gothic farmhouses, probably designed by Francis Hiorne (1744–89): named Fort Putnam and Bunker Hill after the American general and his famous victory (1775), their style subversively recruits the American Revolution into the gothic saga. Inheriting his title and the family seat of Arundel Castle, Sussex in 1787, the Duke immediately signalled his political and stylistic intent by building the gothic Hiorne's Tower, named in memory of the architect. He then embarked on rebuilding Arundel Castle as a vast Gothic Revival fortress, laying the foundation stone of the Barons' Hall, the ideological core of the whole complex, in 1806. Its dedicatory Latin inscription begins: 'To Liberty, vindicated by the Barons in the reign of John ...'.

Evidently, by the mid-eighteenth century, a landed gent of either Whig or Tory persuasion could find satisfaction in surveying the country from his gothic tower, or flirting with gothic history in a ragged ruin on the margin of his park. Nevertheless, in the design of the country house itself, Palladian classicism was paramount: symmetrical elevations, scrupulously proportioned, the entrance front centred on an imposing pedimented portico, the plan symmetrical too, often disposed around a grand hall. Dignified, rational, convenient, backed by an authoritative body of theory, it had all the prestige deriving from the Renaissance and from the European Enlightenment. Landowners endorsed the dominant aesthetic: it was one of the badges of belonging, a mark of solidarity. Even Sir George Lyttelton, builder of Hagley Castle, was persuaded out of a gothic scheme for the great house of Hagley Hall and settled for Palladianism.

Gothic, however, had one prize asset that classicism did not: direct access to the immense imaginative resource of British history. Garden gothic rose by the power of historical association – national, patriotic and increasingly naturalized. The building of gothic ruins created 'historical ground'. Translated into domestic architecture, into the big house itself, gothic could imply a lived heritage, a family's active and continuing engagement in the historical drama of making the nation. Helping to sustain such claims were the genealogical and heraldic records accumulated, and sometimes fabricated, by antiquarians. The period that brought revived gothic to country house design was also the great age of English local and county history – from Sir Robert Atkyns' *The Ancient and Present State of Glostershire* (1712) to the twelve volumes of Edward Hasted's *History and Topographical Survey of the County of Kent* (1797–1801). Quite as important was the *Gentleman's Magazine*, beginning its long run in 1731, its rather smudgy columns packed with details of ancient families, scraps of old documents, heraldic gleanings from tombs and stained-glass windows. Here, in the crabbed pages of the antiquaries, often on a parish-by-parish basis, were the minutiae of the private and public history that tied a propertied class, temporally and geographically, to its place in the country.

Much of this is evident in the eighteenth century's first revived gothic house, Clearwell Castle, Gloucestershire (1727), designed for Thomas Wyndham by Roger Morris – the architect of the Whitton tower (see 29). Clearwell (39) is symmetrical, as one would expect in a classicizing age, but all its features are gothic, from crenellated parapet to buttresses and mullioned windows (40). Its stylistic character, however, is allusive rather than imitative. The Wyndhams were gentry of long standing, settled across half a dozen English counties: Clearwell's gothic established an appropriate framework of historical reference and heraldry located the family within it. The Wyndham's lion's head crest is carved on every other merlon (solid section) of the battlements (41), their arms embellish gateways and curtain (connecting) walls. Such a mix of general medieval style and specific heraldic

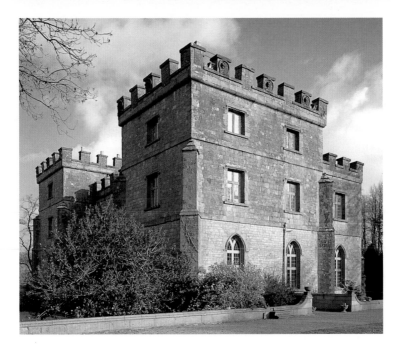

39
Roger
Morris,
Clearwell
Castle,
Gloucester-
shire, 1727

display became a paradigm for the Gothic Revival house, for it
promoted a key element in the value system of landed property:
the conviction that the dynastic family was intrinsic to the
historical continuity of the nation itself, both its product and
guarantor.

Clearwell seems to have been little known. Far more celebrated
were William Kent's exercises in domestic gothic, such as the
remodelling of Esher Place, Surrey (1733); a recladding of
the house at Rousham (1738); and his unexecuted designs for
similarly recladding Honingham Hall, Norfolk (42). Importantly,
the original style of all four would then have been identified as
gothic. The first one was medieval, the second two Jacobean,
thought of as a kind of gothic hangover. So there was stylistic con-
sistency, even a nascent historicism, in Kent's approach. He had,
however, no sense of – or no interest in – gothic as a system of
construction. Rather, Kent's gothic was a stylistic skin stretched
over the structural bones of a building, and in formal terms was
straightforward enough: a number of basic elements – ogivally
headed windows and doors, quatrefoils, dripstones (projecting

mouldings to throw off water) and string courses, battlements – manoeuvred into symmetrical elevations. This set of gothic features constitutes a repertoire, a selection of forms and motifs that collectively connote gothic style. Tyrrell's Gothic Temple (see 28) has similar characteristics, as too has Jackson's Brasenose fan-vault (see 18). But Kent's use of the repertoire systematically to replace earlier features of an existing building with gothic of his own devising represents a new development.

Paradoxically, though Kent took as his point of departure buildings understood as being in the gothic style, the act of revival did not necessitate the preservation of those architectural features that identified the buildings as gothic in the first place. As the reader will recall, it was not enough that the battlefield of Edgehill was historic: Miller had to build his tower, make an explicit cultural intervention, before the site was recognized as 'historical ground'. So also with the buildings Kent remodelled. It was not enough that they were old and gothic: their antiquity and gothicness had to be announced, signalled, through an act of style. History, in this context, was accidental, a contingency of time and place. Style, by contrast, was purposive. Kent's

40–41 Roger Morris, Clearwell Castle, Gloucestershire, 1727 **Right** Mullioned window **Far right** Lion's head crest on the battlements

70 80 90 100 foot

42
**William
Kent,**
Unexecuted
design for
gothicizing
Honingham
Hall,
Norfolk,
1738.
Pen, pencil
and wash on
paper;
33 × 49 cm,
13 × 19¼ in.
Royal
Institute
of British
Architects,
London

repertoire gothic, as we might call it, was not designed to repli-
cate a building's stylistic character, but to reinvent it; and by
reinvention to isolate and intensify a desired historical identity.

The nature of that identity is clearly laid out by an anonymous
contributor to the *Gentleman's Magazine*, writing in 1739.

Methinks there was something respectable in those old hospitable
Gothick halls, hung round with the Helmets, Breast-Plates, and Swords
of our Ancestors; I entered them with a Constitutional Sort of Reverence
and look'd upon those arms with Gratitude, as the Terror of former
Ministers and the Check of Kings ... Our old Gothick Constitution had
a noble strength and Simplicity in it, which was well enough represented
by the bold Arches and the solid Pillars of the Edifices of those Days.

Here, of course, is the tradition of gothic constitutional liberty,
inherited and safeguarded by the owners of the 'Gothick halls',
which have characteristics – 'hospitable', 'bold', 'solid' – that
are really moral qualities attributable to the original builders,
the martial race whose weapons were 'the Check of Kings'. The
associative process is seamless: the moral constitution of 'our
Ancestors' was expressed through a political constitution,
exemplified in its turn by the architectural constitution of their
houses. People, polity and buildings share the same 'noble
strength and Simplicity', and occupy an identical space within
the gothic semantic. Kent's repertoire gothic points to this same
cluster of meanings. At its core, consolidated by gothic's identity
as national and natural, is a myth of British character.

Precisely the roughness and unsophistication that Congreve's
Mistress Millamant found so deplorably 'gothick' in 1700, have
turned into virtues, supposedly the Briton's peculiar inheritance
from an illustrious medieval past. Britain by the 1730s was fast
emerging as an international power, and increasingly vying with
France for pre-eminence among the nations of Europe. The
mythology of national character that accompanied this rise had
at its heart the double inheritance of gothic liberty at home and
medieval military prowess overseas – which, by including the

Elizabethan period, could conveniently encompass naval power. Domestic history was configured around the freedom-loving lineage of Saxon assemblies, Magna Carta and constitutional government; and abroad, around the glorious trouncing of foreigners, especially Frenchmen, on fields such as Crécy (1346), Poitiers (1356) and Agincourt (1415). Gothic was acquiring a more aggressive identity: not just national, but nationalist. It was for a play of 1740 about King Alfred, hero of gothic constitutionalism and founder of the navy, that James Thomson penned the chorus, 'Rule, *Britannia*, rule the waves; / *Britons* never will be slaves.'

From the early 1740s the revival of domestic gothic becomes recognizable as a distinct architectural movement, concentrated initially on the stylistic reworking of earlier buildings. Sanderson Miller was a pioneer, starting with his own house Radway Grange (1744–6), to which he added a medley of gothic features. Similar gothic elements recurred in his other designs: for example, at Arbury Hall, Warwickshire (1746), where his work constituted the first phase of a lavish gothicizing; at Adlestrop Park, Gloucestershire (1750–9); and at Lacock Abbey, Wiltshire (1754). This last, carried out for John Ivory Talbot, is one of the most interesting of Miller's houses, with a gothic great hall (43) as the centrepiece, its coved ceiling decorated by heraldic shields set in frilly plaster quatrefoils, its walls sporting canopied gothic niches with terracotta busts and lively statues. Lacock had been a medieval Augustinian priory, and seems to be the first substantial example of revived domestic gothic applied to a building that was originally monastic. Moreover, the heraldic display in the great hall associates the Talbots with the priory's founders and patrons, some of whom are represented in statuary. Heraldry, sculpture and gothic style conspire to propose an orderly historical process by which the past has evolved into the present, carrying with it the ownership of land, for the eighteenth-century estate was substantially that of the medieval priory. What is elided is the historical truth: the violent act of appropriation, whereby Lacock, like all the property of the religious orders, was seized into secular hands.

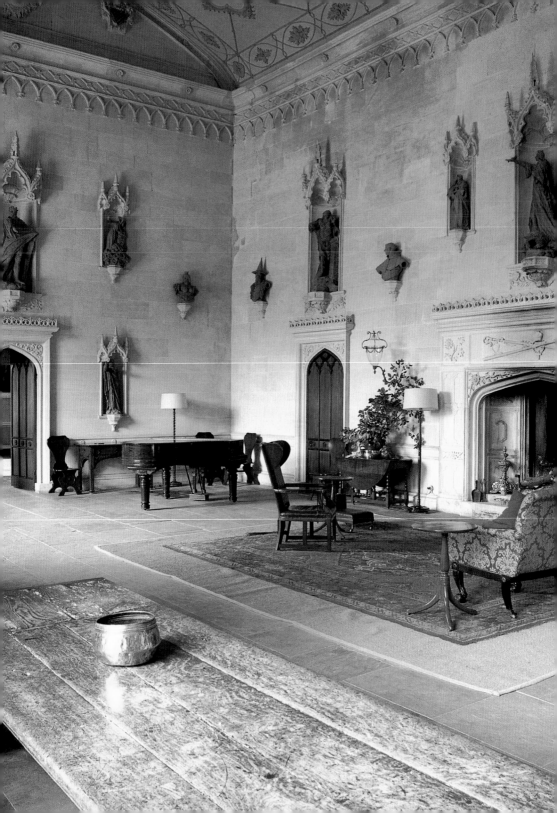

Other architects began to pick up on domestic gothic from the mid-century. Daniel Garrett – whose garden buildings were discussed earlier – designed the gothic Hunter's Gallery at Raby Castle, Co. Durham (1751–3), and gothicized the great house of Kippax Park, Yorkshire (c.1752), now demolished. James Paine (1717–89), one of the most prolific country house architects, did several small-scale gothic jobs, including the library (c.1752) at Felbrigg Hall, Norfolk, before undertaking the restoration and remodelling of Alnwick Castle (from 1756) for the Duke of Northumberland. The castle's historical importance and the prestige of its owner contributed largely to the establishment of medieval revivalism in northeast England. In the grounds Robert Adam built garden gothic, but he also concocted an extravagant suite of gothic interiors, with fan-vaulted ceilings and filigree tracery smothering every surface, all done in plasterwork set off by a cheerfully unmedieval colour scheme.

43
Sanderson
Miller,
Great Hall,
Lacock
Abbey,
Wiltshire,
1754

The Alnwick interiors were later lost in Victorian alterations, but equally fantastic gothic interiors survive at Arbury Hall. Miller's work of 1746 opened a campaign of remodelling and decoration that occupied the owner, Sir Roger Newdigate (1719–1806; 45), for much of the rest of his life. He designed most of it, working with a succession of architects of whom the most important was Henry Keene, Surveyor to the Fabric of Westminster Abbey and – somewhat incongruously – designer of the Vandalian Tower. Newdigate's pursuit of gothic at Arbury had a peculiar single-mindedness. All the external elevations are differently handled and of different dates, the most ambitious being the cloister-like south front (44). But it is the sequence of interiors and the cumulative richness of their plasterwork that make Arbury unforgettable: from the library (1754–61), its bookshelves ranged under ogival arches set within panels of Tudor tracery, to the dining room (from 1765) and the climactic saloon (1776–86), both fan-vaulted in the manner of the Henry VII Chapel (see 2), but out-elaborating the original in the crowded intricacy of the detail (46). Arbury's influence on the Revival was limited. Perhaps unsurprisingly, for it strikes me as a house that is passionately

personal, the slightly unnerving outcome of a private fascination, as if Newdigate had spun himself an inner world of gothic lace-work. Arbury had one offspring, however: 18 Arlington Street, London (1760), the interiors – including a fine stair hall panelled with plaster tracery in a late fifteenth-century style – designed by Newdigate himself for his sister-in-law, the Countess of Pomfret, an early enthusiast for all things medieval. Shamefully, it was demolished in the 1930s. It was probably the only medieval-style house erected in eighteenth-century London – evidence of how far gothic was construed as rural rather than urban, identified with the naturalized order of country landowning (which funded so many of the smart town-houses in the Georgian city).

Although few aspired to Arbury's elaboration, gothic's use as an interior decorative style, particularly in plasterwork, spread quite widely from the 1750s. The style's antiquarian associations gave it a certain popularity for libraries: Felbrigg Hall has already been mentioned, and there are other examples at Malmesbury House, Salisbury (c.1750; 47), and Milton Hall, Berkshire (1765). Not infrequently the cusped and curving lines of gothic slid into the sinuosities of rococo, the decorative manner associated with landscape naturalism and derived from Baroque: elegantly inventive at Alscot Park, Warwickshire (from c.1752), feverishly busy in the Gothic Room of Claydon House, Buckinghamshire (from c.1757). Chimneypieces were frequent recipients of gothic detailing, and gothic elements often got into ceiling decoration, though plaster recreations of the three-dimensionality of gothic vaulting were understandably rare. An unusual effort is in one of Ireland's first Gothic Revival houses, Castle Ward, Co. Down (1760), where the sitting room ceiling is formed of inverted ogees, bulging blowsily in fishnet tracery.

Within the broad cultural and historical associations gothic accumulated, the domestic style must have had personal mean-ings for the people who adopted it, recoverable now only by inference. Behind individual choices hide individual motives. Even so, it is clear that the semantics of gothic were sufficiently

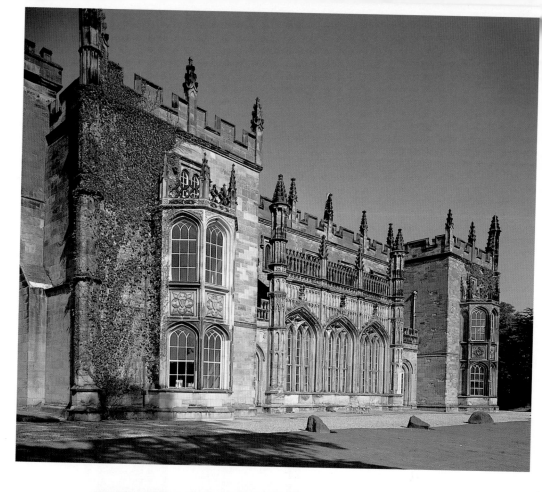

44
South front,
Arbury Hall,
Warwick-
shire, from
1746

45
Arthur
Devis,
Sir Roger
Newdigate in
the Library
at Arbury
Hall, c.1757.
Oil on
canvas;
89×76·2cm,
35×30in.
Private
collection

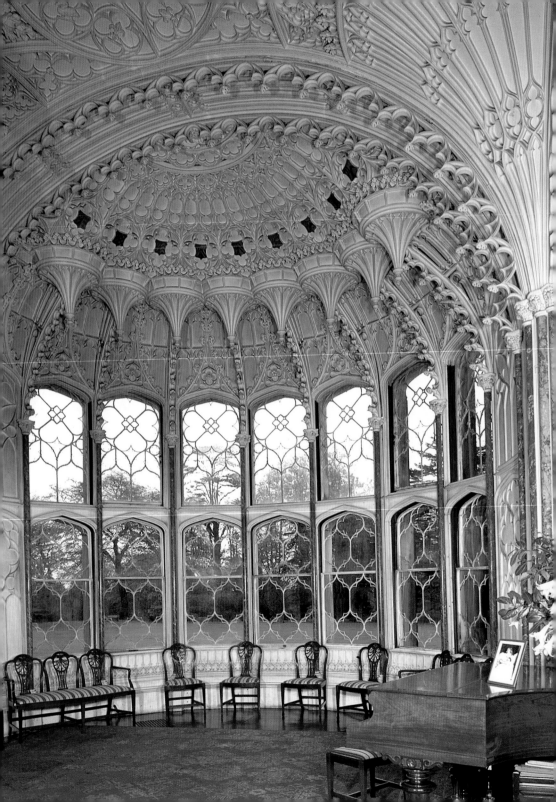

flexible to satisfy a diverse range of them. Newdigate, for instance, was a High Tory and probably a Jacobite sympathizer. He was educated at Oxford, later becoming its MP for thirty years, and gothic meant for him, I think, what it had for the university in the seventeenth century: the medieval authority of Church and King, and ultimately the divine right upon which monarchical power rested. It is suggestive that fan-vaulting, spectacular and artfully significant in Oxford's gothic, reappears as a dominant motif at Arbury. By contrast, the strikingly early gothicizing of Hampden House, Buckinghamshire (from c.1738), resonates at the other end of the political scale. Possibly carried

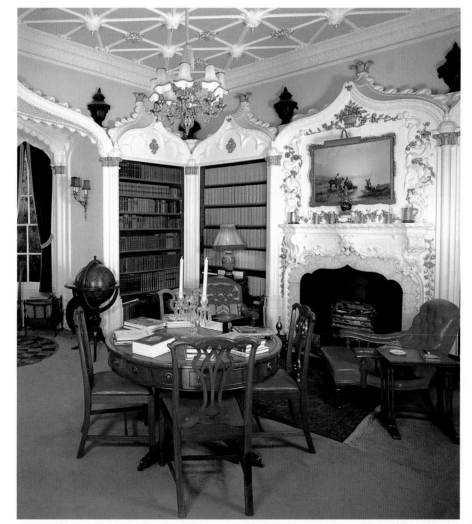

46
The Saloon, Arbury Hall, Warwickshire, 1776–86

47
The Library, Malmesbury House, Salisbury, c.1750

out to the owner's designs, it is a thorough job: crenellations,
ogee-headed windows, the entrance set within a huge pointed
arch (48). The house had belonged for generations to the
Hampden family, and had been the home of the most celebrated
of seventeenth-century parliamentarians, John Hampden, whose
opposition to the crown made him one of the Civil War's earliest
martyrs. In 1743, the centenary of his death, he was commemo-
rated by an eloquent monument in Great Hampden church;
the contemporary remodelling of his house was also, surely,
commemorative, celebrating through style the whole cause of
gothic liberty. It was doing so, moreover, with reference to the
fabric of the house itself, for its medieval central block was
known as King John's Tower, a neat link to that earlier drama
in the gothic story, Magna Carta. In a way which will now be
familiar, it signals itself, if not exactly as 'historical ground',
then as 'historical house'. Its gothic signifies not only the
meaning of Hampden's life, but also the particular version
of national history in which his life was played out.

From gothic's growing expressiveness and capacity for complex
meaning came the best-known product of the eighteenth-century
Gothic Revival: Horace Walpole's house, Strawberry Hill (50).
We have met Walpole (1717–97) several times already. His bright,
sometimes spiteful chatter haunts the period's every avenue.
Which helps explain why Strawberry Hill – which he usually
referred to just as 'Strawberry' – became so important: Walpole's
vast correspondence and tireless propaganda ensured it did. But
it also ensured that gothic architecture and all things medieval
assumed a central position in cultural debate.

49
Stair-hall
ceiling,
Strawberry
Hill,
Twickenham,
1754

The youngest son of Sir Robert Walpole, the prime minister,
Walpole had a clutch of government sinecures to help fund his
enthusiasm for literature, antiquarianism, connoisseurship
and, above all, collecting. Having bought an undistinguished
small house with a few acres in the then fashionable and arty
neighbourhood of Twickenham, west of London, Walpole
decided in 1750 'to build a little Gothic castle'. The castle
became Strawberry Hill, the first revived gothic house that
was neither a remodelling of an earlier 'gothic' building, nor
built on a site that had medieval associations. It thus advanced
the process, discussed in Chapter 3, that liberated gothic from
a dependence on particular historical locations: the power of
evoking the past came to reside in the style itself.

To superintend the creation of his castle Walpole recruited
various friends onto a 'Committee of Taste', of which the most
constant member was John Chute (1701–76), a country squire
with considerable architectural ability. Strawberry was designed
and built accretively from 1752 and was not finished until the
mid-1770s, Walpole's hoard of artworks, antiquities and curiosi-
ties moving to fill each part as it was finished. The result was

unlike anything else built at the time: long, rather low, and highly irregular in its plan and elevations. At the east end, a set of rooms, including the Library, was disposed around a stair-hall and a landing grandly called the Armoury. For the south front, there was an arcaded Great Cloister with pointed windows above lighting the Gallery; on the north, the Little Cloister with an Oratory tacked on, and a lumpily uneven sequence of rooms, including the Holbein Chamber for displaying pictures, and the ingeniously shaped Tribune, containing Walpole's most precious treasures. A sturdy round tower with a slender, circular turret, finished everything off at the west end.

Strawberry is even more singular inside, its interiors designed for public show – at once containers for exhibits and exhibits themselves. Unfortunately, Walpole's collections were sold off in 1842, but eighteenth-century illustrations show rooms crammed with curio cabinets, busts and vases, pictures and leather-bound folios. The visitor's route was carefully contrived: starting in the shadowy well of the staircase (49), past the glittering weapons in the Armoury, to the Library (53), with traceried bookcases lining the walls; then through the dusky little Star Chamber to the Holbein Chamber, partitioned by a densely carved screen; then the Gallery (51), its spectacular fan-vault made from papier maché, side mirrors in intricately canopied alcoves reflecting the Walpole armorials in the stained glass; finally into the intense, constricted space of the Tribune (52), all angles and alcoves, top-lit through yellow glass, the vaulted ceiling crawling with tracery in the gloom. At Strawberry Hill gothic assumed a new character, for its conception was theatrical, even melodramatic. Walpole, connoisseur and collector, was also a showman, indeed a show-off, and he designed his house to play to an audience.

A flair for melodrama seldom goes with a regard for accuracy, yet Strawberry Hill was also the studied product of antiquarianism. Walpole was the first gothic revivalist consistently to base designs on actual examples of medieval gothic. Initially, his sources were antiquarian illustrations, but from 1753 he and Chute began

50
John Chute, Horace Walpole and others, Strawberry Hill, Twickenham, 1752 to mid-1770s; the block to the left is a Victorian extension

51 Overleaf Thomas Pitt and John Chute, The Gallery, Strawberry Hill, 1760–3

visiting medieval buildings and copying their features back at
Strawberry. The house became a palimpsest of architectural
quotations. Bookcases were based on the choir screen of Old St
Paul's, copied from Hollar's illustrations of the cathedral before
the Great Fire of London (1666); the stair-hall wallpaper was
based on a screen at Worcester Cathedral, the Holbein screen
on the Rouen Cathedral choir gates; the staircase came from
one in Rouen; Archbishop Bourchier's tomb at Canterbury
Cathedral modelled for the Gallery canopies, Bishop Ruthall's
at Westminster for the chimneypiece of the Little Parlour; chairs
designed for the Great Parlour had tracery backs (54), and so on

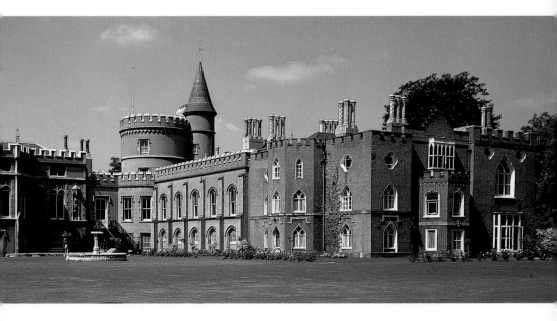

throughout. Walpole's copies are both conscientious and cavalier.
Faithful enough in form and detail, they are wildly discrepant in
scale and material, and blithely ignore architectural propriety.
Liberated into pure style, the historical products of medieval
gothic no longer had to stay at home in their cathedrals and
abbeys. They were free to roam and find new lodgings – in the
first instance at Strawberry Hill, subsequently in revived gothic
houses throughout the country. For Walpole the identity and
associations attaching to an authentic medieval precedent were

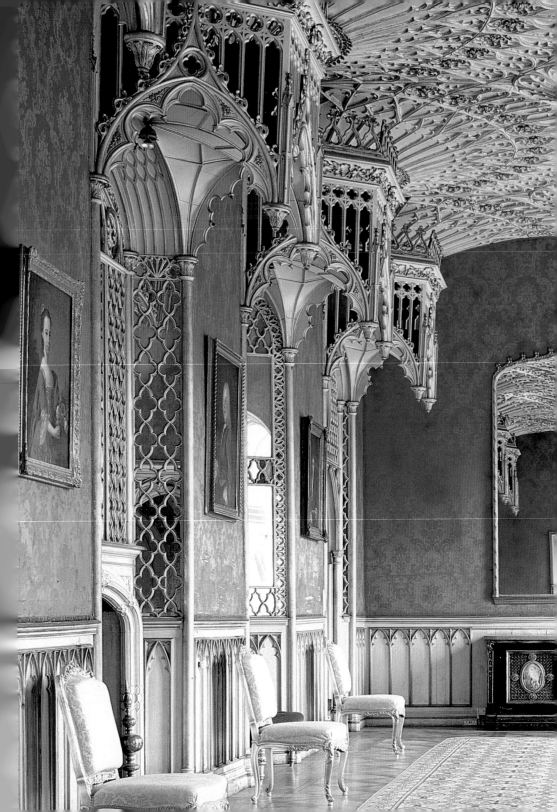

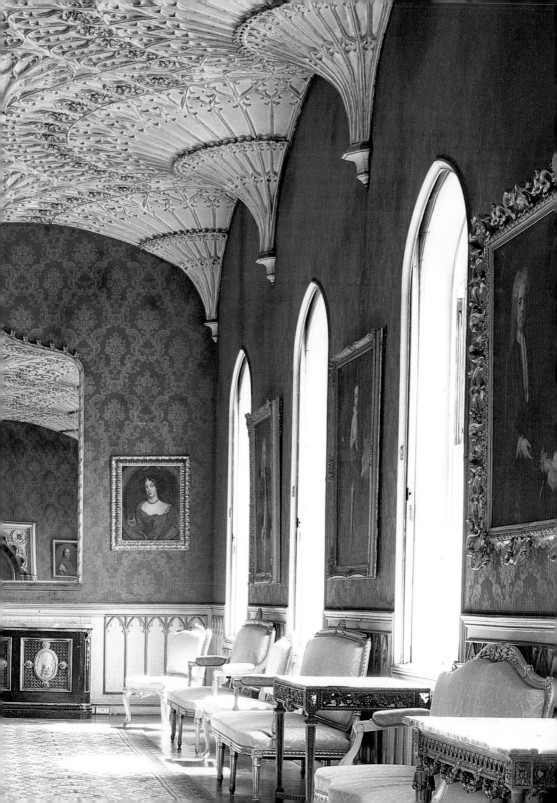

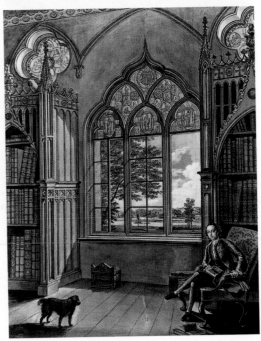

52
*The Tribune,
Strawberry
Hill,*
engraving
from
Walpole's *A
Description of
… Strawberry
Hill,* 1784

**53
Johann
Heinrich
Müntz,**
*Walpole
Seated in
his Library,
Strawberry
Hill,* late
1750s.
Watercolour
on paper.
Private
collection

quite strong enough to survive the move. Where the Gothic Revival's earlier appropriations of the Middle Ages had been metaphorical, Walpole's were literal, the architectural booty plundered from the gothic past and reassembled to meet the requirements of the present. Walpole, after all, was a collector.

In deriving gothic's vocabulary from specific historical examples, Walpole challenged the exclusive certainties of Neoclassicism, the sober, solid and archaeologically conscious form of classicism that had emerged by the mid-eighteenth century, in part a successor to Palladianism, in part a reaction to the licence of late Baroque architecture and rococo decoration. Neoclassicism was itself to have a long history, and claimed a unique warrant from the past, epitomized by the sanctified details of the five Vitruvian Orders. Strawberry's antiquarian precedents opened up the possibility of a rival body of historically validated architectural knowledge. It was not quite a new idea. As gothic began to appear in gardens and houses, architectural writers started to supplement their illustrations of the Orders with gothic designs. Among the earliest was *Ancient Architecture, Restored, and*

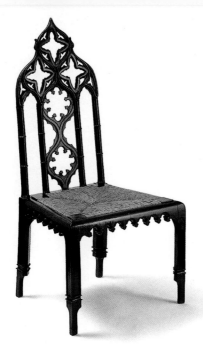

54
Richard
Bentley
and Horace
Walpole,
Chair from
the Great
Parlour,
Strawberry
Hill, 1754.
Beech
stained to
simulate
ebony;
h.126 cm,
49⅝ in.
Victoria
and Albert
Museum,
London

Improved (1742), later reissued as *Gothic Architecture, Improved by Rules and Proportions*, by the wonderfully named Batty Langley (1696–1751), an energetic producer of pattern books who combined a reverence for the Orders with a patriotic zeal for gothic, which he considered the national style. In *Ancient Architecture, Restored* he attempted to reconcile his two passions. From prolonged study of Westminster Abbey, he discovered that gothic was also based upon five Orders of columns, which he illustrated along with fixed proportions and variant entablatures (55) and made the basis for a pot-pourri of designs for windows, doors and garden buildings (56). Sadly, his ingenuity was ridiculed, among others by Walpole. But Langley's sortings and Walpole's borrowings were two halves of the same project: establishing a corpus of knowledge about medieval gothic as an alternative to classicism. Langley's concern for classification anticipates later, more successful efforts to identify and categorize different types of gothic, while Walpole's concern for precedents anticipates the increasingly close attention scholars would give to studying and accurately recording gothic buildings.

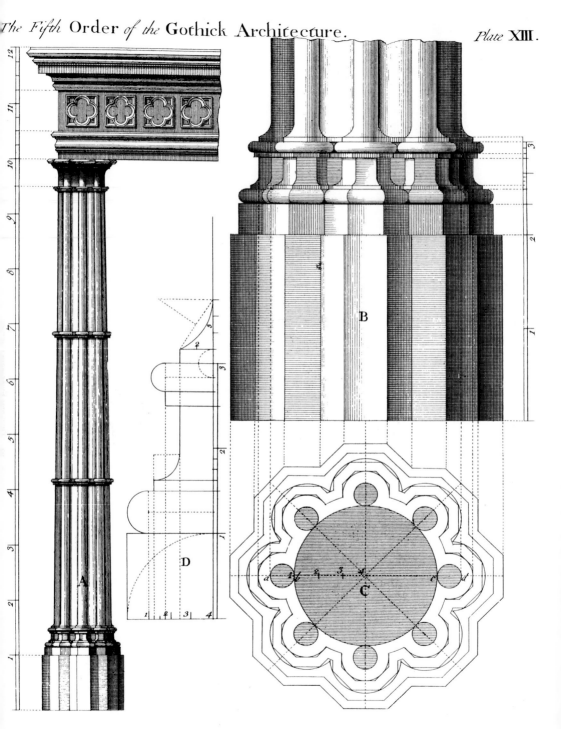

A B C D

Batty and Thomas Langley Inv. and Sculp. 1741.

Strawberry Hill challenged the regime of classicism in another way too. Walpole always intended its plan and composition to be asymmetrical, and the house's accretive development came to emphasize this. No other gentleman's house of the time was so conceived. Walpole must be credited with the idea of making revived gothic asymmetrical. To jettison symmetry was to trespass against the order, proportion and decorum of classicism, to court the very barbarity from which the Renaissance had reclaimed architecture. Such a move was part of a consistent, though untheorized, creative strategy. In his letters about Strawberry, as well as saying he is 'fond' of 'lack of symmetry', Walpole always refers to it as 'little', 'diminutive', and stresses his pursuit of 'variety' and 'charming irregularities'. These are the criteria of a new aesthetic category, the Picturesque, which

55–56
Batty Langley,
Gothic Architecture, Improved by Rules and Proportions,
1747
Left
The Fifth Order of Gothic Architecture
Right
Designs for Gothic temples

originated in landscape painting, nature poetry and gardening, and was beginning its long cultural career as Strawberry Hill was taking shape. Picturesque taste promoted the pleasures of the eye, aesthetic values that were primarily pictorial. Architecture that seemed to belong naturally to its landscape was admired; buildings that prompted imaginative associations were charming; the irregular, the visually various, the apparently accidental were prized; and the quaintly diminutive was just delicious. The ideals of the Picturesque were not systematically analysed until later, but Walpole's gothic exemplifies them, for in Strawberry Hill he created the first Picturesque house.

Forming an important contrast to Strawberry is another early Gothic Revival house, though one hesitates to call it a house:

Inverary Castle, Argyllshire (57). Started in 1745 and taking more than forty years to complete, Inverary was built for the third Duke of Argyll, whom we met earlier in his garden at Whitton (see 29). The architect, as at Whitton and, interestingly, Clearwell Castle (see 39), was Roger Morris. Inverary is certainly gothic, but not as we have known it so far: massively severe, more so before Victorian alterations softened it; a colossal rectangular structure, strictly symmetrical, with circular corner towers, and lines of pointed, traceried windows, small in proportion to the great stretches of granite walling. Its effect on contemporary sensibility is nicely caught by John Lettice, visiting in 1792, who felt 'awful emotions excited ... by the stern and Gothic air of its exterior aspect, and the martial stile of its entrance'. Lettice's 'awful emotions' fix Inverary in the realm of aesthetic experience the eighteenth century called the Sublime. Its most important theoretical exposition was *A Philosophical Inquiry into the Origin of our Ideas of the Sublime and the Beautiful* (1756), by

57
Roger
Morris,
Inverary
Castle,
Argyllshire,
1745–90

Edmund Burke, Irish lawyer and orator, then at the beginning of a brilliant political career that would make him the leading Tory thinker of his day. The sensation of sublimity, says the *Inquiry*, is a mental 'swelling and triumph' which 'is never more perceived, nor operates with more force, than when without danger we are conversant with terrible objects.' Sublimity gathers around Vastness – vast power, size, height, depth, distance. Whatever seems endless, whether by repetition or uniformity, can induce a sense of the final Vastness, infinity itself. For Vastness points ultimately to the Infinite and the Obscure, realms beyond comprehension that can excite feelings of Terror and Horror. Such qualities were already being explored in poetry, as we will see, and were found to characterize the savage landscapes of the Italian painter Salvator Rosa (1615–73), whose work was particularly admired in Britain. Confronted by the Sublime, the appropriate aesthetic response is awe – just what Inverary provoked in Lettice. Inverary is as strikingly early an example of the gothic Sublime as Strawberry is of the gothic Picturesque. The two buildings complement one another, as do their aesthetic

categories, which were to have a long history together and a profound effect upon the Gothic Revival.

Inverary stands, or perhaps looms, at the commencement of eighteenth-century castle building in the spirit of the Sublime, and it directly influenced the remarkable series of structures that comprise Robert Adam's 'Castle Style' – among them, Culzean Castle, Ayrshire (1777–92), and Seton Castle, East Lothian (1789–92). Their formidable geometrical massing marks them as sublime, and with their towers, turrets and crenellations they are certainly medievalist. But they are largely tangential to the history of the Gothic Revival, for their designs owe more to the austerity of Palladian classicism than to gothic – indeed, Adam does not use a single pointed arch in any of them. Less sophisticated, but more clearly gothic are the efforts of Adam's contemporaries, from the now-demolished Douglas Castle, Lanarkshire (from 1757) by John (1732–94) and James Adam (1721–92), Robert's brothers, to Melville Castle, Midlothian (1785–9) by James Playfair (1755–94), whose design consciously harks back to Inverary.

58
Ogee-headed window, Hellbeck Hall, Brough, Cumbria, 1775–7

In northern England gothic was mainly used for castles. James Nisbet (d.1781) gothicized Ford Castle, Northumberland (from 1762) for the powerful Delaval family, and work at Raby Castle included a dramatically vaulted carriage hall (1768) by John Carr (1723–1807). Of would-be gothic castles on new sites, Castle Eden, Co. Durham, is a tame Georgian house with battlements and Tudorish windows, while Twizzel Castle, Northumberland (from 1771), though far more whole-hearted as a medieval creation, was half-brained as a practical proposition: it got to several towers and storeys before being abandoned, and is now a wandering mound of ivy-swaddled rubble. The castle model for domestic gothic was by no means confined to Scotland and the north, however. There are many examples scattered across England, particularly in the rolling country to the west, from the elegant remodelling of Croft Castle, Herefordshire (c.1765) by Thomas Farnolls Pritchard (1723–77), to Enmore Castle, Somerset (from

1762), originally a vast rectangular affair built above a honey-comb of subterranean service rooms and stables. One of the oddest of these many efforts is Arnos Castle, Bristol (1760–5), probably designed by James Bridges (fl.1760). Housing the stables and offices of gothic Arnos Court, enthusiastically endowed with battlements and turrets, it is memorable for being built from slabs of blue-black slag, debris from the copper smelting works of the original owner, William Reeves – the basic stuff of modern industrial wealth literally converted into gothic style.

59
James
Wyatt,
Lee Priory,
Kent, 1783.
Engraving
by J P Neale,
1826.
11·7 × 16·3cm,
4⁵⁄₈ × 6¹⁄₂ in

Apart from full-blown castles, whether remodelled or new built, castellar details crop up widely, often as nothing more than a battlemented parapet or two, just enough to nudge the memory with martial associations from the medieval past. They mingle with gothic elements from other sources, often from the pattern books published by the contemporaries and successors of Batty Langley. Aimed at craftsmen and builders, works such as William Halfpenny's *Rural Architecture in the Gothick Taste* (1752), William Pain's *The Builder's Companion* (1758) and Paul Decker's *Gothic Architecture Decorated* (1759), as well as Langley's own, were quarried for the details of both garden and domestic gothic. They had a surprisingly long life and a national distribution: the ogee-headed windows (58) of the 1775–7 Hellbeck Hall, in remote Cumbria, are largely identical with those of Stouts Hill, Uley, Gloucestershire, more than thirty years earlier and some 400 km (250 miles) to the south. Around London, and perhaps more widely, the influence of Strawberry Hill was felt – less as a practical model than as a cultural icon, a gothic epitome fashionably current but existing more through discourse such as journalism and letters than through concrete imitation. Essentially, Strawberry Hill's most innovative characteristics, its asymmetry and use of specific medieval sources, did not become regular gothic practice for a generation. It was not until 1783 that Walpole, visiting Lee Priory in Kent (59), the new house of his friend Thomas Barrett, found a revived gothic building that was antiquarian, asymmetrical and picturesque, its ecclesiastically flavoured ingredients gathered around an octagonal library,

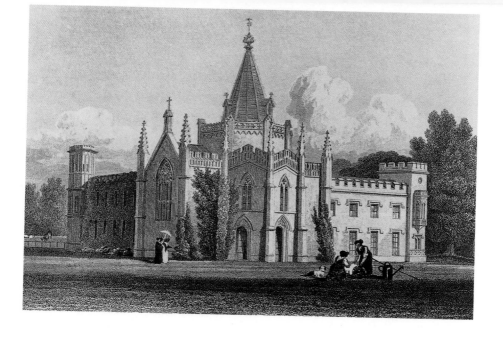

dramatically lit from above and topped by a spire. Walpole greeted it as 'a child of Strawberry, prettier than the parent'.

Even so, the revived gothic house became established architecturally between the 1750s and the 1770s. Almost invariably it was rationally planned and symmetrical, its gothic a stylistic skin made up of largely formulaic elements developed from the Kentian repertoire, sometimes with castellar features, sometimes with details cribbed from the pattern books, and just sometimes with a flavour of Strawberry. The gothic house – as distinct from the castle – was also predominantly English: there are none in Scotland, few in either Wales or Ireland. This is unsurprising, for the historical and political meanings gothic had accrued were essentially English; their extension to connote Britain and Britishness helped consolidate England's leadership – some would say domination – of the other countries of the kingdom. Contrasting examples picked from different ends of the country are Nisbet's Fowberry Tower, Northumberland (1776–8), with dainty gothic plasterwork inside, and Milton Abbey, Dorset (1771–6), a daunting pile that is the only gothic creation of the great classicist Sir William Chambers (1723–96).

During this period, the gothic agenda was set by secular buildings – garden structures as well as houses. Churches largely followed, in terms of both style and cultural resonance. Indeed, the richest exploration of gothic's religious associations came not in a church but a house: Strawberry Hill, of course. Although the infant Strawberry started life as a little 'castle', it finished up in holy orders. It had two cloisters and an oratory; borrowings came largely from abbeys and cathedrals; pious images and churchy curios graced the collections; stained glass washed the main rooms in 'dim, religious light', to repeat one of the period's favourite Milton quotes; and Walpole intended the Tribune 'to have all the air of a Catholic chapel – bar consecration'. Though sceptical in matters of faith, Walpole craved religion as an aesthetic fulfilment and, by corollary, found in art a deputy for religion. Heightened by the melodramatic sense of initiation and mystery with which the house unfolded, Strawberry Hill exhibited art as a religious experience. Walpole wanted gothic's associations with the medieval Catholic Church, with the lost world of the monastic life, where cloisters were for real and the illuminated missals in the Library at Strawberry were the scriptorium's daily product. For Walpole – and others would follow him – an odour of sanctity hung about the gothic objects of England's Catholic past, even if they were only papier mâché copies: but it was the sanctity of art not of faith.

Which explains why English churches in the mid-eighteenth century and beyond were so tardy with gothic. Strawberry could put on monastic garb, but aesthetic flirtation with the religion and worship of the Middle Ages had no place in Protestant Anglicanism. It was irrelevant, and would instantly have been condemned as too closely associated with Roman Catholicism. Even as Walpole built, medieval parish churches were being further stripped of their surviving fittings as interiors were altered to meet Protestant requirements. Instead of the ceremonial and processional nature of Catholic liturgy, focused on the eucharist and the altar, the Anglican Sunday service of the period centred on the sermon, delivered from a towering pulpit in a nave fitted

out as an auditorium, with box pews and galleries all smartly classical. With the architectural fabric, some sense of gothic's appropriateness for churches persisted. This was at its culturally most prestigious in Hawksmoor's completion of Westminster Abbey's west front (1734–45), his leavening of gothic with Baroque elements analogous to the bastions of Castle Howard. But medieval style appeared in provincial churches too. Edward (c.1697–1766) and Thomas Woodward (1699–1761), who worked at Alscot Park, rebuilt Alcester church, Warwickshire (1730) and St Swithin's, Worcester (1736) in gothic, though with classical interiors, and produced a gothic remodelling of Preston-on-Stour (1752) for Alscot's owner, the antiquary James West. The rebuilding of Galby, Leicestershire (1741) by John Wing (d.1752) at the expense of the local squire, William Fortrey, included windows copied from the medieval originals. At Wicken, Northamptonshire (1758–67), which boasts plaster vaults in nave and chancel, the rebuilding was actually designed by the squire, Thomas Prowse. Important as such acts of revival were, they had little to do with Walpole's religious evocations. Rather, they testify to the control of the local landowner, whose authority gothic's associations helped to validate.

This is clearest in those churches that were conceived as gothic show-pieces within the larger strategy of the landscaped park. As early as 1742, the medieval church of Werrington, Cornwall (60), was given fancy pinnacles, miniature towers and gothic statues as a means of enhancing the view from Werrington Park. In 1752–6, complementing improvements to the grounds of Shobdon Court, Herefordshire, the church was turned into a chic architectural toy, with lots of curling ogee arches and the daintiest set of benches (61). Hartwell church, Buckinghamshire (1753–7) – disgracefully allowed to collapse in the 1960s – was designed by Henry Keene, Newdigate's man at Arbury, as a gothic focus for the vista from Hartwell House; it was octagonal, twin-towered, with a wonderful plaster fan-vault ingeniously adapted from that favourite model, Henry VII's Chapel (see 2). Essentially, such churches belong to garden gothic, and were

integrated into the geographical and ideological domain of property. In their case, the landed power that produced them and to which they attest operated very directly indeed: in two out of every five parishes the right to nominate the parson was in the hands of a secular patron, frequently the local squire. And that right was owned by the patron as legal property, just like land.

The Woodwards' church in Worcester borrowed some of its gothic from other churches in the city, a very early use of specific medieval precedents. Also evident, in different ways, at Galby

60
St Martin's,
Werrington,
Cornwall,
remodelled
1742

61
St John the
Evangelist,
Shobdon,
Hereford-
shire,
1752–6

and Hartwell, this historical consciousness gradually spread. It is striking at King's Norton, Leicestershire (1760–1), designed by John Wing the younger (1728–94), the son of Galby's architect, and funded by the same patron. The west tower has decorative details and belfry windows that closely follow medieval patterns, and the east window tracery copies fourteenth-century work at Goadby Marwood in the north of the county. Work of the 1760s and 1770s by the Cambridge architect James Essex, including restorations and fittings at Ely Cathedral and Lincoln Cathedral,

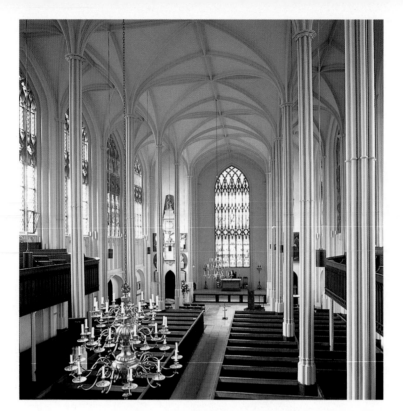

62
Francis
Hiorne,
St Mary's,
Tetbury,
Gloucester-
shire,
1777–81

shows not only an understanding of medieval design, but also some grasp of gothic construction. These were signs of things to come. So too, in a quite different way, was St Mary's, Tetbury, Gloucestershire (1777–81) by Francis Hiorne. Larger than any earlier church of the eighteenth-century Gothic Revival, St Mary's has a spectacularly tall interior (62): nave and aisles stretch to the same height; clustered wooden piers, theatrically slender thanks to having iron cores, branch into plaster rib-vaults high overhead; huge windows fill the side bays with traceried light. Although knowledge of medieval originals is displayed, the church is scarcely antiquarian, and the use of iron marks the arrival not only of modern industrial materials but also of novel construction. Moreover, Hiorne's stress upon verticality, his theatrical feeling for light and dark, above all his sense of space, create an architectural drama that reaches towards the Sublime. It anticipates much that was soon to make itself felt in the emotional timbre of the Gothic Revival.

The revival of gothic architecture was, until the later eighteenth century, almost wholly a British affair, any influence elsewhere in Europe restricted to landscape design. There are a handful of gothic garden buildings in Germany, and the shattered gothic towers and archways built around 1780 in a landscaped setting at Betz, north of Paris, show that the cult of ruins managed at least one export. Neoclassicism was effectively institutionalized in France, promoted and maintained with all the cultural authority of the Academie Française, which dominated architectural education, appointments and commissions. Strongly rationalist in its values, the French tradition showed an intermittent interest in gothic's structural qualities – largely ignored in Britain. In 1737, Amadée-François Frézier (1682–1733) published an analysis of gothic rib-vaulting, and architects such as Jacques-Germain Soufflot (1713–80), designer of the Paris Panthéon, and Étienne-Louis Boullée (1728–99), praised the lightness and lofty proportions achieved in the construction of medieval cathedrals. Theoretical admiration was one thing; actually putting up gothic buildings quite another. Nobody in continental Europe followed the stylistic lead of Inverary or Strawberry Hill.

63
Boris Karloff
as the
monster
in the 1931
film of Mary
Shelley's
Frankenstein

Nevertheless, a sense of the imaginative possibilities of gothic and the medieval past began to quicken across Europe; it spread not through architecture but literature. The Renaissance did not totally extinguish interest in medieval literature: the thirteenth-century courtly allegory *Le Roman de la Rose,* for example, had a considerable vogue in the seventeenth-century French court. Overall, however, the Academies of France and Italy successfully policed high culture on behalf of classicist theory and practice. This hegemony was far less secure in Britain, and it was here that the revival and reinvention of medieval literature had its most important point of origin. The English sense of gothic, its feeling

for stylistic meanings and associations, had a strong literary base. Among the materials gathered by the antiquaries who helped shape this response were the remains of the literary culture itself – the songs and romances of an older England.

Although pioneer antiquaries such as William Camden and John Aubrey gathered 'quaint lore' from the oral tradition, interest focused on written and early printed texts, because they were physically collectable. Popular ballads were a favourite, especially those printed as broadsides (64) in black letter – a typeface the eighteenth century called Old English or, significantly, Gothic. The diarist Samuel Pepys built up a large collection of broadside ballads; in 1711 Joseph Addison, a key arbiter of Neoclassical taste, devoted two issues of his periodical the *Spectator* to the late medieval poem 'Chevy Chase', calling it the 'favourite ballad of the common people of England'; and interest was sufficient for a three-volume *Collection of Old Ballads* to appear in 1723–5. The process culminated in 1765 with *Reliques of Ancient English Poetry*, edited by Thomas Percy (1729–1811), a clergyman-scholar

64
A New Song Called A Lover's Tragedy; or Parents' Cruelty, broadside c.1600. 29·2 × 21·2 cm, 11¹⁄₂ × 8³⁄₈ in. British Library, London

whose patron was the same Duke of Northumberland who employed Paine and Adam to regothicize Alnwick. With the *Reliques* antiquarianism enters into the mainstream of British writing. Its arrival was not accidental. Enlightenment values and aesthetics, and aristocratic education in the literature and culture of the Antique, had given the classical inheritance premier status. But the development of commerce, including an increasingly well-organized book trade, and the growth of a literate middle class with leisure, created a new reading public with no allegiance to classicism. The *Reliques* established a genealogy for English poetry that was native, in the sense both of national and natural, and medieval: rather than values grafted on from Greece and Rome, the true roots of English verse – as of Englishness and, by extension, Britishness – were bedded in gothic soil.

As the valuation of medieval literature shifted, so also did the theoretical positions that underlay critical opinion. In 'Conjectures on Original Composition' (1759), the poet Edward Young bemoaned the dull decorousness of contemporary verse and urged the merits of untutored originality – the robust, imaginative qualities he found in works written before the Neoclassical muses claimed a literary monopoly. In *Letters on Chivalry and Romance* (1762), Richard Hurd challenged classicist prescription directly, identifying a separate literary tradition he described as gothic. Vigorous, intense, enamoured of the marvellous and extraordinary, there was 'something in the Gothic Romance peculiarly suited to the views of a genius, and to the ends of poetry'. Hurd's advocacy deployed an architectural metaphor as timely as it was appropriate.

When an architect examines a Gothic structure by Grecian rules, he finds nothing but deformity. But the Gothic architecture has its own rules, by which when it comes to be examined, it is seen to have its merit, as well as the Grecian.

The political liberty connoted by gothic architecture, in gothic literature becomes imaginative liberty, the distinctive characteristic of 'genius', a quality of essential creativity born of nature

rather than culture. For Hurd it is peculiarly a feature of English poetry, found in what he saw as the 'gothic' trinity of Edmund Spenser, William Shakespeare and John Milton. The gothic genius that loves freedom liberates English poetry from Grecian regulation, just as it had liberated English institutions from Roman imperialism. And because such genius was especially English, with Shakespeare promoted more and more as the exemplar, it was thought of as native – both natural and national.

As the strands of literary medievalism came together in the 1760s they were woven into some remarkable works of literary imitation. The prose epics *Fingal* (1762) and *Temora* (1763), which were purportedly translations from the ancient Gaelic bard Ossian, were in fact written by James Macpherson. A number of the poems and plays supposedly 'written at Bristol, by Thomas Rowley, and others, in the fifteenth century' – to quote the title page – were actually by the teenage Thomas Chatterton. Macpherson's *The Works of Ossian* (1765), published less than twenty years after Culloden, proposed a Celtic and bardic origin for national literature. Chatterton conjured a whole medieval fantasy, from foxed and faded manuscripts covered in spidery gothic scribblings, to tantalizing poetic fragments that included part of a 'lost' epic on the Battle of Hastings. Though eventually denounced as forgers, Macpherson and Chatterton were profoundly concerned with the medieval beginnings from which the present could be fabricated – simultaneously counterfeited and created. The criminal accomplices of legitimate literary antiquaries, they helped invent a cultural genesis independent of Neoclassicism's logical prescriptions, one more tangled in history and character, more native, more primitive – an inheritance both older and darker. Its origins lay in those unkempt areas of experience beyond the neatly tended realms of reason. To explore them, Enlightenment rationalism was inadequate. All this was gothic's domain, however: had not the Renaissance said so? From the 1720s English writers began to explore and reclaim the irrationality that reasonable aesthetics could not reach. They concentrated on the horrid and uncanny, those mental and

material regions in which our most primitive feelings were believed to originate. Within a few years the mode of sensibility that emerged was being labelled 'gothic'.

Early exponents of this new gothic genre were the poets nick-named the Graveyard School. Turning their backs on the daytime world poets such as Thomas Parnell in *Night-piece on Death* (1722), and Edward Young in the widely read *Night Thoughts* (1749–51), pursued insomniac contemplations of the tomb. The recurrent setting for their sometimes gruesome musings was the midnight churchyard. In one of the School's most celebrated products, Robert Blair's *The Grave* (1743), 'Doors creak, and Windows clap, and Night's foul Bird / Rook'd in the Spire screams loud'; 'In grim Array the grizly Spectres rise'; 'Again! the Screech-Owl shrieks'. And again, through any number of such poems. Authors discovered a ready appetite for the macabre and spooky, the audience growing as literacy spread throughout those ranks of society known as 'the middling sort'. The morbid fantasy in the mouldering shrine, with all its nocturnal machinery, soon became standard literary fare, from William Collins's *Ode to Fear* (1746), to the lugubrious prose of James Hervey's *Meditations among the Tombs* and *Contemplations on the Night* (1745–7). Most famously, gothic sensibility suffuses the opening of Thomas Gray's *Elegy Written in a Country Churchyard* (1751), with its tolling curfew, 'glimmering landscape', 'ivy-mantled tower' and inescapable 'moping owl'.

The dominant condition was melancholia, and its focus was the ruin. Wandering amid ruins, the melancholy man's reflections on life's brevity could encompass the universal transience that breathed in the crumbling walls of monastery or castle. A sentimental overview of mortality, a pious sense of the vanity of human wishes, gave piquancy to the knowledge that one belonged to the class that owned, built or visited ruins, and had the leisure necessary for their proper contemplation. Heightened sensibility, a readiness to shudder at the grave or sigh amid the ruin, became an aspect of class superiority – as natural as the

property ownership from which power sprang. Mutually support-
ive, gothic architecture and gothic literature rested upon
narrative. With buildings, the meanings loaded on to medieval
style were narrative claims on the past, whether as family
anecdote and genealogical record, or as part of the national
saga of kings and constitutions. Literary antiquarians similarly
uncovered, or counterfeited, histories of local or national poetic
tradition. And gothic sensibility dwelt on the melancholy tale of
mortal evanescence, or indulged nightmare fantasies of death
and decomposition. As it was understood in Britain, gothic was
a wonderfully fruitful source of stories.

Gothic's many narratives turned into a novel with Horace
Walpole's *The Castle of Otranto* (1764), subtitled *A Gothic Story*,
written, he claimed, after dreaming of a giant armoured presence
on the gloomy staircase of Strawberry Hill. Dated vaguely to the
Crusades, the plot is as baffling as the labyrinthine Italian castle
in which it is set. Conducted at frenzied pace through supernat-
ural events, sudden deaths and dark secrets, it tells the story of
Manfred's attempts to secure his dynasty's illicit hold on Otranto
by fathering an heir on the unwilling person of Isabella, his dead
son's virtuous bride-to-be. Page after page, she flees from him
through the castle's vaults and tunnels, escaping at last to marry
Otranto's true heir, while Manfred, having accidentally killed his
daughter, disappears into a monastery. Whereupon, the castle
falls down.

65
John Carter,
*The Entry
of Prince
Frederick
into the
Castle of
Otranto*, 1790.
Pen and wash
on paper;
58·1×48·3 cm,
22⁷₈×19 in.
Lewis Walpole
Library,
Farmington,
Connecticut

Otranto is the first gothic novel, the founding text of the genre,
both in the machinery of its plot and in its imaginative concerns.
Central is the gothic building itself (65): rambling, disorienting,
claustrophobic, its outlandish inhabitants isolated from daylit
normality, its cumulative strangeness compounded by the ghostly
operations of the Other World. Thematically, the fiction concen-
trates on the protagonists' horrors and terrors, experiences that
belonged peculiarly to the Sublime. *Otranto* is not concerned to
explain but to excite the fears and anxieties that are its subject.
Rather than looking *at* an irrational world, we look from *inside* it,

as meshed in the plot as Isabella in the castle's subterranean maze. Gothic fiction's divorce from Neoclassicism is here most absolute, because rationality itself is abandoned – and with it goes all sense of decorum or proportion. The outcome, the experience of the novel, is both unsettling and fantastic.

Otranto's fantasies, its terrors and forbidden desires, are historical. The pervasive fear is of untrammelled power exercised by a hereditary aristocratic class. Manfred is the first of gothic fiction's tyrants bloodily bent on founding a dynasty, pursuing a lust for dominion without legal or moral constraint. He is, of course, the nightmare embodiment of the absolute monarch abhorred by all supporters of free gothic institutions. Moreover, power in *Otranto* operates sexually – necessarily so, for dynastic rule required an oppressive politics of gender. The smooth transmission of landed property needed an heir of unquestionable legitimacy, so the sexual conduct of women, who produced the heirs, was tightly controlled, ultimately by men because they inherited the property and the power it gave.

In *Otranto*'s sexual politics something else becomes evident too. When dynastic succession fails, Manfred's patriarchal authority transmutes into sexual violence, into the threat of rape. Through the motif of pursuit that is recurrent in gothic fiction, that threat becomes the stuff of illicit fantasy, of fearful longings for absolute gratification and absolute surrender. Gothic's contradictory attitude towards the Catholic Church moulded the fantasy. Though medieval religion drew gothicists aesthetically, as good Protestants they deplored its superstition and supposed sexual 'unnaturalness', speculating voyeuristically on nunneries and convents, celibate priests, the secrets of the confessional and the cult of the Virgin. Gothic fiction exploited such themes for prurient fantasies of sexual transgression. But in gothic's construction of sex, as of medieval religion and political tradition, there was duality. Threat and pursuit were predicated on a heroine who could protest, resist, act to save herself, break free. Covertly, gothic fiction's very unreality afforded women

66
James Northcote,
Le triomphe de la Liberté en l'élargissement de la Bastille, engraving by James Gillray, 1790.
49×61 cm,
19¼×24 in

writers and readers a means of rehearsing and challenging the constraints of their real lives. It was the work of women novelists that moved the genre forward after *Otranto*, stories like Clara Reeve's *The Old English Baron* (1778) or Charlotte Smith's *Emmeline, the Orphan of the Castle* (1788). Largely omitting Walpole's supernatural fireworks, they concentrated upon their heroines' struggles to defend the domestic citadel from male political and economic ambitions. But such developments were tentative. Some further stimulus was needed.

The historical moment of the gothic novel, the emblematic point at which the text of fiction merged with the text of history, came on 14 July 1789 with the storming of the Bastille (66), the fortress that dominated eastern Paris. Symbolizing royal power, feudal, despotic and dynastic, here was a real medieval castle brought down by the irresistible passion of a people long-suppressed and desperate for liberty. The gothic drama of the French Revolution had begun. The great struggle that ensued took on the unmistakable character of the Sublime, and in its sites and events – in anonymous denunciations and midnight arrests, in the shadow of La Guillotine – were all the materials of fear and horror. The 1790s became the decade of the gothic novel. In Britain, at war

with France from 1793, gothic was produced and consumed more avidly than any other fictional genre. Not that the novelists were much concerned with actual events. The thrills and terrors of insurrection were managed metaphorically, often so as to displace revolutionary impulses and dissipate them on the apolitical objects of fantasy, leaving the status quo untouched, even reasserted. Nevertheless, such matter was inflammable.

Disturbance and reassurance were manoeuvred with particular success by Ann Radcliffe, whose six novels included the most famous of early gothic fictions, *The Mysteries of Udolpho* (1794). Set in the sixteenth century, its central episode details the sufferings of the super-sensitive Emily St Aubert, imprisoned in the castle of Udolpho by the devilish Marquis Montoni, who subjects her to night after creepy night of menace and terror, before she makes a heart-stopping escape through the funereal vaults of a ruined chapel. In the end, with conspiracies exposed, ghosts dispelled and villains punished, the novel conservatively

reaffirms the virtues of hearth and home. But the portrayal of the powerful tyrannizing over the powerless, Emily's struggle against oppression, and the excited reaction of Radcliffe's readers, all subverted the conformity preached by the conclusion. More shocking was Matthew Lewis's *The Monk* (1796), which left critics aghast – and not without cause. Revelling in sexual transgression, the novel pursues Ambrosio, the monk of the title, through the transports of intensifying lust to abduction, incestuous rape and murder, while sub-plots linger over satanism and torture, all taking place in a stifling maze of underground passages. Going far beyond the standard use of the Catholic Church to exemplify absolute power, Lewis is engrossed by a politics of domination visited directly on its victims' bodies. He was not alone: a satirical hyperbole in the work of the English caricaturist James Gillray (1757–1815; 67), bodily dismemberment was an appallingly casual actuality of the fighting in Spain as recorded by Francisco Goya (1746–1828) in his etchings *Disasters of the War* (1812–20). *The Monk* scorns the very idea of a normative social order, acknowledging only relationships that are abusive, defined by the rending of one human being's body by another.

67
James
Gillray,
*Un petit Souper
a la Parisienne
– or – A Family
of Sans Culotts
refreshing after
the fatigues of
the day,* 1792.
Coloured
etching;
25·2 × 35·3 cm,
9⁷₈ × 13⁷₈ in.
British
Museum,
London

One contemporary reader, whose fantasies of rape and dismemberment outdid Lewis's, had no doubt about *The Monk*'s significance. Discussing fiction in *One Hundred and Twenty Days of Sodom*, the Marquis de Sade praised *The Monk* as 'superior in all respects to the strange flights of Mrs Radcliffe's brilliant imagination', and as 'foremost' among the 'new novels' of horror that were 'the inevitable result of the revolutionary shocks which all Europe has suffered'. For de Sade, the shocks emanating from France registered through the moral and imaginative shocks of gothic fiction; and the shocks Lewis inflicted on the human body were like those wracking the European body politic. Crucially, the French Revolution's defining act was chopping off the king's head. We have a gothic pattern: gothic political theory helped justify dismembering the body of an anointed king in the English Civil War; later, a gothic tower was built to stand sentinel over the field where that king first did battle with the people who would

execute him. Later still, gothic fiction sprang into life as another king was decapitated in Paris. The fate of constitutions – the political constitution of a state, the physical constitution of a human being and the embodiment of both in the person of a king – had been decided to a gothic accompaniment.

Gothic's long literary history in Britain and its European emergence under the stimulus of the French Revolution directly affected German literature and culture. From the 1730s, influenced by English developments, the Swiss critics Johann Jakob Bodmer and Johann Jakob Breitinger began to argue against Neoclassical imitation, urging a poetics based in individual creativity, and rooted in native soil. Bodmer produced editions of German medieval poetry, and in 1757 brought out the *Nibelungenlied*, the epic repository of Teutonic myth whose northern gods and heroes could outface the deities of Greece and Rome. Admiration for Shakespeare grew. Percy's *Reliques* and Macpherson's *Ossian* were enthusiastically received and helped inspire a rhapsodic flurry of self-styled 'bardic' poetry. The emerging aesthetic was formulated theoretically by Johann Gottfried von Herder. In its highest forms and also in primitive societies, he argued, poetry was simultaneously the spontaneous, often enraptured, expression of the individual imagination and the product of the common culture of the folk. Cultural change was organic and created national character, so national history was a kind of natural history, and in medievalism Herder saw the recovery of an organically evolved Germanic identity. His ideas thrilled the young Johann Wolfgang von Goethe, and together they wrote *Von deutscher Art und Kunst* (*Of German Race and Art*, 1773). It became the manifesto of a new cultural movement calling itself *Sturm und Drang* (Storm and Stress): energetic in expression, idealizing creative spontaneity and individual genius, vigorously nationalist in temper. *Sturm und Drang* aspirations had their fullest realization on the stage, most influentially in *Die Räuber* (*The Robbers*, 1781), the first play (68) by Johann Friedrich Schiller. To the movement's creative tumult Schiller added political radicalism in the person of his bandit chief, the

68
Caspar David Friedrich, *A Scene from Schiller's 'Die Räuber'*, c.1800. Brush, pen and sepia on paper; 20·3 × 26·3 cm, 8 × 10¾ in. Museum der Stadt, Greifswald

aristocratic revolutionary Karl Moor: 'Two such men as I', he
boasts, 'would destroy the entire moral structure of the world.'

Such turbulence perfectly matched the imaginative upheaval of
the gothic novel, eagerly seized upon by *Stürmers und Drängers*,
and from Schiller particularly came the variant on the genre
known as terror fiction. After *Die Räuber*, the gloomy forests that
cloaked the dreary mountains around the ruined castle were
always likely to be populated by bandits with revolution in mind.

The authority of Neoclassicism in France, sustained through
the revolutionary period and consolidated in the Empire style
of Napoleon's court, delayed the emergence of French gothic
fiction, though much was imported from Britain and Germany
in the 1790s. It was in Paris, though, during the winter of 1792–3,
around the time of Louis XVI's execution, that the showman Paul
de Philipsthal significantly extended gothic's gamut of sensations

with a new optical entertainment called La Fantasmagorie (69).
In 1801 it opened in London under the name 'Phantasmagoria'.
Using magic lanterns, with special effects that included project-
ing images on smoke, accompanied by music and noises off
stage, the Phantasmagoria comprised a sequence of illusions
in which pleasant landscapes were transformed into moonlit
graveyards, spooks and skeletal forms glimmered in the gloom,
and disembodied heads floated towards the audience. Onlookers
gasped, screamed and – even more gratifyingly – fainted.
Something more than the vicarious pleasures of the printed
page, the Phantasmagoria offered gothic sensation produced
to order by technological means: it was among the prototypes
for a new theatre of optical wonders.

By the early nineteenth century gothic sensibility was common
currency in the literature of western Europe. On a famous
windswept night in 1816 at the Villa Diodati near Geneva, the
poets Lord Byron and Percy Bysshe Shelley, Mary Wollstonecraft
Godwin (who married Shelley later that year), and other friends
and lovers, read a collection of gothic tales and decided to
outdo them by writing their own. The collection they read was
Fantasmagoriana, a French translation from a work originally
published in German. The two new stories that came out of that
night appeared in 1818: Mary Shelley's *Frankenstein* and John
Polidori's *The Vampyre*. The unhinged scientist and the undead
aristocrat have lurked in the Western imagination ever since –
and will return later in this book.

The Villa Diodati episode illustrates another aspect of gothic's
literary emergence. The book that stirred that élite reading group
was not a medieval manuscript or a black-letter tome, but the
contemporary product of popular publishing. In Germany
and France but particularly in Britain, gothic literature took
on a new commercial vitality. Keeping production costs down,
taking advantage of improved means of distribution, British
publishers issued heaps of low-priced fiction, made up of hack
horror stories, assorted spooky tales and abridged versions of

longer and artier gothic novels. The public called them 'shilling shockers'. What was new about them, revolutionary indeed, was their economic rationale. They were not 'popular' in the sense of having originated from the folk, but in the modern sense of being commercially devised for the consumption of a mass audience. With the shilling shockers the era of pulp fiction had arrived, and it dawned gothic. Sensation and titillation for all, with titles unrestrained in promising instant thrills: *The Affecting History of Louisa, the Wandering Maniac* (1804); *The Midnight Groan, Or, The Spectre of the Chapel* (1808; 70); *The Abbess of St Hilda; A Dismal, Dreadful, Horrid Story!* (c.1800).

69
La Fantasmagorie in Paris, 1797. Engraving

Gothic – as historical discourse, as architecture, as literature – was an originating and shaping force of the Romantic Movement. At Romanticism's core was a repudiation of the rationalist assumptions that had governed European high culture since the seventeenth century. To its opponents, the rationalist project had divorced people from feeling and imagination, turned knowledge into a lifeless mechanism, reduced the universe to a vast machine running inexorably on laws proclaimed by empirical science. Romantic reality was different, centred not in external prescription but in the individual's dynamic engagement with the

encompassing world. Naturalness was set against artificiality, the organic against the mechanical, creativity against academic rule, uniqueness against generality. And on the radical wing, personal freedoms – political, religious, artistic – were paramount, even if they meant overthrowing established order. Romanticism twined with gothic and medievalism in a dense semantic texture. Gothic meant political liberty and constitutional rights; gothic was natural, its culture an organic growth; in medievalism, nations reclaimed the identities classicism had chosen to forget; in gothic, people recovered the identities rationalism had chosen

Inc as Horatio gazed, the beautious features
nish'd and presented to view a perfect skeleton

THE

MIDNIGHT GROAN;

OR THE

SPECTRE OF THE CHAPEL:

INVOLVING

AN EXPOSURE OF THE HORRIBLE SECRETS

OF THE

NOCTURNAL ASSEMBLY.

A GOTHIC ROMANCE.

I stand immoveable like senseless marble!
Horror has frozen my suspended tongue:
And an astonished silence robb'd my will
Of pow'r to tell you how you shock my soul!
AARON HILL.

London:
PRINTED FOR T. AND R. HUGHES,
35, LUDGATE-STREET.
1808

to suppress; gothic sublimity – amid great ruins, great passions, or great acts of revolt – shook the souls of citizens and states; and the gothic world turned on marvels, not on mathematics. Not all Romantics were goths, but it was axiomatic that all gothic was Romantic. However, gothic's semantic diversity ensured that its relationship to Romanticism would be asymmetrical, uneven, contrary. Gothic might connote political freedom, but gothic castles housed feudal tyrants; monastic ruins might evoke medieval faith, but also recalled bigotry and religious persecution; gothic

might reconnect the present to an organic history, but the weight of the past could stifle any young Romantic's love of liberty.

Behind the artistic energies that generated Romanticism, and the political forces that produced the French Revolution, were fundamental economic changes, driven on by extraordinarily rapid population growth. In Britain – where the population of England and Wales virtually trebled between 1750 and 1850 – the Agricultural Revolution and the Industrial Revolution wrought these changes first and fastest. Between them, they established capitalism as the dominant mode of economic activity. That altered everything, not least the whole course and meaning of the Gothic Revival.

During the eighteenth century British agriculture, by far the largest sector of the economy, became a capitalist enterprise, and the effects transformed the basic structure of all social relations. Pre-capitalist society – to use a very generalized model – was hierarchical and paternalistic, the top and bottom of the social pyramid connected by reciprocal ties of responsibility and deference. Economic relations were traditional, fixed by custom; interactions – from maintaining order to dispensing charity – were characteristically personal, conducted face-to-face. The social environment was broadly public, individuals identifying themselves with reference to the social body as a whole and their acknowledged place within it. This pre-capitalist form of organization, which my description has necessarily simplified, was labelled 'community' (*Gemeinschaft*) by the nineteenth-century German sociologist Ferdinand Tönnies. The Agricultural Revolution dismantled community's pattern of economic practices and relations to create a free market in labour – a market, that is, in which labour is a commodity to be bought and sold. The resulting social structures, characteristic of capitalism, Tönnies called 'association' or 'associational grouping' (*Gesellschaft*). Contractual relations replaced customary ones and society's defining economic transaction became the exchange of cash for labour. Hierarchy remained, but as the vertical ties of

responsibility and deference receded, it was split horizontally into the divisions of class. Class separation spelt the end of 'face-to-face' dealings between different levels of the social order, and steadily eroded communal values. Within classes or class segments, individual identity, rather than resting in the public domain of a community, became increasingly private, dependent particularly upon the family – within the middle class, upon that emotionally self-sufficient little unit, the nuclear family.

The profound social changes effected by the Agricultural Revolution were accelerated by the Industrial Revolution, which turned Britain into the first global industrial power. As the British economy was industrialized, so also was it urbanized: the Manchester conurbation, for example, grew from a population of 36,000 in the 1770s to over 300,000 by 1851. In the raw industrial townships, though working folk might cling together for mutual support, the old hierarchical values of obligation and deference rapidly disintegrated. Aristocracy and gentry, traditional social leaders, hardly existed in the new cities. Rather than the old paternalism, the free market doctrines of *laissez-faire* economics and the factory system dictated relations between owners and hands. As the nature of work changed, so also did its physical setting, most dramatically in the great manufacturing districts and in ever-spreading London. If workers mourned the stable, lost world of 'community', they also knew it had been immobile; and though the new world of 'associations' was radically insecure, it was nothing if not dynamic.

For better and for worse, the Agricultural and Industrial Revolutions remade Britain. Setting in a bit later, similar forces transformed other parts of northern Europe and the United States. In the new order, or the new disorder, the self attained an unprecedented autonomy. The basic change in the individual's economic role underlay Romanticism's cult of the personal and subjective. Romantic individualism had many guises: the cultural warrior of Storm and Stress; the citizen-champion of revolutionary France; the artistic genius whose imagination

could recreate the world; the entrepreneur who could become the creation of his own enterprise, 'a self-made man'.

The villains of gothic fiction, as we saw earlier, sprang from fear of absolute hereditary power. They were also terrifying embodiments of the new individualism, their unbridled desires a grotesque translation of the economic appetites capitalism promised to satisfy by abolishing all customary impediments to a free market. With gothic's characteristic duality, these villains represent both the horror of a past from which the present cannot escape, and the horror of a present that has forgotten the past. In the Romantic period, gothic's abiding engagement in the relationship between past and present, previously centred largely upon questions of legitimacy, expanded to take in the nature of the self and its origins. The individuality liberated by economic and political revolution made such issues urgent. Writers, from the authors of the American Declaration of Independence (1776) to Mary Wollstonecraft (Mary Shelley's mother) in *A Vindication of the Rights of Woman* (1792), sought to announce a new age by reaching for new definitions of individual identity. Meanwhile, landless labourers in the regime of the capitalist countryside, and industrial workers amid the roar of the textile mills, every day confronted new and more brutal definitions of who they were and what they were worth. Personal and political coincided. They had to, for what was in question was nothing less than what it meant to be human.

The question reverberates through the greatest gothic fable of origin and identity, Mary Shelley's *Frankenstein* (see 63 and 71). Inspired by high-minded notions of a perfect future, Victor Frankenstein, the representative of an ancient land-owning élite, breaks through the limits of the most innovative scientific thinking, locks himself up in a laboratory equipped with the latest technology, and manufactures a human being. Having violated an established order both divine and natural, Frankenstein abdicates responsibility for the being he has made, abandonment turning the painfully human creature into a monster, an

71
Frontispiece,
Mary
Shelley's
Frankenstein,
1831 edition

inhuman 'other', without rights, without even a name. It is the dereliction peculiar to *laissez-faire* capitalism: abandoned to the unregulated operations of a free market, the majority of the population, propertyless and stripped of customary rights, are created as a separate class, a different category of human being. And once seen across the chasm of class, working people, like Frankenstein's creature, could appear as 'other', sometimes as monstrous, more often simply as a nameless mass.

Without background or lineage, the creature is seen by Shelley as double-damned, the outcast both of nature and history. But the creature is the product of human culture and its historical development: *Frankenstein*'s nightmare is the terror of history itself. In an age when revolutions had torn the present from the past, when change had not been organic, Shelley yearns for a history that is natural, one that does not make monsters. The monsters Shelley feared, of course, were those that she believed had been born of revolutionary turmoil – from the Parisian mob crowded round the guillotine, to the alienated workers packed in the new industrial cities.

Before the late eighteenth century, gothic architecture's origins were obscure, its development little more than a blur. The first, tentative ideas came from a Cambridge-based group of scholars and enthusiasts, including the antiquaries William Cole and James Bentham, the poet Thomas Gray and the architect James Essex. Bentham got into print with *History and Antiquities of the Conventual and Cathedral Church of Ely* (1771), which identified round-headed arches and massive pillars as 'the Saxon or Norman style', and claimed that the pointed arch, which he saw as diagnostically gothic, derived from features of this earlier manner. Gothic was thus an indigenous style – native, in the various senses and with all the associations we have already seen accruing to the concept. It also had a developmental history, for Bentham recognized that gothic was not homogeneous but exhibited all the signs of an internal stylistic evolution: distinct phases could be deduced from evidence of 'a manifold change of the mode as well in the vaulting and make of the columns as the formation of the windows'.

In 1771, the same year *Ely* appeared, Richard Gough was elected Director of the Society of Antiquaries. The rivals of the Antiquaries, the Society of Dilletanti, had earlier seized the leadership of classical architectural studies by sponsoring *The Antiquities of Athens* (from 1762) by James Stuart and Nicholas Revett. Gough concluded that the attention lavished on Greece and Rome should be turned to England, to, as he put it later, 'the works and monuments of our own priests and heroes'. From 1780, in the series *Vetusta Monumenta*, the Antiquaries began to issue large engravings of medieval remains: combining views with measured elevations and details, they were the finest representations of gothic architecture yet published. Among the artists was John Carter (1748–1817), who rapidly established himself as the

72
Caspar
David
Friedrich,
*City at
Moonrise*,
c.1817.
Oil on
canvas;
45×32 cm,
17¾×12⅝ in.
Oskar
Reinhart
Foundation,
Winterthur

period's leading gothic draughtsman (73), producing, with Gough's support, seminal works that included *Specimens of the Ancient Sculpture and Painting, Now Remaining in this Kingdom* (1780–94) and *Views of Ancient Buildings in England* (1786–93). In 1795, with Carter as executant and principal author, the Antiquaries began publishing the *Cathedral Series*, nothing less than an attempt to describe and illustrate comprehensively all the English medieval cathedrals. Scholarly interest was stirring outside the Society too: John Taylor's *Specimens of Gothic Ornaments* and Joseph Halfpenny's *Gothic Ornaments in the Cathedral Church of York* both appeared in 1794.

By the mid-1790s, the whole perception of gothic architecture in Britain had shifted. The change coincided with gothic fiction's great expansion and had the same catalysts: the French Revolution and the decades of war that ensued. While French arms barred Europe to British travellers, the august monuments of Roman civilization were inaccessible. Penned within their own islands, British antiquaries turned to the study of native gothic, to the remains of the country's medieval past. Though pragmatically driven, this move was effectively an occupation of long-prepared cultural positions. For gothic, charged with a formidable complex of meanings and associations, was a kind of ideological armoury, assembled almost unconsciously but primed and ready for use. Generally and specifically, the components of gothic's semantic – Britishness, martial prowess, free institutions, constitutional monarchy, national liberty – could all be wheeled out to do ideological battle with France. In this context the discourses of literary and architectural gothic were complementary: where gothic fiction managed revolutionary dangers by displacement and dissipation, gothic architecture met them by confrontation and defiance. There were sparks of political gothic's revolutionary past: would-be reformers such as John Cartwright and Francis Burdett clung to the radicalism of primitive Saxon liberty, as did that aristocratic oddball the eleventh Duke of Norfolk, rebuilding Arundel to honour the barons who humbled King John. But such

dissent could be dismissed or suppressed. Throughout the French wars and beyond, those aspects of the gothic semantic that stressed inherited authority and legitimated existing power were paramount. Gothic lined up with the Establishment.

Deployed against the violence of revolutionary change, there was much in the gothic position of the 1790s that would have satisfied Mary Shelley's later longing for an organic history that would not produce monsters. That the French Revolution *had* produced monstrosity was indubitable to such opponents as Edmund Burke, whose *Reflections on the Revolution in France* (1790) represented it as 'unnatural', 'a monstrous tragi-comick scene'. Significantly, Burke attributed France's deformity to the abandonment of a moral regime with roots deep in the Middle Ages: the aristocratic code of chivalry. For Burke, the emblematic moment had come in 1789, when a revolutionary mob had roughed-up Queen Marie Antoinette herself.

73 Overleaf left John Carter, Vaulting bays and windows, York Minster, *Ancient Architecture of England*, 1814

74 Overleaf right Frederick Mackenzie, The nave, Salisbury Cathedral, from John Britton's *Cathedral Antiquities of England*, 1814

I thought ten thousand swords must have leaped from their scabbards to avenge even a look that threatened her with insult. But the age of chivalry is gone. That of sophisters, economists, and calculators, has succeeded; and the glory of Europe is extinguished for ever.

Europe's inglorious new age belongs to 'sophisters, economists, and calculators'. That is, the theorists and entrepreneurs of the Agrarian and Industrial Revolutions, who replaced the paternalist – Burke would say chivalrous – values of ancient community with the new logic of capitalism. Chivalry's foes, the enemies of gothic and medievalism, are the economic revolutionaries whom Burke sees lurking behind political revolt. Burke's *Reflections* articulate one of the period's most powerful, if paradoxical, forces: Romantic conservatism. Here was a militant attachment to the past, most often the medieval past, which could be reinvented and mobilized – in books, pictures, buildings – against the emergency of the present. There was in this a central irony: the past was only available for reinvention because of the revolutionary disruptions conservatives abhorred, for discontinuity, a decisive break with the past, is the condition of historicism, the

Pub. as the act directs by I. Carter, May 1.st 1810, London.

J.C. d. 1806.

A.

B.

10 f.

Etched by H.Le Keux, from a Sketch by F. Mackenzie, for Britton's History &c. of Salisbury Cathedral.

SALISBURY CATHEDRAL CHURCH,

View of the Nave looking East.

TO THE VERY REV.ᵈ CHARLES TALBOT, *Dean of Salisbury &c. &c.____This Plate is inscribed by the Author.*

London, Published Aug.ᵗ 1, 1815 by Longman & C.º Paternoster Row.

Printed by Hayward.

creative engagement with historical cultures and societies that was an all pervasive feature of Romanticism. Only dissimilarity gives the past an identity distinct from the present, a shape or pattern that can be explored in the quest for origins, that can be imagined, invented, desired. Only because the gothic world was irretrievably lost could Romantic conservatism remake it.

Beyond antiquarian circles an audience for patriotic gothic was growing. In families of 'the better sort' from the 1790s to 1815, sons were away fighting Napoleon, wives and daughters turned out to watch the local yeomanry exercise, fathers groaned under the burden of war-taxes. Writing in the *Gentleman's Magazine* in 1797, John Carter knew 'of no way that can so well aid the general cause, as to stimulate my countrymen to think well of their own national memorials'. Scholarly accuracy and effort raised the cultural status of the country's medieval buildings, consolidating their role as 'national memorials', both emblems and evidences of continuing nationhood.

'England, home, and beauty' sang the famous tenor John Braham in 1811: what could be more English, homely and beautiful than gothic architecture? 'A knowledge of the Antiquities of England and Wales is at this Juncture particularly sought after by *all ranks of People*', wrote Alexander Hogg in *Antiquities of England and Wales* (1795), probably the first book expressly aimed at the new readership, his phrase 'at this Juncture' nicely combining a consciousness of England in an hour of need with a sense of hitting the market at the right moment. From the early nineteenth century that market expanded rapidly, led by the publications of the remarkable John Britton, whose famous and interminable *Beauties of England and Wales* (1801–15) led on to *Architectural Antiquities of Great Britain* (1807–14) and *Cathedral Antiquities of England* (from 1814). Offering 'correct delineation and accurate accounts ... drawn and engraved with scrupulous accuracy', Britton made gothic available as never before (74). He also showed that the entrepreneurship Burke reviled as anti-chivalric had created a whole new audience of medievalist

consumers. Britton – and perhaps Britain – could serve gothic and the market simultaneously.

In such a context, the lack of a history of gothic architecture, as distinct from illustrations and descriptions, was both a scholarly and a patriotic dereliction. Even so, substantial progress from Bentham's *Ely* did not come until 1798, with the publication of *Antiquities of Winchester* by John Milner, a Roman Catholic bishop and close friend of Carter. Taking his lead from Bentham, Milner argued that the history of gothic could be traced from the development of the simple pointed arch. Also, that the term 'gothic' should be replaced by 'the pointed order' – thus erasing any connotations either of barbarity or of political radicalism. By reading one element within the style developmentally, Milner invented a model for establishing gothic's chronological sequence. His ideas were reprinted by Taylor in *Essays on Gothic Architecture* (1800), with much earlier pieces by Thomas Warton and Francis Grose, and an extract from Bentham. The *Essays*, republished several times, gave the new audience for gothic a handy summary of the present position: 'the subject' opined Taylor's preface, 'is peculiarly interesting to every Englishman'. In 1811, Milner's *Treatise on the Ecclesiastical Architecture of England, during the Middle Ages* advanced a definite chronology for gothic – or 'pointed'. He proposed a tripartite division: the First Order of the Pointed Style, illustrated by Canterbury Cathedral, dated to 1175; the Second Order, shown in the nave of York Minster, built *c.*1300; and the Third Order, exemplified by that firm eighteenth-century favourite, Henry VII's Chapel (see 2). Milner not only provided gothic with its first periodized history, he also invested it with a moral trajectory. From the youthful but sometimes gauche vigour of the First Order, 'the aspiring arch' matured into 'the chaste grandeur' of the Second Order, then declined into the suspect 'ingenuity' and 'undue depression' of the Third. An epitome of natural process, a metaphor for the human condition, a cultural melodrama – The Rise and Fall of the Pointed Arch: a Cautionary Tale – the moralization of gothic's development proved compelling to an

age that produced unequalled prosperity and undreamed of problems, for it combined two of the nineteenth century's most characteristic narrative patterns: the inspirational story of progress, and the minatory story of degeneration.

Though it had a long cultural life as a moral tale, Milner's account of gothic was supplanted in 1817 when Thomas Rickman (1776–1841) brought out *An Attempt to Discriminate the Styles of Architecture in England, from the Conquest to the Reformation.* A practising architect, Rickman combined an extensive knowledge of medieval buildings with an analytical habit of mind. The modestly titled *Attempt* moved the understanding of gothic on

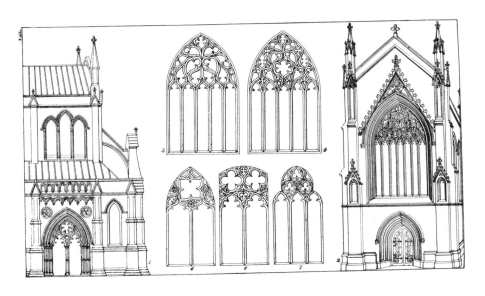

to a different plane, methodically describing a selection of gothic features – doors, windows, arches, piers – as they appeared at different times in the Middle Ages, with plentiful reference to actual examples (75). Rickman's scientific method, with the quality and quantity of his empirical evidence, gave the stylistic periods he identified an unprecedented authority. And they made his book famous. Having distinguished between Saxon and Norman building, an issue that had befogged antiquaries since the mid-eighteenth century, Rickman settled on a four-part chronology: Norman style (1066–*c.*1190); Early English style

(*c.*1190–*c.*1300); Decorated English (*c.*1300–*c.*1390); Perpendicular English (*c.*1390–*c.*1540). The importance of Rickman's work was immediately recognized, and his terminology rapidly adopted. Variously refined and adjusted, the *Attempt*'s stylistic periods became the basic conceptual categories of the Gothic Revival for the rest of the nineteenth century, and have structured the discussion of gothic down to the present day. The staccato short-hand of EE, Dec and Perp peppers architectural descriptions from the Victorian pages of Murray's county *Guides* to Nikolaus Pevsner's *Buildings of England* (1951–74).

Though Rickman acknowledged gothic's parallel histories in other European countries, he carefully reserved to England credit for its origination and growth. He terms the style 'English', identifies its phases with particular kings, claims 'English architects were ... prior to their continental neighbours' and finds English gothic distinguished for 'pure simplicity and boldness' – attributes which go back to eighteenth-century notions of Britishness. Here was the voice of the mainstream. It was not quite unanimous. G D Whittington's *Historical Survey of the Ecclesiastical Antiquities of France* (1809) located gothic's origins in twelfth-century France. He was quite right, but was ignored – apart from a tart dismissal in Milner's *Treatise*. With Britain and France locked in mortal combat, such academic objectivity looked downright feckless.

75
Thomas
Rickman,
Plate VIII in
*An Attempt to
Discriminate
the Styles of
Architecture
in England,*
1835 edition,
showing
examples of
Decorated
English

Ironically, France was not interested in claiming gothic: the style was tainted by association with the *ancien régime*, and Napoleonic rule found its cultural and military forebears in imperial Rome – the ancient enemy of all gothic folk. The revolutionary abolition of the medieval past consigned it to a museum, quite literally. In 1791, in an abandoned medieval convent, Alexandre Lenoir opened the Musée des Monuments Français, stacked with fittings, stained glass, tombs and statuary from religious buildings ransacked by the revolutionaries (76). No previous collection of antiquities had so self-consciously exhibited a nation's cultural history back to it, especially when

that history had been so sensationally disowned. Objects that barely two years before had sustained identities continuous with their original medieval purposes, now occupied a space wholly other to that in which the present conducted its bustling life. Lenoir's museum was a cultural retirement home where medieval France could be looked after and visited; it became one of the sights of Paris. Evidence of a more active French medievalism came with *Génie du Christianisme* (1802) written as France was seeking an accommodation with the papacy by the politician François-René de Chateaubriand, whose evocation of the spiritual riches of the Middle Ages, including gothic architecture, gave a fervently Catholic turn to Romantic conservatism. Though immediately acclaimed, the book's impact, by no means confined to France, was not fully felt until the 1820s, when a new religious impetus began to shape the Gothic Revival.

Germany, or the assorted states that then comprised it, seemed a more obvious rival to England as gothic's originator: gothic history started with Germania, and to the Italian Renaissance

76
Jean Lubin
Vauzelle,
*The Musée des
Monuments
Français*,
c.1815.
Watercolour
on paper;
37·5 ×
52·5 cm,
14¾ × 20⅝ in.
Musée du
Louvre, Paris

medieval architecture was 'the German manner'. In 1770, *Sturm und Drang* emotions turbulent in his breast, Goethe visited Strasbourg Cathedral and was promptly overwhelmed. In the impassioned essay that followed, *Von deutscher Baukunst* (*Of German Architecture*, 1773), he hailed Strasbourg as an organic expression of the Germanic imagination, Nature herself speaking through the supposed architect, Erwin von Steinbach, whose genius, 'prompted by intense, individual, and original feeling', exemplified that of the German people. Natural, native, national, just what the English discovered in gothic. But Goethe's enthusiasm sprang from a painful consciousness of Germany's splintered condition. Where gothic could symbolize British nationhood, in Germany it was emblematic of a unity that existed only as history or as hope. Not until the end of the Napoleonic Wars did reviving gothic as a symbolic focus of national unification become practical.

Meanwhile, scholars struggled with gothic's development and a nomenclature to go with it. Conscious of the medieval debt to classical Italy, they often concentrated on the architecture that preceded gothic – the styles that the French antiquary, Arcisse de Caumont, would label 'Romanesque' in his 1825 *Essai sur l'architecture religieuse*. In *Geschichte der zeichnenden Künste* (*History of the Arts of Design*, 1798–1808), Johann Dominik Fiorillo followed Goethe in substituting 'German' for 'gothic', but confused things by finding Arabic and Lombardic origins as well. Friedrich Schlegel wanted to replace the phrase 'gothic architecture' with 'Romantic architecture', and to call round-arched styles 'Early Christian'. Later writers, such as Sulpiz Boisserée and Carl Friedrich von Rumohr, complicated matters further by emphasizing Byzantine influences. None of this helped much when it came to sorting out a chronology for gothic, or even a vocabulary. The British had the advantage of being more narrowly focused and less troubled (as ever) by first principles. And nobody in Germany got hold of actual medieval buildings with the kind of classificatory zeal that Rickman displayed.

The Romantic historicism that made medieval gothic the subject of disciplined study also informed those twin aspects of Romantic sensibility, the Sublime and the Picturesque, the aesthetic categories of awesome Inverary and deliciously irregular Strawberry (see 57 and 50). The Sublime and the Picturesque were ways of feeling and creating meaning as well as ways of seeing. That is, as aesthetic paradigms they were also ideological. Notions of the Sublime derived from accepting the necessity of submission to higher authority; from discovering aesthetic, ultimately psychological, fulfilment through the self's subordination to an external power that is absolute, even annihilating. Reciprocally, the Picturesque reinforced the self by locating power internally, in the imagination's ability visually to construct and control the world around; so the all-composing eye (I) becomes the creator of its own universe of gratificatory pictures. Both categories relate to the complex – and continuing – negotiation between state power and individual rights characteristic of modern society. And both were shaped by capitalism, which requires its agents (all of us) to submit to the impersonal dictation of economic forces, but also promises personal empowerment through a free market that will realize everybody's productive potential. The reward for accepting economic discipline is the freedom to enjoy an abundance of goods and commodities. In the parallel economy of aesthetics, the pay-off for submission to the Sublime was the unprecedented emancipation of the individual imagination that Romanticism achieved. Just as the French Revolution, for all its tyrannical extremes, really *was* about human liberty, equality and fellowship, so also the Sublime and the Picturesque, however comic or questionable their excesses, were the vehicles of great creative adventure, genuine visual discovery. They too were a means of freeing us, that we might remake the world.

Part of that remaking came with the gothic and medieval subjects central to the Romantic visual arts: gothic buildings in every state from abject ruin to imaginary perfection; landscapes punctuated by churches and castles, sublime amid tempest-racked mountains, picturesque amid rain-washed fields; medieval scenes of

77
J M W Turner, *Norham Castle, Sunrise*, 1845. Oil on canvas; 90·8 × 121·9 cm, 35¾ × 48 in. Tate Gallery, London

78 Overleaf John Sell Cotman, *Croyland Abbey, Lincolnshire*, c.1804. Pencil and watercolour on paper; 29·5 × 53·7 cm, 11⅝ × 21⅛ in. British Museum, London

cottages, hamlets, cloisters, battlefields; visionary vistas where gothic features carry secret meanings. Every medium was used and images of gothic architecture disseminated throughout the cultural market: academic canvases for country house collections; volumes of antiquarian and topographical plates aimed at middle-class readers; stage sets for productions of Shakespeare, and the many forgotten plays that took the Middle Ages as their theme; publicly exhibited panoramas attracting eager audiences across Europe. Only an indication of the range is possible here.

In the paintings of Joseph Mallord William Turner (1775–1851), ruined medieval castles that testify to a history of human conflict are repeatedly defined by or resolved into light, creation's primary element: *Carnarvon Castle* (1799), its masonry shell harsh against an apocalyptic sunset; *Norham Castle* (1845), the ruin's substance no more solid than its reflection, dissolved in a final serenity of light (77). Visionary in a quite different way, the idyllic landscape of *Dedham Vale* (1802; 1828) by John Constable

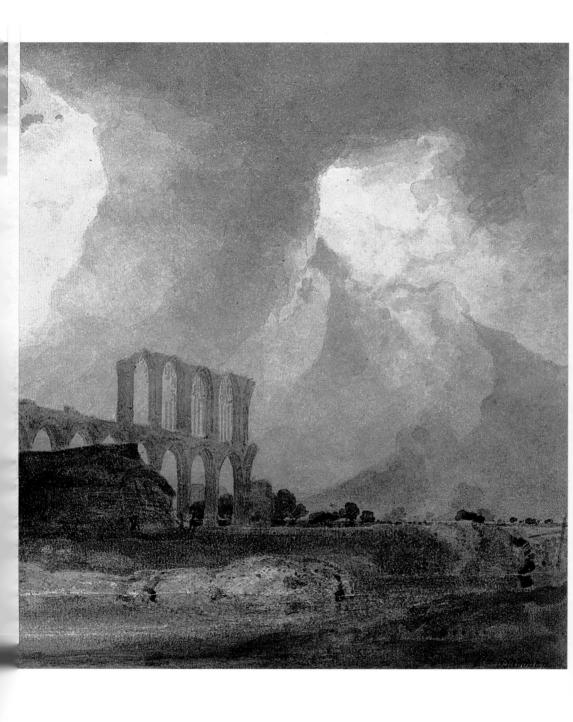

(1776–1837) falls evenly back into a pastoral infinity, signposted by the gothic tower of Dedham church in the middle distance. In his Salisbury Cathedral canvases, Constable ranged from the optimism of the view from the Close (c.1820), with the great spire springing into a summer sky, to the turbulence of the 1831 view from the Meadows, the cathedral distanced and beset by storms. Watercolourists, lured by the evocativeness of British gothic under native skies, produced thousands of paintings nuanced between the picturesquely crumbling textures of the plates in *Village Scenery* (1812) by Samuel Prout (1783–1852), and the ominous *Croyland Abbey, Lincolnshire* (c.1804) by John Sell Cotman (1782–1842) – purple ruin and stupendous sky looming over a sunlit foreground where a solitary child paddles, indifferent to the sublime drama of history and nature at his back (78).

Sublimity supports more specific symbolic meaning in the German landscapes of Caspar David Friedrich (1774–1840). The gaunt remains of monastic churches, depicted with hallucinatory intensity in *Abbey in the Oakwood* (1810) and *Monastery Graveyard* (1819), signify the lost world of medieval spirituality, while the complete gothic churches of *Winter Landscape with Church* (1811) and *City at Moonrise* (1817; see 72) are tantalizingly out of reach, behind the mist or over the river, emblems of spiritual wholeness beyond flawed mortality. Where Friedrich is introspective, the visionary gothic edifices of Karl Friedrich Schinkel (1781–1841) – architect, Berlin urban planner, artistic favourite of the Prussian court – are statements of optimism and national pride. In *Cathedral* (1811) and *Gothic Cathedral by the Water* (1813) gothic piles climb high above busy streets, their traceried towers set against the sunlight (79); in *A Medieval City on a River* (1815), painted as Prussia emerged triumphant from the Napoleonic War, a medieval host marches towards a national gothic cathedral (80), its unfinished state symbolizing the unsettled business of unifying Germany. Meanwhile, Germany's actual medieval buildings began to receive the full Romantic treatment: in 1818–23 Domenico Quaglio (1787–1837) published a series of lithographs of gothic castles perched sublimely on Alpine crags.

79
**Karl Friedrich
Schinkel,**
*Gothic Cathedral
by the Water,*
1813.
Oil on canvas;
80×106·5 cm,
31½×42 in.
Nationalgalerie,
Staatliche
Museen,
Berlin

80
Karl Friedrich Schinkel,
A Medieval City on a River, 1815
Oil on canvas;
95 × 140·6 cm,
37⅜ × 55⅜ in.
Nationalgalerie,
Staatliche
Museen,
Berlin

In Napoleonic France, it was heroic Neoclassicism not gothic that provided the index of patriotic style. Medievalism, though, was fashionably represented by paintings of the Troubadour School – decorous courtships in picturesque costumes, the themes vaguely derived from the aristocratic love poetry of the Middle Ages. Even so, the School managed occasional artistic adventure, particularly in *The Tournament* (1812) by Pierre-Henri Révoil (1776–1824), its flattened perspective, enamelled finish and meticulous architectural detail matching the medieval subject by evoking the conventions of late gothic painting (81). There is no direct imitation: but the exquisiteness of the Limbourg brothers' *Très Riches Heures du Duc de Berry* (*c.*1410), the concentrated detail of the *Adoration of the Lamb* (1432) altarpiece in Ghent by Jan van Eyck (*c.*1395–1441) and the compositional management of the *Rout of San Romano* (1450) by Paolo Uccello (*c.*1396–1475) are all at least suggested. Révoil's elegant revivalism was earnestly paralleled by the Nazarenes, a Rome-based group of young German painters led by Franz Pforr (1788–1812) and Friedrich Overbeck (1789–1869), dreaming of medieval Catholicism and labouring devotedly to recreate the style and technique of the Age of Faith. Though Overbeck's manner was Italianate, Pforr, who died young, worked directly out of northern European gothic. His *Entry of Rudolf von Habsburg into Basle in 1273* (1808–10), crowded, quaint and colourful, is an extraordinary feat of reinvention (see 1).

Extraordinary in quite opposite ways, for their scale and their popular appeal, were the huge transparencies of gothic ruins painted in the 1820s by Louis Daguerre (1787–1851) for his newly invented Diorama in Paris – an optical show using giant transparencies that was the successor to the Fantasmagorie. Schinkel had experimented with transparencies in Berlin, including a version of his *Gothic Cathedral by the Water*, but without the Diorama's special effects. Now surviving only in easel versions, Daguerre's views of Scottish ruins (82) were made to appear and disappear in every combination of dusk and dawn, moonlight and sunlight, fog and snow. Magic medievalism, the Diorama was

**81
Pierre-Henri
Révoil**,
*The
Tournament*,
1812.
Oil on canvas;
133×174 cm,
52³⁄₈×68¹⁄₂ in.
Museé des
Beaux-Arts,
Lyon

greeted on its 1825 opening in London as 'the greatest triumph ever achieved in pictorial art'. Daguerre went from exploring gothic under different effects of light to a greater triumph, the discovery of the photographic process. Oddly enough, the Gothic Revival was also linked to early photography in England: Daguerre's fellow-pioneer, Henry Fox Talbot, conducted his experiments at Lacock Abbey, in large part Sanderson Miller's gothic creation of the 1750s (see 43).

Daguerre's canny choice of subjects for his Diorama drew on the hugely popular writings of Sir Walter Scott. A collector, antiquary and enthusiast for gothic architecture as well as an author, Scott's medievalism started with poetry, anthologizing ancient ballads and penning his own verse narratives – among them *The Lord of the Isles* (1815), full of the fourteenth-century heroics of Robert the Bruce. Though unusually thorough, such medievalism

was part of the currency of British Romantic poetry, to be found, variously blended, in major poems such as Robert Southey's *Joan of Arc* (1795), Samuel Taylor Coleridge's *Christabel* (1797–1800), William Wordsworth's *The White Doe of Rylstone* (1807) and John Keats's *The Eve of St Agnes* (1819). And beyond such literary high ground stretches a vast terrain of poems, essays, letters and journalism crowded with the picturesque impressions and sublime feelings that came so readily to those enchanted by the Middle Ages. Though Scott's poetry was popular, it was his novels that gained him his largest audience, a mass readership sustained throughout the nineteenth century across the whole of Europe. Almost all the fiction known collectively as *The Waverley Novels* is historical. Eight novels deal directly with the Middle Ages, the best known being *Ivanhoe* (1819). Others, such as *The Monastery* (1820) and *Kenilworth* (1821), have gothic architecture as a major ingredient – almost as a character in its own right. Scott's Middle Ages are aristocratic and martial, structured by feudal loyalties and the prescriptions of the Church. Social threat comes from within: from dynastic ambition, ready violence, religious fanaticism. The values of chivalry – the code Burke saw vanish in the French Revolution – are absolutely pervasive, and with it comes glamour. Those exhilarating moments when bugles flourish, caparisoned chargers paw the earth, paladins spur to succour the oppressed and knights pledge fealty to high-souled damsels.

Beneath its surface allure, Scott used chivalry to counter the fears and dark fantasies of that other form of medievalizing fiction, the gothic novel. There is plenty of gothic creepiness in Scott, but he also conjures the core gothic horror of untrammelled power, at once political and sexual; thus, in *Ivanhoe*, the two heroines Rowena and Rachel are pursued through a castle by Norman aristocrats bent on rape. To this, chivalry is the perfect answer, for it both controls power and prescribes its use: the chivalrous prince will protect, not exploit, the populace; the chivalrous knight will cherish, not ravish, the lady. As a social, political and sexual model, chivalry later became one of medievalism's most important contributions to shaping Victorian

82
Louis Daguerre, *Ruins of Holyrood Chapel*, c.1825. Oil on canvas; 211 × 265·5 cm, 83 × 101 in. Walker Art Gallery, National Museums and Galleries on Merseyside

culture. The chivalric paradigm was, of course, ideologically conservative, premised upon inequalities of both class and gender, its social relations paternalistic, its gender relations patriarchal. But it was more than merely reactionary. Burke saw the death of European chivalry in Marie Antoinette's mistreatment, her symbolic rape, by the Paris mob – a version of the gothic pattern whereby the political shock of revolution was visited directly on the bodies of its victims. Scott's fictive reinvention of chivalry responded to this gothic history: chivalry would safeguard the body of the state, just as it protected the bodies of its vulnerable citizens. The idea of chivalry was an attempt to mend those bodies the Revolution had broken.

Scott was more sympathetic to economic change than Burke had been, but the chivalric society of his novels is, by definition, pre-capitalist, pre-urban, pre-industrial – basically a glamourized and particularly hierarchical version of Tönnies's 'community' (see Chapter 5). Scott's medieval world was a crucial imaginative space in which Romantic conservatives could regroup, and from which the emergent capitalist world could be tested. There was a further ideological turn. The chivalric society is secured by an aristocratic, landowning, military élite; their ideological descendants and class equivalents, when Scott's novels appeared, commanded the army and navy which had just put paid to that revolutionary upstart, Napoleon Bonaparte. There is a logic to the chivalric paradigm: the security and prosperity of Britain, the state with the most advanced capitalist economy on earth, depended upon its pre-capitalist inheritance. Britain – the logic runs – had not been saved by commerce, but by the heirs of *Ivanhoe*. An unprecedented urbanizing and industrializing society relied finally upon precedent; that which seemed without history, upon history. Modernity depended on the Middle Ages.

Romanticism's impact on how gothic architecture was imagined, experienced and – incredibly – built, was exemplified by Fonthill Abbey, Wiltshire (1796–1812), the house of William Beckford. Though now only a fragment, Fonthill was originally a vast cruciform structure (83), its north and south arms single galleries, seemingly endless, its octagonal central saloon, vaulted 36·5 m (120 ft) above the floor, surmounted by a tower rising 91 m (300 ft) and originally projected to carry a spire that would have topped nearby Salisbury Cathedral's. The architect was the successful James Wyatt (1746–1813), whose first gothic mansion had been

83
Charles
Wild,
*Fonthill
Abbey*,
c.1799.
Watercolour
on paper;
29·2 ×
23·5 cm,
11¹₂ × 9¹₄ in.
Victoria
and Albert
Museum,
London

Sheffield Park, Sussex (from 1776), who had designed Lee Priory (see 59), the house Walpole thought prettier than the parental Strawberry, and who was responsible for large-scale cathedral restorations at Hereford (from 1786), Lichfield (from 1788) and Salisbury (from 1789). But the conception of Fonthill was Beckford's own. Having inherited one of the largest fortunes in England, Beckford was a recluse, marginalized by a murky homosexual scandal and notorious as the author of the oriental novel *Vathek* (1786), its central character as great a tyrant as any in gothic fiction. Beckford's social isolation confirmed his sense of himself as a most superior being. 'I am an Autocrate', he wrote in a letter of 1790, 'determined to make the most of every situation.' Fonthill Abbey, hemmed in by thick forest, enclosed by a wall 9·6 km (6 miles) round, was at once the Romantic genius's retreat from an insipid, uncomprehending world and a colossal act of self-assertion, both domineering and sulkily withdrawn. A gothic moral fable, Fonthill rose, was packed with Beckford's accumulated treasures, and fell. In 1825 the central tower collapsed, taking much of the building with it; bored and nearly bankrupt, Beckford had already sold up and moved to Bath.

The two main branches of the secular Gothic Revival during the Romantic period were monastic gothic, of which Fonthill is the

supreme statement, and castellar gothic. Monastic gothic evoked medieval learning and piety, as aestheticized by Walpole at Strawberry. Amid the illuminated manuscripts in Fonthill's galleries, or wandering through its cloisters, Beckford played the retired scholar; and in the Abbey's inevitable oratory staged a personal cult of St Anthony of Padua that was more about sensuousness and silver candlesticks than sanctity. Monastic gothic also signified wealth. Since monks swear vows of poverty this may seem perverse, but every schoolboy knew that, at the Dissolution of the Monasteries, gold and silver had issued from the religious houses by the cart-load. Such riches were both occult, segregated from the multitude's profane touch, and sacred, owned by the Church and often in the form of devotional objects. One of Beckford's prize exhibits was a reliquary dating back to St Louis (Louis IX, r.1226–70) and the Crusades, apparently bought from the sale of the St Denis Treasury in revolutionary Paris – a sacred object literally rescued from the hands of the mob. Fonthill's blurring of religion and art conferred an ironic blessing on Beckford's wealth, much of it derived from West Indian slave plantations. But monastic gothic's association with sanctified hidden treasure had a broader ideological significance. Beckford's wealth was new, originating in the commerce that was basic to Britain's capitalist revolution; capital was also hidden, its transactions impersonal – though it was influencing everybody's life. And contemporary economists claimed that the principles governing the capitalist market were immutable and inevitable, just like the laws of God.

An extreme expression of an extreme aesthetic, Fonthill was the gothic Sublime *in excelsis*. Contemporary engravings produced by John Rutter (84) and John Britton convey effects of height, space, distance and sheer size that clearly derive from Burke's formulations. Here was a manifestation of power epitomizing the link between the Sublime and the gathering forces of capital. But Fonthill's power was not only that of wealth. For all his silliness and sadness, Beckford had the temerity to burst the bonds of mundane common sense in pursuit of a creative vision. In the

Romantic canon, such acts belong to genius and are unique. Fonthill's power was that of originality. For all its historicism, Fonthill's gothic could only have been conceived by the Romantic imagination at its most unfettered – some would say unhinged. In a letter of 1818, John Keats coined the phrase 'the egotistical sublime' to describe Wordsworth's poetry. It is just right for Fonthill Abbey: the egotistical sublime in stone.

A few other monastic gothic houses essayed the Sublime. Designed by William Porden (*c.*1755–1822), Eaton Hall, Cheshire (1803–25), now demolished, had an exaggeratedly long entrance front, with ranks of stretched windows and attenuated buttresses finishing in a bristling phalanx of pinnacles, and opulent interiors

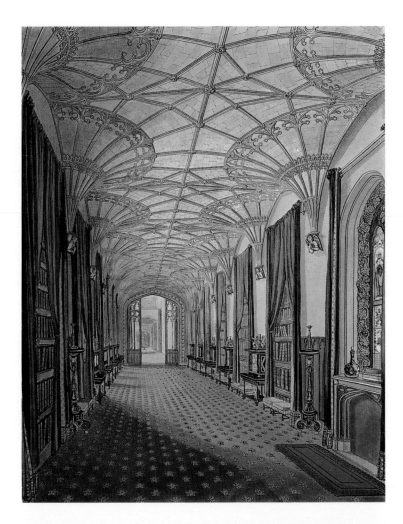

84
Perspective from St Michael's Gallery to King Edward's Gallery, aquatint from John Rutter's *Delineations of Fonthill*, 1823

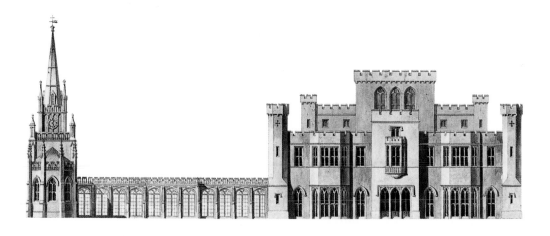

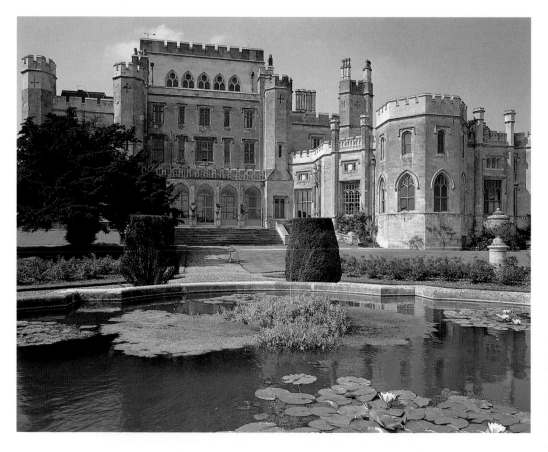

filled with traceried plasterwork, heraldic decoration and an unparalleled array of gothic furniture. Happily still standing is Ashridge Park, Hertfordshire (1808–20), designed by Fonthill's own James Wyatt and his nephew Jeffry Wyatt (1766–1840): a mammoth complex, composed around the free-standing chapel and the main block of the house, linked together by a cloistered range (85, 86). The soaring interior volume of the chapel tower and the great void of the house's stair-hall, sensationally lit from windows in the top storey, are exercises in spatial sublimity that recall engravings of Fonthill. The now ruinous Lowther Castle, Cumbria (1806–14), by the young Robert Smirke (1780–1867), later architect of the British Museum, has one monastic gothic front (87), the other castellar, both long and symmetrical, massing powerfully to a central stair tower. Evidence of how readily gothic's political significances were grasped comes in a Wordsworth sonnet of 1833, which sees Lowther's combination of 'Cathedral pomp and grace' with 'the baronial castle's sterner mien', as a 'Union significant of God adored, / And charters won and guarded by the sword / Of ancient honour'. Religious tradition and aristocratic continuity between them guarantee English liberty. However, associating Lowther and its owner, the Earl of Lonsdale, with 'ancient honour' was stretching things. Lonsdale was an industrial plutocrat, his wealth derived from coal and shipping, and the earldom dated from 1807, its creation the occasion for building the house. Like Fonthill, Lowther was the product of the capitalist revolution. So also Eaton and Ashridge; the first financed by the Earls of Grosvenor from property development in London, the second built on the fortune left in 1803 by the third Duke of Bridgwater, agrarian entrepreneur, owner of coal mines and pioneer canal-builder. Only the Grosvenors had some kind of medieval aristocratic lineage, which Eaton's armorial decorations made the most of. The *parvenu* needed ingenuity and impudence; Beckford, for example, contrived a heraldic scheme at Fonthill which linked his daughter back to all seventy-one original Knights of the Garter, and spuriously proclaimed his family's descent from all six sons of Edward III.

85
James Wyatt, Design for the south elevation, Ashridge Park, Hertfordshire (detail), c.1807. Pen and wash on paper; 41×53·5 cm, 16⅛×21 in. Royal Institute of British Architects, London

86
James Wyatt and Jeffry Wyatt, East front, Ashridge Park, Hertfordshire, 1808–20

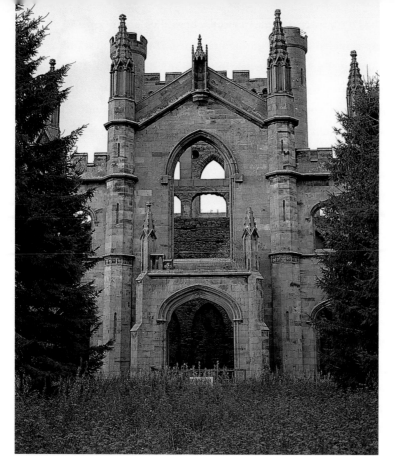

87
**Robert
Smirke**,
Monastic
gothic front,
Lowther
Castle,
Cumbria,
1806–14

Apart from plutocratic sublimity, monastic gothic was particularly used for remodelling houses with an historical monastic past, often to the owner's designs. Such houses as Combermore Abbey, Cheshire, worked over in 1795 by Sir Robert Cotton, whose family had been there since the Dissolution, or Nether Winchenden, Buckinghamshire, a former Netley Abbey property recast by Scrope Bernard in 1798–1803, show an enthusiasm for the gables, pointed windows and little stretches of cloister that could give the appropriate monastic *frisson*. In Scotland, owners turned more readily to professionals. An important exemplar was the rebuilding of the formerly monastic Scone Palace, Perthshire (1803–12) by the English architect William Atkinson (*c.*1773–1839), who had worked with Wyatt, and who went on to design Rossie Priory, Perthshire (1810), an agreeable medley of cloisters and

spire-capped towers, now largely destroyed. Among Scottish architects, James Gillespie Graham (1776–1855) remodelled Ross Priory, Dunbartonshire (from 1810), following it with Crawford Priory, Fife (from 1811).

As these houses were being built, revived gothic began to register the impact of the antiquarian studies that had taken off in the 1790s. With topographical and architectural views widely disseminated, clients were more conscious of what medieval buildings actually looked like. Equipped with the measured drawings of draughtsmen such as Carter (see 73), architects were increasingly aware of medieval precedent. Once Rickman's *Attempt* had identified gothic's different periods by their component features, the well-informed style-spotter was able not only to date old buildings, but also to criticize the historical accuracy and stylistic consistency of new ones. Conscious archaeological correctness, first introduced to the Gothic Revival by Walpole, grew ever more important in gothic design. Particularly influential in the cause of fidelity were the compilations of Augustus Charles Pugin (1769–1832): *Specimens of Gothic Architecture* (1821–3) and *Examples of Gothic Architecture* (1828–36), in which he was helped by his son, Augustus Welby Northmore Pugin (1812–52), of whom much more in due course. A sense of medieval precedent pervades monastic gothic in the later Romantic period, though to different degrees. Two splendid and contrasting examples are the energetically varied ensemble of Conishead Priory (88), at Ulverston, Lancashire (1821–36) by Philip William Wyatt (d.1835), James's youngest son, and the contemporaneous Toddington Manor (89), Gloucestershire, where the owner, Charles Hanbury Tracy (1778–1858), acted as his own architect. Toddington, the work of the amateur, is the more archaeologically informed, its design quarried from Pugin's *Specimens* and Oxford's medieval colleges. What they share, however, and have in common with all monastic gothic houses that are not downright sublime, is a commitment to the compositional principles of the Picturesque – for which we must turn to the Gothic Revival's other great paradigm in the Romantic period, castellar gothic.

Romantic castellar gothic began a quarter of a century before Fonthill, with Downton Castle (90), Herefordshire (1771–8), designed by its owner Richard Payne Knight (1750–1824). Downton's interiors are Neoclassical, and Knight was a noted collector of classical antiquities. For connoisseurs, proud of a broad cultural expertise, such enthusiasms could happily be sustained along with an interest in gothic, just as architects – James Wyatt for one – developed an ability to design in both styles. Downton is an instance of such stylistic coexistence, for the exterior belongs wholly to gothic. Emphatically asymmetrical in plan, the external massing is strikingly irregular: ranges chopped into different lengths, towers of diverse heights and sorts, a squat off-centre block in the main elevation, odd little turrets and lots of battlements. Dramatically sited high above the River Teme, Downton is designed to be seen obliquely, conceived in terms of how it might look in the eye of a spectator. It is the Gothic Revival's first consciously designed picturesque castle, the harbinger of a crenellated legion.

As acknowledged symbols of power, long-established features of the British countryside, castles were particularly suited to the

88
Philip
William
Wyatt,
Conishead
Priory,
Ulverston,
Lancashire,
1821–36

89
Charles
Hanbury
Tracy,
Toddington
Manor,
Gloucester-
shire,
1819–23

ideological task of naturalizing land ownership and its attendant political authority. At the same time their historical associations could summon up those stirring episodes – Magna Carta, Barons' Wars and the rest – that were part of the Whig version of gothic liberty. But Downton, precisely because it was conceived in the spirit of the Picturesque, did more than just consolidate existing codes of meaning.

The estate came to Knight from his grandfather, a self-made man who amassed a fortune as a Shropshire ironmaster, who bought it because he wanted the timber in the nearby Bringewood Forest as fuel for his furnaces. The seemingly medieval castle, erected on industrial money, commands a panoramic view over the apparently natural forest, exploited for industrial purposes. At Downton one of the Industrial Revolution's basic raw materials and one of its sophisticated cultural products confront one another, but the industry that turned the forest on one side of the valley into the castle on the other is nowhere apparent. Industrial capitalism converts timeless nature into history and culture then disappears – along with labour, conflict and exploitation. In Romantic gothic's ideological landscape, the mysterious, wealth-producing forest and the magically built castle join the monastery with its hidden treasure as archetypes in a modern fairy story. The landscape is held in being by the sorcery of capital, and the enchantment, at Downton, is woven by the Picturesque. It is a participatory enchantment, for where the Sublime overawes, the Picturesque woos, and the spectator, entranced by visual pleasure, becomes aesthetically and ideologically complicit, helping to make and validate the meanings of castellar gothic and sylvan setting: both what is signified and what is skipped.

Like so much else that was gothic, picturesque castles became popular as Britain went to war with France. While consolidating the ideology of property, the castle's martial resonances further associated proprietorship with resolution in the cause of national defence. At the same time, the miscellaneous ideas and practices of the Picturesque received their first theoretical treatment, in

90
Richard Payne Knight, Downton Castle, Herefordshire, 1771–8. Coloured etching, 1879. 19·6 × 14·3 cm, 7 3/4 × 5 5/8 in

the writings of William Gilpin, Uvedale Price and Richard Payne Knight himself. Though their emphases differed – Gilpin's were primarily pictorial, Price's psychological, Knight's intellectual – all were enamoured of the effects of untamed nature, which fitted well-established notions of gothic as rugged and organic, and vitally encouraged a taste for the kind of visual variety gothic offered. But their principal concern was landscape: architecture was secondary, and issues of style tangential.

More directly addressed to architecture was the modified version of picturesque theory in *Sketches and Hints on Landscape Gardening* (1795) by Humphry Repton (1752–1818), a professional and highly successful landscape gardener, famous for the *Red Books* he produced to explain and illustrate estate improvements to prospective clients. In *Sketches and Hints* Repton endorsed the pursuit of the Picturesque, but rejected wild nature in favour of an aesthetic of 'propriety and convenience' that emphasized the

social and political meaning of landownership. The layout of the whole estate should announce 'appropriation' – Repton's own term – and thus signify the 'unity and continuity of unmixed property' belonging to the landowner. Repton made explicit the covert ideological strategies that were described earlier in discussing eighteenth-century landscaping. An expression of Romantic conservatism, Repton's aesthetic of 'appropriation' was a strategic bid to reinforce the physical presence in the British countryside of its traditional governors, the hereditary landed interest, and thus the regime of paternalism and deference that Burke, and later Scott, identified with chivalry. Repton's 1791 *Red Book* for Tatton Park, Cheshire, suggests decorating 'the church, and churchyard ... in a style that shall in some degree correspond with that of the mansion', erecting similarly designed buildings on the estate, and putting up structures which 'bear the arms of the family' – all to achieve 'the appearance of united and uninterrupted property'. Though Repton prescribes no particular style – Tatton is Neoclassical – gothic's association with ancient landed families, patriotism and the continuity of British institutions made it a perfect vehicle. A particularly overt statement of ideological purpose, 'appropriation' resonates through the secular gothic of the Romantic period, and beyond, through the thousands of gothic and near-gothic estate buildings erected by landowners during the nineteenth century.

John Nash (1752–1835), the king of the picturesque castle, was Repton's partner between 1796 and 1802. Nash's early practice centred on Carmarthen, and he knew the circle of Knight and Price, gothicizing Hafod House (1794) on the estate of Knight's cousin Thomas Johnes, and designing the gothic Castle House (1795), beside the sea at Aberystwyth, for Price himself. Nash's partnership with Repton followed his move to London, the start of a social career that made him the pet architect and crony of the Prince Regent (later George IV, r.1820–30). The first major product of the Repton collaboration was Luscombe Castle, Dawlish (1799), on the salubrious south Devon coast, for the banker Charles Hoare, who had a large income and a sickly wife.

Repton's picturesque planting was matched by Nash's highly inventive house (91), all angles and irregularities, with an octagonal, battlemented tower, a veranda-cum-conservatory lit by huge gothic windows, and a kitchen range set obliquely and terminating in a turret. More intimately varied as well as more compact than Downton, Luscombe is altogether friskier; and a lot further away from any castle that the Middle Ages put up.

Luscombe was Nash's first complete picturesque castle, but in 1798 he had started building his own country house on the Isle of Wight, East Cowes Castle – demolished, disgracefully, in 1950. With its principal rooms in three big towers clustered at one end, their lofty silhouette set off by an extraordinarily long embattled conservatory, East Cowes Castle took artistic risks, pushing at the limits of asymmetry, its masses arranging and rearranging as the picturesque spectator moved round the building. Nash had the decisive knack of pictorial composition, and gothic castles brought out the best in him, making up a major part of his output in the first decade of the nineteenth century. He carried out a half dozen larger commissions in England and many smaller. All reveal the same brilliant, experimental sense of three-dimensional geometry, parts locked together like some ingenious toy, interior shapes shifting intriguingly from volume to volume – a picturesque feeling for space, as well as a pictorial sense of composition. Alas, it is hard to experience any of it now: of all of them, only Caerhays Castle (1808), tucked into a wooded hillside on the Cornish coast, and Knepp Castle (1808), in Sussex, still stand.

The picturesque castle became one of the Gothic Revival's central building types, and, with Nash as chief magician, spread its enchantment over Romantic Britain, most winningly, perhaps, amid upland scenery. They were designed by architects of every status. Some were men of national repute, like Nash's main rival, James Wyatt, who produced a clutch of castles and castellar structures from the mid-1790s. The best of these are Norris Castle, East Cowes (1799), adjacent to Nash's house, and

Pennsylvania Castle (1800), on the Isle of Portland in Dorset. In 1801 he began rebuilding Belvoir Castle, Leicestershire, medieval stronghold of the Dukes of Rutland. Then there were the local architects, between them probably responsible for most of the country's picturesque castellar buildings. For example: Crosby Lodge, Alstonby, Cumberland (1801–10), a lively composition of square and octagonal towers from the county surveyor, Peter Nicholson (1765–1844), and Watermouth Castle (from 1825), sitting below the north Devon cliffs, eventually completed in the 1840s by George Wightwick (1802–72) of Plymouth. And there were amateurs – usually, as with monastic gothic, the owner. To take one especially ambitious example, Cholmondeley Castle (92), Cheshire (1801–5) was designed by the first Marquess of Cholmondeley, celebrating his family's long connection with the site in an entrancingly various display of pointed windows, turrets and towers. While new castles were being built, ancient houses with real medieval defences were spruced up to meet the demands of picturesque composition: thus fifteenth-century Helmingham Hall, Suffolk, famous moated and fortified seat of the Tollemache family, was romanticized with battlements and

91
John Nash and Humphry Repton, Luscombe Castle, Dawlish, Devon, 1799. Engraving

92
First Marquess of Cholmondeley and others, Cholmondeley Castle, Cheshire, 1801–5

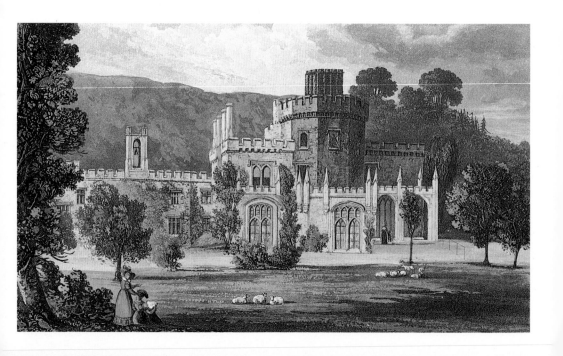

gothic porches in 1800 by Nash and John Adey Repton (1775–1860), Humphry's son. And staid classicizing houses could be gingered up altogether, such as the seventeenth-century High Street House in Chiddingstone, Kent, which got the full castellar treatment from William Atkinson around 1805, and found itself renamed Chiddingstone Castle.

In its early years the picturesque castle was perfunctory in its detailing and unmedieval in its massing. As archaeological knowledge grew, however, details, as in monastic gothic, were increasingly drawn from medieval precedent, and composition became more historically informed. Revived gothic had arrived at a need for authenticity, which resided largely in style. Reviving an architectural style was like learning an historical language, its 'grammar of ornament' – to quote the title of Owen Jones's famous work of some forty years later – and the rules governing its composition. Logically, it was a peculiar sort of authenticity, for the buildings were all modern inventions contrived to meet the needs of their own time. No castle of the Middle Ages had a breakfast room in the sunny southeast turret, any more than monasteries had ballrooms. But it was an authenticity that

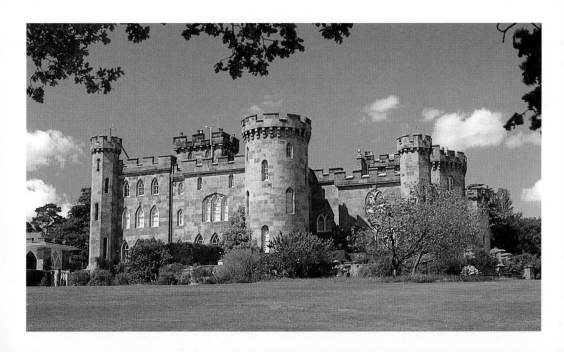

belonged to the pervasive historicism of contemporary culture, and is paralleled in Scott's novels, where well-researched details of medieval society are deployed to create a glamorized chivalric world responsive to the ideological needs of the times.

The later products of castellar gothic, aware of the actualities of medieval military architecture, seem to be trying to embody Scott's chivalry in its martial aspect. But copying originals changed what castellar gothic meant, because it challenged the aesthetic basis of the Picturesque. For no medieval castle had been built to charm. Mighty thicknesses of masonry, vast expanses of wall pierced only by tiny embrasures, great physical strength: these were not the winning ways of the Picturesque, but the stern stuff of the Sublime. Later Romantic castles tend to become bigger and bulkier – super-castles, their business seemingly too serious to be entrusted to the wiles of pictorial composition. Where picturesque castles coax us into political complicity, sublime castles demand consent. This ideological shift was not accidental. Picturesque castles had expressed, among much else, patriotic resistance to a foreign threat; sublime castles appeared as social insurrection stirred at home.

93
James Wyatt, Elizabeth, Duchess of Rutland and John Thoroton, Belvoir Castle, Leicester-shire, 1801–c.1830

A protracted period of hardship and instability for millions of working people began in the second decade of the nineteenth century. The breakdown of traditional structures of control and social support under the impact of capitalism and the free market in labour was accelerated by population pressures and a trade slump. Unrest was widespread, from machine-breaking to crop-burning. The government responded repressively, often brutally: most notoriously in the Peterloo Massacre of 1819 when yeomanry sabred into a peaceful mass meeting in Manchester. This was the Britain in which later Romantic castles were built, and their sublime expression of power was purposeful. Potent emblems of a hereditary political order, bastions against sedition and disorder, they also symbolized the paternalist responsibility that would soothe the people's pains – the chivalry that issued on the world, thanks to Scott, through gothic portals. Such a position was

replete with irony, for the cause of unrest, in the final instance, was the revolutionary impact of capitalism, and castles were built on wealth generated by capitalist farming, often backed by profits from capitalist industry and commerce. And the chivalric code itself derived from the old hierarchy of paternalism and deference, which capitalism was in the process of dismantling.

The first of the Romantic super-castles was Belvoir, jointly conceived by Wyatt and Elizabeth, Duchess of Rutland (1780–1825), largely carried out by the amateur Sir John Thoroton (d.1820). Picturesquely massed on a sublime scale, combining martial

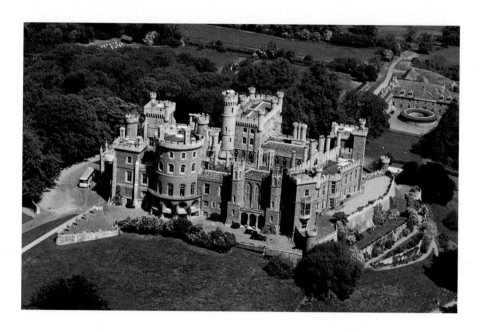

swagger with a fantastic multiformity (93), in a so-called 'Saxon' amalgam of gothic and Norman partly drawn from Lincoln Cathedral, Belvoir was thirty years in the building. Robert Smirke, architect of Lowther (see 87), outdid his previous work at Eastnor Castle, Herefordshire (1812–20): rectangular, with quatrefoil corner towers, massive, thumpingly Norman in detail, it stands high on a battlemented terrace above a lake that converts its looming bulk into insubstantial reflections. No such immateriality softens the four-square severity of Taymouth Castle, Perthshire, built between 1806 and 1810 for the fourth Earl

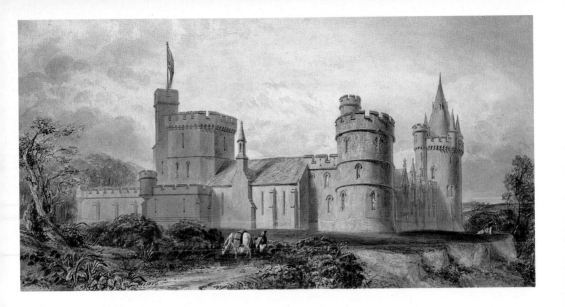

94
Edward
Blore,
*Goodrich
Court,
Herefordshire*,
1828.
Watercolour
on paper;
26 × 49.5 cm,
10¼ × 19½ in.
Royal
Institute
of British
Architects,
London

of Breadalbane, its design by Archibald Elliot (1760–1823) and his brother James (1770–1810) deliberately surpassing the scale of that sublime original, Inverary. For glamour, muscle and stylistic authenticity, however, no Romantic period recreation of the medieval castle surpassed Goodrich Court, Herefordshire (1828–31), designed by Edward Blore (1787–1879) for Sir Samuel Rush Meyrick – both friends of Walter Scott. An authority on medieval gothic, Blore became a leading revivalist architect, developing a late medieval or Tudor manner for country houses that we will come to shortly. His designs for Goodrich (94) carried real conviction, based on both English and Continental precedents, from the drum towers of the drawbridged entrance to the open-timbered Great Hall stretched along one side of the courtyard. Populated as well as permeated by the Middle Ages, the castle was created to display Meyrick's unrivalled collection of weapons and armour. 'At Goodrich Court', wrote Thomas Roscoe in 1837, 'we dream of … chronicles of arms and chivalry'. But we dream no longer: the collection was dispersed in the 1870s, and Goodrich itself flattened in 1950.

The summation of the Romantic castle, architecturally and ideologically, was Windsor (95), as reconstructed – effectively

95
Windsor
Castle,
from 1170s

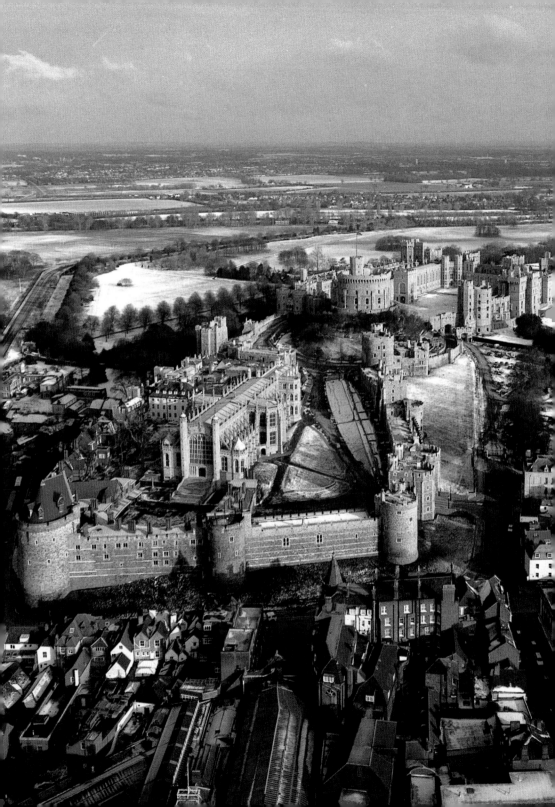

reinvented – for George IV and William IV (r.1830–7) by Jeffry Wyatt, who became Sir Jeffry Wyatville in the process. Intensely pictorial and purposively martial, Windsor was the super-castle to top them all. It also performed a key function for the institution of monarchy. The long madness of George III, an unseemly sequence of sexual scandals involving George IV and his brothers, and the unblushing extravagance of the court, gravely damaged the standing of the royal family and jeopardized the crown itself. Designed to be the principal national seat of British royalty, Wyatville's Windsor was inspired propaganda, identifying the monarchy, particularly in the person of Victoria (r.1837–1901; 96), with a heavily mythologized version of the country's history.

A royal castle since the Norman Conquest, Windsor had witnessed many of the most celebrated episodes in English history. King John left Windsor for Runnymede where Magna Carta was signed; Edward III instituted the chivalric Order of the Garter there, complete with an Arthurian round table. In Windsor's St George's Chapel Henry VIII, founder of the English Reformation, was buried, as too was Charles I, beheaded in the Civil War; and the castle was William of Orange's headquarters during the Glorious Revolution. Here was gothic history: the struggle for free institutions, feudalism, hereditary political and religious authority, martial prowess, chivalry, even the shadowy King Arthur. Of course, Windsor had these associations before Wyatville put up a single turret; but the act of reinventing the castle, making it bigger and better – outstandingly gothic, extraordinarily picturesque, egregiously sublime – turned everything into epic theatre, thrilling but strangely neutralized. It no longer matters who was on which side, whether the king was for us or against us. All the past's unevennesses are smoothed, all scores fully settled, in a drama which always has the crown as principal player. Monarchy is made to embody a legendary continuity, while the revolutionary fractures, the discontinuities, between the nineteenth century and the Middle Ages become mere episodes in that totalizing story which is the mythological history of the British nation. In the process, gothic's radicalism

96
Sir Edwin
Landseer,
*Queen
Victoria and
Prince Albert
at the Costume
Ball of 12 May
1842*, 1844.
Oil on
canvas;
142·6 ×
111·8 cm,
56¼ × 44 in.
Royal
Collection

97
**Nathaniel
Mills,**
Snuff box
showing the
east front
of Windsor
Castle,
1835–6.
Chased
metal,
coloured
gold;
5·4 × 8·3
× 2·2 cm,
2⅛ × 3¼ × ⅞ in.
Victoria
and Albert
Museum,
London

is accommodated and elided. Narrative becomes tableau, a great pictorial composition, just like Windsor Castle. The final triumph of Romantic historicism was to deny the discontinuity from which it was born, discovering instead a past of fabulous stability on which to construct the present. In Windsor Castle the Gothic Revival created the definitive architectural icon of British monarchy: by the end of Victoria's reign, the famous set-views from the Thames and the Great Park (97) had been reproduced in every medium, from the largest oil painting to the humblest pictorial transfer on souvenir china. As of course they still are.

During the Romantic period, Ireland rivalled England as a country for castles. Costs were lower, and the landscape every bit as conducive. Glenflesk Castle in Killarney (c.1820), for example, was built by one John Coltsmann, who, visiting the district and 'becoming enamoured of its beauties', decided to stay and add a castle to the scenery. But Irish castle-building, though it shared much with English, had different political meanings. The reason, of course, was colonialism. The 1801 Act of Union brought Ireland directly under the crown, the culmination of more than two centuries of colonial rule, which – at the cost of countless dead – had marginalized indigenous Irish culture, tried to suppress the majority Catholic faith and introduced a large Protestant settler population, particularly in the north. The

Act of Union was a spur to country house building. The Act's provisions included compensation to landowners deprived of the boroughs they had controlled in the old Dublin parliament, and much of the money went into building or rebuilding family seats. At the same time, Union redirected perceptions of the legitimacy of power and possession, often onto questions of origin – that key Romantic concept. Castellar gothic could provide both a fashionable new house and the right kind of political symbolism. Redolent of hereditary authority, it recalled much of Ireland's indigenous medieval architecture, and a few borrowings – such as stepped battlements and the little angle turrets known as bartizans – sufficed to give the revived style a distinctive national character. As a result, the Romantic castle in Ireland served as an architectural focus for the competing claims of the interests jockeying for power.

Some castles seem to embody colonial ascendancy. Promoted in the peerage for services rendered in the run-up to the Act of Union, the first Viscount Charleville promptly built the great battlemented pile of Charleville Forest, Co. Offaly (1800–1) to the designs of Francis Johnston (1760–1829), whose Dublin-based practice was then probably the most important in central Ireland. Similarly, Moydrum Castle near Athlone, a handsome composition massed around a machicolated gate-tower, was designed by Johnston's main rival, Richard Morrison (1767–1849), for William Handcock in 1812 – the year he was created first Baron Castlemaine as a pay-off for changing from an opponent of Union to an ardent supporter. Less opportunistic, more complex, were the responses of established settler families, resident since the sixteenth and seventeenth centuries. Their castle-building can be read as expressing loyalty to the colonial power that had established them, or commitment to the country that had been colonized, or indeed both. With differences in income and perceptions of personal status, such ambiguities made for diversity. At one end of the scale, Birr Castle, Co. Offaly, originally a fortified house on a medieval site, was gradually recast in castellar gothic from c.1800 by the Earls of Rosse, who

were descended from settlers who came at the time of Elizabeth I. At the other end stands, or sprawls, Tullynally Castle (98), Co. Westmeath, begun 1801 and created over forty years by Johnston, Morrison and others for the Earls of Longford, who acquired their estates after the Cromwellian campaign of the 1650s. A fantasy at once chivalric and colonial, set amid its country like a fortified town, Tullynally is Ireland's largest castellar mansion.

As well as the settlers' castles were those of the native nobility, who were often as staunchly Protestant but whose origins were rooted deep in the myth-rich soil of the Irish Middle Ages. Lough Cutra Castle, Co. Galway (from 1811), dashingly picturesque in its lakeside setting, was built by James Pain (c.1779–1877) and his

98
Francis
Johnston,
Richard
Morrison
and others,
Tullynally
Castle, Co.
Westmeath,
from 1801

brother George Richard Pain (c.1793–1838), previously articled to Nash, for the second Viscount Gort, whose lineage ran back to the Norman barons of twelfth-century Ireland. The descendants of the mightiest of that distant Norman nobility, the Geraldines and the Butlers, built Romantic castles on a startlingly grand scale: the third Earl of Kingston employed the Pains in a colossal £100,000 recreation of the Geraldine fortress, Mitchelstown Castle, Co. Cork (1823–5), while the Butler stronghold, Kilkenny Castle, was redone (from c.1826) in a spanking castellar gothic for the nineteenth Duchess of Ormonde. Romantic Normans were

matched by even more Romantic Gaelic ancestors at Dromoland Castle, Co. Clare (from 1826), seat of the O'Briens, who claimed descent from the High Kings of Ireland. Designed by the Pains, it is among the most perfectly realized of Romantic castles, its disparate battlemented towers and detailed ranges hovering fantastically upon the surface of a lake. Finally, among Ireland's hereditary governors, the residual – and resilient – Catholic aristocracy also underlined their claims through castellar gothic. Thus, in 1803–4, the leader of the Catholic nobility, the eighth Earl of Fingall, his family origins – according to the *Complete*

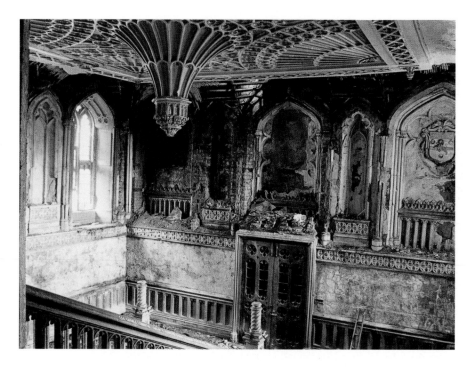

99
Entrance hall, Killeen Castle, Co. Meath, 1803–4. Photographed in 1981 before restoration

Peerage – 'so remote that nothing certain can be ascertained as to the precise period', turned medieval Killeen Castle, Co. Meath, into an imposing towered and turreted block, its theatrical entrance hall fan-vaulted and dripping with pendants (99).

Stylistically, Irish architects, headed by the classically trained Johnston and Morrison, tended to hang on to symmetry longer than their English contemporaries. Nash's Killymoon Castle, Co. Tyrone (1803), winningly small-scale and typically ingenious,

introduced consciously picturesque design. The Picturesque's emergence in Johnson's output was influenced by his clerk, James Shiel (c.1790–1867), who later practised independently; and in Morrison's by his son, William Vitruvius Morrison (1794–1838), who had a first-hand knowledge of developments in England and could combine picturesque piquancy with borrowings from medieval originals – as at Ballyheigue Castle, Co. Kerry (c.1809). Much of Nash's own work has been seen off by the twentieth century: Kilwaughter Castle, Co. Antrim (1807) and his largest Irish castle, the once splendid Shanbally, Co. Tipperary (1819) are particularly deplorable losses. But Nash's pictorialism was championed and developed by the Pains, who added a flair for sensational massing and a far richer knowledge of medieval sources. Castellar gothic was taken up by local architects, enthusiastically and often very ably: Thomas A Cobden (1794–1842) of Carlow produced the battlemented profusion of Duckett's Grove, Carlow (1830), and William Tinsley (1804–85) of Clonmel designed Tullamaine Castle, Co. Tipperary (1835–8) on a similar scale.

Big as these are by any standards, they remain committed to the principles of the Picturesque. With a few exceptions, Mitchelstown among them, Irish castellar gothic preferred picturesque cajolery to the coercions of the Sublime. Not so, however, with the trio of castles in the kindred revival style of Norman. Gosford Castle, Co. Armagh (1819), designed by Thomas Hopper (1776–1856); Glenstal Castle, Co. Limerick (from 1837) by William Bardwell (1795–1890); and Barmeath Castle, Co. Louth (from c.1839) by Thomas Smith (1799–1875) speak of naked power not persuasion. Though the clients came from different political backgrounds, it is surely significant that all three architects were English. However they bid for authority, Romantic castles remained popular among Irish landowners until the catastrophe of the Great Famine of 1846–7 wrenched out of joint the social and cultural being of the whole country – and exposed the cruel inadequacy of those who claimed to govern it.

England and Ireland were the great castle-building countries of Romantic Europe. In Scotland, despite scenic inducements, the castellar Picturesque did not arrive until Robert Lugar (*c*.1773–1855) – an English architect adept in the Nash manner – built the Dunbartonshire castles of Tullichewan (1808) and Balloch (1809), publishing their designs, along with some of his English work, in 1811. In practice, Scots frequently melded picturesqueness with a native liking for architectural toughness, as at Craigend Castle, Stirlingshire (1812) by Alexander Ramsay (*c*.1777–1847) and Castle Forbes, Aberdeenshire (from 1814) by Archibald Simpson (1790–1847), synthesizing asymmetry and classically derived severity. Scotland's most successful purveyor of the picturesque castle, doubtless helped by his marriage into the gentry, was James Gillespie Graham, whose monastic gothic was mentioned earlier. The richly detailed remodelling of Duns Castle, Berwickshire (1818–22) is probably the best in the series of Graham's castellar commissions, from Drumtochty Castle, Kincardineshire (1815) to Ayton House, Berwickshire (1851).

In much of continental Europe, Romantic castles were primarily symbolic reassertions of monarchical power – none of the gothic liberty that in Britain hung on tenuously even to a super-castle such as Windsor. Near Kassel, in the mid-German state of Hesse, the Löwenburg (1790–9; 100) – crumbling walls and bastions,

100
H C Jussow,
The
Löwenburg,
nr Kassel,
1790–9

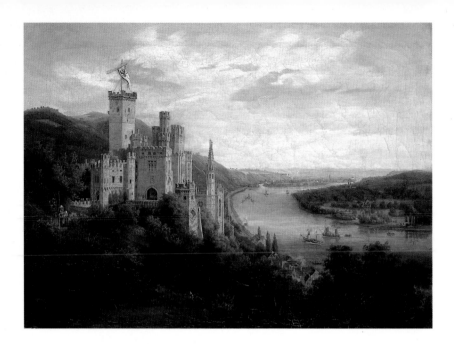

101
Daniel Freydanck,
Schloss Stolzenfels am Rhein,
1847–8.
Oil on canvas;
28·3 × 36·3 cm,
11⅛ × 14¼ in.
Schloss Charlotten-burg, Berlin

102
Domenico Quaglio,
Schloss Hohen-schwangau,
Bavaria,
1833–8

towers, spires, and conically topped turrets springing up like gothic mushrooms – was built by H C Jussow for the Landgrave Wilhelm IX, whose fondness for tournaments and medieval play-acting was an accompaniment for the serious business of political repression. On the edge of the Vienna woods, the fantasy castle of Franzenburg (1798–1801), designed by Franz Jäger (1743–1809), made similar provision for the imperial Austrian autocrat Franz II (r.1792–1835). It also housed his great collection of medieval exhibits. As late as the 1840s castellar gothic was used for absolutist symbolism in Portugal, where the queen's consort, Ferdinand of Saxe-Coburg, facing civil war over constitutional reform, had the castle of Pena built outside Cintra to announce his own high view of the prerogatives due to princes.

In Prussia, as we saw before, gothic was identified with national-ist aspirations. Schinkel's Monument to the Liberation (1821), an iron pinnacle on the Kreuzberg above Berlin, is an imposing patriotic memorial, but his grander gothic schemes were never built. His only original gothic castle, Schloss Babelsberg (1833–49) outside Potsdam, is a disappointingly tame affair. However, the restoration of the medieval Schloss Stolzenfels,

which Schinkel began in 1836 and others finished, created the nonpareil Romantic Rhineland castle (101). Hanging high above the river, its lofty keep closely hemmed in by subsidiary towers and turrets, it was also a political statement. Prussia had acquired the Rhine Provinces in 1815 and integration – or absorption – was proving difficult; the Stolzenfels restoration was both persuasive, a stylistic appeal to a greater German identity, and minatory, a castellar testimony to Prussian power.

In Bavaria, King Maximilian II (r.1848–64), married to Princess Marie of Prussia, was also drawn to castellar gothic. The Bavarian Alps provides the Sublime backdrop for Schloss Hohenschwangau (1833–8; 102), designed by the engraver Domenico Quaglio, while Schloss Berg (1849–51), by the court architect Eduard Riedel (1813–85), sits amid the foothills south of Munich. Whereas Schloss Berg is undemonstrative, Hohenschwangau is a Romantic set-piece of gothic in the land-scape, its pale, turreted keep set on a dark, pine-clad ridge between blue-green lakes, everything miniaturized by the encompassing Alps. Yet both announce themselves as family houses, down to the striped blinds provided for the plentiful windows. Rightly so, for while they invoke the medieval descent of the ruling dynasty, Bavaria was a constitutional monarchy, and Maximilian, who succeeded when a liberal uprising deposed his brother, accepted the crown's limited and largely symbolic role.

Not all continental Romantic castles were engaged in the politics of royalty, or even in striking martial attitudes. Pictorialism is paramount in the gatehouse of Kasteel van Moregem (c.1800), near Oudenaarde, Belgium, by the Ghent (Gand) architect Jean-Baptiste Pisson (1763–1818), as too in his more ambitious rebuilding of Kasteel van Wissekerke (from 1803), southwest of Antwerp, completed by the French architect François Verly (1760–1822), prettily posed on the edge of a lake. A generation later, the 1832 restoration of the medieval Kasteel van Bouchout, outside Brussels, by Tilman François Suys (1783–1861) produced something far tougher and historically more self-conscious. It reflected a new-found political identity, and a consequent pride in national antiquities, particularly gothic ones: in a liberal revolution of 1830–1, Belgium had achieved independence from the Netherlands, with a constitutional monarchy on the English model. As the very name 'Belgium' signalled the nation's distant origins in the Belgae, identified as one of the Germanic tribes, Suys's earnest medievalism may well have invoked not only the martial Middle Ages, but also those free gothic polities so important in the English Revival. The reverence accorded to the

103
Auguste-Marie Vivroux, Kasteel Les Masures, Pepinster, Belgium, 1835–7. Engraving

gothic of a national monument such as the Kasteel van Bouchout is a far cry, however, from the gleeful unconcern with which Auguste-Marie Vivroux (1795–1867) assembled Belgium's showiest Romantic castle, the now-demolished Kasteel Les Masures, Pepinster (1835–7; 103). It was a hotchpotch of gothicizing shapes and structures: a brace of drum towers shouldered up against a chapel with an octagonal steeple, which nudged into a house sporting a spired corner tower, and an extension giving on to the lawn through traceried windows. Built for Edouard de Biolley, a textile magnate, the castle was a product of the economic revolution transforming European society. Its jolly gothic medley came not from cultural illiteracy, I think, but from an attempt to meet new social and personal requirements. Sitting picturesquely in its park, it allowed an informal interchange between house and grounds, provided convenient reception rooms that could be used without ceremonial grandeur, and furnished private accommodation along with service offices. In effect, Les Masures' towers did not really make it castellar, any more than its chapel and steeple made it monastic; instead, its gothic was determined by the needs of wealthy, bourgeois family life.

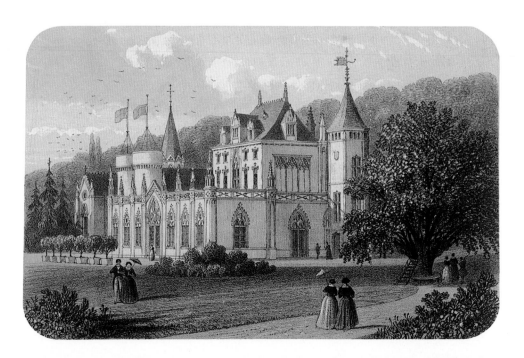

Kasteel Les Masures tackled a problem that had been exercising British architects and their clients since the start of the century. How could gothic be made to answer the social and domestic requirements of the middle and upper classes? Historical style made a building speak, and by the Romantic period gothic had acquired an extraordinary eloquence. However, gothic's increasingly archaeological emphasis made the practicalities of planning and design ever more difficult, particularly as the nineteenth-century country house grew in size and functional complexity. Internal arrangements became more specialized; there were more family rooms, more bedrooms for guests, more service rooms and offices; there were greater numbers of servants to be accommodated, so elaborate circulation routes were needed, both for efficiency and to keep people to their proper sphere; and there were continual technical innovations to be incorporated, from plumbing to plate-glass windows. The difficulties of managing all this architecturally, while observing the layout of a fourteenth-century castle, or replicating the elevations of a fifteenth-century abbey, could be intractable. Demanding historical fidelity made castellar and monastic gothic inflexible.

As early as 1799, that influential man Humphry Repton concluded that 'Castle Gothic' was 'calculated for a prison' and 'Abbey Gothic' suitable only for 'halls and chapels of colleges'. He proposed a new stylistic paradigm: Elizabethan. However, not until the 1820s did new models regularly begin to supplant castles and abbeys. And when they did, the alternative was not quite Repton's Elizabethan, but an extended range running from Tudor gothic, through Elizabeth's reign, to Jacobean. Once adopted, however, Tudor, Elizabethan and Jacobean Revivals slid into one another, sometimes combined with castellar or monastic features, for the rest of the century and beyond, stylistically earlier or later according to taste, variously grafted to produce hybrids such as Tudorbethan and Jacobethan.

Unlike castellar and monastic gothic, the new model was mainly domestic, affording a wide range of examples still standing and

still lived in, from small gentry houses to the 'prodigy' houses of Elizabeth's courtiers. The great mansions were certainly imitated, but manor houses provided historically authentic models appropriate to the purses and political standing of the squirearchy and country gentry. Comprising the numerical bulk of the landed interest they were a politically crucial group: on them – far more than the great magnates – social management and control at a local level depended. The new paradigm gave them an architecture of their own, and they adopted it with a will. The result was a group of buildings, from the quite modest to the substantial, in what became known as the Manorial or Manor House style. The Elizabethan century was lauded as England's first great age, when a reformed national church headed by the crown was established, and the foundations of naval supremacy, worldwide commerce and the Empire laid. Its architecture, for the conservatively minded squirearchy, hit all the right associative notes.

Some of the earliest works in the new manner came from Humphry's son, John Adey Repton, for example Apsley Lodge, Woburn (1804), for the Duke of Bedford, with timber-framing and ornate Tudor chimneys, and the Elizabethan remodelling of Barningham Hall, Norfolk (1805). He was assisted by his brother, George Stanley Repton (1786–1858), whose own output included Kitley House, Devon (1820–5), rebuilt for a long-established gentry family and an epitome of the Manor House style (104): compact, carefully scaled, with symmetrical elevations and clustering chimneys, picturesquely set in one of Repton senior's parks. Jeffry Wyatt's contributions include Endsleigh (1810), designed for the Bedfords on their west Devon estates around Tavistock (105). It combines informality, Tudor details and the fancifully heightened effect of the rustic cottage, favoured for their estates by landowners with a picturesque eye, but rarely done on such a large scale or for the landowning family itself. Endsleigh's grounds, landscaped by Repton, merge into the lush scenery of the Tamar Valley, along which, veiled by trees and far below the house, boomed a great mining industry, largely owned

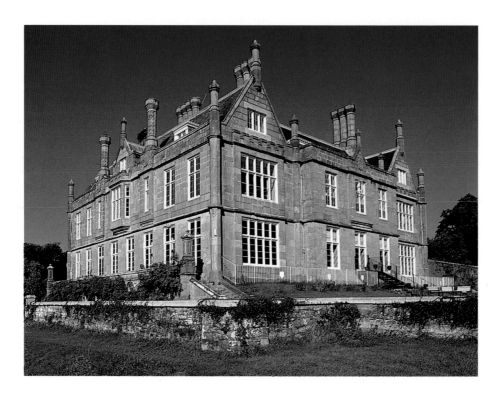

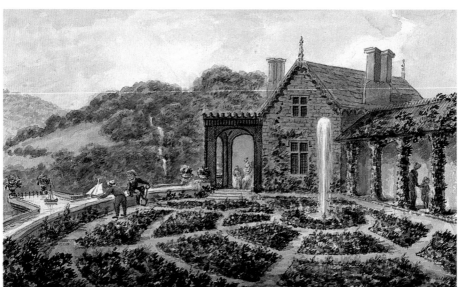

by the Bedfords – an ideological relationship between wealth-source and picturesque product reminiscent of Downton (see 90).

Revived sixteenth-century style came to Scotland with Dalmeny House, West Lothian (1815–17), by William Wilkins (1778–1839). Its rather bland elegance contrasts with near-contemporary Abbotsford, Roxburghshire (1816–22), Scotland's most famous Romantic house, the home of Walter Scott (106). His collection of armour and antiquities filled the interiors, particularly the heavily gothic hall and library, with furniture designed in an Old English style, heraldic painting and stained glass, and oak grained woodwork everywhere. Designed by William Atkinson, with ideas from Edward Blore and Scott himself, Abbotsford's highly asymmetrical massing belongs to picturesque gothic, but its details come largely from Scotland's native late sixteenth- and early seventeenth-century architecture – some bits literally so, for they were garnered from demolished buildings in Edinburgh. Abbotsford's use of indigenous architectural forms anticipates the later Victorian revivalist manner known as Scottish Baronial, which derived from early seventeenth-century aristocratic houses. But Wilkins's Dalmeny, and his subsequent Dunmore Park, Stirlingshire (1820), were more immediately influential. Particularly on William Burn (1789–1870), whose phenomenal success was based on perfecting a country house plan in which servants circulated quite separately from family and guests, whose needs could thus be met without the moral irritant of constantly running across the people who were doing the work; it was another disappearing trick to add to the magical repertoire of capital. Stylistically, Burn moved from Tudor variations, as at Blairquhan, Ayrshire (1820–4), through experiments in sixteenth-century vernacular, like the sadly demolished Milton Lockhart, Lanarkshire (1829–36), to a flexible Jacobean–Scottish mode exemplified by the palatially elaborate Falkland House, Fife (1839–44). That is, Burn shifted the paradigm's historical centre ever later, eliminating Tudor and Elizabethan components to move eventually out of gothic altogether.

104
George Stanley Repton, Kitley House, Brixton, Devon, 1820–5

105
Humphry Repton, Children's cottage and garden, Endsleigh, Tavistock, Devon, watercolour from the *Red Book* for the house, 1814

189 Domestic Gothic 1775–1850

The Irish Tudor Revival started with William Vitruvius Morrison, his Killruddery, Bray, Co. Wicklow (1820) confidently deploying various sixteenth-century features in a composition that melds irregular massing with symmetrical elevations. Eclectic too are the interiors – a gothic–Jacobean amalgam for the Great Hall, ornate Neoclassicism elsewhere. Stylistic mixing became characteristic of Morrison's neo-Tudor – as far as one can tell, for almost all his houses have been lost or wrecked. His Tudor competitors have been more fortunate: Belleek Manor, Co. Mayo (c.1825), by John B Keane (d.1859); the Pain brothers' Castle Bernard, Co. Offaly (1833) and Carrigglas Manor, Co. Longford (1837–42), by Daniel Robertson (fl.1825–45) attest the style's popularity in the years before the Great Famine.

The diligent practice of Edward Blore, as accurate in his building estimates as in his period detail, demonstrates neo-Tudor's dissemination throughout the United Kingdom: from Corehouse, Lanarkshire (1824–7), to the Tudor-castellar hybrid, Crom Castle, Co. Fermanagh (1838–41). His work tends to be competent and craftsmanly, if at times a little dull. Which makes even more deplorable the twentieth-century demolition (yet again!) of Weston Park, Warwickshire (1827), a vigorously irregular composition, heaped up around a monumental tower at one end, the whole silhouette bustling with cupolas and chimney shafts – surely Blore's most exciting Tudor–Elizabethan house. His contemporaries built in a range of related styles. Thomas Rickman did the masterly Matfen Hall, Northumberland (1828–30), Elizabethan elevations wrapped around a gothic Great Hall to rival Wyatt's Ashridge. John Dobson (1787–1865) designed the lovely Holme Eden Hall (1833–7), in Cumbria, all pink sandstone in the pastoral embrace of the Eden Valley. The Oxford-based draughtsman-cum-architect John Buckler (1770–1851) designed the Tudor gothic Halkin Castle, Clwyd (1824–7), and his son, John Chessell Buckler (1793–1894), produced the astonishing – but now flattened – Costessey Hall, Essex (from c.1826), its red-brick ranges running every which way about the base of a massive tower.

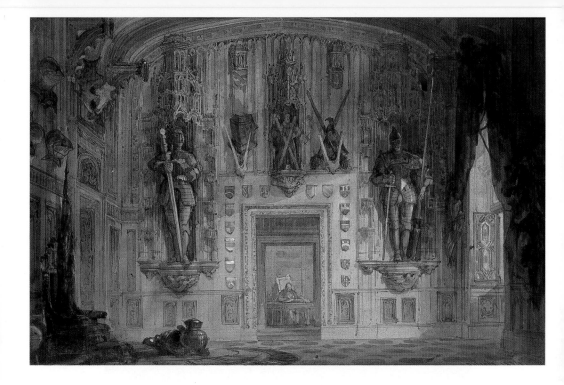

Although Tudor and Elizabethan persisted, stylistic models in England, as in Scotland, were shifting later. The remarkable George Webster of Kendal (1797–1864), architect of several good gothic houses in the northwest, launched a one-man Jacobean Revival with Eshton Hall, Yorkshire (1825–7), and Underley Hall, Cumbria (1825–8). Blore moved into Jacobethan on a monumental scale for Pull Court, Worcestershire (1834). The master of the Jacobean manner, however, was Anthony Salvin (1799–1881), who united a scholarly taste for seventeenth-century precedents with a flair for architectural theatre, as in his first major commission, Mamhead Park, Devon (from 1825). After some exercises in Picturesque Tudor, Salvin embarked on Harlaxton Manor, Lincolnshire (1831–44), an exuberant mix of Jacobean and Baroque, as astounding in its way as Fonthill, but no longer gothic. While Harlaxton was being built the Gothic Revival was being remade (see Chapter 9), but, for a major part of British domestic architecture, the full emergence of Jacobean marked a decisive move into post-medieval, post-gothic design. Rather

106
David Roberts, *The Hall, Abbotsford*, 1834. Watercolour on paper; 8·1×12 cm, 3¼×4¾ in. Private collection

than the Middle Ages, seventeenth-century style evoked the brave new world of the English Renaissance, linking imaginatively with the Italianate *palazzo* style, introduced by Charles Barry (1795–1860) for London clubs, and then for country houses.

In a letter of 1818, Scott hoped Abbotsford would recall an 'old English hall such as a squire of yore dwelt in'. His wish encapsulates a key ideological impetus of the Tudor, Elizabethan and Jacobean Revivals. For Romantic conservatism the manor house, the 'old English hall', epitomized the ancient paternalist order that was characteristic of community (Tönnies's *Gemeinschaft*) and was promoted in strictly hierarchical form by the ethos of

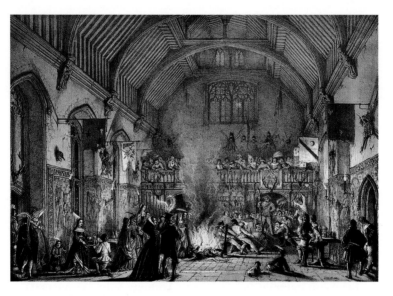

107
Joseph Nash, *The Hall, Penshurst, Kent*, lithograph from *The Mansions of England in the Olden Times*, 1839–48

chivalry, with all its accompanying castles. The Manor House style evoked chivalry's genial aspects, for the hall was the site of that central symbolic act of good lordship, the dispensing of hospitality. Here, in the mythological world of Olde England, tenantry and peasants feasted together under the paternal gaze of their natural governor, consolidating and celebrating their communal identity. Here was the defining location of a social order that conducted itself face-to-face. So it was in Scott's novels, in medievalizing Romantic and Victorian literature, and in Joseph Nash's influential *The Mansions of England in the*

Olden Times (1839–48), its illustrations of ancient houses, predominantly Tudor and Jacobethan, lively with historic figures and sociable jollities (107). So it was, by implication, in the halls of the Manor House style. But never really: nineteenth-century landowners were agrarian capitalists not feudal lords; cash payment had replaced reciprocal duties; class divisions severed squire from tenants, tenants from labourers. Similarly, Burn's clever house plans kept servants out of sight of those they served, whatever the building's style suggested about good old communal values. In this sense, 'community' was an ideological fiction that colluded with the people who ran the show. Unsurprisingly, the associations of the Manor House style were fostered. Tudor's adaptability made it ideal for buildings beyond the country house itself: lodges, the home farm, the village schoolroom, estate workers' cottages. Used in this way, the Tudor styles could express Repton's notion of 'appropriation' while providing historical associations suitable to paternalism and social control.

Yet it must be acknowledged that many landowners who thought about these things were sincere. To take just one example: on his Tavistock property, between the 1840s and 1860s, the seventh Duke of Bedford built over 300 Tudorish cottages for estate workers (108). Almost all had a garden or an allotment, and most had somewhere to keep a pig. On one level, the building programme secured a biddable workforce, for the duke's agents kept a close eye on how the cottagers behaved themselves. But, in a state without welfare provision, it was also an expression of Bedford's sense of social responsibility: certainly paternalistic, it nevertheless provided hundreds of working-class families with houses that were sanitary, comfortable, affordable. Almost certainly they lived longer, and quite possibly were happier. The Bedfords relinquished their interests in Tavistock in the 1950s; all the cottages are still there, and still lived in.

Gothic soon began to be adopted for smaller middle-class houses, particularly villas. The villa started its British career as a rural retreat for the landowner or man of affairs. Its rather limited

108
Bedford
Estate
Cottages,
Tavistock,
Devon,
*c.*1850

109–111
Gothic villas
Top left
Marford,
Clwyd, Wales
Top right
St John's
Wood,
London
Below
Sidmouth,
Devon

purpose in life was transformed by the revolution in the national economy and the new-found prosperity of an expanding middle class. The bourgeois villa was a family home, its representative owner affluent but not super rich. It had its own name and its own enclosed garden, and it was built on the edge of a town or city (109, 110). Where previous generations had lived with their businesses, often in the packed streets of an urban centre, the early nineteenth-century bourgeoisie moved out to semi-ruralism and salubrity, travelling daily to and from work in the town. Suburbia was born, and the villa was its inaugural building type; the consequences have been with us ever since, of course.

From being an aristocratic retreat, the villa became the middle-class family's stronghold and refuge, a bulwark against the harsh economic world of the city. And for all Burke had said about capitalism murdering the Middle Ages, the villa was a place of romance and chivalry. Kept safe by the deeds of its overlord, daily riding to battle at the factory and exchange, the villa protected the vulnerable, who garrisoned it as a place of love and emotional sustenance. Much of the domestic role of middle-class women in the nineteenth century was created in, and because of, the villa. And for people honourably retired from the economic battle, the suburban villa could be replicated at the seaside, in the so-called

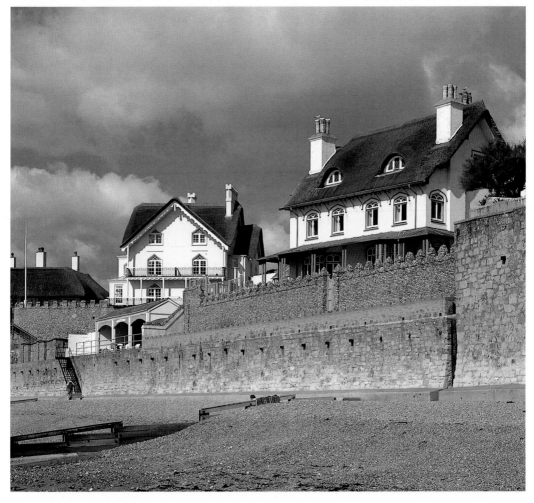

marine villa (III). As the one spread around the margins of the cities, so the other proliferated in the better-class resorts strung along England's south and southwest coasts.

Although only one of the styles for villa design, gothic was a great mixer, particularly with Tudor as its base: castellar or monastic elements, Elizabethan details, vernacular timber-framing, fancy cottage features, could all be stirred in, to give each design the individuality on which an entrepreneurial culture prided itself. Picturesque, conveniently planned, looking well amid the flower-beds of its modest grounds and enjoying the wonderful richness of associative meaning that had gathered to grander buildings, the gothic villa enabled middle-class folk to make medievalism an architectural language of their own, just as their moral culture turned chivalry from an aristocratic and martial ethos into one that was bourgeois and domestic.

The designers of villas, suburban and marine, were legion, mostly local men with a canny eye on the growing market for quality bourgeois housing. They were assisted by a growing pile of publications, most usefully by books of original designs that could be adapted or copied wholesale. Many contained ideas for estate buildings as well as villas, proffered a variety of historical styles, and, as the market broadened, were gradated according to cost. Robert Lugar's *Architectural Sketches for Cottages, Rural Dwellings, and Villas* (1805) is an early example, but the boom came in the 1820s, with Tudor to the fore. Particularly prolific was Peter Frederick Robinson (1776–1858), whose publications, most of which ran to several editions, included *Designs for Ornamental Villas* (1825–7), *Domestic Architecture in the Tudor Style* (1837) and *A New Series of Designs for Ornamental Cottages and Villas* (1838). His energy was matched by Thomas Frederick Hunt (1791–1831), a Tudor specialist whose penchant for the quainter kinds of original detail is evident in *Half-a-dozen Hints on Picturesque Domestic Architecture* (1825), and the revealingly titled *Exemplars of Tudor Architecture Adapted to Modern Habitations* (1830).

Outdoing all competition, however, was the *Encyclopaedia of Cottage, Farm and Villa Architecture and Furniture* (1833), a slab of a book compiled by the landscape gardener and voluminous horticultural writer John Claudius Loudon (1783–1843), assisted by his wife, the equally remarkable Jane Loudon *née* Webb (1807–58), who had a gothic shocker called *The Mummy!* (1827) to her name. The *Encyclopaedia*, like the *Architectural Magazine* (1834–8) Loudon edited, was aimed squarely at the middle-class market and had the villa at its core – morally as well as architecturally. It offered hundreds of elevations and perspective views in a stylistic assortment from Greek to Swiss, all enticingly picturesque. But gothic is favourite, usually tinged Tudor or 'Old English', and the most striking designs are those by Edward Buckton Lamb (1806–69), his piquant irregularities given an expressive vigour that anticipates gothic in High Victorian hands. In the theoretical essay which concludes the *Encyclopaedia*, Loudon makes clear the importance of architecture's historical resonances and associations, but connects these with ideas of functional fitness, crucially defined to include social purpose. To be really alluring a building needs more than a pretty face and the suggestion of a colourful past. It needs a social role, which should be announced through the language architecture inherits from its society: historical style. It is through style that architecture engages the issues – political, economic, religious, cultural – of the social world we all inhabit. Social meaning, Loudon recognized, is not distinct from functional design but integral to it (just as it had been integral to the Revival from its very beginnings). Men of a younger generation than Loudon's, also convinced of architecture's semantic responsibilities, would soon turn the meanings of gothic into the stuff of a crusade.

One of the *Encyclopaedia*'s admirers, and a correspondent of Loudon's, was the American landscape designer Andrew Jackson Downing (1815–52), jointly responsible, with his later partner, the New York architect Alexander Jackson Davis (1803–92), for introducing the picturesque villa into the United States. In 1832 Davis designed America's first picturesque gothic house, Glen

Ellen, outside Baltimore – asymmetrical, with a lanky hexagonal corner tower and lushly traceried windows – and over the next few years built a sequence of villas in the Hudson River Valley, its rural delights conveniently close to New York. His 1836 gatehouse to Blithewood, Annandale-on-Hudson, was the prototypical American gothic cottage: compact, gently irregular, with board and batten walls, Tudorish chimney shafts and windows, and lacily carved gable ends. He followed it with substantial, and very varied, gothic villas such as Knoll, Tarrytown (1838; 112), Linwood Hill, Rhinebeck (1841), and Kenwood, south of Albany (1842).

Davis's book of architectural designs, *Rural Residences* (1838), and Downing's *Cottage Residences* (1841), to which Davis contributed, became the standard handbooks of the American Picturesque, and Davis's design for a 'Cottage in the English or Rural Gothic Style' (113) was copied countless times. Importing English domestic gothic was not unproblematic: America's struggle for independence was still recent, the Anglo-American War of 1812–13 more so, and the style itself was associated with hierarchy and traditional authority. Davis probably knew this, and wrote of the need for adaptation to America's different circumstances: 'the English plans are on a scale far more extended and expensive than we can accomplish with our limited means or ... too inconsiderable and humble for the proper pride of republicans.' Davis was rejecting both the palaces that spoke of aristocratic power and the lowly habitations that announced a subservient populace. Rejecting, that is, the paternalism and deference with which Romantic conservatism had inscribed gothic, and doing so in the name of republicanism. In effect, remembering the old gothic history, he was reclaiming the style for democracy.

Davis could well have known that gothic history and the theory that went with it. In 1843 the philologist George Perkins Marsh published *The Goths in New England*, which proposed an American myth of origin. Marsh diagnosed two conflicting traits in the historical character of the mother-country, England: love of freedom, the gothic inheritance; and servility, the Roman

112
Alexander
Jackson
Davis,
Elevations
for Knoll,
Tarrytown,
New York,
1838.
Watercolour
and ink on
paper;
36·2 × 25·4 cm,
14¼ × 10 in.
Metropolitan
Museum of
Art, New
York

legacy. Sickened by the latter, liberty's sturdiest champions, those most steeped in Essence of Goth, took themselves across the Atlantic and, in the hallowed persons of the Pilgrim Fathers, founded New England. Their gothic independence had been vindicated by the War of Independence: 'It was the spirit of the Goth that guided the *Mayflower* across the trackless ocean; the blood of the Goth that flowed at Bunker Hill.' Given Davis's awareness of the 'proper pride of republicans', the spirit of liberty may well have been among the charms of picturesque gothic for the children of the American Revolution.

DESIGN II.

A COTTAGE IN THE ENGLISH, OR RURAL GOTHIC STYLE.

Fig. 9.

Fig. 10.

113
Alexander
Jackson
Davis,
*Cottage in
the English
or Rural
Gothic Style*,
from Andrew
Jackson
Downing's
*Cottage
Residences*,
1841

114
A W N
Pugin,
Red earthen-
ware tile with
buff encaustic
decoration,
made by
Minton for
the Palace of
Westminster,
c.1850.
Victoria
and Albert
Museum,
London

Gothic's success in Romantic Britain brought it into ever wider
secular use, at a time when population pressures and economic
growth were stimulating increasingly intensive building.
Cambridge University took up gothic for the first time since
Cosin's day. At King's College, Wilkins completed Great Court
(1824–8), his Tudor hall range linked to the famous chapel by a
Perpendicular screen with a jauntily domed gatehouse. At St
John's, Rickman and Henry Hutchinson (1800–31) built New
Court (1826–31), complete with a great tower and stone-vaulted
cloisters; Hutchinson's daintily enclosed bridge over the Cam,
the 'Bridge of Sighs' (see 16), connected new work to old just
down from the revived gothic library of 1623. The connection is
not just physical. As in the seventeenth century, the university's
Romantic gothic invoked continuity and the medieval tradition
of Christian learning; but these were now deployed against revo-
lutionary politics and the philosophical systems of the economic
radicals Burke had accused of murdering European chivalry.
Particularly obnoxious was utilitarianism, or Benthamism as
it was often known after its founding father, Jeremy Bentham.
The heir of scientific empiricism, utilitarianism was rationalist,
libertarian though often narrowly dogmatic, and impatient of
tradition. Its pragmatic moral calculus reduced Christian ideas
of good and evil to no more than the preponderance of happiness
over misery, and judged the effectiveness, the utility, of all social
institutions accordingly. Its reformist zeal menaced not only the
ancient universities but the Church of England itself. When
University College, London, was set up on a non-religious basis
in 1826, the year gothic returned to St John's, its principal
founders were utilitarians and its college buildings were classical.

In schools gothic similarly signalled a reassuringly Christian
grounding for knowledge, and was widely adopted. At Rugby
School, the Old Buildings (1809–13) represent a pioneering effort

in castellated Tudor by Henry Hakewill (1771–1830). Far more sophisticated, a reflection both of the Revival's stylistic progress and of civic pride, was Charles Barry's consummate exercise in Perpendicular, Edward VI's Grammar School, Birmingham (1833–7) – another victim of twentieth-century demolition. For smaller schools, Blore's studious sixteenth-century manner seemed especially appropriate, as at Harpur Street, Bedford (1833–7) and Tavistock Grammar (1837) in Devon. And there were hundreds of parish schoolrooms, often funded by the squire or parson, frequently designed by a local builder-architect, in which gothic identity and religious allegiance were indicated by little more than lancet windows and a pointed door below a gabled porch. When educational provision began to extend to public libraries, gothic's aura of orthodoxy played its part in calming establishment fears about popular access to knowledge. In Carlisle, Rickman and Hutchinson garbed the public Newsroom and Library (1830–1) in gothic, and in proletarian Greenock, at the heart of Scotland's industrial revolution, Blore's Tudor cast a medievalizing cloak over Greenock Library (1835–7).

The authority implicit in school gothic is explicit in the use of castellar gothic for judicial and penal architecture. Smirke's Carlisle Assize Court (1810–12), built on the remains of sixteenth-century fortifications, has an imposing pair of drum towers pierced by slit windows. For the County Gaol and Sessions House, Morpeth, Northumberland (1822–8), Dobson provided a formidably brooding gatehouse (115), supposedly derived from Edward I's Welsh castles. In Leicester the County Surveyor William Parsons (1796–1857) went for the full castle effect in his New County Gaol (1825–8) – including entrance towers and a mock portcullis. Judicial gothic was more than just strong-arm stuff, however. Legal tradition – remember Magna Carta – was an important part of the old gothic history, and the Common Law was fondly regarded as a mainstay – indeed a bastion – of age-old rights. In his renowned *Commentaries* (1765–9), Sir William Blackstone approvingly likened English law to 'an old Gothic castle erected in the days of chivalry, but fitted up for modern

115
**John
Dobson**,
Gatehouse,
County Gaol,
Morpeth,
Northumber-
land, 1822–8

habitation', and this semantic informed judicial gothic, culmi-
nating with the London Law Courts in the 1870s (see 233). None of
which alters the fact that the law was anything but an instrument
for securing the popular liberty of which gothic theory dreamt.

Complementing gothic's sterner moods, the paternalist associa-
tions of the Manor House style made its characteristic Tudor
appropriate for charitable institutions. The half a dozen
almshouse complexes erected in south London at this period
all run through Tudor variations, the most exuberant being
the Free Watermen's and Lightermen's Almshouses, Penge
(1840–1), designed by George Porter of Bermondsey (c.1796–1856),
their battlemented gate towers topped off by ogee domes (116).
Evocative not just of charity but of a more personal social order,
gothic was also used for the slowly growing number of buildings
providing for public welfare; an excellent early example is the
carefully detailed Tudor of Dobson's Lying-In Hospital,
Newcastle (1825–6).

The British version of gothic political history was given its
most famous architectural embodiment in the New Palace of
Westminster, better known as the Houses of Parliament (117).
The old Palace, where parliament had met since the Middle Ages,

116
George Porter, Gatehouse, Free Watermen's and Lightermen's Almshouses, Penge, London, 1840–1

burnt down in October 1834, only Westminster Hall and St Stephen's crypt, below the Commons chamber, surviving the blaze. Mindful of the site's history and the style of the remaining structures, the competition held to find a design for a new Palace stipulated that it should be 'either Gothic or Elizabethan'. Charles Barry won, with a synthesis of Perpendicular and Tudor gothic. Though most architects had previously been willing to work in different historical styles, the competition polarized opinion. In a flurry of pamphleteering and posturing, quickly labelled 'The Battle of the Styles', classicists struggled to wrest Westminster from gothic hands. They failed, and Barry retained the commission. In retrospect any other outcome seems unthinkable. Not only were the reasons for stylistic continuity on the site compelling – among them the retention of Westminster Hall and

the proximity of Westminster Abbey – but gothic was resonant with all those meanings traced in this book. Gothic was national, patriotic, signalling prowess abroad and steadfastness at home; it symbolized legitimate authority, a chivalric social order based on land, both medieval pageantry and medieval chivalry; it connoted religion, learning, the law; and threaded throughout, though contradictory and battered by compromise, ran the tradition of primitive liberty, of free institutions inherited by a free people. Against such richness, classicism could not compete: gothic was the stylistic language of government in Britain.

Barry was a thorough professional with a flair for exciting composition, but to get his gothic right he enlisted Augustus Welby Pugin (119), whom we met earlier as co-compiler, with his father, of *Examples of Gothic Architecture*. Pugin had been drawing medieval buildings and artefacts from childhood. By 1835, still only twenty-three, he was an exquisite draughtsman, his knowledge of gothic matched by his talent for decorative invention; he had designed gothic furniture and plate for Windsor Castle, gothic sets for the London stage, gothic ornament and detailing for James Gillespie Graham and, at Birmingham's Edward VI Grammar School, for Barry himself. Pugin was a gothic prodigy; and a zealot, ever more fervent about the medieval world his imagination inhabited and endlessly reinvented.

The New Palace of Westminster was created jointly by Barry and Pugin, though later their architect-sons squabbled about which of their fathers should take most credit. As well as exterior details, Pugin's designs determined the decorative character of the Palace's interiors, in thousands of drawings of woodwork, metalwork, stained glass, tiles, even wallpapers, and he was principally responsible for its most breathtaking scheme, the House of Lords (120). The overall conception, however, was Barry's: the plan and structure, composition, internal and external proportions, and the relationships, both spatial and conceptual, between the parts. Pugin's famously dismissive remark about the Palace, 'All Grecian, sir; Tudor details on a classic body', is unfair, to his own

work as much as Barry's. Pugin's decoration, both profuse and intense, is disciplined by the clarity of Barry's architectural lines, and complemented by the whole composition, resolving obliquely around the asymmetrical accents of the mighty Victoria Tower at the south end, and the frilly Clock Tower, containing Big Ben, at the north. Barry's conception, matching his collaborator's sense of texture, was picturesque, his aesthetic as much a product of Romantic gothic as Pugin's. Their great work was not finished until 1868. Pugin, his health and sanity broken by ceaseless labour, died in 1852; Barry in 1860. His son, Edward Middleton Barry (1830–80), supervised the last stages.

Semantically and physically, the Palace is organized by Barry's plan (118): a grid of rooms, courts and corridors laid out around a spinal axis running the length of the building from north to south, with an octagonal Central Lobby where a shorter west–east axis crosses the spine. The spine links the legislature's upper and lower chambers, Lords to the south of the Central Lobby and Commons to the north, their role determined by the Glorious Revolution's doctrine of the sovereignty of the Crown in Parliament. That is: the monarch is only sovereign because royal power is exercised through parliament, but parliament is only legitimate when summoned by the sovereign. Barry's plan enacts the doctrine as theatre. Ceremonially entered through the

117
Charles Barry and A W N Pugin,
The Palace of Westminster, 1835–68

118
Plan of the principal floor of the Palace of Westminster, after Barry's own pocket plan, with the north-south and east-west axes highlighted. (A) Victoria Tower, (B) Royal Robing Room, (C) Royal Gallery, (D) Prince's Chamber, (E) House of Lords, (F) Central Lobby, (G) House of Commons, (H) Clock Tower, (I) Westminster Hall, (J) St Stephen's Hall

119
J R Herbert,
Augustus Welby Northmore Pugin, 1845. Oil on canvas; 90 × 70 cm, 35½ × 27½ in. Palace of Westminster

120 Overleaf
Charles Barry and A W N Pugin,
The House of Lords, Palace of Westminster, 1835–68

121–123
**Charles
Barry and
A W N
Pugin,**
The Palace of
Westminster,
1835–68
Left
The Royal
Robing
Room
Above right
The Royal
Gallery
Below right
The Prince's
Chamber.
The tables
and chairs
were
designed by
A W N Pugin

Victoria Tower, the southernmost apartments (121–123) of the
spine form a processional sequence through which the monarch
moves to the throne in the House of Lords when summoning
parliament. Beyond the Lords, a corridor connects to the
Central Lobby, from where the spine continues to the House
of Commons, to ministerial offices beyond, and to the Clock
Tower at the north end. Were all the doors between the two
legislative chambers opened, the monarch enthroned in the
Lords and the Speaker on the Speaker's Chair in the Commons
would confront one another down the gothic perspective of the
spine, each legitimating the other's constitutional presence.

With legislative and regal power disposed north–south, Barry's
west–east axis catered for the people. Using Westminster Hall,
lying awkwardly to the west, as a colossal entrance, he took the
public route up a flight of stairs on to the lateral axis, and then to
the Central Lobby through St Stephen's Hall, occupying the exact
site of the previous Commons chamber. The public route's spatial

drama – from Westminster Hall's shadowy vastness up through the bright length of St Stephen's Hall – counterpoints the processional theatre of the central spine. It took people through the sites of their own political history – from the spot where Charles I stood trial, through the place where parliamentarians had championed constitutional government – to the Central Lobby and the spinal axis joining, like vertebrae, the Commons, Lords and Crown, the access of the populace bringing a symbolic pressure to bear on the very centre, the literal crux, of the whole arrangement. East of the Lobby, completing the lateral axis, a corridor runs quietly to a public waiting room, where sits a statue of Barry himself, with a plan of the Palace in his marble hand.

Concentrated in the processional chambers that climax in the House of Lords, Pugin's decorative schemes emphasize the principles of monarchy and aristocracy. Motifs are drawn from late medieval royal sources, and heraldry dominates (125): dynastic shields, motto scrolls and monograms, British national badges and Tudor roses all the way, crowned, centred in sunbursts, or bowered in a wonderful variety of foliate designs. All surfaces are coloured – encaustic tiles (see 114 and 126), stained glass, the painted woodwork of the ceilings – with delicate gothic patterns picking out the architectural membering of doors and windows. Gilding is everywhere, culminating with the throne in the Lords, overarched by a glittering canopy intricately fretted and traceried, with miniature figures representing the Orders of Knighthood (124). In their gothic elaboration, polychromatic warmth and visual richness, Pugin's interiors are Romantic conservatism's most imaginatively compelling architectural expression. Half a century after Burke pronounced chivalry dead, the British parliament shimmered and glowed with all the sumptuousness of a passionately reinvented Middle Ages.

The Commons chamber was destroyed in World War II, and subsequently rebuilt more plainly. But in any case, the Commons half of the Palace of Westminster was never as ornate as the Lords, the hierarchy of ornament reversing a balance of power

124
A W N Pugin, The Throne and Canopy, The House of Lords, Palace of Westminster, c.1846

125
A W N Pugin,
Wallpaper
design for
the Palace of
Westminster,
*c.*1848.
Watercolour
on paper;
62 × 53 cm,
24$\frac{1}{2}$ × 20$\frac{7}{8}$ in.
Victoria and
Albert Museum,
London

126
A W N
Pugin,
Encaustic
tiles made by
Minton for
the Palace of
Westminster,
c.1850

127
C W Cope,
*Burial of
Charles I
at Windsor*,
1857.
Wall-painting.
The Peers'
Corridor,
Palace of
Westminster

that shifted ever more firmly towards the people's representatives as the century progressed. This countervailing tendency is articulated through the wall-paintings and statues introduced by the Commission established to supervise the Palace's decoration. Some expand upon gothic's monarchical theme, such as the Arthurian frescos by William Dyce (1806–64) in the Royal Robing Room, where the crown's progress begins amid the mythic dawn of monarchy itself. But some recall political struggle, moments when the forces Barry ranged hierarchically along the spinal axis opposed one another. The frescos of 1856–66 in the Peers' Corridor by Charles West Cope (1811–90) memorably show episodes from the Civil War and the seventeenth century's constitutional and religious conflicts, including the burial of Charles I (127); champions of parliamentary resistance such as John Hampden stand in St Stephen's Hall; in the Lords, statues of the Magna Carta barons look down on the throne whose powers they curtailed. They admit the historical reality of struggle, contributing to an ideological complexity that is richer than the totalizing history promoted by near-contemporary Windsor. The story Westminster tells us is far more open-ended. Cumulatively, Barry and Pugin, the sculptors and fresco painters, narrate, dramatize, bind together the two divergent traditions of medievalism within British constitutional history, the feudal authority and the gothic liberty that had been integral to the Revival's semantics from the start. But though interwoven, the traditions are never merely merged: for in the one the British people are subjects whose rights are concessions; in the other, fellow-citizens whose rights are inherent.

Wyatville's Windsor became the national icon of monarchy; Barry's Westminster was more. It triumphantly confirmed gothic as a contemporary stylistic language. Through gothic, a political constitution, unquestionably liberal in European terms and still modernizing, could demonstrate continuities – albeit paradoxical and unresolved – with traditions both of authority and of change. Here was modernity related not statically but dynamically to medievalism. At the same time, the building of

Westminster utilized all the resources available to the world's first industrial nation: from the processes that manufactured the Palace's decorative materials, to the fireproof cast-iron frame of its fabric, to the structural iron skeletons of its two great towers. Here was medievalism quite literally built upon the stuff of modernity. Such ready concourse of old and new chimed with the ideological construction of Britain as both progressive and traditional, and did so at an historical moment critical to the emergence of the nation state. Westminster is about the making of a nation. In the Houses of Parliament, the Gothic Revival created the most abiding architectural icon of British national identity.

Barry's reuse of Westminster Hall and Wyatville's revamping of
Windsor are signal examples of the way in which the meanings
of the gothic past could be created by remaking its buildings.
The word 'restoration' first appeared in an architectural context
during the Romantic period. James Wyatt's cathedral schemes
were among the earliest restoration programmes. They were
drastic affairs, sweeping through medieval features and fittings,
and earned him the nickname 'Destroyer'. But he was not alone:
there were similar schemes at Winchester, Ely, Peterborough and
Westminster Abbey. They outraged John Carter, whose articles
in the *Gentleman's Magazine*, fizzing with denunciations of
'the Monster Innovation' and 'the improving mania', reveal him
as the first architectural conservationist. His protests sprang
from the whole temper of Romantic historicism; but so too did
Wyatt's 'innovations', committed as they were to realizing
gothic's potential for architectural sensation. The unbroken
internal vistas he contrived at Lichfield and Salisbury were
versions of the corridor perspectives that thrilled visitors to
Fonthill; the spire he intended for Durham's central tower
would have hiked medieval sublimity into the super-sublime.
Such violent reshapings of medieval fabric were gothic not just
in style but revolutionary spirit.

With the Revival's increasing emphasis on scholarship and
precedent, Wyatt's schemes looked not only brutal but ignorant.
Antiquarianism encouraged a quite different approach to
restoration: authoritative elevations, measured details and dated
features gave architects a lexicon from which medieval design
could be reproduced. Properly informed, they could recreate a
medieval building depleted by time, deprived of a totality it
must once have had, or simply left unfinished by its original
builders. Historicism could mend what history itself had skipped

128
**A W N
Pugin,**
Apparel for
an alb for St
Augustine's,
Ramsgate,
*c.*1846.
Victoria
and Albert
Museum,
London

or marred, and so retie the severed connections between past and present. From around the end of the Napoleonic Wars – perhaps not coincidentally – works take on a new historical conscientiousness. Examples include the restorations at Winchester (1812–28) by William Garbett (c.1770–1834), and at Rochester (1825–6) by Lewis Nockalls Cottingham (1787–1847), a Carter protégé who also published elaborate studies of Westminster Hall (1822) and Henry VII's Chapel (1822–8). Similarly, Cottingham gave Magdalen College Chapel, Oxford, a new stone screen in crisp Perpendicular (1829), and J C Buckler painstakingly recreated the entire suite of fifteenth-century chancel fittings at Adderbury, Oxfordshire (1831–4).

More than antiquarian or aesthetic exercises, these restorations carried the first hints of a far broader ideological renewal in the Church of England. Consonant with the Gothic Revival's whole imaginative strategy, they implied a future that would be built, literally and symbolically, upon the medieval past. At this period, however, that future looked far from secure. For all its power, the Church was ill equipped to deal with the economic and social forces revolutionizing Britain. Clerical incomes were distributed with scandalous inequity; many parishes had no resident parson; pastoral care was often skimped; church services could be perfunctory; and Anglicanism's alliance with the landed interest meant that ordinary people often perceived it as the morally coercive arm of the ruling élite. Rapid population growth made church accommodation inadequate, even in rural areas. Particularly alarming in the eyes of the establishment were the densely crowded proletarian districts of the cities, where sheer numbers had swamped church provision. Aggravating churchmen's anxieties was the challenge of nonconformity – the grouping of Protestant denominations outside the Church of England – particularly the so-called New Dissent spearheaded by Methodism. More flexible organizationally, direct in its appeal, empowering for many working people, nonconformity was recruiting in exactly those areas where Anglicanism was thought to be failing.

129
Thomas
Rickman,
St George's,
Everton,
1813–14

Very few Anglican churches, classical or gothic, were built in the period 1780–1810; the uncertainties of protracted war, institutional rigidity and ponderous legal requirements combined as obstacles. Then, slowly, things began to stir. In Liverpool, Rickman designed St George's, Everton (1813–14; 129), and St Michael's, Toxteth (1814–15), both largely funded by a local iron-founder, John Cragg. Roomy, with west towers and big windows in the gothic Rickman subsequently labelled Perpendicular, they are remarkable for their iron construction, a passion of Cragg's that Rickman picked up. Tracery, arcades and galleries, ceiling panels, at St Michael's even the door frame and plinth moulding, are all iron – and the consequent effect wholly unmedieval. In the textile districts of Yorkshire several gothic churches were designed by the Leeds architect Thomas Taylor (c.1778–1826), notably the robust and historically convincing Christ Church, Liversedge (1812–16). Similar Anglican initiatives in the industrial Midlands produced the enjoyably quirky St Thomas, Dudley (1815–18), by William Brooks (1786–1867), and the now-demolished St George's, Birmingham (1818–22), a major Rickman church where iron tracery went along with knowledge-able gothic detail and composition. For most parishes, though, additional accommodation was achieved by altering the existing church, which was usually medieval. To vestries, the bodies principally responsible for parish administration, protecting the interests of local ratepayers who had to finance the work was a major concern; reverence for historic fabric did not normally have a high priority. Pews were crammed into any available corner. Galleries on cast-iron legs were added along gothic aisles, fitted into transepts and even wedged in under the chancel arch. Although practical, such aesthetic nonchalance was increasingly at odds with the historicist sensitivities encouraged by the likes of Carter and Cottingham.

Despite local efforts the government was eventually persuaded that state intervention was needed if the Anglican Establishment was to provide for the population. In the bitter years after the Napoleonic Wars, the motivation was quite as much fear of the

revolutionary potential of the godless masses as concern for their eternal wellbeing. In 1818 the Church Building Commission was set up, with a grant of £1,000,000, increased in 1824 by a further £500,000. At the same time the Church Building Society was founded to marshal voluntary efforts. The urban centres were the main target, and Commissioners' Churches, as they were known, were intended to be big, with maximum seating. Stylistically, gothic was by no means the automatic choice. Neoclassical style had changed as the influence of ancient Rome was overtaken by a Greek revival – more refined, severe and historically consistent, with several fine churches, as well as houses and civic buildings, to its credit. The Commissioners, however, were neutral on matters of style, and were happier with utility and economy than with art. Eventually, gothic was preferred because it worked out cheaper, and it was adopted for 170 of the 214 churches built under the Commission.

The best were those where additional funds were available, and pride of place must go to St Luke's, Chelsea (1820–4), by James Savage (1779–1852) – structurally the most creative of any Commissioners' Church (130). Savage, a civil engineer and bridge designer, erected a genuine stone rib-vault, complete with flying buttresses, over the whole church, the first time it had been done since the Reformation. It moved the Revival's historicism into a new stage. Earlier, visual display might have no structural basis, for example in the use of plaster imitation fan-vaulting. Whatever the cultural or historical associations such vaults evoked, they had literally no significance for how a building actually stood up. Savage reunited gothic's visual aesthetic with the logic of its construction. Without losing any of its cultural significances, the vault reacquired its structural meaning. Within a few years, the concept of structural integrity was to be central to a reformulated gothic semantic.

Although no other gothic Commissioners' Church matches St Luke's in importance, many are impressive enough. There are numerous examples throughout England. St George's, Ramsgate,

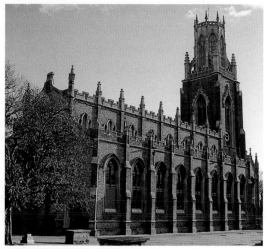

Kent (1824–7), designed by Henry Hemsley (*c.*1792–1825), and completed by Henry Edward Kendall (1776–1875), has a sprightly version of the famous East Anglian medieval church tower known as the Boston Stump, tricked out with a miscellany of gothic ornament (131); in Francis Goodwin's Christ Church, West Bromwich (1821–8), Perpendicular wiriness consorts with cast-iron windows; and Holy Trinity, Bolton (1823–5), is a studiously Perpendicular design by Philip Hardwick (1792–1870). Such grandly scaled efforts were there to impress as well as accommodate the populace. But in areas of dispersed settlement, the Commissioners built smaller gothic churches, usually in a simplified Early English known from the windows as the Lancet Style. Scores went up in the semi-industrial and mining villages of Yorkshire's West Riding, for example, designed by local men such as Peter Atkinson (*c.*1776–1843) of York, Robert Dennis Chantrell (1793–1872) of Leeds, and John Oates (d.1831) of Halifax. They are unassuming buildings, often no more than a capacious nave lit by bald pointed windows, with a shallow chancel and a western bellcote. But a little ingenuity or extra cash could make them less formulaic, and an able architect such as Chantrell could concoct variety from the lean rations the Commissioners made available. Be they ever so humble, gothic Commissioners' Churches appeared from Redruth to Newcastle, Dover to

130
James
Savage,
St Luke's,
Chelsea,
1820–4

131
Henry
Hemsley
and Henry
Edward
Kendall,
St George's,
Ramsgate,
1824–7

Carlisle, supplemented by others erected by the Church Building Society, which had diocesan branches and often acted with the Commission. The result was the speedy dissemination of gothic as the style for new Anglican churches, all the more successful for involving local architects and local funding. In and around London, Greek-influenced Neoclassicism remained fashionable, with occasional forays into the rest of the country. But elsewhere, particularly in the north and west, gothic became the dominant Anglican style, at once national and regional.

The church-building initiatives both drew upon and encouraged civic pride: enhancing a town's architectural make-up could coincide with the patriotic and religious duty to expand Anglican accommodation. Two gothic examples from different ends of the country are St Peter's, Brighton (1824–8), by Barry, and St Thomas's, Newcastle (1828–9), by Dobson, both designed as focal points in the townscape. In the countryside, the national effort began to pull in the personal wealth of the landed class, the Church's habitual allies. Some of the most impressive landown-ers' churches were designed by Rickman and Hutchinson: among them Hampton Lucy, Warwickshire (1822–6), funded by the Lucy family and built in Rickman's profusely carved Decorated, with all the verticals stretched tall and taut; and Oulton, Warwickshire (1827–9), for the squire John Blayds, in stately Early English, exceptional in Rickman's output – and historically important – for being vaulted not in plaster but brick. Other contemporary, individually funded churches can be set beside these; most remarkably, Theale, Berkshire (1820–32), a stupendous effort by Edward William Garbett and John Buckler (132), its details and proportions drawn from Salisbury Cathedral, all funded by the rector's sister, Sophia Sheppard, commemorated inside by a real medieval chantry chapel filched from Magdalen College, Oxford.

By the early 1830s, Anglican architecture was broadly committed to gothic; stylistically the Church reached back to its medieval past to confront the modern age. The need for such historical recruitment was pressing. After 1824, it was made clear that no

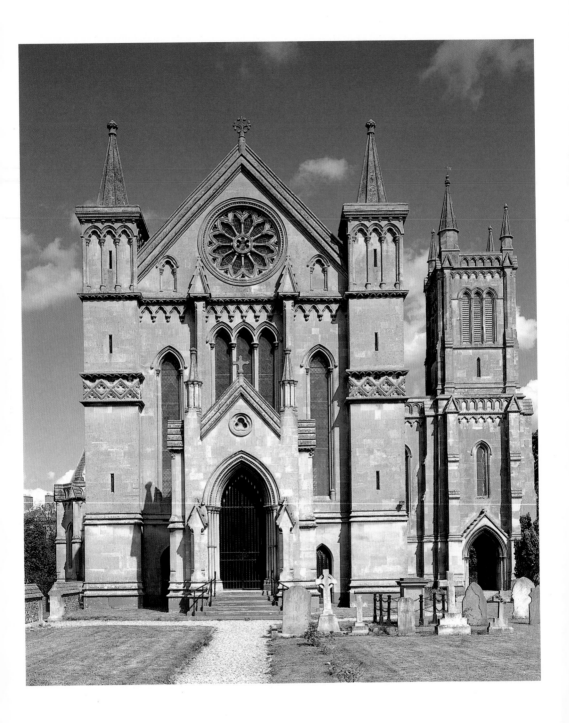

more public money would be used to support the Church. With the abolition of residual penalties against nonconformists in 1828 and Roman Catholics in 1829, Anglicanism lost the legal sanctions that protected its position against other denominations. After the bishops had opposed the parliamentary Reform Act of 1832, the newly constituted Commons, egged on by radicals, utilitarians and popular feeling, determined to tackle ecclesiastical reform. At which point the Church of England rallied around its own history, as constructed by the Oxford Movement.

132
Edward William Garbett and John Buckler,
Holy Trinity, Theale, Berkshire, 1820–32

133
Robert Dennis Chantrell,
St Peter's, Leeds, 1837–41

The ultra-conservative product of Oxford's High Anglicanism, led by the theologians John Henry Newman and Edward Bouverie Pusey with the poet-priest John Keble as an abiding presence, the Movement denied the right of any mere parliament to interfere in the affairs of a Church whose institution was traced back through the Middle Ages to early Christendom and Christ himself. In *Tracts for the Times* (1835–41), whence the name Tractarianism, Oxford's stalwarts stressed Anglicanism's continuity with

medieval Catholicism, emphasized the mysteries of the sacraments, particularly the eucharist, and promoted high-flying notions of the priesthood's spiritual dignity and independence. The Tractarians' heroes were precisely those seventeenth-century High Anglicans – clerics such as Laud and Cosin, cavaliers such as Sir Robert Shirley – who had first used revived gothic to affirm the medieval lineage of the Church's authority (see Chapter 2). So too, in Leeds in 1837, the Tractarian vicar William Farquhar Hook, backed by Pusey, rebuilt St Peter's to Chantrell's designs; the result is perhaps the most thorough-going work of revived ecclesiastical gothic of its date – cruciform in plan, with clerestories to nave and chancel, a mighty north tower and closely studied Decorated ornament (133). Though its enemies saw the Oxford Movement as closet popery – a view which was seemingly confirmed by Newman's defection to the Roman Catholic Church in 1845 – most Tractarians remained Anglican, crucially influencing the emergence of church-building as the vanguard of the Gothic Revival.

The Oxford Movement was part of a religious revival that battled with the growing forces of secularization across Europe in the nineteenth century. At different rates in different places, the influence of economic and political revolution, and the scientific, technological dynamics within industrializing, urbanizing societies, ousted organized religion from many of its earlier spheres of influence. But in the process, by the very fact of being confined to its own sphere, religion was also confirmed in its possession. The result was intensification, with different European churches, Protestant and Catholic, fighting to retain areas threatened by secular forces and recapture territory already lost. Versions of the past were simultaneously part of the battlefield and part of the weaponry, both what people fought over and what they fought with. Religious interests repeatedly laid claim to the Middle Ages, often in tandem with arguments about national identity. Gothic was integral to such disputes, and they fuelled the Revival's extraordinary cultural vitality in the middle decades of the century.

The catalyst for gothic's transformation in 1830s Britain was not a building but a book, *Contrasts: or, A Parallel between the Noble Edifices of the Middle Ages and Corresponding Buildings of the Present Day* (1836) by Pugin, working at the time on the details of Barry's Westminster. Without formal architectural training, a convert to Roman Catholicism, Pugin – for all his acknowledged skills – was to an extent an outsider, and *Contrasts* was heartily committed to scourging the status quo. Gothic, the book affirms, is uniquely 'Christian Architecture', even better 'Catholic Architecture'. All classical styles are instances of 'the revived Pagan Principle'; classicist buildings are evidences of a 'mania for paganism', and classical churches 'the revived shrines of ancient corruption'. Pugin is convinced that architecture embodies the beliefs of the society that produced it: if classicism was to him a profanity, then modern gothic was an imposture, aping the language of medieval Christendom in a world without its spiritual and social values. *Contrasts* is not just – not even primarily – about architecture; it is a polemic on 1830s Britain, and reads Britain's buildings as signs of the times.

The polemic begins from the contrasted title pages (134). On the medieval side, a black-letter text in an ornate gothic surround with clerics and architects, plans in hand, inhabiting the gorgeous structure they have inspired. On the modern side, a crude grid in 'the new square style' frames flat designs in thin Neoclassical and thinner gothic, their architects absent but for a couple of name tags. Where the medieval architects belong to their architecture, modern professionals have deserted their own buildings, their dissociation evidence of cultural fracture. For the nineteenth century, blankness and alienation; for the Middle Ages, fullness and integration: social fragmentation against an image of organic community. The gothic page is not just medieval as opposed to modern: it is pre-capitalist. The book's dedicatory plate emphasizes the point by taking the form of an architectural billboard covered with the diagnostic signs of a capitalist culture, advertisements.

The political purpose of *Contrasts'* opening pages is pursued through all the book's plates, satirical dramatizations which set an architecturally rich, socially coherent medieval past against an impoverished, discordant present. 'Contrasted Residences for the Poor' shows a splendidly expansive medieval almshouse with its great church, as against a brutally utilitarian modern workhouse (135). In the marginal illustrations to the first, the inhabitants are fed and clothed as members of a community, the dead reverently buried by their brethren; in the second, the inmates are starved and scourged, the dead boxed up for

dissection. In 'Constrasted Chapels', a pilgrim kneels in prayer outside an ornate medieval chapel, while an unseemly crowd jostles in the bald streets around a coarse gothic church in suburban London. The climax comes with 'Contrasted Towns' (136), which Pugin added in 1841. Spires and towers rise above the gabled houses of a 'Catholic town in 1440', a tree-lined river curving past an abbey and on towards rural England. Wharves and bottle-kilns crowd the river bank of 'The same town in 1840', churches maimed or demolished, skyline spires replaced by

chimneys, a gaol squatting on the foreground fields where the children of the Middle Ages played. The Mammonite, utilitarian city replaces the Christian gothic town, spilling out to obliterate the countryside that was community's historical home. It is not just a style that has gone, but a whole faith, a whole world.

There are a number of contemporary analogies to *Contrasts'* arguments, from the fervently Catholic medievalism of Henry Kenelm Digby's *The Broad Stone of Honour* (1822), to the radical William Cobbett's angry lament for lost community in *Rural Rides* (1830). Closest, however, is *Past and Present* (1843) by Thomas Carlyle, written, like his earlier essay *Chartism* (1839), in response to 'The Condition of England Question', the phrase Carlyle coined for the social crisis caused by the economic slump of the years around 1840. The widespread misery experienced by industrial workers helped forge the organized militancy of the Chartist Movement, a mass campaign to secure working-class representation in parliament and a radical democratization of government, its name derived from the charter that embodied its aims. *Past and Present* contrasts medieval and modern Britain. Under the authoritarian Abbot Samson, Carlyle's perfect paternalist ruler, twelfth-century St Edmundsbury, a true community, becomes a model of purposive social effort based on face-to-face transactions and personal leadership. Modern Britain, with millions unemployed and starving, is the opposite, a nightmare version, an anti-society unable to deal in human terms, with 'cash-payment the sole nexus between man and man'. Even Chartist revolt is futile. Because nobody accepts responsibility for market forces, the capitalist world is literally faceless: 'Our enemies are we know not who or what; our friends are we know not where!'

In Pugin and Carlyle, the medieval past, so often appropriated to serve present interests, becomes a weapon with which to attack the modern world. This change in medievalism's – and gothic's – ideological temper was at root a reaction to the ascendancy of industrial capitalism. Imaginatively, gothic belonged to 'the land'

134
A W N
Pugin,
The double
title page
from
Contrasts,
1836

135 Overleaf
left
A W N
Pugin,
*Contrasted
Residences
for the Poor*,
from
Contrasts,
1836

136 Overleaf
right
A W N
Pugin,
*Contrasted
Towns*, from
Contrasts,
2nd edition,
1841

MODERN POOR HOUSE

CONTRASTED RESIDENCES FOR THE POOR

ANTIENT. POOR. HOYSE.

THE SAME TOWN IN 1840.

1. St. Michaels Tower, rebuilt in 1750. 2. New Parsonage House & Pleasure Grounds. 3. The New Jail. 4. Gas Works. 5. Lunatic Asylum. 6 Iron Works & Ruins of St Maries Abbey. 7. M.Evans Chapel. 8. Baptist Chapel. 9. Unitarian Chapel. 10. New Church. 11. New Town Hall & Concert Room. 12 Wesleyan Centenary Chapel. 13. New Christian Society. 14. Quakers Meeting. 15. Socialist Hall of Science.

Catholic town in 1440.

1. St Michaels on the Hill. 2. Queens Croft. 3. St Thomas's Chapel. 4. St Maries Abbey. 5. All Saints. 6. St Johns. 7. St Peters. 8. St Alkmunds. 9. St Maries. 10. St Edmunds. 11. Grey Friars. 12. St Cuthberts. 13. Guild hall. 14. Trinity. 15. St Olaves. 16. St Botolphs.

– that conflation of ideas that identified the physical countryside and its ownership with the nation as a whole. By the 1830s, however, landed power was threatened, by reform in parliamentary representation and attacks on the Church, but principally by macroeconomic change: before 1850, agriculture had surrendered its dominant position in the national economy to manufacturing, mining and commerce, and the majority of Britain's inhabitants had become urban dwellers. The world that this change produced was precisely the target of 'Contrasted Towns'. *Contrasts* was committed to the view that architecture embodied its society's values; with vigorous illogic, Pugin wanted to make society enact the values of his architecture. As Christianity possessed absolute truth and gothic was its unique architectural expression, gothic had to have its own absolute verities, however they had been ignored or distorted. The task was to rediscover them – and pull modern Britain in their wake.

Contrasts' polemic cleared the way for a gothic crusade, but was hazy on how to proceed. Directions, both theoretical and practical, came in Pugin's *True Principles of Pointed or Christian Architecture* (1841). Revived gothic had to be based on total fidelity to medieval architecture, not just its external forms but its inner rationale: 'We *can never deviate one tittle from the spirit and principles* of pointed architecture.' The key lay in structure and function: '*there should be no features about a building which are not necessary for convenience, construction, or propriety.*' Construction should be demonstrated – 'A buttress in pointed architecture at once shows its purpose' – and should express its material. Decoration and structure are reciprocal: for while '*all ornament should consist of the essential construction of the building*', gothic '*does not conceal her construction but beautifies it.*' And both should serve to make a building legible, its '*external and internal appearance … illustrative of … the purpose for which it was designed*'.

Pugin's insistence that a building should be 'illustrative of' its purpose reveals his profound concern for how architecture is

137
A W N
Pugin,
Chromo-
lithographic
title page
from *The*
Glossary of
Ecclesiastical
Ornament,
1844

read by the people who use it. Like Loudon, Pugin wanted
buildings to speak of their social roles, but, unlike Loudon,
he hated eclecticism because stylistic mixing meant garbled
language. The issue of architectural meaning relates *True*
Principles to the political and religious themes of *Contrasts*.
Structure was the basis of architectural semantics, but was
not itself enough: 'the smallest detail should *have a meaning*
or serve a purpose.' Meaning and purpose, in this formulation,
become complementary equivalents because gothic – the
only style permissible in a Christian society – is for Pugin the
vehicle of religious symbolism. Throughout a gothic building
structural function and semantics coalesce. A pinnacle, to take
one example, is both 'mystical and natural', its verticality making
it 'an emblem of the Resurrection', while it is simultaneously 'an
upper weathering, to throw off the rain'. With such meanings
embedded in gothic's form and fabric, decoration and fittings
amplify symbolism into a unifying system, as Pugin says in *The*
Glossary of Ecclesiastical Ornament (1844; 137).

The symbolic associations of each ornament must be understood and considered ... Altars, Chalices, Vestments, Shrines, Images, Triptychs, Lecterns, and all the furniture of a Catholic Church was formed after a Christian moral and idea: all spoke the same language.

For all its Catholic turn, Pugin's feeling for what a building signifies is inherited from the long literary tradition of the Gothic Revival in Britain, but he unites it with a new insistence on architectural truth – truth to structure, to function and to material. The fusion is indivisible: in gothic buildings, meaning has a material presence in a way that is analogous to the Catholic doctrine of Christ's physical presence in the eucharist. Gothic is a means to salvation, spiritual and social, for behind Pugin's emphasis upon architecture as language is *Contrasts*' lost world of gothic community, where everybody, as well as every building, spoke the same tongue.

Pugin worked out his ideas through his own churches, though many suffered from the relative poverty of the Roman Catholic

**138
A W N
Pugin,**
St Mary's,
Warwick
Bridge,
Cumbria,
1840–1

congregations for which he built. One issue confronting him was which gothic style to build in. Here 1830s eclecticism ensured he had the whole range to choose from: he had an early flirtation with neo-Norman, notably in the first of his Irish churches, at Gorey, Co. Wexford (1839–42); he essayed Perpendicular for St Marie's, Derby (1838–41), and St Marie's, Macclesfield (1839–41), both accurately detailed but frosty; and at St Chad's Cathedral, Birmingham (1839–41), he was clearly influenced by the fourteenth-century brick churches of northern Germany. But Pugin's distinctive manner – historically authentic, structurally and materially expressive – emerges most consistently in a series of small Early English churches designed around 1840. Drastic alterations have meant that we can judge most of them only from designs, but one survives: St Mary's, Warwick Bridge, near Carlisle (1840–1). Built of local stone, it comprises no more than a nave and chancel (138), with porch, sacristy and western bellcote. But component elements are as distinct as building-blocks, their separate functions articulated externally; proportions as well as the details are convincingly medieval; structural integrity is announced through the character of the masonry and the big, open timber roof; and the chancel glows with polychromatic decoration that focuses the whole interior upon the east end. Everything – to use Pugin's phrase – speaks the same language, with a consistency of purpose and intensity wholly new in the ecclesiastical Gothic Revival.

Pugin used Early English on a large scale and with impressive austerity for Nottingham and Killarney cathedrals, both started in 1842, but by now he had moved into the style he considered the culmination of English gothic – Decorated, or, as it was often known after Milner, Second Pointed. Decorated combined structural expressiveness, strong architectural forms and a bold handling of space with ornamental elaboration – naturalistic carving, rich mouldings, inventive tracery design, gorgeously patterned textures. It is the style of his most complete church, St Giles', Cheadle, Staffordshire (1841–6), built for his most important patron, the sixteenth Earl of Shrewsbury. Of warm local

139–140
A W N
Pugin,
St Giles',
Cheadle,
Staffordshire,
1841–6

sandstone, the exterior is composed from carefully distinguished masses, dominated by the western steeple. Internally, every surface is decorated, colour and patterning intensifying eastward towards the altar, the cumulative effect as gorgeous as the Palace of Westminster schemes, but more concentrated, more emotionally vivid (139, 140). From St Giles' onward, Pugin developed the whole vocabulary of Decorated: in cathedrals for Newcastle-upon-Tyne (1841–4) and Enniscorthy, Co. Wexford (from 1843); in collegiate buildings, such as the great Irish seminary of St Patrick's, Maynooth (from 1846); in churches from rural Marlow, Buckinghamshire (1845–8), to London's Fulham (1847–9); in the church he funded himself, St Augustine's, Ramsgate (1845–51), standing next to his own house, The Grange (141). Over the same period he became increasingly adventurous in his use of asymmetry, relatively novel in ecclesiastical design though long established in domestic gothic's picturesque aesthetic. Asymmetry freed up Pugin's planning, allowing a more complete response to functional needs, while composition became more three-dimensional, fuller in its expression of structural massing.

Pugin's Decorated and his pursuit of asymmetry profoundly affected Victorian church-building; so too did his prodigious output of designs for fittings and furniture, vestments (see 128), plate, tiles and stained glass. Realizing these designs – and with them Pugin's vision of a fully integrated gothic – required a combination of new skills and revived craft methods. Pugin came to trust a small group of firms: George Myers, carver and builder (142); John Hardman of Birmingham for metalwork (143, 144) and stained glass; the decorators J G Crace & Son; Herbert Minton for ceramics. They became an informal consortium of art-manufacturers with Pugin as their principal designer; at the 1851 Great Exhibition their gothic wares filled the Medieval Court (145–147), a showcase for the Revival, assembled under Pugin's direction. Medievalist as Pugin and his collaborators were, however, their production processes and organization of labour, means of distribution and supply, and – witness the Medieval Court – their eagerness to advertise, were not medieval at all but

141
A member
of the Pugin
family in
The Grange,
Ramsgate,
Kent,
*c.*1890

142
**A W N
Pugin**,
Dining-room
cabinet for
The Grange,
probably
made by
George
Myers,
*c.*1845.
Private
collection

modern. Inevitably, they were capitalist, and largely based in places not unlike the hated industrial city of 'Contrasted Towns'. It was an ironic contradiction at the heart of Pugin's gothic vision and he could not escape it – but then, neither could anybody else.

Pugin's ideas were conducted to Anglicans through the unlikely medium of the Cambridge Camden Society. An undergraduate club named in honour of the sixteenth-century antiquary William Camden, it was founded in 1839 by John Mason Neale (1818–66) and Benjamin Webb (1819–85), both reading for Holy Orders. Its irreproachable aims were the study of ecclesiastical architecture, and the promotion of church building and restoration. But Neale and Webb, later joined by the wealthy layman Alexander James Beresford Hope (1820–87), were crusaders. Passionately committed to the doctrines of the Oxford Movement, they concluded that a High Church revival necessitated radical changes in what Anglican churches looked like. The result was a compound of dogmatic theology gleaned from the Tractarians and dogmatic architectural theory gathered from Pugin. As Anglicanism was Catholic by historical descent, and gothic uniquely 'Catholic Architecture', churches must be gothic, built with all the rigour of 'True Principles'. Church design, Neale wrote, was not a matter 'of mere *taste* ... of trade, convenience, caprice, or arbitrary arrangement', but a discipline akin to a holy science. The Camdenians called it ecclesiology; their journal took the name the *Ecclesiologist* (1841–68), and after 1846 they became the Ecclesiological Society.

Ecclesiology started as a young man's movement, and the Camdenians roasted the Church of their fathers, whose worship was 'low', whose churches were little better than 'preaching-boxes', and who had despoiled the medieval temple with box pews, galleries and similar 'abominations'. All this had to be swept away. Ancient churches must be restored to their medieval, Catholic identity; new ones must embody and proclaim Catholic principles. Interiors must be axially arranged, focused on the altar, in its own distinct chancel; planning should allow for

143
A W N Pugin and John Hardman, Silver gilt chalice made for a church in Worcestershire, c.1848. h.17·8 cm, 7 in

144
A W N Pugin and John Hardman, Reliquary, electroplated brass and enamel, c.1850. h.72·4 cm, 28½ in. St George's, Southwark

processions; and congregations should be marshalled into open benches all facing east. Stylistically, all new churches should be Decorated, the summit of English medieval architecture; and as Camdenians accepted Milner's notion of gothic's rise and fall, they identified perfection, the moment at which the peak peaked, in gothic dating from the first decade of the fourteenth century, humourlessly labelled Early Late Middle Pointed. Fidelity to medieval precedent and architectural truth were paramount: truth to structure, function, materials. 'In GOD's House', trumpeted the first number of the *Ecclesiologist*, 'every thing should be *real*.' That Puginian imperative included religious symbolism as inherent to gothic's identity: three-light windows represented the Trinity; hagioscopes – apertures between transept and chancel – symbolized 'the Wound in Our Blessed LORD's side'; the corners of a crossing emblematized the four evangelists; and much more. In their 1843 translation of Durandus's *Rationale*

145
Louis Haghe, *The Medieval Court in the Great Exhibition*, chromolithograph from Dickinson's *Views of the Great Exhibition*, 1851

146
A W N Pugin, Jardinière made by Hardman and Minton, *c.*1850. h.29·2 cm, 11½ in. Victoria and Albert Museum, London

147
A W N Pugin, Bread plate made by Minton, *c.*1849. diam. 33 cm, 13 in. Private collection

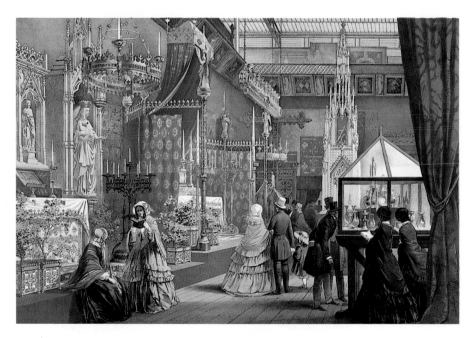

Divinorum Officiorum, a medieval treatise on symbolism, Neale and Webb declared that 'the material fabrick symbolizes, embodies, figures, represents, expresses, answers to, some abstract meaning.' This coextension of sign and substance constituted 'Christian Reality' or 'Sacramentality'. The Middle Ages had literally built meaning into gothic: the Revival must do so again.

The ecclesiologists were driven by a hunger for meaning, and in gothic found a way of filling the built world with significance – with the Glory of God indeed. Here was a response to the urban

148
Joseph
Nash,
The Maypole,
*c.*1840.
Engraved by
Charles
Cousen

blankness and industrial desolation pictured in *Contrasts*; to the city of Carlyle's cash-nexus, menacing, alienating, its massed population seemingly as impersonal as its massed buildings, literally incomprehensible. In Neale's book, *Hierologus; or, The Church Tourists* (1843), chats on old churches are accompanied by denunciations of the processes turning England 'into one huge manufacturing town ... one senseless heap', and evocations of a vanishing countryside, communal values still hanging on 'in counties which are not cursed with manufactures'.

Unsurprisingly, ecclesiology's gothic exemplar, both social and architectural, was the medieval rural parish church. Its companion building was the manor house, the 'hall', whose reinvention was discussed earlier. In gothic's emblematic landscape, they stand together, just as in Pugin's illustration of an 'Old English Mansion' in *True Principles*. For the parson in his gothic church and the squire in his gothic hall embody the traditional religious and secular authorities who maintained and secured the timeless community. Hierarchical it all certainly was; reactionary and politically self-serving too, perhaps. But its impact on Victorian church-building throughout England was profound: thousands of country parish churches were built, rebuilt or restored by rural landowners, or by the revitalized alliance of parson and squire. More broadly, the image of the rural community, where everybody is safe and everybody belongs, had and still has a compelling hold on the British imagination. Joseph Nash's painting, *The Maypole* (c.1840), captures it: Tudor rustics gleefully welcoming in the spring on the village greensward, protected – or policed – by an Elizabethanish manor house on one corner and a gothic parish church on the other (148).

In his *Recollections* (1879), looking back over an immensely successful career in the gothic cause, George Gilbert Scott (1811–78) dated his 'awakening' to architectural truth to 1841 and the simultaneous impact of Pugin and the Camdenians. Awakening could be uncomfortable: the *Ecclesiologist*'s cocksure reviews of new churches and restorations pronounced and denounced, prescribed and proscribed, to formidable effect. Camdenian judgements on the correctness of an architect's gothic increasingly influenced who got church jobs and who did not. This power was often resented, but for architects willing to be schooled the rewards were more than just financial. Mastering ecclesiological design and Decorated required expertise that uniquely combined technical know-how with scholarly accomplishments. The result was a new authority. Church architects acquired class, both an enhanced cultural status and an improved position in the social hierarchy. When

it came to restoring medieval churches, where Camdenians were eager to reinstate Decorated – gothic of the 'best' period – architects became skilled in spotting archaeological clues, deducing earlier fabric and recreating the building in the conjectural image of its own perfection. Through science and art the architect could make time's muddled, rickety fabric stable, coherent, godly – just like people's dreams of an ideal past. Even if we now lament what was lost, many such restorations were extraordinary acts of the creative, or recreative, imagination. In an uncertain world, delivering such dreams mattered – not least because, at the same time and by equally extraordinary efforts, geologists were deducing long-vanished creatures from fossil clues, and reconstructing an alarmingly different kind of past.

Decorated gothic designed on Puginian and ecclesiological principles became the vanguard style of the 1840s. Almost all the architects who would lead Anglican church-building in the quarter-century after 1850 – the years of High Victorian gothic – joined the Cambridge Camden Society in its first decade. Richard Cromwell Carpenter (1812–55) became a member in 1841, though his early death was to rob the movement of one of its principals; Scott joined in 1842, William Butterfield (1814–1900), most challenging of the High Victorians, in 1844. A somewhat younger group followed: George Edmund Street (1824–81), from Scott's office, and William Burges (1827–81), from Blore's, both in 1845; William White (1825–1900), with his own practice in Cornwall, in 1848; George Frederick Bodley (1827–1907), a relation of Scott's, in 1849. Of other major goths, Samuel Sanders Teulon (1812–73) regularly attended the Society's meetings, and John Loughborough Pearson (1817–97) joined belatedly in 1859.

The Camdenian leadership particularly favoured Carpenter and Butterfield. Carpenter's scholarly gothic was modelled on the medieval rural church, which he movingly evoked at Monkton Wyld (1847–9), a synthesis of picturesque composition and Puginian correctness set in remote Dorset countryside (149), but also deployed successfully for urban churches such as St Paul's,

Brighton (1846–8), and St Mary Magdalene's, Munster Square, London (1849–51), both memorable for their asymmetrical composition of gables and steeple. Butterfield's first church, at Coalpit Heath in Gloucestershire (1844–5), is an immediate contrast: robust and concentrated, it is paired with a parsonage designed to emphasize functional asymmetry, structural honesty and vernacular materials – foretastes of much that was to come. So too the austere ranges he designed for St Augustine's Missionary College, Canterbury (1844–8), a centre for exporting ecclesiological principles to the Empire, and the dramatically massed buildings of Cumbrae College (150), Scotland (1844–51). Alongside Carpenter and Butterfield, the range was wide: from Scott's ambitious London church of St Giles', Camberwell (1842–4), to his perfect Camdenian rural church at Hixon, Staffordshire (1848); from Street's boldly simplified Par, Cornwall (1848; 151), and White's equally striking Baldhu (1848) in the same county, to Pearson's first London work, the grandly steepled Holy Trinity, Bessborough Gardens (1849–50). Scores of other, regionally based architects pursued *True Principles*, ecclesiology and Middle Pointed, variously combined. Thus in Exeter, John Hayward (*c.*1808–91) produced St Andrew's, Exwick (1841–2), judged by the *Ecclesiologist* 'the best specimen of a

149
Richard Cromwell Carpenter, St Andrew's, Monkton Wyld, Dorset, 1847–9

150
William Butterfield, Cumbrae College, Great Cumbrae Island, Scotland, 1844–51

151
George
Edmund
Street,
St Mary's,
Par,
Cornwall,
1848

152
William
Wailes,
West window
of Dorset
aisle, St
Mary's,
Ottery
St Mary,
Devon,
1843–4

modern church we have yet seen'; and in Lancashire, Edmund Sharpe (1809–77) experimented with terracotta and Decorated detail for the 'pot-churches' of Lever Bridge, Bolton (1842–5), and Holy Trinity, Manchester (1845–6). The progress of ecclesiological gothic pulled architectural arts and crafts with it. All Pugin's collaborators worked for Anglican clients too; and because the market was much larger and wealthier, the provision of ecclesiastical fittings eventually – and ironically – assumed industrial proportions. In 1850 all this still lay a few years ahead, but enterprise had already mobilized artistic skill to meet the new demand. Stained-glass makers such as Thomas Willement (1786–1871), William Warrington (1786–1869), Michael (1801–67) and Arthur O'Connor (1826–73), and William Wailes (1808–81; 152) offered windows that were gothic in both design and technique; masons and woodworkers learned medieval patterns; Maw & Co. produced encaustic tiles, revived from medieval examples, in competition with Minton. Moreover, as railways spread major firms distributed their ecclesiastical wares nationwide.

153
John Leech,
'Which
is Popery,
and Which
is Puseyism?',
Punch, 1851

154
Poulton &
Woodman,
Jewry Street
Chapel,
Winchester,
1852–3

Master Punch. "PLEASE, Mr. BISHOP, WHICH IS POPERY, and WHICH IS PUSEYISM?"
Bishop. "WHICHEVER YOU LIKE, MY LITTLE DEAR."

In their new gothic churches, built or restored on the best
medieval models, walls sprinkled with symbols, windows
glowing with sacred scenes, High Anglican clergy celebrated
the mystery of the eucharist and yearned for services to match.
The resultant campaign for more elaborate ceremonial worship
became known as Ritualism. Its story lies largely beyond this
book, but its origins sprang from medieval revivalism and 1840s
gothic. To Anglicanism's Protestant adherents, ecclesiology
and early Ritualism confirmed their dire suspicions about
Tractarianism: it all began to look like a papist plot. There
was violent opposition, though the conflict now seems comically
remote – from the Camdenians being condemned for erecting
a stone altar in St Sepulchre's, Cambridge, in 1843 to London
mobs rioting in the late 1840s over surplices and altar candles.
Yet it seemed critical to Anglicanism's identity, and certainly
affected what gothic meant. A thunderous pamphlet of 1844
by the evangelical Francis Close declared *The 'Restoration*
of Churches' is the Restoration of Popery and, following the re-
establishment of the Roman Catholic hierarchy in 1850, *Punch*
denounced ecclesiological gothic as one of the internal enemies
that had betrayed national religion (153).

For all the sectarian furore, the effect on gothic was to reinforce its identity as God's own architecture. In consequence, gothic was claimed for religious positions broader and more diverse than those of the crusaders for 'Catholic Architecture'. When nonconformist denominations embarked on major building in the 1840s, many chapels they erected were gothic. Though in country areas often no more than lancet boxes, in towns they sometimes rivalled Anglican efforts. Two good examples are Chorlton-cum-Medlock Congregationalist, Manchester (1847–8), big and Early English, by the distinguished architect of commercial buildings, Edward Walters (1808–72), and the polygonal Jewry Street Chapel, Winchester (1852–3), also Early English, by the Reading firm of Poulton & Woodman (154). The Unitarians commissioned chapels in the Decorated style, for example Dukinfield, Cheshire (1840–1), by Richard Tatersall of Manchester, and Hyde Chapel, Gee Cross, Cheshire (1848), thoroughly and convincingly fourteenth-century, by Bowman and Crowther, also of Manchester.

Gothic's adoption by nonconformists was a sort of democratization, one strand in a larger Victorian pattern. In part, chapels drew on gothic's vaguer – though long-established – religious connotations, and no nonconformist architect cared much about Sacramentality or elaborate symbolism. But structural honesty, truth to materials, the functional purpose asymmetry could express – these were different. They gave architecture an exhilarating vigour; through them stylistic meaning, religious and otherwise, could be revitalized, old associations made fresh and immediate. They were ideas and ideals that re-energized the Gothic Revival itself. The campaign for True Principles encapsulates one of historicism's central paradoxes: having gone in search of origins it came back with originality. Puginian and ecclesiological gothic did not take fire because it was medieval, but because it was modern.

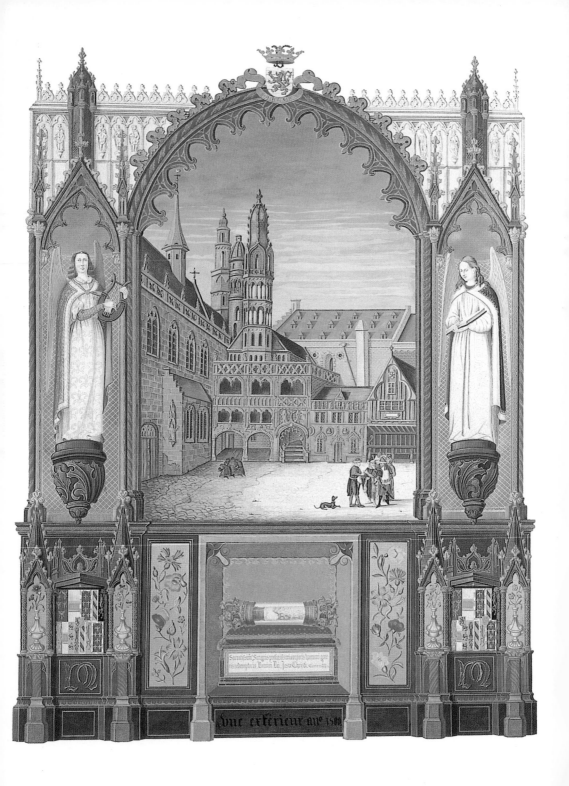

Gothic's reformulation in Britain directly influenced the whole European Gothic Revival – one of the relatively few instances of British architecture having a major impact on the rest of the world.

In Germany, gothic's identification as a patriotic and national style had been complicated by religious differences. If the gothic of the medieval cathedrals was the product of Teutonic genius, then it belonged to all Germans. But surely the Catholics of the Rhineland and the south had better claims to continuity than the Protestants of the north? And if so, what were the gothic credentials of Protestant Prussia in its bid to lead a united Germany? The peculiar political and cultural position of Cologne Cathedral offered a means of resolution. It was in the Rhineland and Catholic, but a crucial concern for Prussia, to whom the Rhineland had been ceded in 1815. Left unfinished in the sixteenth century, the cathedral loomed above Cologne like the fragments of a giant's puzzle, its half-built south tower still crowned by a medieval construction crane, jib pointing skyward (156). What was there exemplified the glories of past German culture; what was not testified to discord, national incompleteness, an unresolved history. These are the same meanings Goethe had read at Strasbourg, and Schinkel had inscribed in his 1815 painting of a medieval German city (see 80). In Cologne, Prussia acquired a ready-made metaphor for the whole mission of German unification. In the patriotic enthusiasm following Napoleon's defeat at Waterloo in 1815 the idea of finishing the cathedral was embraced. But events moved slowly: not until the 1830s did Ernst Zwirner (1802–61) begin drawing up proposals for completion, and building did not actually begin until the 1840s, by which time the whole complexion of the Gothic Revival in Europe had changed.

155
Ferdinand
de Pape,
*Chapel of the
Holy Blood,
Bruges,* 1843.
Gouache.
Koninklijke
Verzameling,
Brussels

While Cologne Cathedral's rebuilding hung fire, elsewhere in Germany gothic stirrings were fitful, largely ignored by the professional establishment ensconced in the conservative, classically dominated architectural academies – principal among them Prussia's Bauakademie in Berlin. The one gothic church Schinkel actually built, Berlin's Friedrich-Werder Kirche (1824–30), squarely high-bodied with a pair of square towers, tries to make the style behave by detaining it inside a lot of right-angles. Symmetry also rules Munich's Mariahilfkirche

**156
Lorenz Janscha**, *Cologne Cathedral*, coloured engraving by Johannes Ziegler, 1798. Stadt-museum, Cologne

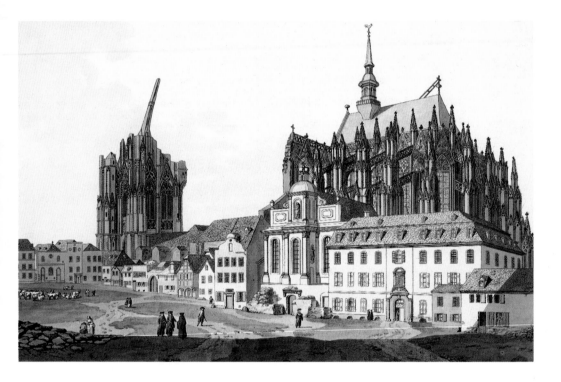

(1831–9), by Joseph Daniel Ohlmüller (1791–1839), and the Apollinariskirche near Remagen (1839–43) by Zwirner – both ambitious buildings that sport features copied from cathedrals. In 1840, however, the Revival was refocused on Cologne by the generous, and politically astute, offer of the new Prussian king, Friedrich Wilhelm IV (r.1840–61), to pay half the cost of completion. After sharp debate, the Rhinelanders agreed to find the rest. Building started in 1842; it was to continue for more than forty years. The arguments over the Prussian initiative brought

August Reichensperger (1808–95) to the forefront of the German Revival; he remained the central figure throughout its course.

A Catholic Rhinelander, lawyer and architectural amateur, Reichensperger was also committed to German unification, which meant accepting the leadership of protestant Prussia. Completing Cologne, he claimed, would affirm pan-German culture and serve the cause of unity, but would also reassert and revitalize the Rhineland's medieval Catholic inheritance, thus offsetting Prussia's hegemony. Reichensperger's ideas made him a principal of the Cologne Dombauverein, the cathedral building union established to oversee completion. Under his editorship the Dombauverein's journal, the *Kölner Domblatt* (1842–92), became Germany's leading gothic periodical, its articles reviewed and reprinted in the *Ecclesiologist* and *Annales Archéologiques* (1844–81). When the restoration started, Reichensperger's sense of medieval gothic, though passionate, was sketchy. Pugin's *True Principles* broke on him like a revelation: here he discovered a practical basis for gothic building that made architectural theory coterminous with Catholic truth. With a convert's fervour he wrote *Die christlich-germanische Baukunst und der Verhältniss zur Gegenwart* (*Christian Germanic Architecture and its Relationship to the Present*, 1845). This was the first such work in Germany, and it championed a full Puginian programme: structural integrity, functional expression, truth to materials, fidelity to medieval example.

Working from his own political agenda, however, Reichensperger urged that True Principles should be disseminated through *Bauhütten*, building lodges, attached to cathedrals as in medieval times, organized like the one being created at Cologne. Merging theory into practice, the *Bauhütten* would be both schools and construction sites, where architects and craftsmen would learn together. From them would emerge Germany's new gothic, medieval in genesis as well as style, rooted in a strong regional identity. The *Bauhütten* would supplant the *Bauakademien*, specifically the one in Berlin, replacing unGerman classicist

orthodoxy – irreligious, abstract, imposed from above – with native Christian gothic, regionally diverse, sprung from the working experience of people engaged in practical building. Here was the political core. By opposing architectural dictatorship and homogeneity, the *Bauhütten* would show the way to a new Germany whose unity and identity would be wrought from the independence of its parts. The building lodge was a special version of the organic community promoted by Pugin and the Camdenians; indeed, Reichensperger's antithesis between gothic bands of mason-architects and modern professionals recalls *Contrasts*' title pages (see 134). But with a crucial political difference. Though conditioned by Catholic authority, the *Bauhütten* were conceived as free collectives, assembled for a communal purpose supported by the common people. Their hierarchies were those of skill and experience: unlike so many English redactions of community, they did not simultaneously embody the inherited power of a governing élite. Quite the opposite: for that élite, from a Rhinelander's standpoint, was Prussian.

The concept of the *Bauhütte* resonates with the old history of gothic liberty. Beyond the medieval cathedral lodges lay the near-legendary territory of ancient Germania and freedom-blessed gothic folk. Ironically, where sixteenth-century German Protestants had invoked gothic history in battling with the imperial sway of Catholic Rome, the nineteenth-century *Bauhütte* proposed a gothic polity through which Catholics could contest the encroaching dominion of a Protestant empire. It is not known how conscious of such connections Reichensperger was, but in this regard his response to developments that finally settled the issue of gothic architecture's national origins is suggestive. Briefly, French and German scholars in the 1830s and early 1840s proved that the pointed vault, from which all gothic derives, first arrived in France. In Britain, gothic's specific national origin was no longer a central issue. In Germany, however, gothic origins were important. And scholars were able to demonstrate that many features of Cologne Cathedral, nationalism's key exhibit, derived from Amiens Cathedral. In the 1846 *Kölner*

Domblatt, Reichensperger accepted the facts, but claimed that when gothic appeared in France, the country was under the sway of the Franks, a Germanic people. Back in 1573 Hotman's *Franco-Gallia* had similarly identified the Franks in order to claim gothic liberty as a French birthright. According to Reichensperger, gothic had not been created by a country but a people: the descendants of the Germanic tribes settled across northern Europe, in Scandinavia, France, Britain, as well as Germany. His geography was that of gothic history, of Scandza and its offspring (see Chapter 2). Reichensperger rediscovered the internationalism of the mythical connection between gothic architecture and gothic liberty, with the *Bauhütten* making the crucial imaginative link: by recreating Europe's medieval architecture they would be restoring Europe's primitive freedom.

The *Bauhütte*'s cultural career lived up to such internationalism. As well as influencing the whole German Revival, with Cologne as a centre, it can be traced in the way French cathedral restorations were organized, and in the structure of the Belgian Sint Lucasscholen – Schools of St Louis – ecclesiastical workshops established from the 1860s. In Britain, the concept of the building lodge as a site of collective creative endeavour and political freedom has parallels in the work of the art critic John Ruskin (1819–1900; see Chapter 11). Taken up by Ruskin's self-avowed disciple, the designer and writer William Morris (1834–96), the *Bauhütte* model influenced the workshops and utopian collectives formed by architect-designers of the Arts and Crafts Movement (see Chapter 13), such as Charles Robert Ashbee (1863–1942) and William Richard Lethaby (1857–1931), even though what they produced was no longer gothic stylistically. Ultimately, Arts and Crafts idealism, mediated through the anti-academic artists of the Vienna Secession (from 1898), was to be grafted back on to the German *Bauhütte* tradition to produce that founding institution of architectural Modernism, the Weimar Bauhaus (1919–32).

Reichensperger was particularly keen to foster links between Germany and England. Reichensperger first visited Britain in

1846, when he started a long friendship with George Gilbert Scott, was shown round the Palace of Westminster by Barry, and attended the consecration of Pugin's St Giles', Cheadle. Touring the country, he decided that the cathedrals – excepting Salisbury – lacked the stylistic purity of France and Germany, but that the nineteenth-century gothic was unsurpassed. His conclusion was striking: English revived gothic is qualitatively more consistent than its medieval sources, reinvention eclipsing the original – a triumph for historicism. He thought England the 'land of the Gothic Revival', a judgement both political and architectural. In

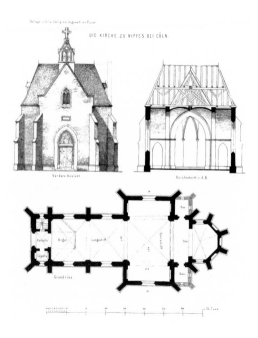

DIE KIRCHE ZU NIPPES BEI CÖLN.

157
Vincenz Statz, Design for the Marienkapelle, Nippes, Germany, 1847, from *Organ für Christliche Kunst*, 1851

158
George Gilbert Scott, Nikolaikirche, Hamburg, 1845–63

Britain's emphasis on private and local initiatives, individualist ethic and distrust of the state, and evolved constitutional balance, Reichensperger saw gothic inheritance and modern adjustment uniquely combined. From the freedom-loving goth, with his elected king and his own bit of land, to the self-helping bourgeois, with his vote and his villa: from Germania to suburbia. Whatever Pugin or Carlyle might have said, it was a view that flatteringly endorsed the continuities the Revival had long worked to establish. 'England for ever', wrote Reichensperger in a spasm of admiration, 'England is more Germanic than Germany.'

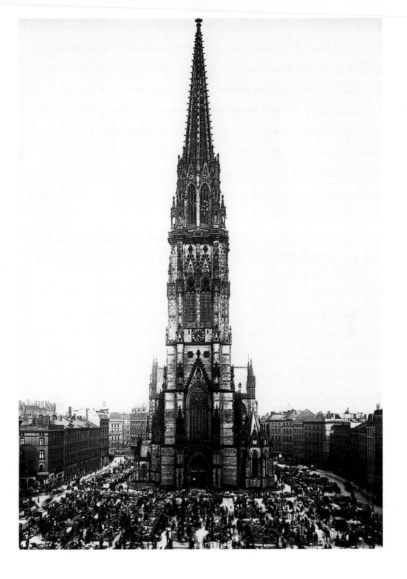

Back home, Reichensperger added what he had learned from his
travels to the precepts of *Die christlich-germanische Baukunst*,
as evidenced in the work of his protégé, Vincenz Statz (1818–98),
one of the graduates of the Cologne *Bauhütte*. To take just two
examples: Statz's Marienkapelle, Nippes (1847–57), is the first
in the German Revival to adopt the medieval rural church as a
model (157), and at St Hedwig's Hospital, Berlin (1851–5), he was
the first to exploit asymmetrical massing as a means of functional
expression. Meanwhile, mercantile Hamburg had imported the
English Gothic Revival directly. In 1845 Scott won a competition

for the Nikolaikirche (1845–63), his design synthesizing such medieval German features as the western axial steeple and the triple-apsed east end to create an effect not only scholarly but spectacular, particularly in the mighty composition of the tower and spire (158). Though Protestant, it influenced Catholic church-building extensively, and Reichensperger hailed it as an inspiration for the whole Revival in Germany. Back in England, the *Ecclesiologist*, sectarian as ever, huffed mightily about wasting good gothic on a set of Lutherans. Yet the Nikolaikirche was the greatest achievement of Scott's early career, and a beacon of the Revival's growing internationalism – which makes all the more tragic its gutting by Allied bombing in World War II.

Reichensperger's gothic campaign was directed not only against Prussian empire-building but also against the authority of French classicism, as embodied in the centralized power of the Academy and its École des Beaux-Arts. While Germany had been reassessing gothic for its own purposes, in France a special relationship had been developing between the state and gothic architecture. Following Napoleon's defeat – first in 1814, finally at Waterloo in 1815 – the restoration of the French monarchy encouraged an insubstantial, and largely sentimental, alliance between royalism, Catholicism and gothic. The royal corpses ejected from St Denis were returned amid nocturnal rites that would have suited a gothic novel. Court ceremonial dabbled with medieval pageantry, royals showed an interest in the Middle Ages and gothic enjoyed a light-hearted vogue through the artefacts of the Troubadour style – named after the painters (see Chapter 6). Troubadour gothic is a wholly decorative manner, with a peculiarly French devotion to elegant knick-knacks (159), from gabled clocks with little bellcotes to chime the hours, to desk sets and pen holders and in gothic openwork, all done in very expensive materials. More seriously, the influence of Chateaubriand's *Génie du Christianisme* began to be felt, and cultural interest turned to France's great medieval cathedrals – topographical in Charles Nodier's and Isidore Taylor's *Voyages pittoresques et romantiques dans l'ancienne France* (from 1821); learned in

Nicholas Joseph Chapuy's *Cathédrales français* (1823–31); melodramatic in Victor Hugo's immensely successful novel *Notre-Dame de Paris* (1831), its cathedral as complex and moody as any gothic hero. There was practical work too, characteristic of French tradition in their interest in structure and materials: an iron roof for Chartres Cathedral in the 1820s, and an iron gothic spire for Rouen, begun in 1827.

The restored monarchy was out of touch with the shaping forces of post-Napoleonic France: implacably reactionary, the crown opposed all moves towards liberalizing government, resented and resisted the growing power of the bourgeoisie, ignored the interests of commerce and industry, even alienated the army. A brief but bloody revolution in 1830 overthrew Charles X (r.1824–30), replacing him by the 'citizen king', Louis-Philippe (r.1830–48). His regime had no claim on historical continuity: he was neither heir to the throne nor vindicating parliamentary rights. But his government included the historian François Guizot, who promptly established the Historic Monuments Commission (Commission des Monuments Historiques) to identify and restore buildings of national importance. The first body of its kind, well staffed and funded, the Commission turned historicism into a government project. It was premised on discontinuity, on a divorce between the present and the buildings of the past. Even if they continued in use, their primary function became that of *being* historic. Once this separation from the present was fixed, old buildings could be given new roles: Guizot used them to construct a generalized national past for Louis-Philippe to inherit. The Commission discovered or invented, preserved or recreated, a corpus of buildings, headed by medieval cathedrals, to exemplify France's historical identity. By taking the buildings into its own special care, a regime discontinuous with history became history's keeper. At the same time, the deposed French royal family sought to maintain their historic claim on the throne by medievalizing artefacts such as the *Chambord Missal* (160), created for the Comte de Chambord, grandson of the deposed Charles X, as an evocation of monarchical tradition.

159
Pair of
candlesticks
in the
Troubadour
gothic
manner,
1837.
Gilt bronze;
h.106·5 cm,
42 in.
Victoria
and Albert
Museum,
London

The 1833 essay 'Du Vandalisme en France' by Charles René Forbes de Montalembert (1810–70), attacking the mistreatment of medieval churches, was extracted at length by Pugin in an appendix to *Contrasts*, and encouraged the more militant of the young men associated with Guizot's Commission des Monuments Historiques. Anti-classicist and anti-Academy, the architects Jean-Baptiste Lassus (1807–57) and Eugène-Emmanuel Viollet-le-Duc (1814–79) began to wax militantly gothic, supported by Adolphe-Napoléon Didron (1806–67), who launched *Annales Archéologiques* in 1844. It was here that Reichensperger, seeking to broaden support for his gothic

160
Chambord Missal, Written and illuminated for Henry, Comte de Chambord, Paris, *c.*1844. 22 × 14·8 cm, 8½ × 5¾ in. Victoria and Albert Museum, London

crusade in Germany, found allies, who in turn forged contacts with the British Revival. Articles and opinions moved regularly between the *Annales*, the *Kölner Domblatt* and the *Ecclesiologist*, and Didron, like Reichensperger, was at Cheadle's consecration.

The most characteristic architectural expression of the French Gothic Revival, both its product and its focus, was the large single building – whether new or restored. From the start there were very big churches, gothic not just in style but in construction – French architectural tradition needed no lessons from England on structural integrity. Rouen's Notre-Dame-de-Bon-Secours (1840–7), by J-E Bartélèmy (1799–1868), was probably the first to be based closely on medieval models. More scholarly still, and even larger, is Lassus's St Nicholas, Nantes (1843–68), stylistically thirteenth-century, its choir based on Chartres, and stone vaulted throughout. The Revival entered Paris on a similarly grand scale with Ste-Clotilde's (1846–57), by Franz Christian Gau (1790–1853). It is an imposing early fourteenth-century affair (161), the ornate west front symmetrically composed between twin steeples, the interior loftily vaulted and sharply linear. Rhetorically expansive but also precisely correct, Ste-Clotilde's is a touch pompous, a bit of a stuffed shirt. Its symmetry, lucidity and even finish are all virtues belonging more obviously to the logic of classicism. Like Nantes and Rouen, Ste-Clotilde's is monumental; but it is not quite a gothic monumentality.

The cultural prestige, and much of the funding, of revived gothic in France was tied to central government through the Commission and its quest for National Monuments. Despite their oppositional stance, Didron, Lassus and Viollet worked for and through the state's cultural apparatus, and centralization shaped both individual careers and individual buildings: we can read Ste-Clotilde's as an aspirant National Monument. The undoubted National Monuments were France's medieval cathedrals and major churches. Since they had been formally owned by the state since the Revolution, work on them attracted not only government money but also cultural status. Which is why

the restoration of medieval buildings, rather than the design of new ones in the gothic style, became the defining act of the French Revival. Consequently, the *Annales Archéologiques* remained principally, though not exclusively, committed to medieval architectural scholarship; and Viollet, beyond question France's most important gothic revivalist, spent most of his career on restorations, building relatively few new works compared to his contemporaries elsewhere in Europe.

From a cultured and well-connected bourgeois family, Viollet (162) trained in an architect's office rather than the academic École des Beaux-Arts. Joining the Commission, he started by restoring the Romanesque abbey of Vézelay (from 1840), then worked with Lassus on that thirteenth-century wonder, Paris's Sainte Chapelle (from 1842), before the two of them picked up the most public and symbolically charged restoration of all, Notre-Dame in Paris (1844–64). Viollet went on to the cathedrals of Amiens (1850–66), Reims (1861–73) and Clermont-Ferrand (from 1862), among others, and to the amazing recreations of Pierrefonds and the defences of Carcassonne (see Chapter 12). But Notre-Dame fixed his ideas on restoration and crystallized his whole interpretation of gothic. His conclusions appeared in appropriately monumental form: the ten-volume *Dictionnaire raisonné de l'architecture française du XIe au XVIe siècle* (*Analytic Dictionary of French Architecture from the 11th to the 16th Century*; 1854–68). For Viollet gothic was primarily – as time went on, almost exclusively – a structural system, and its greatest products, the thirteenth-century French cathedrals, unsurpassed exemplars of inexorable constructional logic (163): like the *Dictionnaire*, each part predicated every other. Gothic, to Viollet, had an essence outside or above the accidents of mere history: in its structure he perceived not just rationality, but the incarnation of Reason. As the *Dictionnaire* says of gothic construction, 'All of its efforts and improvements tend toward the conversion of its principles into general laws': historical contingencies turn into Truths. History comes in to provide a myth of origin: as twelfth-century France freed itself from monastic domination,

161
Franz
Christian
Gau,
Ste-Clotilde,
Paris,
1846–57.
Lithograph
after a draw-
ing by Jules
Gaildrau,
c.1860

162
Eugène-
Emmanuel
Viollet-le-
Duc in 1840,
aged 26

163
Eugène-
Emmanuel
Viollet-le-
Duc,
Ideal
cathedral,
from
*Dictionnaire
raisonné de
l'architecture*,
1854–68

a 'wholly new and modern spirit of research and progress'
prompted the gothic of 'a powerful new school of builders who
were lay people', and the liberal institutions created in northern
mercantile towns. Gothic sprung not from belief, but from the
bourgeoisie. Secularist and anti-clerical, Viollet detached
gothic and its greatest buildings from the Church. For to him,
the French cathedrals *were*, in effect, secular: they were owned
by the state, which funded his work on them, the point of which
was to create a National Monument, not encourage the faithful.

Ideologically, Viollet's version of gothic countered Pugin's, the
one claiming it for reason as the other did for religion, while both
were sure that medieval architecture embodied the values of the
society that built it. Viollet was also putting forward a variant

on the old theme of gothic liberty: in his account, the arrival of pointed arches equates with the achievement of political rights. Viollet, sharing Reichensperger's belief that gothic had emerged from the cathedral building lodges, urged the reorganization of French architecture on medieval lines, and even proposed scrapping the Academy in favour of architects' guilds. For all such historicist common ground, however, Viollet's conception of gothic itself was clearly different; this becomes apparent in the nature of his restorations.

While church restoration in Britain sought to recreate churches in the image of an ideal past, Viollet's restorations were impelled by a determination to exhibit the absolute logic of gothic's structural system, and, in consequence, to promote stylistic purity as an expression of consistent purpose. Such an enterprise tended to remove gothic from history altogether; but for Viollet, Reason was both transhistorical, an absolute, and the distinguishing historical characteristic of French culture. What could be more appropriate for a French National Monument, then, than to restore it in a way that demonstrated its flawless rationality? The consequences for historic fabric, often lamentably and unpatriotically illogical, could be drastic – more so, indeed, than with many similar restorations in Britain. To take the most notorious example: at Notre-Dame Viollet replaced gothic's earliest flying buttresses in the nave with others to his own design because the originals did not fully carry through the constructional logic of the vaulting system. It is ironic that the man who almost certainly knew more about medieval structure than anybody else in Europe should have destroyed the world's first flying buttresses because they were not quite flying-buttressy enough. Ironic, but not contradictory, for once gothic is conceived as a system of essential principles, it can be divorced from its historical occurrence in actual buildings: the architectural system is independent of the architectural substance through which it is articulated. Logically, though not perhaps very reasonably, Viollet's theories turned gothic into an abstraction.

From Britain, Germany and France came the ideas that shaped the European Revival between the 1830s and 1850s, and formed the basis for much that followed. They also provided a cultural stimulus that spread gothic, and particularly ecclesiastical gothic, well beyond their own borders. Newly created Belgium followed the lead of Guizot and Louis-Philippe with the establishment of the Royal Commission for Monuments and Sites in 1835. Local initiatives were already under way, as municipal authorities began to promote medieval towns such as Louvain (Leuven), Liège (Luik), Ghent and Bruges (Brugge) on the strength of their surviving gothic buildings. And where modernization risked disappointing the tourist, it could always be reversed: many of Bruges' famous gothic house-fronts are nineteenth-century reinventions. The Belgian Revival was fuelled by an alliance between Catholics and liberals that saw the country's medieval architecture as a source of national pride, promoting the erection and restoration of gothic churches as both a religious and patriotic duty. The architectural historian A G B Schayes (1808–59), who claimed for Belgium's medieval buildings a European pre-eminence, estimated that, in the twenty years after 1837, some 1200 churches, at least half of them gothic, were built, rebuilt or restored. Small wonder that in 1848 the Belgian *Journal de l'Architecture* declared 'churches are decidedly in fashion'. Antwerp and Liège were centres of gothic activity, producing between them architects such as Ferdinand Berckmans (1803–54), Joseph Jonas Dumont (1811–59), François Durlet (1816–67), Joseph Poelaert (1817–79), Jean Charles Delsaux (1821–93) and, a little later, Petrus Josephus Cuypers (1827–1921), who studied at the Antwerp Academy and later led the Revival in Holland.

Berckman's Church of Our Lady (1841–6), in Borgerhout, Antwerp, and Dumont's St Boniface's (1847–9), Elsene (Ixelles), are characteristic churches of the early years: big, urban and eye-catching, but both owing more to Munich's Mariahilfkirche than to anything medieval. More historically conscious is Antwerp's St Joris (1847–53) by Leo Suys (1823–87), whose double-spired west front crosses Antwerp Cathedral with Paris's

164
Joseph
Poelaert,
Church of
Our Lady,
Laken,
Brussels,
from 1852

Ste-Clotilde. Outdoing them all, though, is Poelaert's Church of Our Lady at Laken (164), north of central Brussels (from 1852), a colossal memorial to the popular and recently deceased Queen Louise-Marie, the western steeple rising between flanking towers like gargantuan pinnacles, the memorial chapel marked by a great conical roof, the vaulted vistas of the interior dizzyingly tall. The medieval precedents are fourteenth century, but the real analogues are Fonthill and Schinkel's visionary cathedrals

(see 83, 79, 80); it is a late emanation of the Romantic Sublime. Rural Belgium, meanwhile, also got its crop of new churches in a building programme that paralleled the Church Commissioners' efforts in Britain. Many were by the state-appointed architects overseeing each of the Belgian provinces, figures from the older generation such as Matthias Jozef Wolters (1793–1859), who produced prettily detailed simple churches with lancet windows for East Flanders, but also coming men such as Delsaux, who took over Liège in 1845. As well as designing historically informed

**165
Jean
Charles
Delsaux,**
Main
courtyard
of the
Courts
of Justice,
Liège,
Belgium,
1849–52

**166
François
Durlet,**
Detail of
carved
groups,
Antwerp
Cathedral
choirstalls,
from 1839

churches in the province, he published a study of Liège's
medieval architecture and restored the cathedral (from 1850),
making the north front conform to the thirteenth-century nave
in a way that combines Viollet's devotion to consistency with the
ecclesiologists' passion for gothic of the best period. Delsaux's
historicism is most accomplished in the Liège Courts of Justice
(1849–52; 165), a deft addition to the medieval bishop's palace,
which he also restored. Spirited, scholarly, its compound of late
gothic and early Renaissance anticipates the manner that virtu-
ally became a Belgian national style in the Revival's later stages.

The crafts that accompanied ecclesiastical gothic gave the
Belgian Revival much of its distinctive character. The national
tradition of figural and architectural wood-carving had already
adopted medievalism by the late 1830s. The Antwerp Cathedral
choirstalls (166), designed by Durlet in 1839 and carried out
over many years by a team of carvers headed by Karel Hendrik
Geerts (1807–55), are an outstanding example: stylistically and

decoratively inventive, crowded with little figures, they are in advance of any contemporary gothic buildings in Belgium, and rival in quality even the best work produced by Pugin's craftsmen. Belgian metalwork shows a similar response to gothic's decorative density, and the vigour of the national Catholic Church created an expanding market for liturgical and devotional objects, from chalices and monstrances to shrines and reliquaries. Mural painting, expressly encouraged by the Royal Commission on Historic Monuments, grew into a major feature of the Revival, both secular and religious, in the second half of the century. Stained glass was also being revived: the windows designed in 1835 by Jean-Baptiste Capronnier (1814–91) for St Goedel's, Brussels, make an early attempt to recreate a complete gothic glazing scheme; ten years later Jean-François Pluys (1810–73) began an even more ambitious programme for the pilgrimage site of the Heilige Bloedkapel – the Chapel of the Holy Blood – in Bruges (see 155).

Bruges, in close touch with gothic developments in Britain, was becoming a centre of the national Revival, with the Heilige Bloedkapel at its hub. In 1845 Jean-Baptiste Bethune (1821–92) settled in the city, drawn by its intense Catholic and gothic fusion.

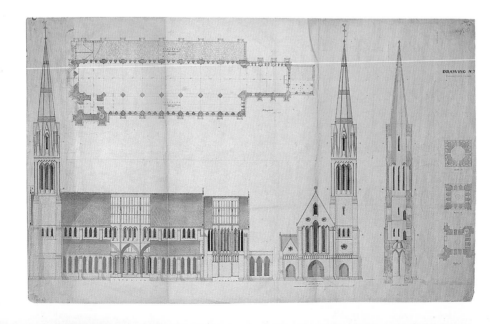

Originally a painter, he acquired some basic architectural training and, after a trip to England, became a disciple of Pugin, with whom he started to correspond. In 1850, one of Bethune's circle, the English architect Thomas Harper King (1822–92), produced the first French translation of *True Principles*, adding plates in the *Contrasts* manner, with modern Belgian monstrosities lampooned beside the country's medieval marvels. In 1851, King took charge of the ambitious programme for decorating the Chapel of the Holy Blood. In the following year, Pugin died and Bethune lost his mentor; but he was positioned to launch and to lead the Belgian Gothic Revival into its most fervent phase.

Writing in the *Annales* on the occasion of Pugin's death, Didron claimed that ecclesiastical gothic was conquering Europe. There was much to support him: beside the national revivals in Britain, Germany, France and Belgium, gothic churches were planned or being built in Austria, Spain, Switzerland, even Russia; and European imperialism had exported gothic from its historical home to new colonial settlements. Most of the exporting was done by Britain. In India, ecclesiastical gothic made a start with St Paul's Cathedral, Calcutta (from 1839), by Major W N Forbes (1796–1855), but St John the Baptist's, Bombay (1847–58; 167), by

167
Henry Conybeare, Design for St John the Baptist's, Bombay, 1847. Print with coloured wash; 59×92 cm, 23¼×36¼ in. Royal Institute of British Architects, London

168
William Wailes, Stained glass, St John the Baptist's, Bombay, c.1858

the city engineer Henry Conybeare, shows the long reach of ecclesiology: Early English, robustly structural, with encaustic tiles and glass (168) by William Wailes. Though St John's yokes 'Christian Architecture' to the Empire's cause, it does so with a certain ideological ambiguity, for it commemorates the soldiers who died in the disastrous Afghan campaign of 1841–3. Addressed to the needs of the colonists rather than the wider audience of the colonized, St John's was far more consolatory than missionary.

In the so-called colonies of white settlement – particularly, in the mid-century, Australia, New Zealand and Canada – churches were needed for permanent emigrant populations, in what was usually thought of as virgin territory. It was sometime before the arrogance of the assumption, and the outrage to the rights of indigenous peoples it entailed, were widely acknowledged. Church-builders and gothic revivalists were not exempt from the cultural and racial attitudes involved, though it is also clear that colonial clergy were often active in defending the interests of native populations. Colonial churches particularly concerned the Camdenians, anxious to see True Principles take root in the settler societies of Greater Britain. Plans were provided, medieval exemplars suggested: Carpenter designed a wooden Decorated church for – of all places – Tristan da Cunha in the South Atlantic; his partner William Slater (1819–72) created an all-purpose iron one, prefabricated for easy shipping abroad.

In 1847, the *Ecclesiologist* reported on progress in Australia: churches on the right gothic lines had recently been built in St Lawrence, Sydney, at Allyn and Wivenhoe, New South Wales; at Elderslie, Tasmania; the correct chancels of Camperdown and Ashfield in Sydney were particularly satisfactory. Roman Catholics were also busy: Pugin provided plans for the Bishop of Sydney, and little scale models for the Bishop of Hobart. St Benedict's, Sydney (1846–8) was based on Pugin's church at St Peter Port, Guernsey (1846–51), and remote rural settlements got versions of his Early English; variously interpreted, his models produced the Tasmanian churches of Oatlands (1850),

Colebrook (1857) and Campbell Town (1856–7), the last carried out by Henry Hunter, beginning a thirty-year career in which he became Tasmania's leading gothic architect.

Gothic arrived in New Zealand in 1842 with its first bishop, the Camdenian George Augustus Selwyn (1809–78), who came equipped with Pugin's books, ecclesiological designs and casts of Romanesque details deemed suitable for anticipated Maori carvers. The planning was faultless; the local stone was not. After two churches had disintegrated on him, Selwyn finally succeeded with St Mary's, New Plymouth (1845–6), by Frederick Thatcher (1814–90), its correct Early English a testimony to ecclesiological stubbornness. Timber, however, was plentiful, and Thatcher proved masterly in reinterpreting gothic principles for wooden construction. In St John's College Chapel, Auckland,

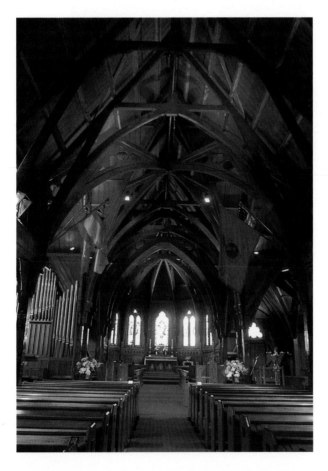

169
Frederick
Thatcher,
Old St Paul's,
Wellington,
New
Zealand,
1861–6

and All Saints', Howick (both 1847), crisp articulation combines with a robust expression of structural essentials, leading on to the dynamic open timber roof of Old St Paul's, Wellington (1861–6), Thatcher's finest building (169). Taken up by Arthur Purchas (1821–1906) and, most distinctively, by Carpenter's pupil Benjamin Woolfield Mountfort (1825–98), as in his early church at Kaiapoi (1854), Thatcher's manner became a New Zealand national gothic, both a style and a constructional method.

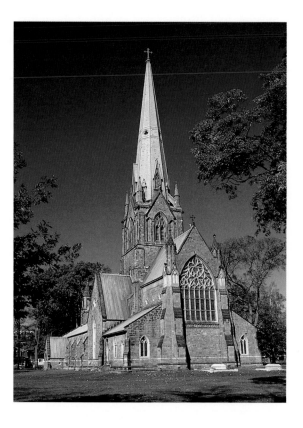

170
Frank Wills and William Butterfield, Fredericton Cathedral, New Brunswick, Canada, from 1847

171
James Renwick, Jr, Grace Church, New York, from 1843

In French Canada, Catholics got their gothic in first with Notre-Dame Cathedral, Montreal (1823–9), by the Irish immigrant architect James O'Donnell (1774–1830). A cavernous box, designed on a modular system, with tiers of galleries and a fancifully ribbed roof, it splendidly exemplifies most of what Pugin subsequently denounced. Anglican ecclesiology landed in New Brunswick in 1845 with Bishop John Medley (1804–92), accompanied by gothic plans and a gothic architect, Frank Wills

(*c.*1822–56), trained in John Hayward's Exeter office. Wills designed St Anne's, Fredericton (1846–7), in an elegant, slightly attenuated Early English that is distinctly personal, and started Fredericton Cathedral (from 1847), modelled on fourteenth-century Snettisham in Norfolk, before moving to New York in 1848. Medley continued building, completing his cathedral (170) to amended designs supplied by Butterfield. Obtaining usable stone was often difficult, however, and Medley turned increasingly to the possibilities of timber. His son, the priest-architect Edward Shuttleworth Medley, realized those possibilities in All Saints', McKeen's Corner (1861–2), and St Mary's, New Maryland

(1863–4), their construction influenced by Davis's board and batten villas, their timber gothic a fascinating parallel to the work of Thatcher and his successors in New Zealand.

Frank Wills' transfer to New York was a career move, for he promptly helped found the New York Ecclesiological Society. His key clients were Episcopalians, relatively small in numbers, but self-consciously an intellectual and social élite. Before 1840, American gothic churches – a mere handful – are basically classicist, their elementary medieval features symmetrically disposed, stylistically naïve compared with the contemporary

villa. Ideas from the ecclesiastical Gothic Revival in Europe gradually settled in the eastern States. Trinity Church, New York City (1841–6), by Richard Upjohn (1802–78), shows a clear visual debt to Pugin; St Alphonsus', Baltimore (1842–4), designed for German Catholics by Richard Cary Long (1776–1849), derives, appropriately enough, from Munich's Mariahilfkirche; New York's Grace Church (from 1843) by James Renwick, Jr (1818–95), combines Puginian composition with continental European detailing (171). Ecclesiological gothic was first imported through the Philadelphia churches of St James's (1846–8), closely copied from thirteenth-century Long Stanton in Cambridgeshire, and St Mark's (1847–8) by John Notman (1810–65), a Decorated design complete with an asymmetrically set steeple. Architectural directions had come straight from the Camdenians, solicited by a local merchant, Robert Ralston, in his efforts 'to humanise the people' in Philadelphia's 'iron and coal region' – a demonstration of how readily gothic's ideological identification with paternalist community could transfer across the Atlantic.

Once started in the States, the Camdenians did their best to ensure that nascent American ecclesiology grew up properly. They backed Wills and the New York Society, and reviewed articles from the *New York Ecclesiologist* (1848–53). Though Americans soon grew tired of being patronized by the English, ecclesiology's progress was considerable. Wills's output was substantial though crowded into a few years before his premature death, ranging from St John the Baptist, New York (1849), to rural churches in Annandale, Mississippi (c.1853) and Oberlin, Ohio (1855). Wills stuck to the English parish church model, but Richard Upjohn's work reveals another aspect of ecclesiology's impact: its capacity to generate what is, in effect, a new gothic. In the New Jersey churches of Burlington (1846–8) and Elizabeth (1854), he began to reduce gothic to its basic geometry, underlying forms and structures. Such paring-down allowed gothic to be built cheaply and with simple means, thus meeting the needs of the small, often remote settlements typical of American westward expansion. Coupled with Upjohn's feeling for materials, such

172
Richard Upjohn
St John Chrysostom, Delafield, Wisconsin, 1851–3

characteristics produced – in parallel to what happened in
New Zealand and New Brunswick – the distinctive personal
manner of his wooden churches: among them, Hillsboro' (1851)
and Reisterstown (1853), both in Maryland, and his finest work,
St John Chrysostom's, Delafield, Wisconsin (1851–3), its radical
economy and the clarity of its planes and lines coming close
to formal abstraction (172). Upjohn's churches move beyond
ecclesiology, but they illustrate what gothic True Principles
encouraged in American architecture: structural explicitness,
utility, truth to materials, a sense of the building in its landscape.
They were to prove enduring themes.

To the American Episcopalians who imported it, historically
correct gothic helped consolidate religious and cultural links
between the New World and the Old. And behind ecclesiastical
gothic were all the connotations of Romantic medievalism,
evocations of nationhood and naturalness, even the still small
voice of gothic liberty. The liquidity of the gothic semantic meant
that it could be invested as a cultural resource in climes unknown
to the style's medieval originators. In a colonial set-up, gothic's
connection with ancient community affirmed the identity, the
togetherness, of settler societies, sometimes at the expense of
cultures and communities they had displaced: Upjohn's Delafield
church was built on land seized from Native Americans only a
few years earlier. Gothic on the frontier was a long way – in
every sense of the phrase – from the gothic of Pugin's church
at Cheadle, from the Nikolaikirche or Cologne Cathedral,
from Ste-Clotilde's in Paris. Yet gothic's semantic web was
spun between them all. Didron was right: by the early 1850s the
Gothic Revival was global. Some of its greatest architectural
achievements would come in the next few decades; so too the
long shadow of its eclipse.

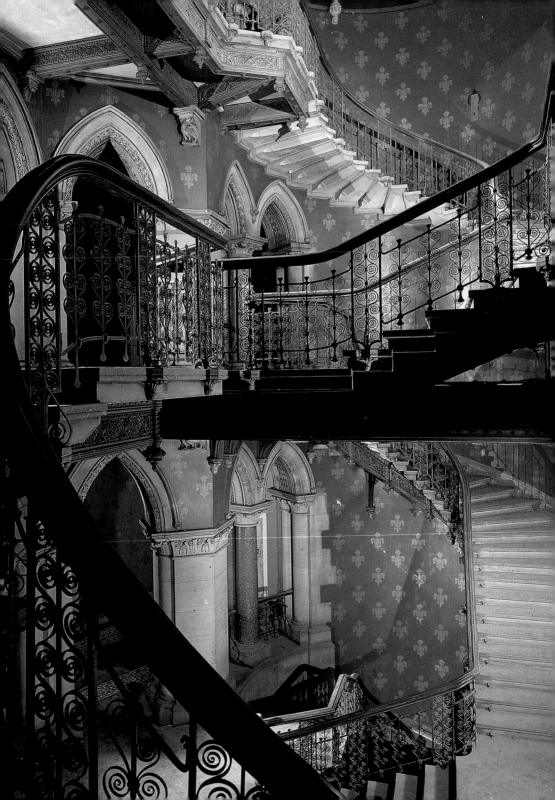

In 1848, 'The Year of Revolutions', liberal and nationalist insurrections in Europe overthrew governments and brought crowned heads to the dust, shaking even those countries where there was no direct assault on established power. A year or so later, the brave new revolutionary governments had all collapsed or been crushed; with few exceptions, authoritarian rule was everywhere re-established, seemingly stronger than before. Despite some Chartist disturbances, Britain, a liberal regime compared with most of Europe, was largely unscathed. The young Queen Victoria was popular, and her Consort Prince Albert was astutely manoeuvring the crown into the role of national figurehead. Real political power rested with parliament, which was increasingly responsive to middle-class interests. Above all, after the slump of the late 1830s, the economy, led by industry, was recovering strongly, and there were the first moves to improve the grim conditions in which many working-class people lived and laboured.

To Karl Marx and Friedrich Engels, the upheavals of 1848 anticipated a European struggle against the ultimate foes: capitalism and its directors, the bourgeoisie. The future, beckoning through the mayhem of the coming battle, would belong to socialism – so they said. As for the past's relationship to the present, the *Communist Manifesto* (1848) was succinct.

The bourgeoisie … has put an end to all feudal, patriarchal, idyllic, relations … torn asunder the motley feudal ties that bound man to his 'natural superiors', and … left no other nexus between man and man than naked self-interest, than callous 'cash payment'.

Marx and Engels were no friends of things medieval: good riddance to the Middle Ages, dumped in history's march towards the proletarian dawn. Nevertheless, their conception of medieval

**173
George
Gilbert
Scott,**
Grand
staircase,
Midland
Grand Hotel,
St Pancras
Station,
London,
1868–77

174
**Paul
Delaroche,**
*Edward V
and the
Duke of York
in the Tower,*
or *The Princes
in the Tower,*
1831.
Oil on
canvas;
43·5 × 51·3 cm,
17⅛ × 20¼ in.
Wallace
Collection,
London

society was shaped by the discourse of medievalism itself. Far from being consigned to the past, the Middle Ages, with gothic in the vanguard, were dynamically engaged in the present – so much so that medievalism's meanings, and the significances attached to gothic, were everywhere changed by the traumas of 1848.

In Britain, the most advanced capitalist state in Europe, 'the bourgeoisie', to use the *Manifesto*'s language, had 'felled feudalism to the ground' long before. But bourgeois culture was assiduously helping feudalism get on its feet again. Medievalism was pervasive. Alfred Tennyson's *Poems* (1842) quarried the Middle Ages for themes and models; such lyrics as 'The Lady of Shalott' and the epic fragment 'Morte d'Arthur' were brilliant reflections of a reawakened interest in the Arthurian stories – which Tennyson was subsequently to recreate as *The Idylls of the King*. Later writers drawing on the tales of Arthur included William Morris (whose startling collection *The Defence of Guinevere* appeared in 1858), Matthew Arnold and Algernon

Charles Swinburne. Edward Bulwer-Lytton produced his own epic *King Arthur* (1848), but was more successful with historical novels that picked up on Scott's popularity, including medievalist heavyweights such as *The Last of the Barons* (1843) and *Harold: The Last of the Saxon Kings* (1848). The Scott lineage was crossed with that of Victor Hugo in William Harrison Ainsworth's best sellers *The Tower of London* (1840), *Old St Paul's* (1841) and *Windsor Castle* (1843) – the last bedecked with architectural illustrations. Gothic gets pumped for symbolism in the Condition of England novel *Sybil* (1845) by that politician on the up, Benjamin Disraeli, the Chartist heroine making her début singing hymns amid the ruins of a medieval abbey. There were battlefield heroics in *Philip Augustus* (1831) and *Agincourt* (1844), just two of G P R James's innumerable historical yarns, and feudal domesticity in the tales of Anna Eliza Bray. The medieval novel peaked during the 1840s, but remained popular for decades, from Charles Reade's *The Cloister and the Hearth* (1861) to Arthur Conan Doyle's *The White Company* (1890).

Similarly popular were medieval genre paintings, often widely distributed as engravings and, later, as book illustrations. Subjects ranged from the sombre pathos of *Edward V and the Duke of York in the Tower* (1831; 174) by the French artist Paul Delaroche (1797–1856), through the glamour of *The Spirit of Chivalry* (1848), a House of Lords' fresco by Daniel Maclise (1806–70), to the antiquarian exactness of *Chaucer at the Court of Edward III* (1856–68) by Ford Madox Brown (1821–93). From 1849, medievalism clustered most powerfully around the works of the Pre-Raphaelite Brotherhood: John Everett Millais (1829–96), William Holman Hunt (1827–1910) and Dante Gabriel Rossetti (1828–82). Influenced by the Nazarenes (see Chapter 6), the Brotherhood's bright, sharply detailed paintings rejected academic conventions for characteristics derived from the art of the late Middle Ages and identified by contemporaries as gothic. Their enthusiasm for Arthurian subjects, particularly Rossetti's (175), launched a painterly procession of Camelot's inhabitants who marched on through British art well into the twentieth

**175
Dante
Gabriel
Rossetti,**
Arthur's Tomb,
1855
(dated 1854).
Watercolour
with gum
arabic, pencil
and pen on
paper;
23·5 × 37·8 cm,
9¼ × 14⅞ in.
British
Museum,
London

century, where they all found parts in the movies. A real-life
Victorian recreation of the Middle Ages appeared at the 1839
Eglinton Tournament organized on *Ivanhoe* lines by young
Tory aristocrats miffed by utilitarian cuts in royal ceremonial;
levelled by the weather, everybody got drenched. In 1842, sensibly
indoors, Victoria herself staged a medieval costume ball, appear-
ing as Queen Philippa, with Prince Albert as Edward III (see 96),
paragon of patriotism and chivalry – attributes that, as a German
and (worse) an intellectual, Albert lacked in the eyes of the court.

Accompanying the medievalist books, paintings and parties were
gothic artefacts of all kinds. Robust gothic furniture, based on
medieval sources, was available from Pugin; fancier varieties,
busily pinnacled and traceried, came from manufacturers less
concerned with theoretical verities (176). Details cribbed from
cathedrals and castles reappeared on wallpapers and fabrics;
churchy books had gothic windows and crocketed borders
decorating covers and title pages; needlework samplers curled
into cusps and quatrefoils; illuminated texts were copied from

176
Gothic
bench,
*c.*1850.
Oak with
inscribed
elm seat.
Private
collection

177
Gothic
tombs from
Kensal Green
Cemetery,
London,
and Leicester
Cemetery

Henry Shaw's *Alphabets, Numerals and Devices of the Middle Ages* (1845); jewellery turned gothic to befit a range of occasions, from christenings to buryings. And in churchyards, or the new urban cemeteries, pinnacles and tabernacles grandiloquently announced the Christian grave (177), while humble headstones for the first time took on the profile of the pointed arch.

The boom in the cultural production of gothic and the Middle Ages depended on material production, on industrialization and its concomitants: concentrated urban markets, national distribution of goods and raw materials, rapidly expanding access to publications – including, pertinently, the *Builder*, which began its weekly coverage of architectural topics in 1843. Production, material and cultural, focused key issues in industrial capitalism. Who did the producing? Under what conditions? And for whom? Such questions occupied the career of John Ruskin (178); his answers shaped much of the Gothic Revival's future.

The only child of wealthy middle-class parents, Ruskin had a cultured and high-minded upbringing. He combined an intense love of art and architecture with an often troubled religious seriousness and a precocious talent as a writer. Already famous as the author of *Modern Painters* (from 1841), Ruskin made his grand entrance as a goth in *The Seven Lamps of Architecture*

178
John Everett
Millais,
John Ruskin,
1853–4.
Oil on
canvas;
78·7 ×
67·9 cm,
31 × 26¾ in.
Private
collection

(1849), contemporary events urgent in his ears: 'the blasphemies
of the earth are sounding louder, and its miseries heaped heavier
every day', says the introduction, with the apocalyptic note
that was both his strength and his weakness. The main work of
Seven Lamps was to extend the whole field of gothic, stylistically
and – most of all – semantically. Ruskin had a driving concern
with what buildings mean, a commitment to reading architecture
that makes him perhaps the greatest heir of the English Gothic
Revival's literary tradition. Well aware of the Revival's progress
in France and Germany as well as Britain, he was neither a
propagandist for 'Catholic Architecture' nor a proponent of
gothic's ineffable logic. Although the lamps that light the way
to architecture – Sacrifice, Truth, Power, Beauty, Life, Memory,
Obedience – are hung upon Pugin's principles, Ruskin's cate-
gories are primarily ethical and moral. Even when dealing with

Power and Beauty, he bases aesthetic qualities upon broadly religious moral precepts. For sculptural decoration to be beautiful, for example, it should derive from the natural world, where 'God has stamped those characters of beauty which He has made it man's nature to love', while the power of architectural design embodies 'an understanding of the dominion ... vested in man' over 'the works of God upon the earth'.

Buildings talked morally to Ruskin because he was convinced that a society's dominant beliefs about the order of things shaped it at every level, down to the most menial task of the lowliest citizen. Architecture is thus 'the embodiment of the Polity, Life, History, and Religious Faith of nations'. It is also created under the eye of eternity: as he says in 'The Lamp of Memory', 'when we build, let us think we build for ever.' Though some of his conclusions are fanciful, Ruskin's arguments effected an extraordinary expansion in the range of potential meaning that could be got out of, or put into, architecture – particularly gothic, the stylistic focus of *Seven Lamps*. Critics have often censured Ruskin for regarding buildings as 'sermons in stone'. But good sermons – and Victorian culture was full of them – are no mere exercises in moral instruction: they argue and explicate, appeal to us, move us, admonish, excite, inspire. They are performances, dramatically pitched at the heart of human concerns, and the architectural sermons Ruskin read turned buildings – all of them, not just religious ones – into moral dramas on the grand themes of mortal destiny.

The vehicle of architectural semantics is style, and *Seven Lamps'* stylistic programme – crucial for the creation of High Victorian gothic – betrays anxieties that, in the end, are political. In 'The Lamp of Obedience', as dictatorial as Pugin or any Camdenian, Ruskin asserts the need for a uniform national architecture. Away with eclectic muddle and debates about whether the nineteenth century had its own style, an issue that occupied many Victorians. 'We want no new style of architecture', but 'we want *some* style ... a code of laws ... accepted and enforced'.

He might hope for acceptance, but how could stylistic obedience be 'enforced'? Art-police roaming the land, dawn-raiding architects' offices after a hidden stash of Doric details? Ruskin himself admits 'It may be ... impossible.' Yet the rhetoric is not as vapid as it seems. Its real object is apparent in the chapter's first pages: 'how false is the conception, how frantic the pursuit, of that treacherous phantom which men call Liberty.' The 'phantom', of course, had shaken Europe the year before *Seven Lamps* was published, and Ruskin's imagery strikingly, and doubtless coincidentally, echoes a more famous version of the ghosts of 1848: 'A spectre is haunting Europe – the spectre of Communism', in the opening words of the *Communist Manifesto*. Ruskin equates freedom with anarchy, a violation of the principle of law which orders the universe, and should govern both politics and architecture. Hence the insistence upon stylistic conformity, the nonsense about enforcement a measure of just how desperate, how spectre-haunted even, Ruskin was.

When Ruskin comes to stylistic prescription, however, the spirit of liberty seems less to have scared him than seduced him.

The choice would lie I think between four styles: – 1. The Pisan Romanesque; 2. The early Gothic of the Western Italian Republics ... 3. The Venetian Gothic in its purest development; 4. The English earliest decorated ... perhaps enriched by some mingling of decorative elements from the exquisite decorated Gothic of France ...

Hardly a recipe for conformity, but its very lack of dogmatism seems truer both to Ruskin's experience of architecture and to the Europeanism of *Seven Lamps*, based more on Italian and French gothic than British. It suggests a reaction to 1848 far more positive than law and order aesthetics; what Ruskin really sought, after the disruption of the whole continent, was a species of European unity symbolized through a new international gothic.

From his knowledge of Italy's medieval architecture, and his belief that decoration should have a natural basis, Ruskin derived another element of his new gothic: it should exploit the multiple

hues of its building stones to create colour that is an inseparable part of the architectural fabric. Structural polychromy, as it became known, transformed the architecture of the Revival in the 1850s and 1860s, defining much of High Victorian gothic's unique character. Like Puginian or Camdenian painted decoration, it was a reaction against both the whitewashed puritanism of Anglican churches, and classicism's monochromatic *hauteur*. But painted beauty was skin deep; physically bedded into a wall or arcade, structural polychromy reinforced the values of gothic's honest, expressive construction, demonstrating that even decoration was integral to the style's purposiveness and seriousness.

For Ruskin, structural polychromy was also part of gothic internationalism. The schemes he envisaged would require stone from widely dispersed sources; resonantly symbolic, gothic might embody the geology, the bedrock, of a whole country or even a continent. At the same time, his response to colour was sensuous and immediate, grounded in a passionate attachment to the particular. That attachment explains why, in 'The Lamp of Memory', Ruskin pitches so violently into architectural restoration – 'the most total destruction which a building can suffer'. Restoration erases a building's uniqueness, the specificness Ruskin found not in design, which can be copied, but in the wear and tear that witness to the cumulative life of centuries. Every feature of an ancient structure is irreplaceable because it speaks of a history that is uniquely its own. The particularity of Ruskin's gothic, derived as it was from a literary tradition of semantic association, was diametrically opposed to the abstraction of Viollet's, derived from a logical tradition of structural analysis. Equally opposed, of course, were their attitudes to restoration, burgeoning – as we have seen – throughout the European Revival at this time. Much of what the restorers did was essential. The results could be cack-handed, more often routine, but the best restorations, which were by no means the most conservative, were authentically creative responses to the medieval past, both inventive and reinventive. This Ruskin would never acknowledge, and most architectural history still does not. Restoration was

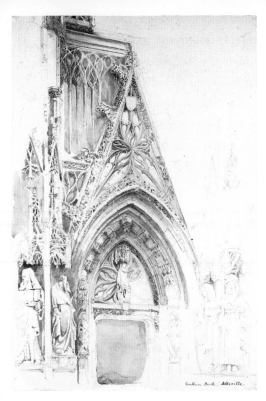

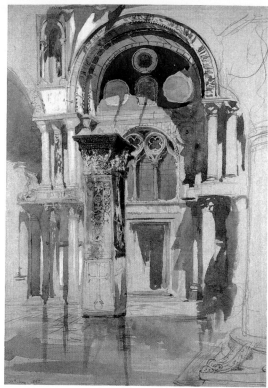

179–180
John
Ruskin,
Above left
*The South
Porch of
St Vulfran,
Abbeville*,
1868.
Pencil
and wash
on paper;
47·3×31 cm,
18⅝×12¼ in
Above right
*Part of St
Mark's,
Venice, after
Rain*, 1846.
Watercolour
on paper;
42×28·5 cm,
16½×11¼ in.
Ashmolean
Museum,
Oxford

essential to the artistic energy of the Gothic Revival, and Ruskin's
onslaught, for all that he demanded a new gothic, was an attack
on the Revival itself; the repercussions were to be profound.

Fascinated by architecture's physical substance, from the colour
of the masonry to the carved detail (179), Ruskin began to read a
history of human labour in every mark that the blow of adze or
chisel had left on the stone. That history showed him how cultural
production depends on material production. As his thinking
developed, he increasingly concentrated upon the material
conditions, the economic, social and physical circumstances
in which, and out of which, people make the things of their
culture – from cartwheels to cathedrals. They are fundamental
to *The Stones of Venice* (1851–3), Ruskin's architectural and
moral epic, in which St Mark's Cathedral (180) and the Doge's
Palace (181) play the leads – from Byzantine beginnings to
Renaissance ruin. The first volume moves systematically through

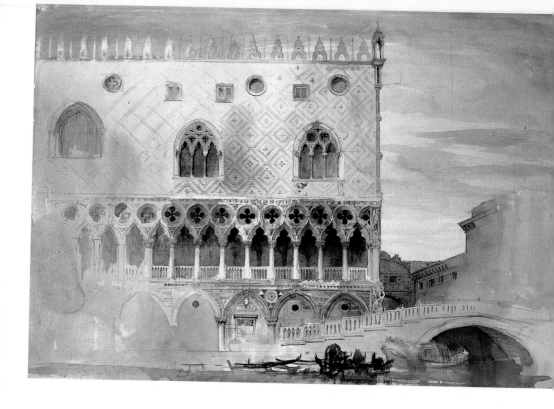

the components of building, its arguments rooted in an understanding of construction but always on the stretch for symbolism: whatever is built is a moral as well as a material fabric. The other two volumes tell the story of Venice's architectural growth, gothic flowering in the thirteenth and fourteenth centuries, and fall. The crucial chapter is 'The Nature of Gothic'.

Ruskin defines gothic in terms of both its necessary 'external forms', most importantly the pointed arch and gable, and its 'moral' or 'internal elements', such as Changefulness and Naturalism, which express 'mental tendencies' in gothic's original medieval builders. The leading 'element' is Savageness, which Ruskin finds in gothic's energy, in the vigour of sculpture which speaks of its carver's rude creative liberty. By contrast, he invites you, the reader, to 'look round this English room of yours', with its ornaments 'so finished', its 'accurate mouldings, and perfect polishings, and unerring adjustments'. No Savageness here; but

181
John
Ruskin,
*The Doge's
Palace, Venice*,
1852.
Pen, wash
and pencil
on paper;
30·2 ×
50·3 cm,
11⅞ × 19¾ in.
Ashmolean
Museum,
Oxford

also neither energy nor individuality, because the modern room, modern smartness and convenience, are expressions not of creative freedom but of economic slavery, the end results of a process by which the very life-force of England's people 'is sent like fuel to feed the factory smoke'. They are the consumer products of industrial capitalism, with its dependence upon the division of labour and upon treating labour as a commodity, as expendable raw material. Turning to medieval gothic, Ruskin rereads it for us, reinterpreting what its past tells our present.

Go forth again to gaze upon the old cathedral front, where you have smiled so often at the fantastic ignorance of the old sculptors: examine once more those ugly goblins, and formless monsters, and stern statues, anatomiless and rigid; but do not mock at them, for they are signs of the life and liberty of every workman who struck the stone; a freedom of thought, and rank in scale of being, such as no laws, no charters, no charities can secure; but which it must be the first aim of all Europe at this day to regain for her children.

This appeal for creative liberty, centred on the image of a cathedral, has clear analogies with Reichensperger's campaign for the *Bauhütte* (see Chapter 10), and much of his argument links back to Carlyle and Pugin. But his objectives were more radical: seeing 'the degradation of the operative into a machine' as the underlying cause of European unrest, he demands the abolition of industrial capitalism. Only by a revolution in the material conditions determining how people labour and produce can Europe secure 'the life and liberty of every workman'. Suddenly, though he would have been appalled by such company, Ruskin stands very close to Marx. In *Stones of Venice* the old radicalism of gothic theory re-emerged in a new alliance between gothic and freedom. Appropriately, it did so as the Gothic Revival reached its peak. Ironically, it undermined the whole basis of that Revival, which everywhere, and unavoidably, depended upon capitalist means of production, distribution and supply. Ruskin could not stay with the revolutionary position he had reached, though he never quite abandoned it. He steadily withdrew support for the

Gothic Revival, angered by continued restorations, embittered because architecture adopted his stylistic proposals while ignoring the reasons he gave for them. But the great man's message was not unheeded. In William Morris, who called 'The Nature of Gothic' 'one of the few essential texts of the nineteenth century' and who made the connection between Ruskin and Marx, gothic radicalism was to find one of its definitive voices.

Stones of Venice was not just an account of the past but a warning for the present. Victorian Britain was like medieval Venice in being a small, entrepreneurial state that had developed immense economic power and become the centre of a sea-borne mercantile empire. Ruskin, like Pugin and others, was using medieval gothic to attack modern society. But revived gothic, as we have seen, took the characteristics they admired in medieval buildings and turned them into the stuff of modernity: architectural truth, symbolic significance, seriousness of purpose, to which list Ruskin himself added creative vigour and expressiveness. These qualities constituted what the Victorians called 'reality' in architecture: it is a term that takes us close to the imaginative heart of High Victorian gothic.

Gothic's 'reality' was a talisman to ward off a world many felt to be increasingly unreal. The thronged cities appeared ever more anonymous and alienating, the face-to-face dealings of community vanished in an impersonal capitalist order. Capitalism itself depended increasingly on intangible credit, fortunes materializing then vanishing in the shadow-lands of economic speculation. Biblical beliefs once beyond challenge looked insubstantial against the geologists' fossil evidence and the evolutionary theories that were to be articulated most famously by Charles Darwin, whose *Origin of Species* was published in 1859. Meanwhile, to return to the imagery of both Marx and Ruskin, the ghost of revolution – who knew how real? – haunted Europe. For all its apparent stability, the mid-Victorian world frequently seemed to writers ominous and estranging, its terrors all the more nightmarish because obscure.

The reader will recognize the symptoms: they belong to literary gothic. 'The world looks often quite spectral to me', Carlyle confided to his journal in 1835, and his writings depict a modern England balefully enchanted, stalked by phantoms of its own creation. Dickens's imagination darkens gothically through the 1850s novels, the gothic castle's corridors transmuting into London's labyrinthine streets, pervaded – particularly in *Little Dorrit* (1855–7) – by a stifling sense of unreality. Gothic horror fixes the mood of Tennyson's monodrama *Maud* (1855) and Robert Browning's various poetic exercises in the grotesque. In 1840s America, Edgar Allan Poe's stories turned the outer mechanisms of earlier gothic fiction into a macabre interior

182
Edgar Allan Poe, Scene from *Fall of the House of Usher*, frontispiece to *Tales of Mystery, Imagination, & Humour*, 1852 edition

world of fear and obsession (182). In Emily Brontë's *Wuthering Heights* (1847) or sister Charlotte's *Jane Eyre* (1847) and *Villette* (1852), repression and mental imprisonment replace the overt persecution suffered by 1790s gothic heroines. Heirs to the shocker, Sensation Novels – for example Wilkie Collins's *The Woman in White* (1860) and *Armadale* (1866), Mary Braddon's *Lady Audley's Secret* (1862) or Charles Reade's *Hard Cash* (1863) – send their fevered protagonists into the gothic environs of the madhouse, the Victorian imagination's equivalent to the medieval dungeon.

The literary gothic that re-emerged in the mid-nineteenth
century internalized terror and fear, made them less escapable,
more commonplace. Nightmares no longer inhabited medieval
piles in far-off locations, but smart suburban villas here and now.
In the real lives of middle-class men and women such apprehen-
sions were variously met, often bravely and humanely – by social
reform, religion, educational initiatives, charity or domestic
affection. Also by the values of High Victorian gothic that were
summarised at the time by the word 'reality' – the truth, serious-
ness and vigour that were a means of striving against corrosive
doubts and anxieties. Here, indeed, was a heroic architecture.

Ruskin's proposals for a new gothic picked up on changes already
under way. The *Ecclesiologist* stopped demanding strict fidelity
to medieval sources and started courting novelty. For new ideas
European gothic was an attractive source, increasingly familiar
from contacts between British and continental goths, and
from such works as *Sketches of Continental Ecclesiology* (1848),
by the Camdenians' own Benjamin Webb, John Louis Petit's
Architectural Studies in France (1854) and Street's influential
account of northern Italian gothic, *Brick and Marble in the
Middle Ages* (1855; 183). The trigger for the creation of High
Victorian gothic, however, was structural polychromy. There
had been odd experiments in London, notably the eclectic
Christ Church, Streatham (1841) by James Wild (1814–93), and,
long before Ruskin and Street, Italian examples were known
through Henry Gally Knight's *The Ecclesiastical Architecture
of Italy* (1842–4; 184). Technological progress made stone
cutting and polishing cheaper, particularly of British marbles.
William Butterfield, already exploring abstract decorative
forms, exploited the new techniques to create the gleaming
geometrical patterns of his 1849 font at Ottery St Mary, Devon.
In the same year, he began work on All Saints', Margaret Street,
London, substantially funded by Beresford Hope, intended as
a model town church, ecclesiologically correct, and – said the
1850 *Ecclesiologist* – 'a practical example of what we are very
anxious to see tested, viz., constructional polychrome'.

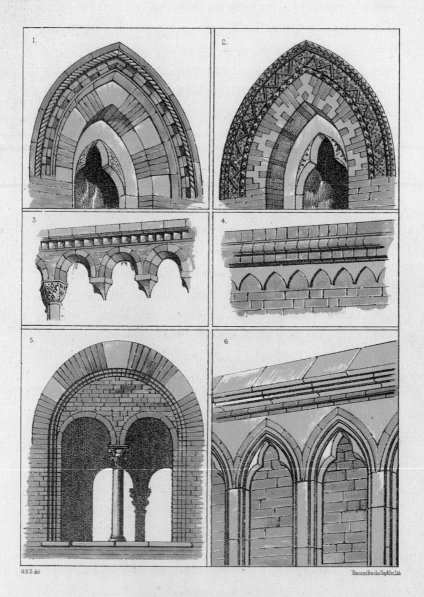

G.E.S del

Vincent Brooks Day&Son Lith

ITALIAN BRICKWORK:

1. 2. Windows at Verona. 3. Cornice S. Ambrogio, Milan.
4. Cornice Broletto Brescia. 5. Window in Broletto, Monza.
6. Wall Arcade. S. Fermo Maggiore.

All Saints' was the nineteenth century's most influential church: with it, High Victorian gothic sprang into being, complete in every vigorous essential. Built of brick as an explicit statement of modernity and urban character, it is designed in the Decorated gothic beloved of Pugin and the Camdenians, with borrowings from northern Germany for the tower and spire, and Italy for the chancel vaulting. Parts have precedents; their combination does not. Neither does the composition: crammed on to an awkward site, accommodating a school and clergy house as well as the

183
George Edmund Street, *Italian Brickwork*, from *Brick and Marble in the Middle Ages*, 1855

184
Domenico Quaglio, *Siena Cathedral*, from Henry Gally Knight's *Ecclesiastical Architecture of Italy*, 1842–4

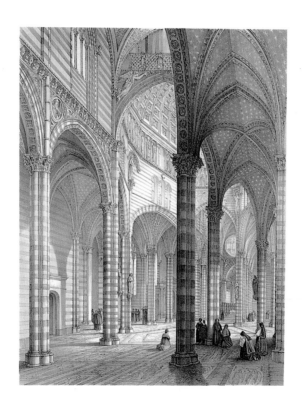

church, the buildings pack around a small entrance yard dominated by the immense steeple (185, 186). Each component is firmly individuated. The asymmetry is emphatic, the surfaces sheer, and the geometry austere. Purposive stress energizes the whole. All announce the characteristics of High Victorian gothic. Into this formal drama Butterfield injected the structural poly-chromy. Externally, bands and zigzags of black brick pattern the red, constantly varied in how they relate – or do not – to windows,

doors and buttresses. So the arrangement of the decoration and the disposition of the architectural forms are allowed to collide with one another. Internally, materials and patterns vary prodigiously, all precise and hard, yet vibrant with colour: geometrical roundels of matt tiles in the arcade spandrels (188), glittering granite piers, stripes and zigzags of brick and tile in the aisles and above the chancel arch. Different patterns abut abruptly on one another; different classes of material, rare and common, expensive and cheap, are bluntly juxtaposed. Each element is dynamically itself, down to the pulpit's bright little roundels of inlaid marble dancing on their checker-board ground, all jostling one another, as if trying to escape the constraints of the architectural form.

Colour, vigour, expressiveness, even a kind of Savageness: these are Ruskinian. But the aesthetic of All Saints' is Butterfield's own; so too the polychromy. Where Ruskin wanted natural forms and hues – 'irregular, blotched, imperfect' – Butterfield's

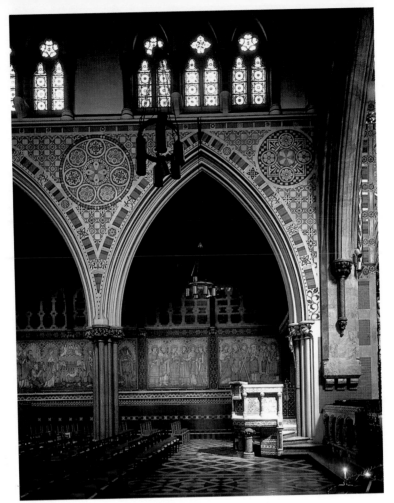

188
William Butterfield, All Saints', Margaret Street, London, 1849–59, showing the arcade spandrels and the pulpit

patterns are hard-edged, geometrically precise (187), and his
material textures assertively artificial: mass-produced bricks
and tiles, marbles mechanically polished to a mirror-like sheen.
All Saints' connotes the industrial regime: in its finishes; in the
compositional discipline that yokes constituents into a corporate
scheme even as it emphasizes their separateness; in the logic
of Butterfield's industrially processed materials; in the way
perfect surfaces and symmetrical shapes evoke the machine.
While the red and black walls of All Saints' were rising, so too,
half an hour's stroll away, was that prototypical structure of the
factory age, the Crystal Palace by Joseph Paxton (1801–65), where
Pugin's Medieval Court consorted with hundreds of the latest

engines and machines as part of the Great Exhibition. Although many goths disliked the Crystal Palace – read as a symbol of industrialization, engineering tricked out as architecture – All Saints' suggests a more positive engagement, its mechanical and industrial associations a means of recruiting emergent technological culture to the purposes of religious affirmation. For All Saints' *is* affirmative, indeed celebratory: not despite its aesthetic conflicts but because of them. They are taken into the building's substance, both expressed and contained by Butterfield's handling, finally to be resolved in the stable, wholly enclosed space of the chancel.

All Saints' visual and spatial tensions imply just the sort of moral drama Ruskin read into gothic. But its semantic, like its aesthetic, is Butterfield's. Both are products of the individualism that was one of High Victorian gothic's most vibrant qualities. For Reichensperger individualism was fundamental to Britain's being 'the land of the Gothic Revival'; he was right. It was an outcome of the long political history that identified gothic with freedom. But where the relationship between the two was previously, in all its various ways, symbolic, the style in High Victorian hands became an enactment of freedom, both in the way it was put together and as a realization of the liberty of the creative self. As such, it qualified, even contested, gothic's equally long identification with inherited authority, hierarchy, paternalism. This set of competing meanings dynamically engaged – responded to – the liberal objectives of the 1848 revolutions, everywhere concerned with the characteristically modern struggle between individual rights and the power of the state. Throughout All Saints', the individuality of the component parts is in tension with the discipline imposed by the design of the whole. In effect, the principle of liberty is set against the equivalent principle of order. Both principles had been shaping gothic's political meanings from the Revival's very beginning.

All Saints' was paradigmatic for High Victorian gothic: its influence is everywhere. Restlessly inventive, Butterfield pushed

compositional drama further, keeping components sharply articulated but increasing their compression, so that forms and volumes appear compacted or telescoped together. Two of many examples are the brick-built London churches of St Alban's, Holborn (1859–62), its vast saddleback tower buttressed by stretched transepts and stair turret, and St Augustine's, Kensington (1870–7), its agitatedly striped and tightly packed west front shouldering in among the blandly stuccoed terraces. Similar qualities are evident in the robust interlocking masses of his country churches, such as Milton, Oxfordshire (1854–6), and parsonages. At the same time, geometrical boldness and clarity of line produced the sheer profiles of churches such as Baldersby, Yorkshire (1855–7), and the sculptural quality of many of his fittings, especially fonts.

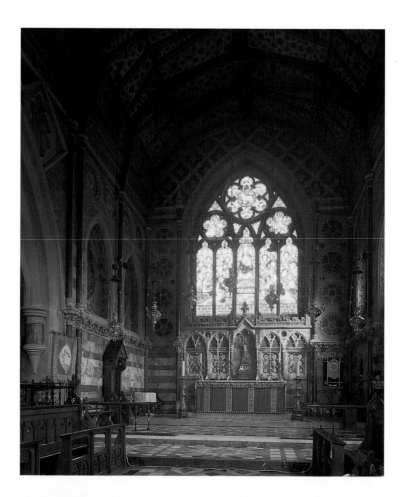

**189
William
Butterfield**,
Chancel,
All Saints',
Babbacombe,
Devon,
1865–74

Along with his explorations of form, Butterfield developed his structural polychromy. Variously executed in brick, tile, inlaid stone and polished marble, they have a wide expressive range, from the serene tonalities of the chancel at Langley, Kent (1854–5), to the tough brickwork patterns marching through Penarth, Cardiff (1864–6). Most elaborate is All Saints', Babbacombe, Devon (1865–74), where a web of raised stone ribs, covering nave and chancel walls (189), is repeated in analogous forms and patterns throughout the church, unifying decoration and structure in an ambiguous system of echoes and half-echoes. Idiosyncratic, intriguing, Babbacombe is among Butterfield's most compelling achievements.

Freed from following close medieval precedents, the modernity gothic acquired from developing Puginian principles was released in the High Victorian period into a dynamic, wholly contemporary expressiveness. The style's individualism allowed architects to respond to the extraordinary expansion in gothic's potential for social and moral meaning brought about by Ruskin, though in ways he scarcely envisaged. High Victorian gothic gave architectural form to the signs of the times, and was consequently similarly diverse and contradictory. High Victorian gothic was simultaneously assured and edgy, optimistic and agitated. Its forms were bold, powerfully massed, triumphant with colour; they were squeezed, stretched, broken into component parts, nervous with flickering patterns. It was also a style for which the starting-point was no longer necessarily English.

Ruskin's stylistic prescriptions are obvious in the Venetian gothic features of Oxford University Museum (1855–60), designed by the Dublin practice of Thomas Deane (1792–1871) and Benjamin Woodward (1815–61). Directly involved with the whole project, Ruskin also ensured decoration everywhere followed natural forms (190, 191), both in the stonecarving and in the marvellously fresh ironwork by Francis Skidmore (1817–96), whose capitals to the columns of the glazed and painted iron roof of the exhibition hall sprout into a great variety of flowers and foliage, their

190–191
Thomas Deane and Benjamin Woodward, University Museum, Oxford, 1855–60
Right Stone and iron capitals
Opposite The exhibition hall

designs created from direct study of the plants themselves. Deane
and Woodward went on to design houses in the same stylistic
vein, such as the now ruinous Llys Dulas, Anglesey (1856–8), and
Brownsbarn, Co. Kilkenny (1858–64). The gothic of continental
Europe entered Anglican churches largely through George
Edmund Street. A Camdenian insider by the early 1850s, Street's
contributions to the *Ecclesiologist* advocated continental urban
churches as models, naves designed on European lines for
congregational worship, and a *Bauhütte*-influenced guild of
ecclesiastical architects. His Italian travels (see 183) produced

192
George
Edmund
Street,
St James
the Less,
Westminster,
London,
1859–61

the spicy polychromy of the church at Boyne Hill, Berkshire
(1855–65), the first major work of his maturity. In the slum
parish church of St James the Less, Westminster (1859–61),
grouped with slightly later communal buildings, Street fused
continental sources and High Victorian expressiveness to produce
a tough new gothic (192). The vigorous exterior polychromy – red
and black bricks with yellow stone – speaks of Italy rather than
Margaret Street; the sweeping apsidal end and tall nave clerestory
are of French descent; the free-standing campanile, with its
sheer brick surfaces, is Italianate and Ruskinian; emphasizing

geometrical robustness, window tracery is uncusped. Through the tomato-red interior stride square-profiled arches, their massiveness just offset by notched brickwork decoration, their capitals dense with stylized foliage.

The aesthetic toughness Street drew out of continental gothic was soon labelled 'muscularity', which was particularly inspired by the example of French thirteenth-century gothic, with its structural clarity and clean lines, strong geometrical forms, simple tracery and boldly stylized carving. Signifying moral as well as physical vigour, the notion of muscularity enjoyed considerable cultural vogue, particularly through the earnest, energetic churchmanship termed – with just an edge of malice – Muscular Christianity. Architectural muscularity worked through a species of calculated over-statement: structure was to be brawnier, function more purposeful, honest materials more forthright. Columns stubby with the effort of bearing their load, windows flush with the wall plane to emphasize the unbroken mass of the masonry, plate tracery to suggest apertures punched through solid fabric, bold patterns and strong colours for the polychromy – all combined to give a design what was known in architectural slang as 'go'. The qualities thus promoted were gendered, weighted towards values thought of as masculine. This is made particularly intriguing by the contemporary emergence of what the Victorians called the Woman Question, its debates and campaigns about equal rights laying the basis for the modern Women's Movement. Such a context suggests a complex relationship between gothic and gender in the High Victorian period, one different from that found in the gothic novel and its sensational successors, and from that promoted by the chivalric code of Romantic conservatism. Though architectural 'go' and muscularity were masculinized, they were not just assertively male. Their expressive qualities, within the broader context of High Victorian gothic, were far wider and could consort, for example, with sculptural delicacy and the kind of ambiguity found in Butterfield's work. Nor, of course, were the values involved the exclusive property of men. The great London philanthropist

Angela Burdett-Coutts employed Henry Darbishire (1839–1908) to design the vigorously expressive gothic houses of Holly Village, Highgate (1865), and the awesome French gothic of the now-demolished Columbia Market, Bethnal Green (1866–9). Street's St James the Less itself was wholly funded by three sisters.

The buildings Street produced after St James's have plenty of toughness, but are never muscle-bound; his sensitivity to texture, and the poised lucidity of his management of space ensure that. Witness the balance and tonal harmony of the Early French gothic SS Philip and James, Oxford (1860–5), where his large congregational nave was an innovation in ecclesiological planning. Street's stylistic range was flexible: his second London church, St Mary Magdalene, Paddington (1867–73), for example, went back to Decorated, though with a characteristically French verticality, which is carried through into a slender octagonal steeple. Variations in plan and style were aspects of an inventiveness that produced fresh compositional thinking in almost every church Street designed. This resourcefulness characterizes a sequence of seven churches he created on the Yorkshire Wolds estates of Sir Tatton Sykes. Their basic style derives from Decorated, but it is constantly varied by elements drawn from the thirteenth-century gothic of both England and France: all are unmistakably related, and all are different. Taken as a whole they convey the strong impression that Street was enjoying himself.

There is tension between the individualist liberty exemplified by Street's churches and the conservative, hierarchical social model they served – which was also one expression of the Revival's political semantic. Today, the Sykes–Street churches have a valedictory quality, a goodbye look. East Heslerton (1873–7), the last and largest, was being built as the Golden Age of Victorian farming ended in a slump that permanently reduced agriculture's economic importance, sapped the whole basis of landowning and depopulated the countryside. Also at this time, Lord Eldon engaged Street to build a church on his Dorset estate. St James's, Kingston (1874–80), is a colossal, cruciform pile in

Early Anglo-French style, the interior an otherworldly perfection in white, black and grey. It epitomizes the paradox of these land-owner churches: philanthropically built to provide employment for Eldon's recession-hit estate workers, it massively advertised his paternalist authority, bossing the surrounding country from its hilltop site. Perhaps warmed by its social dimension, Street thought Kingston his 'jolliest' church. Equally grand, and conceived for a far more specific model of community, is the 1878 chapel soaring amid the red-tiled roofs of St Margaret's Convent, East Grinstead, Sussex, where Street designed the whole complex (from 1865). However, still to come was his greatest piece of social, multi-functional design, the London Law Courts (see 233).

While Butterfield and Street were in the stylistic vanguard, the public saw George Gilbert Scott as leader of the profession's gothic wing. The output of his office, the nineteenth century's largest, was prodigious: some 900 works at the most recent count. But hard-line goths distrusted him after the notorious Foreign Office competition of 1856–9, when Scott was pressured into abandoning his splendid gothic designs and building in the Renaissance style; the no less splendid result still stands in Whitehall. To twentieth-century critics hot on artistic integrity the sheer number of his works has been against him, especially as he has been set up as the arch-villain of Victorian restoration. Certainly, to modern taste, he was over-tidy with ancient fabric, and some new churches designed from his office are pedestrian affairs. But Scott at his best was an outstanding architect – and his best came far more often than has usually been acknowledged. His feeling for spatial balance and proportion gives his churches a distinctive dignity, movingly intimate in All Saints', Hawkhurst, Kent (1859–61), stately in grand St Mary Abbots, Kensington (1870–2). He responded early to continental gothic, and with the kind of scholarliness evident in Exeter College Chapel, Oxford (1857–9; 193), a subtly Englished version of the Sainte Chapelle in Paris. He could do a line in toughness too, without appearing over-muscled, as in the compactly massed Edvin Loach, Herefordshire (1859).

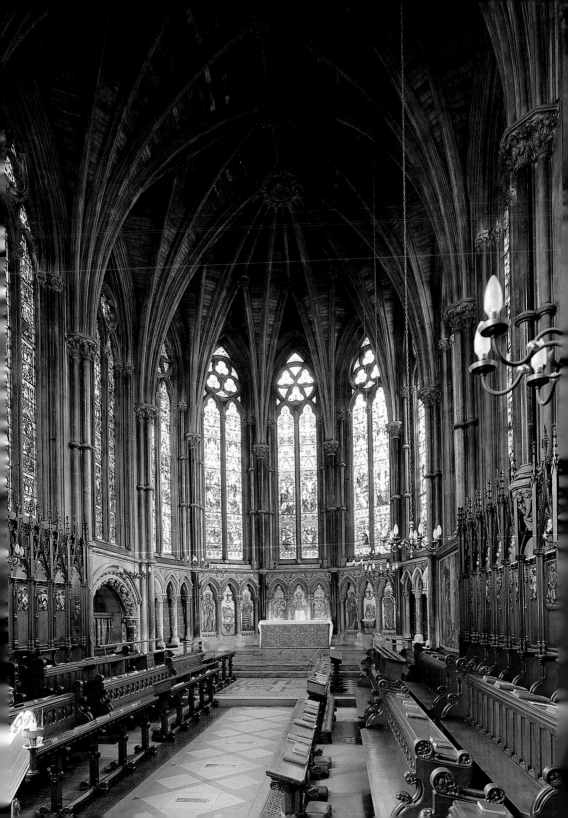

A different sort of sculptural impact distinguishes much of Scott's work, however: carved decoration. Taking to heart Ruskin's injunction that ornament should be based on natural forms, Scott embellished his gothic, both fabric and fittings, with flowers, foliage, creatures, grotesques and, in the more ambitious schemes, figure sculpture. Combined with polychromy, the effect can be exotic, as in the gorgeously coloured, lushly sculpted interior of Exeter College Chapel. On a large scale, carving not only embellishes structure as Pugin demanded, but helps unify the whole building. At All Souls', Halifax, Yorkshire (1856–9), built in richest Decorated touched by Early French, the sculpture, largely by John Birnie Philip (1824–75), is both dense and architecturally disciplined, carefully related to the dynamics of the overall composition; Scott thought it his best church. All Souls' was funded by the local manufacturer Edward Akroyd, who also built adjoining Akroydon for his workers, with gothic housing designed by Scott's office. Church and settlement together make up an industrial equivalent to the paternalist rural community Street's buildings helped promote on the Sykes estates.

193
George
Gilbert
Scott,
Exeter
College
Chapel,
Oxford,
1857–9

Sculptural decoration was just one of the architectural arts which Scott encouraged, and which were central to his cathedral restorations. Though some work seems insensitive, for example the refacing of almost all the exterior masonry at Chester (1868–75), and though we now regret the loss of many post-medieval fittings, in my view Scott was the Revival's greatest restoration architect. And his restorations often resulted in great architecture. Compared to Viollet – the obvious parallel – he was generally more conservative with medieval fabric, and was a far superior designer of new fittings. Architecturally, what he added or remade can be outstanding: for example, the great timber lantern at Ely (1862) and the recreated Chapter House of Westminster Abbey (1864–5). The fittings Scott designed, often a complete suite, are intense and exuberantly inventive. He used the same craftsmen repeatedly, in a way recalling the *Bauhütte* ideal of his friend Reichensperger, but practically tailored to Victorian architectural production. John Birnie Philip and

Henry Hugh Armstead (1828–1905) were principal sculptors; the London firm, Farmer and Brindley, did architectural carving and woodwork; Skidmore produced metalwork; and for painted decoration and stained glass, Scott employed John Richard Clayton (1827–1913) and George Bell (1832–95), who formed what became the nineteenth century's largest glass studio. Despite some destruction, much survives, including a complete ensemble at Worcester (1864–8), glimmering round the tomb of King John, the choir stalls and canopies of Exeter (1870–6), Clayton's and Armstead's sumptuous reredos in Westminster Abbey (1867) and, best of all, the sequence at Lichfield (from 1855), where Scott almost recreated the cathedral, its centrepiece the crossing screen (1859–63) by Skidmore and Philip, its multicoloured metalwork sprouting with enamel fruits and flowers (194).

Matching his ability to think and design on cathedral scale was Scott's capacity for complex planning apparent in his secular commissions. Although his gothic Foreign Office proved abortive, he rivalled its conception with the Midland Grand Hotel (1868–77) for London's St Pancras Station (see 173 and 195). Red brick, with terracotta and buff yellow stone, it spectacularly

194
George Gilbert Scott, Francis Skidmore and J B Philip,
Choir screen, Lichfield Cathedral, 1859–63

195
George Gilbert Scott,
Midland Grand Hotel, St Pancras Station, London, 1868–77

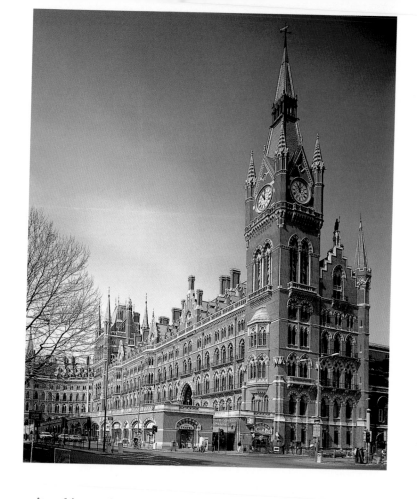

unites thirteenth-century French gothic with the latest iron construction, the asymmetrical elevations sweeping round to the grand entrance at one end, and pivoting brilliantly on the corner clock tower at the other. The work for which Scott is best known, however, is the Albert Memorial (1862–72; 196). Following the sudden death of Prince Albert in 1861, Scott won a restricted competition for a national memorial in London. The process of realizing his design was an extraordinary collaborative enter-prise, of which Scott was artistic and architectural director, 'the bond of union' – as he said – between all the people and activities involved. Structurally ingenious, the Memorial was built by work-men of the contractor John Kelk. A roll-call of leading sculptors, headed by John Foley (1818–74), who made the great golden figure

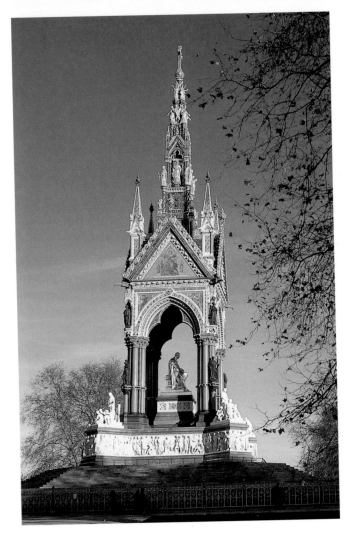

196
George
Gilbert
Scott,
The Albert
Memorial,
London,
1862–72

197
John
Richard
Clayton,
Architectura
mosaic,
The Albert
Memorial,
London,
1866–9

198
James
Redfern,
Faith,
The Albert
Memorial,
London,
1868

199
John Foley,
Asia,
The Albert
Memorial,
London,
1866–70

of the Prince, produced the main statuary groups. The trusty team from the cathedral restorations created the rest: coursing the podium, an army of cultural celebrities sculpted by Armstead and Philip; the architectural carving of the canopy by Farmer and Brindley; Clayton and Bell's mosaics in the gables (197); rocketing above, Skidmore's spire, studded with glass jewels, populated with Virtues by James Redfern (1838–76; 198) and angels by Philip. From the four Continents on the Memorial's corners (199), its symbolic narrative traverses a history of human creativity and social effort, to issue in the Christian hope of eternal community. In commemorating one man, it wrests coherence

from a whole – or not so whole – society. Worldly and religious, individualistic and co-operative, idealizing and intensely material, medievalist and modern – it builds triumphantly on paradox. Scott's climactic achievement, the Albert Memorial is one of the defining statements of High Victorian gothic.

Each in his different way, Butterfield, Street and Scott were principal makers of High Victorian gothic: its development was culturally and architecturally comprehensive. Not only was it a uniquely individualistic style, it was a style shared by a great many individuals – from London-based men with national

200
William White,
St Michael, Lyndhurst, Hampshire, 1858–69

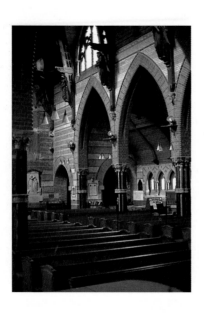

201
Samuel Sanders Teulon,
Elvetham Hall, Hartley Wintney, Hampshire,
c.1859.
Watercolour on paper;
66 × 101·6 cm,
26 × 40 in.
Private collection

practices to jobbing architects contriving a few houses with a bit of 'go'. As the railway system tied Britain more tightly together, binding it ever closer to the metropolis, cultural production took on a new national identity. Along the line from London came letters, newspapers, illustrated magazines, journals, catalogues, sample books – and the latest thing in gothic. Along too came the great architects, or their assistants, inspecting sites, meeting clients, checking buildings that the practice had 'in hand'. Pugin was the first to work in this way. Scott travelled unceasingly in pursuit of his firm's vast output: arriving in the Midlands one morning, he is reputed to have telegraphed back to the office,

'I am in Coventry. Why?' What follows here can only be an indication of the scale on which High Victorian gothic happened.

Butterfieldian polychromy influenced almost everybody. It underlies the brick patterning of many of William White's churches: intense and intricate at St Saviour's, Aberdeen Park, London (1866), boldly disposed at Lyndhurst, Hampshire (1858–69), where the polychromy accentuates the power of the great arches of the nave arcades (200), and complements the tough brick surfaces and hard-edged geometry of the exterior. Hardness as an aesthetic component of High Victorian gothic

is also to the fore in the sheer granite masonry of White's Irish castle, Humewood, Co. Wicklow (1866–70), and is a constant element in the work of Samuel Sanders Teulon. At Elvetham Hall, Hampshire (1859–62; 201), Teulon combined the expressive values of hardness and toughness with a daringly asymmetrical design that breaks the house up into a great variety of component blocks, which are then united visually by the insistent red and yellow stripes of the polychromy. Aesthetic strenuousness of this sort, also evident in such Teulon churches as the mighty St Stephen's, Hampstead (1869–73), served both to give architects a highly personal manner and to emphasize their robust handling

202
Frederick
Thomas
Pilkington,
Barclay
Church,
Edinburgh,
1862–4

203
John
Loughborough
Pearson,
St Augustine's,
Kilburn,
London,
1870–8

of materials and structure. A passion for structural expression typified many of them. Edward Buckton Lamb, who started way back with Loudon, devised low-slung, open timber roofs of great complexity for his London churches at Gospel Oak (1866–8) and Addiscombe (1868–9), their trusses braced and tied in a fever of constructional effort. By contrast, Roman Catholic St Walburge's, Preston (1850–4), by Joseph Aloysius Hansom (1803–82), has a roof of awesome grandeur, rising as high again as the walls of the cavernous nave it encloses.

For structured display and the single-minded pursuit of a personal gothic idiom, however, few High Victorian churches match those Frederick Thomas Pilkington (1832–98) designed for Scottish Presbyterians. Presbyterian worship, unlike that of Anglicans or Catholics, required a single auditorial space. In such churches as Trinity, Irvine (1861–3), Barclay, Edinburgh (1862–4; 202), and St Mark's, Dundee (1868), Pilkington, working up from oddly shaped ground plans, enclosed the undivided interiors in giant-sized gothic, with huge and elaborate roof structures erupting into all kinds of unexpected geometry externally. The extreme muscularity that results takes on an oddly organic quality from the free-form massing. Barclay in particular appears, rather eerily, to have grown itself: in 1880 a bemused writer in the *Builder* described it as 'the most

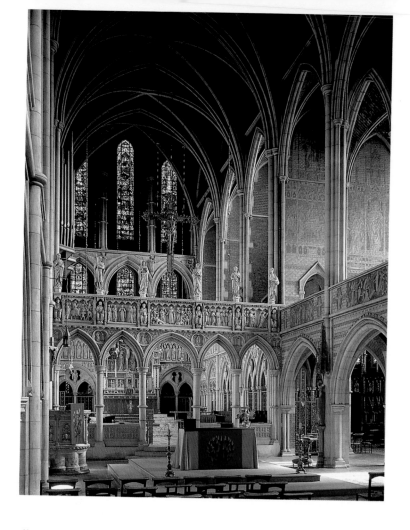

disorderly building in the city ... like a congregation of elephants,
rhinoceroses and hippopotamuses'. Toughness, pushed to
extremes by Pilkington, was the usual concomitant of Early
French, its adoption coming not only from Ruskin and Street
but also from Viollet's *Dictionnaire*. Though Burges claimed 'We
all crib from Viollet-le-Duc', his only thorough-going English
disciple was Benjamin Bucknall (*c*.1835–*c*.1895). Bucknall trans-
lated Viollet's writings into English in the 1870s, having earlier
designed the extraordinary Woodchester Park, Gloucestershire
(from *c*.1858), an attempt to carry out the master's precepts by
making everything an expression of stone construction. Never
finished, the house still stands as a vast masonry skeleton.

A more widely influential response to Viollet and Early French came through the churches of John Loughborough Pearson. After some particularly muscular exercises in continental gothic, such as Daylesford, Gloucestershire (1857–63), he designed St Peter's, Vauxhall, London (1863–5), remarkable at the time for being stone-vaulted throughout. That is evidence of the *Dictionnaire*'s impact. So too is Pearson's design for St Augustine's, Kilburn, London (1870–8; 203). It is a huge church, brick and stone. French gothic rules: the severe west end shoulders up against a vertiginous steeple based on Caen's Abbaye-aux-Hommes; the stone-vaulted interior has internal buttresses derived from Albi Cathedral. Steeply lit from the clerestory, pools of shadow swimming below the galleries and round the east end, St Augustine's is mysterious, numinous, without ever relinquishing the logical clarity of its construction. Vaulting, the product and proof of Viollet's structural system, became Pearson's forte, exhibited, with increasing elegance, in such churches as St Michael's, Croydon (1876–81), and St Stephen's, Bournemouth (1883–1908).

Where Pearson's 1860s churches are consciously robust, those James Brooks (1825–1901) designed as missionary centres in London's proletarian East End are elemental, particularly St Chad's, Haggerston, and St Columba's (204), Kingsland Road, both built in 1868–9. Although they needed to be relatively

204
James Brooks, St Columba's church, school and clergyhouse, Kingsland Road, Hackney, London, 1868–9

205
William Burges, Chancel decoration and carving, St Mary's, Studley Royal, Yorkshire, from 1871

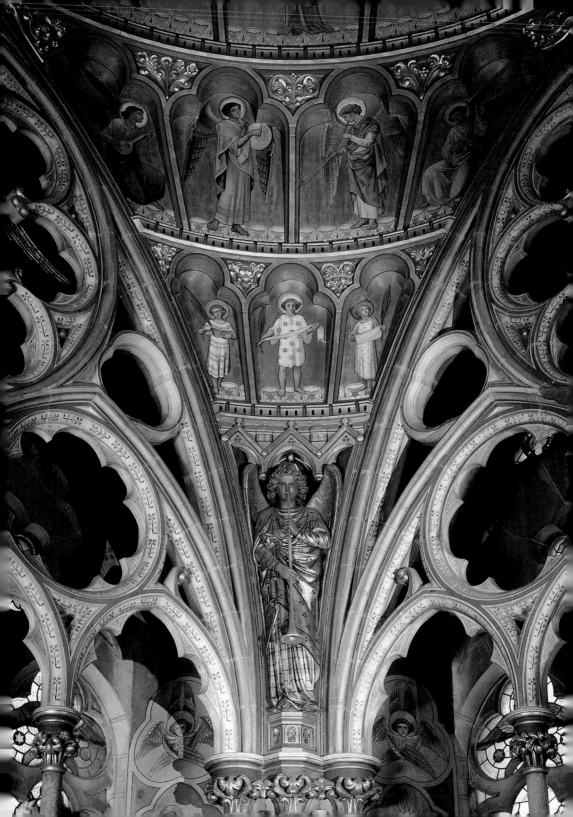

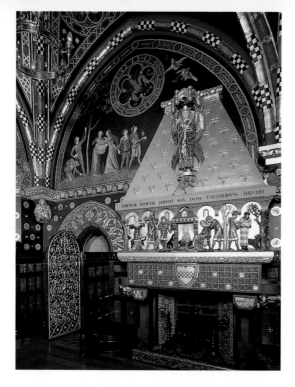

206
William Burges, The Summer Smoking Room, Cardiff Castle, from 1869

cheap, this served only to spur an aesthetic close to ruthlessness: compositional massing unrelieved by ornamental detail; austere architectural forms; no coloured patterns, only precise red brick-work broken by vast clerestory windows, their tracery stripped to geometrical essentials. Gothic's stern 'reality' dominates, and the interiors, cavernous and sombre, evoke the Sublime: no frills, only thrills. Ideologically, these East End churches were Anglican citadels, their purpose not just missionary but colonial and political. In 1851 a Religious Census revealed that most people in proletarian urban areas went to no kind of church, a finding that looked peculiarly ominous in the immediate aftermath of the Year of Revolutions. To middle-class Christians, the unknown reaches of the East End suggested frightening prospects of atheism leagued with anarchy. Bravely going where few had gone before, St Chad's and St Columba's were defensive quite as much as expansionist: nobody builds fortresses in friendly territory. Visually they dominated their humble surroundings: but were the encircling streets and houses dependants or besiegers?

Brooks's taste for elemental gothic was occasionally shared by William Burges, his architectural output relatively small, but almost all of it remarkable. His early works, notably St Finbar's Cathedral, Cork (from 1863), are concentrated and muscular, with a liking for strong geometry. Even so, they have elements of decorative lushness quite foreign to Brooks. It is this that blossomed – or erupted – into Burges's individualist manner in the Yorkshire churches of Studley Royal and Skelton-on-Usk (from 1871), for the family of the Roman Catholic Marquess of Ripon. In Burges's favourite Early French, the churches combine dense architectural detailing with polychromatic and carved decoration of unparalleled lavishness. In Studley Royal's sanctuary and chancel particularly, every plane is painted or structurally coloured, every three-dimensional element moves in a ceaseless play of mass and space, and sculpture flourishes, enmeshed by it all (205). No other English church has anything quite as exotic.

Burges outdid the Yorkshire churches with the secular interiors he conjured at Cardiff Castle (from 1869; 206) and Castell Coch, Glamorgan (1875–81; 207, 208) for another Catholic aristocrat, the Marquis of Bute, owner of the South Welsh coalfields, a troubled would-be mystic and probably the richest man in Britain. The Clock Tower at Cardiff Castle – to seize one example – ascends through incredible room after room, gothic constantly merging into Moorish, brilliantly coloured and gilded, stuffed with decorative invention: the seasons, the labours of the months, the zodiac, gemstones from the Bute estates, birds and beasts, chivalric legends, Greek and Norse mythology and – why not? – the organization of the Cosmos. When you can buy anything, including Everything must be a temptation. The Cardiff Castle interiors unfold like a sequential vision – or nightmare, for they seem to me gothic in all senses. The materialization of an inner world is flawless; but it is the perfection of fantasy, of an alternative reality made wholly by art and artifice. The distance between Burges the enthusiast for elemental Early French, and Burges the executant of Bute's – and his own – dreams, is immense. And if Cardiff Castle stands at one extreme, Brooks's

East End churches stand at the other. The distance is political, stretched between the 'Two Nations' of Disraeli's *Sybil*, the Rich and the Poor; it was the gap that gothic and medievalism, in the minds of many adherents, was supposed to have closed.

There were other major exponents of High Victorian gothic: men such as Alfred Waterhouse (1830–1905), whose Town Hall, Manchester (1868–77), is a masterwork of civic gothic, and Pugin's eldest son, Edward Welby Pugin (1834–75), whose ornate French gothic cathedral at Cóbh (from 1868) in southern Ireland, designed with his partner George Coppinger Ashlin (1837–1921), rises unforgettably above the river approach to Cork. There were accomplished local architects, such as the Bradford firm of Henry Francis Lockwood (1811–78) and Richard Mawson (1834–1904) or John Middleton (d.1885) of Cheltenham, who developed their own distinctive brands of the style. And High Victorian gothic produced remarkable buildings throughout the country, from the brick colossus of St Bartholomew's, Brighton (1872–4), by Edmund Scott (d.1895) to Templeton's Carpet Factory, Glasgow (1888), by William Leiper (1839–1916), its centrepiece cribbed from the Doge's Palace, its vibrant colours advertising the firm's 'orient-dyed' products.

Flourishing on the opportunities, both artistic and economic, opened up by High Victorian gothic were the craft firms. Metalwork was outstanding, from liturgical plate (209), to lecterns and candle standards, to architectural fittings. Street, Butterfield, White and Burges, as well as Scott, were remarkable designers for metal, with makers such as Potter of South Audley Street, Hart Son & Peard, and Leaver of Maidenhead rivalling Skidmore and Hardman. Stained glass was particularly innovative, its design breaking free of specific medieval precedents, and designers claiming greater artistic autonomy – a creative freedom not always welcomed by architects bent on aesthetic control. The company set up by William Morris in 1861, specializing in decoration and fittings as well as glass, is famous and directly influenced the later Arts and Crafts Movement – though Morris's

207–208
William Burges, Castell Coch, Glamorgan, Wales, 1875–81
Above right Drawing room ceiling
Below right Lady Bute's bedroom

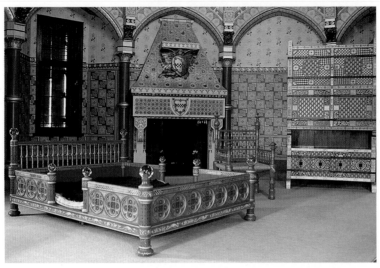

dream of running it like a medieval workshop foundered on economic practicalities. The firm's stained glass was designed by several artists associated with Pre-Raphaelitism, most regularly by Edward Burne-Jones (1833–98), celebrated painter of otherworldly Arthurian canvases. Other designers and firms, often inspired directly by medieval Italian painting as well as Pre-Raphaelitism, were equally impressive. There was John Clayton, of Clayton and Bell (from 1855), Scott's favourites, whose 1860s windows are among the most visually exciting of the whole Revival; Robert Turnill Bayne (1837–1915), the strikingly original designer for Heaton, Butler and Bayne (from 1862;

209
George Edmund Street and John Hardman, Chalice, 1868. Silver with niello decoration; h.24·5 cm, 9⅝ in. On loan to the Victoria and Albert Museum, London, from the Parish Church of St Paul's, Brighton

210–211
Heaton, Butler and Bayne, Details of the west window, St Peter's, Berkhamstead, Hertfordshire, 1868–70

212
Clayton and Bell, Mural decoration, St Mary's, Garton-on-the-Wolds, Yorkshire, 1876–8

210–211); Nathaniel Westlake (1833–1921), whose work for Lavers and Barraud (from 1858), derived from Italian primitives, particularly impressed Burges; and Henry Holiday (1839–1927), principal designer for the prolific James Powell and Sons (from 1862). The main designer for Pugin's collaborators, Hardman and Son, John Hardman Powell (1832–95), had an elegant manner influenced by fourteenth-century Siena. Most of these firms produced mural decoration too, the finest being by Clayton and Bell: their schemes of 1868–77 in Hardwick's ornate church at Newland, Worcestershire (1862–4), of 1868–9 in Pearson's

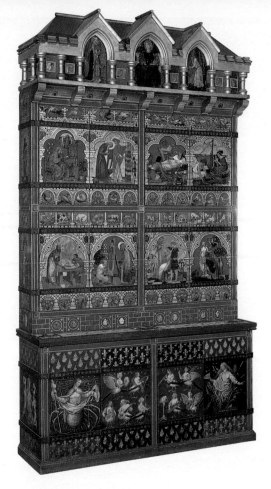

213
**William
Burges
and others**,
The Great
Bookcase,
1859–62.
h.318 cm,
125 in.
Knightshayes
Court,
Devon

Freeland, Oxfordshire, and of 1876–8 in Garton-on-the-Wolds
(212), on Tatton Sykes's Yorkshire estates, are fine examples.

Metalwork, glass, painted decoration; mosaics, stone-carving,
tilework, woodwork and furniture (213), embroidery too – all
contributed to the architecture of High Victorian gothic. Every-
thing, buildings and contents, was unswervingly individualistic,
no one item just like another. Out of such disparity comes an
energetically expressive unity: everything, in Pugin's phrase,
'speaks the same language'. But High Victorian gothic's
linguistic community is conditional not upon conformity,
but – paradoxically – upon difference, the robust independence
of its constituents. Translated into political terms, High Victorian
gothic proposes and exemplifies a democracy of dynamic equals.

12

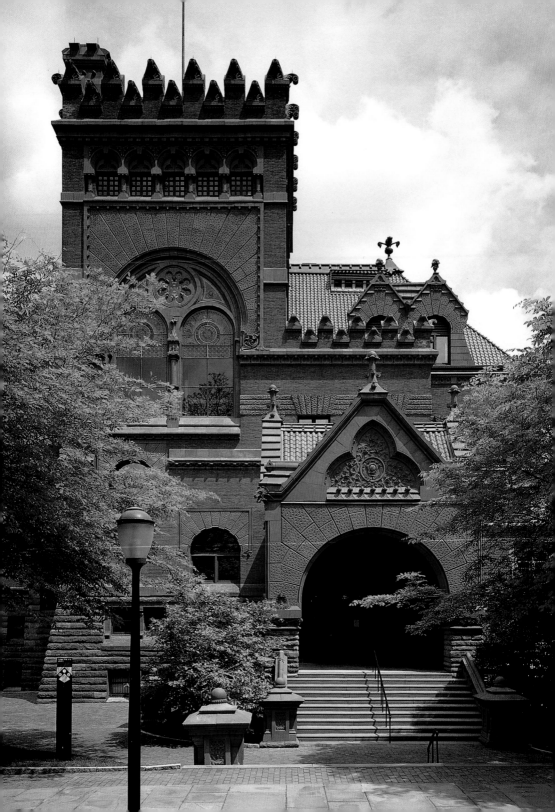

High Victorian gothic was a British style but its characteristics were variously adopted elsewhere, most directly in America. During the second half of the nineteenth century, white settlement expanded across the whole country, driven on by constant immigration from Europe, which also fuelled a prodigious growth of the cities. Economic interests, the railroads and the efforts of the federal government gradually pulled the country's extraordinary diversity into some kind of coherent national identity. Though not until the Civil War (1861–5) had settled the future of the Union, confirmed the ascendancy of the North and laid waste to vast tracts of the South. Behind America's adoption of High Victorian gothic lay Ruskin's moral and social gospel – so much so that American architectural historians usually refer to the style as Ruskinian Gothic. It was used principally for cultural and educational buildings, particularly in northern states intent on exemplary construction, social and architectural, during and immediately after the Civil War.

214
Frank Furness, University of Pennsylvania Library, Philadelphia, 1888–90

Two of the earliest are now gone: New York's National Academy of Design (1863–5; 215) by Peter B Wight (1838–1925), a vigorously striped block with features derived from the Doge's Palace in Venice (see 181); and the Museum of Fine Arts, Boston (1870–6), a polychromatic and deftly asymmetrical composition by John H Sturgis (1834–88) and Charles Brigham (1841–1925). For educational buildings, the significances of Ruskinian gothic overlaid existing associations between medieval architecture and Europe's inheritance of Christian learning, as exemplified by Oxford and Cambridge. American institutions keen to claim that legacy took to revived gothic readily: a particularly early, albeit rudimentary, example is Kenyon College, Ohio (1827–36). High Victorian appears in the colossal pile of Harvard University's Memorial Hall (1870–8; 216) by William R Ware (1832–1915) and

Henry Van Brunt (1832–1903), its character and structural brawn derived less from Ruskin than from Viollet, of whom Van Brunt was the American translator. More directly Ruskinian is the Nott Memorial Library (1872–5) by Edward T Potter (1831–1904) for Union College, Schenectady, New York; it has a domed drum like the baptistery of an Italian cathedral, but everything is overscaled – the windows, wall-piercings and polychromy as elemental as the form of the building itself.

The coarseness in aspects of these buildings does not matter; their energy does. In the architecture of Frank Furness (1839–1912), the greatest American exponent of High Victorian gothic, that energy was yoked to a purpose that was not only broadly social and cultural, but urgently political. Furness was from Philadelphia, where he was at the centre of a cadre of reformers – including financiers and businessmen as well as religious and cultural leaders – battling to defeat the corruption and incompetence for which the city's Republican bosses were notorious. Hyperbolically strenuous, insisting on architectural

and moral effort, Furness's High Victorian gothic articulated the reformers' aspirations, and their struggle. Bracketing his major buildings are two cultural citadels, the Pennsylvania Academy of the Fine Arts (1871–6; 217) and the Library of the University of Pennsylvania (1888–90; 214). Between came a sequence of Philadelphia banks, statements of a characteristically American, and wholly unRuskinian, confidence in aggressively individualistic capitalism as a means to social betterment. They include the

215
Peter B Wight, National Academy of Design, New York, 1863–5

216
William R Ware and Henry Van Brunt, Harvard University Memorial Hall, 1870–8

217
Frank Furness, Pennsylvania Academy of the Fine Arts, Philadelphia, 1871–6

extravagantly butch Provident Life and Trust Company Building (1876–9; 218). Contemporaries, baffled as to style, coined the term 'Furnesque'. All his buildings share a common aesthetic: emphatic weight and solidity; components that seem yoked together by force; strongly contrasted materials, with red brick dominant; decoration so stiff and overscaled that it often appears inseparable from structure – everything taut, hard, intense – muscularity *in extremis*.

Furness's architecture was committed to a political, ultimately ideological campaign. It affirmed hard structural integrity

218
Frank Furness, Provident Life and Trust Company Building, Philadelphia, 1876–9

against the sapped foundations of Philadelphia's government; material honesty against deceit and corruption; effort against civic sloth; primitivism against smoothly decadent sophistication; gothic 'reality' defiant in a world of moral dereliction. Furness's red brick, as contemporaries recognized, repudiated the white masonry classicism popular for American civic buildings in the later nineteenth century, their style originally recalling the ideal republican polities of Ancient Greece and Rome but increasingly and ironically identified with City Hall corruption. Brick also quoted the physical fabric of old Philadelphia, the so-called 'Red City'. It had been built by Quakers from the Puritan stock that George Perkins Marsh hailed as bearers of the gothic inheritance from corrupt Old England to vigorous New England (see Chapter 7). And it had been the scene of the Declaration of Independence, its revolutionary cause identified with the history of free gothic polities. Semantically, Furness's unique style has an equally

unique historical resonance: driven by contemporary political urgency, it unites gothic's jointly architectural and ethical values with America's role in the epic mythology of gothic liberty. High Victorian gothic was heroic, and never more so than in Frank Furness's hands. Which has not saved his architecture: most of his major buildings except the Academy and the University of Pennsylvania Library have been demolished. Modernism and corporate America have seen to that.

Although gothic was widely taken up for churches after 1850, the nature of the country, its size and the pattern of its expansion, made consistent stylistic evolution impossible. For frontier settlements, pointed windows and an approximate steeple sufficed to signal a Christian presence; in the cities, sophistication was erratic. James Renwick, architect of Grace Church (see 171), had been to Europe and designed St Patrick's Roman Catholic Cathedral, New York (1858–79), as a scaled-down version of Cologne: unhappily for structural integrity, escalating costs forced the substitution of plaster vaulting for stone. Urban development and the lack of indigenous historical models prompted stylistic diversity: Romanesque, Lombardic, Italian Renaissance were all requisitioned for ecclesiastical purposes. In such a context, High Victorian gothic was used for churches only occasionally, though impressively enough in Holy Trinity, New York (1873), by Leopold Eidlitz (1823–1908), an unflinchingly hard-edged design restlessly criss-crossed with polychromatic brickwork; and new Old South Church, Boston (1876), by Charles A Cummings (1833–1905), its highly asymmetrical composition just about pulled into coherence by a massive Ruskinian tower.

The European eclecticism of High Victorian gothic appealed to American architects, but was regarded far more dubiously within the nationally self-conscious traditions of continental Europe itself. In 1856 William Burges, partnered by Henry Clutton (1819–93), won a competition for building Lille Cathedral with a vibrantly High Victorian interpretation of Early French, shot through with the expressive vigour characteristic of High

Victorianism. A similarly robust design by Street picked up second prize, while Lassus, the French hope, came third with a handsome but conservative effort in very correct thirteenth-century gothic. The British entries shared the concept of gothic 'development', a notion loosely assembled from a general ideology of Progress, and from the writings and practice of the Revival in Britain: medieval gothic was to be the starting-point for an international gothic style flexibly tailored to modern needs. Things were different in France. As Viollet demonstrated, the stylistic purity of the thirteenth-century cathedral was the perfect architectural expression of a perfect structural logic, which was quintessentially French. How could nineteenth-century architects 'develop' something that had already achieved perfection? The whole trouble with logic is that having arrived at an answer there is nowhere else to go. Lassus's motto, tagged on to his Lille entry, took no prisoners: *'Eclectisme est la plaie de l'art'* – 'Eclecticism is the plague of art'. Logic, nationalism and the difficulty of raising Catholic subscriptions for designs by English Protestants proved decisive. The competition was set aside and the commission awarded to Lassus, who then inconveniently died. During building, his design was heavily amended – not for the better – by the Lille architect Charles Leroy; the church never became a cathedral, and still awaits a west front.

The Lille affair and the triumph of Viollet's arguments effectively forced new gothic churches in France into a thirteenth-century mould. The results, as in Lassus's St Jean Baptiste, Belleville (1853–9), and St Bernard, Montmartre (1858–62), by Auguste-Joseph Magne (1816–85), though imposing, often seem formulaic, as if medieval cultural authority was too great to permit anything other than stylistic submission. This is not the case, ironically enough, with Viollet's own, relatively few, churches. Conscious of medieval regional tradition and the use of local materials – another aspect of gothic's rationality – he produced St Gimer, Carcassonne (1852–9), in the thirteenth-century idiom of southern France. Viollet could also be deliberately tough: Aillant-sur-Tholon, Yonne (1865–7), has a plate tracery rose and

circular clerestory windows that gape like enormous portholes. Other architects were not allowed such licence, especially when it came to construction. In 1855 Louis-Auguste Boileau (1812–96) found himself publicly ticked off for St Eugène, Montmartre, an avowed structural experiment, stylistically thirteenth-century but with cast-iron columns, arcades, windows and roofs. 'Rather childish bad taste', wrote Viollet, and illogical – gothic being the product of stone construction, it could not be simply transliterated into iron. His denunciation, like his strictures on Lille, strait-jacketed French ecclesiastical gothic. St Eugène, like High Victorian gothic, predicated 'development', of which, said Viollet, there could be none, no more in structure than in style. None, at least, *within* gothic's own terms; the possibilities *outside*, beyond the range of the Revival, occupy his subsequent writings. French church design started to lose interest in gothic, particularly in Paris, where the Revival always had to fight hard for recognition. In 1858, as part of his famous replanning of the city, Georges Haussmann announced a church-building programme. Its products were large, well publicized and widely discussed; none was gothic. But the three most celebrated – La Trinité (1860–7), St Ambroise (1863–9), St Joseph (1866–75) – all by Théodore Ballu (1817–85), flirt with gothic forms and details wearing Renaissance and Romanesque dresses, in a way that seems deliberately unprincipled. Having demanded thirteenth-century purity, Viollet had to watch while Paris welcomed a set of churches not only stylistically promiscuous but, by his own nice standards, wholly illogical.

Parisians liked Ballu's churches because they responded to the city's social theatre. Commentators at the time and since have regarded the regime of Napoleon III (r.1852–70), known as the Second Empire, as itself theatrical – both glamorous and illusory. Extraordinarily, and subsequently to his regret, Viollet became part of the act, an architectural courtier close to Napoleon and flattered by the attentions of the Empress Eugénie. During the Empire period, Viollet produced three of the most spectacular creations of French nineteenth-century gothic. Typically,

they were restorations, all of structures that rate as National
Monuments. From 1852, on behalf of the Commission des
Monuments Historiques, Viollet worked at Carcassonne in south-
ern France, turning Europe's most complete set of medieval town
defences into an ideal fortified city, entered through frowning
gate towers, ringed with a wonderful assemblage of ramparts
and bastions (219). For Napoleon, he reconstructed the ruined
medieval château of Pierrefonds (1862–70), near Compiègne,
northeast of Paris, raising its mighty towers, emphasizing its

219
Eugène-
Emmanuel
Viollet-le-
Duc,
The
ramparts,
Carcassonne,
restored
from 1852

massive masonry, topping it with an awesome skyline of battle-
ments and conical roofs (220) outdoing any English super-castle,
and designing sumptuous feudal interiors (221) – unfinished
when the nastily modern militarism of the Franco-Prussian War
(1870–1) swept away the Second Empire. For the Marquis Lodois
de Mauresin, he restored the fourteenth-century Château Neuf at
Roquetaillade, Bordeaux (from 1865), rebuilding the exterior and
creating a suite of richly gothic rooms with a great hall, planned
but never completed, as the centrepiece. More compelling than

Romanticism's scenic evocations, these restorations have all the substance that comes from Viollet's adherence to gothic 'reality' – structural, functional and material. At Carcassonne and Pierrefonds particularly, we not only see, but walk in and through a lost world refound. Or, given Second Empire theatricality, restaged. For there is something in their very consistency unnervingly like a flawless illusion. They have the same quality of perfected fantasy as Burges's work at Cardiff Castle.

Yet while he was acting the consummate impresario to the fantasies of a foolish emperor, Viollet was also engaged on his fullest theoretical exposition, the *Entretiens sur l'architecture* (*Treatises on Architecture*; 1863, 1872), its second volume setting out the bases of architectural design – Viollet's True Principles. A building is the product of a consistently rational procedure: beginning with a functionally conceived plan, the architect devises the structure that will serve it most efficiently, designs external elevations to articulate that structure, in materials whose innate and expressed qualities most suit the constructional requirements. Architects should adopt industrially produced materials, particularly iron, wherever appropriate – Viollet provided some famous and ungainly designs showing what a new iron architecture might look like. Apart from suggesting design analogies with the organism or, alternatively, the machine, Viollet's text is unconcerned with architecture's cultural meaning. Of the literary tradition that shaped so much of the British Revival, there is no trace; of the historical vocabularies of style, scarcely a vestige. What remains of gothic is Viollet's version of its principles – cogent, logical, cleansed of history's clutter. Even as his restorations, wholly enmeshed in historical and cultural semantics, were turning dreams of the Middle Ages into architectural realities, Viollet's theory proposed buildings that signify only themselves, that demonstrate their own conceptual and structural rationality, indifferent to other meanings.

When the Empire collapsed, Viollet nearly lost more than his imperial patron: as a court insider he was sentenced to death by

220 Overleaf Eugène-Emmanuel Viollet-le-Duc, Design for the château of Pierrefonds (detail), 1858. Watercolour on paper; 52 × 65·1 cm, 20½ × 25⅝ in. Centre de Recherches des Monuments Historiques, Paris

221
**Eugène-
Emmanuel
Viollet-le-Duc,**
Salle des Preux,
Château of
Pierrefonds,
Compiègne,
1862–70

the Paris Commune in 1871 and fled the city. The architectural
programme of the second volume of the *Entretiens*, written in
the following year, is a theoretical re-enactment: Viollet and
architecture quit the messy, dangerous realm of politics and
history – personal as well as national – for one in which buildings
are safely self-referential. A theory that abandons history, and
a restoration practice that recreates it, are not contradictions
but corollaries: once Viollet determined there would be no devel-
opment of gothic itself, the Revival could only produce ever more
complete replications of medieval buildings, and architecture
only develop by abandoning gothic. The latter is, in fact, what
happened: the *Entretiens* became a founding text of architectural
Modernism – rationalist, functionalist, anti-historicist. As for
meaning, among Viollet's famous heirs, Frank Lloyd Wright
(1869–1959) in America took over the metaphor of the organism,
Le Corbusier (1887–1965) in Europe that of the machine. Although
both owed a conceptual debt to Viollet, his logical passion for
gothic had theorized and abstracted it out of existence.

In addition to Lille, another mid-1850s European competition was won, and eventually lost, by High Victorian gothic. In 1854, George Gilbert Scott scooped first prize for the Hamburg Rathaus, the town hall, his design melding northern European medieval precedents, particularly the Ypres (Ieper) Wool Hall, with Italianate polychromy in a bold High Victorian synthesis. It was never built, seen off by a press campaign in which anti-gothic academicism connived with anti-English nationalism. Reichensperger had lobbied hard for Scott, urging the appropriateness of his vigorous, eclectic gothic for public purposes and an urban setting. He felt differently about churches, however. An invited judge at Lille, what Reichensperger saw from Burges and Street alarmed him. That it was powerful he could not deny, but was it proper? Having fought for the gothic principles he learned from Pugin and the 1840s Camdenians, he was not going to throw away the rule-book. Especially as the German Revival now actually *had* one, his own *Fingerzeige auf dem Gebiete der kirchlichen Kunst (Hints in the Field of Ecclesiastical Art;* 1854). After Reichensperger's earlier theoretical writings, the *Fingerzeige* pronounced on the specifics of church design. His prescriptions were as firm as they were conservative: thirteenth-century style, a western tower, a distinct apse at the east end, stone vaulting throughout. Despite what was happening in Britain, 'development' is ignored. Though Viollet's influence was strong here, there were also specifically German considerations. In the cosmopolitan, assimilative impetus of gothic 'development', Reichensperger saw a correlative to creeping Prussian annexation, threatening the regional autonomy which for him was the creative and political breath of the Gothic Revival itself.

Rather to Reichensperger's surprise, the *Fingerzeige* was an architectural best-seller, followed for new churches throughout Catholic Germany. Ironically, a movement ambitious for local independence from centralized authority had created an orthodoxy. One, moreover, whose rules could be tightened. Reichensperger shared with other scholars a growing conviction that medieval masons had designed churches, from plan to

pinnacles, according to a set of mathematical ratios. Here, for medievalists, was a riposte to the Vitruvian canon's lingering authority; for architects, the proportions of new gothic churches looked likely to be fixed as inescapably as every other aspect of their design. Even so, the *Fingerzeige*'s orthodoxy was accepted as a necessary discipline. The resultant churches are serious, dignified, with all the virtues of good building: but against High Victorian gothic they lack individuality, and discipline sometimes declines into mere dullness. This is not true of Vincenz Statz at his best, as he is in Linz Cathedral, Austria (from 1857), his greatest work. Linz is orthodox late thirteenth-century, down to the final cusp, but Statz thrives within – indeed, because of – such stylistic constraint: rising from its ground plan with elegant clarity, the tall, cruciform body of the building is wonderfully poised between the western steeple and the chapels clustering busily round the east end.

Reichensperger and the Cologne *Bauhütte*, where Statz worked, were the prevailing influences at Linz and throughout the rather piecemeal Gothic Revival in Austria. The Austrian Empire, a polyglot assemblage of nationalities and cultures sprawling as far as the Black Sea, had nearly been shaken apart by the 1848 revolutions and was only pulled back together by autocratic repression. Reichensperger wanted Catholic Austria as a counterweight to Protestant Prussia in a pan-German unification, and – as ever – linked his political aspirations to an extension of the Gothic Revival. Austrian interest in gothic, at least as a decorative mode, is evident from the gargantuan bookcase Emperor Franz Josef (r.1848–1916) sent to London for the 1851 Great Exhibition (222). But the first major church of the Revival in Austria, Vienna's Votivkirche (1854–79), at once reveals the hand of Reichensperger. Built as a thanks-offering for the Emperor's escape from a particularly doughty assassination attempt, it was designed by the local architect Heinrich von Ferstel (1828–83) with paired western spires and general composition modelled after Cologne. In the preceding competition, prizes had gone both to Statz and to another Cologne graduate, Friedrich von Schmidt (1825–91), who was appointed to the Vienna Academy in 1859, a solitary goth

222
Bernado de
Bernardis
and Josef
Kranner,
Bookcase,
1850.
Oak;
463 × 579 cm,
15 ft 2½ in
× 19 ft,
Victoria
and Albert
Museum,
London

223
Friedrich
von
Schmidt,
Rathaus,
Vienna,
1869–83

Pl. 24.

amid the professors of Habsburg Baroque and High Renaissance classicism. The number of his gothic works in the imperial capital steadily mounted, including the thirteenth-century style Gymnasium Aula (1863–4) and a crop of churches, among them Maria vom Siege (1868–75), thirteenth-century in detail, but domed, octagonal and otherwise Baroque.

Gothic's Viennese progress reached its climax with Schmidt's design for the city's new Rathaus (1869–83; 223). Its eclecticism – northern Italian in the centre, a bit French to the sides, German for the interiors – suggests a High Victorian descent, but the knowing synthesis hints at sophisticated pastiche, and gracefully eschews any earnest striving after vigorous effects. Although the Vienna Rathaus was a triumph, the Austrian Revival remained largely an affair of individual buildings, striking few deeper roots in the national culture. And it never had the political importance Reichensperger hoped gothic might hold for German unification: Austria was excluded from that, humiliatingly defeated by Prussia in the Seven Weeks' War of 1866.

Ironically, the Rhineland's gothic lead was taken up more widely in Protestant northern Germany than in Catholic Austria. The key figure was the architect Georg Gottlob Ungewitter (1820–64), settled in Kassel, the capital of Hesse. After publishing practical illustrations of medieval brick and stone construction, he became closely associated with Reichensperger, collaborating with him and Statz on the *Gothisches Musterbuch* (1856), a digest of details and decorations that became a standard for the German Revival. Ungewitter encouraged the Revival's extension into domestic architecture, always a problem for Reichensperger's ecclesiastically based campaign. In his *Entwürfe zu Stadt- und Landhaüsen (Sketches of Town and Country Houses*; 1858) Ungewitter devised a series of quite fantastic imaginary houses, assembled from medieval sources but bizarrely proportioned and extreme in their asymmetry (224): High Victorian goths would have recognized them as having 'go'. Sadly, none was ever built, but their refreshing liberty encouraged domestic adventure elsewhere. In

224
Georg
Gottlob
Ungewitter,
Imaginary
house, from
*Entwürfe zu
Stadt- und
Landhaüsen,*
1858

Hanover, particularly, Conrad Wilhelm Hase (1818–1902), yet another Reichensperger fan, sparked a revival of secular gothic with his own Hase Haus (1859–61), its brick construction and decoration derived from local medieval architecture, its layout highly – though functionally – asymmetrical. It is the first building of the Hanover School, a whole group of architects linked to Hase, some from Ungewitter's office, who worked in a similar brick gothic vernacular over the next thirty years. Their output further parallels High Victorian gothic in England, where small houses – often parsonages – by Butterfield, Street and White were reviving vernacular building traditions, frequently in brick, and were characterized by asymmetry, feel for materials and structural expressiveness.

In the event, the domestic Gothic Revival Ungewitter helped initiate was always limited; more extensive was his impact on the ecclesiastical Revival. Ungewitter was a Lutheran, and carried the principles of the *Fingerzeige* into Protestant church design, his High Victorian talent for piquant composition and quirky detailing turning orthodoxy into a distinctive personal manner. At Neustadt, Hesse (1856–61), for instance, a robustly straightforward design is pepped up by overscaled windows, beefy buttresses and plate tracery. Ungewitter's early death from tuberculosis was the greatest individual loss to the Revival in Germany. Even so, the success of his designs greatly influenced the Lutheran Church: its church-building regulations of 1861, the Eisenach *Regulativ*, incorporated all the main prescriptions of the *Fingerzeige*. Less than twenty years after the founding of the Cologne Cathedral *Bauhütte*, thirteenth-century gothic had become the official architecture of German Protestantism. It was a remarkable triumph for Reichensperger's Revival, but an ironic one. As north German Protestants laid claim to gothic's religious and nationalist associations, Prussian policy under Bismarck moved into a more aggressive phase. In 1871, at the victorious conclusion of the Franco-Prussian War, all the German states, Catholic and Protestant, willing and less than willing, were united under the imperial crown of Kaiser Wilhelm I (r.1861–88).

Bavaria, with its Romantic castles (see Chapter 7), a product of German gothic unconnected with Reichensperger's Revival, afforded an outlandish parody of Prussian empire-building, and of gothic's long association with the making and unmaking of kings. Succeeding his father Maximilian II, at the age of nineteen, Ludwig II (r.1864–86) believed in absolute monarchy, despite his country's constitution, and in the composer Richard Wagner. From his childhood at Hohenschwangau, Ludwig had steeped himself in medieval legend. Wagner's operas, especially *Lohengrin* (1845), *Tannhäuser* (1848) and the vast brew of Teutonic mysticism and doomed heroics that is the *Ring* cycle (from 1853), came to obsess him. Reality, however, proved intractable. Ludwig's attempt to install Wagner in a purpose-built opera house in Munich ended in a personal and political fiasco. On the larger stage, Bavaria's alliance to Austria in the Seven Weeks' War resulted in military defeat. In 1871, Ludwig had to accede to his country's becoming a subject kingdom of the German Empire. Even before this he began to enclose himself in a private world, not just imagined but built – an alternative reality. Of the three castles through which he gave substance to his dreams, Neuschwanstein (from 1868), Linderhof (from 1870) and Herrenchiemsee (from 1873), only the first is medieval in style: Romanesque but originally designed in gothic. Linderhof is rococo, and Herrenchiemsee nothing less than a recreation of Versailles. Conceived by Ludwig and Christian Jank (1833–88), a brilliant theatrical designer, with Eduard Riedel (who had designed Schloss Berg for Ludwig's father) as the first of several architects, Neuschwanstein is an evocation of Wagner and the heroic age of the Teutonic race.

Neuschwanstein (225) is visually sensational: a massive tower, gabled blocks, turrets and bartizans, all in glistening white masonry set off by copper green roofs, the whole, hallucinatory creation hanging to a crag above the steep wooded valley of the Pöllet. In the interior, never completed, the king's bedroom is gothic, elaborately lacy. Other chambers, panelled and tapestry-hung, are hushed and heavy. The two great rooms,

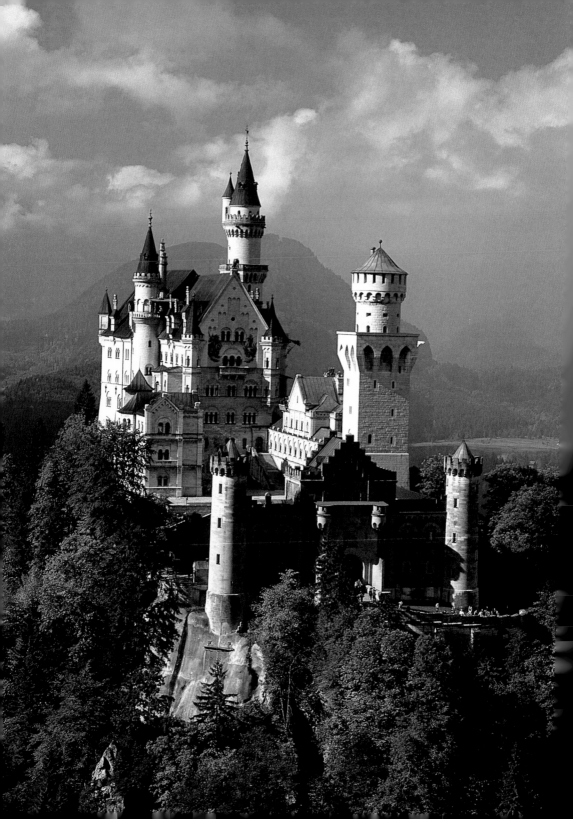

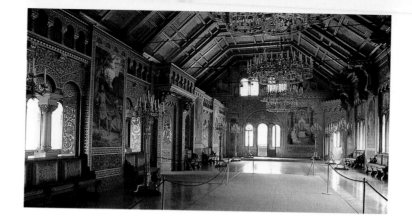

the ideological keys to the castle, are the Sängersaal – the minstrels' hall (226) – and the throne room. The first is based on the Festsaal of the Wartburg, where Wagner set the minstrels' contest in *Tannhäuser*; scenes from the Parsifal legend and inflated Romanesque patterns glow richly, lit by massive golden coronas and candle standards, while beasts crouch dimly in the shadowy roof. Byzantine replaces Romanesque in the throne room, derived – madly enough – from Santa Sophia in Istanbul. Here Ludwig's dream-self could be the semi-divine ruler of Holy Byzantium, as in the Sängersaal he could be the cultural overlord of a mythic Germany. But no minstrels ever sang in the hall, and no monarch ever sat in the throne room. In 1886 a State Commission declared Ludwig insane: he subsequently drowned himself in the Starnbergersee, below the walls of Schloss Berg.

225
Christian
Jank, Eduard
Riedel and
others,
Neuschwan-
stein, Bavaria,
from 1868

226
Christian
Jank, Julius
Hofmann
and others,
The
Sängersaal,
Neuschwan-
stein, Bavaria,
1878–84

Neuschwanstein's promotion of an absolutist cult, backed by a mythology of medieval heroism, was quite different from such precursors as the Löwenburg or Franzenburg, whose builders really were autocrats engaged in exercising political power. Neuschwanstein's medievalism was not merely uncoupled from contemporary reality, but replaced it. In Neuschwanstein the long architectural tradition of the Romantic castle ends in fantasy. It belongs, of course, with Viollet's restoration of Pierrefonds (see 220, 221), which Ludwig knew about, and with Burges's work at Cardiff Castle and Castell Coch (see 206–208). In all of them, to varying degrees, gothic and medievalism turn into anti-history,

for the realities they evoke, the pasts they reinvent, are forever fixed, as removed from historical process as they are from what was going on outside their walls. All are self-contained and self-sustaining: which are characteristics of the new architecture Viollet proposed in the *Entretiens* – to be achieved by repudiating history. Neuschwanstein also shares with the *Entretiens* an indifference to social meaning, for its semantics are addressed to nobody but Ludwig. Ludwig's fantasy of a medieval castle and Viollet's vision of a modern architecture both remove buildings from any socially shared historical context. The one hogs history all to itself, the other casts it off. Both, that is, mark an end to the relationship between architecture and historicism from which the Gothic Revival was made.

Britain, France and Germany all influenced the Dutch and Belgian Revivals. Revived gothic was introduced into Holland, almost single-handedly, by Petrus Cuypers, trained in Belgium and practising from the 1850s in Amsterdam. His early churches in the south of the country are indebted to Viollet, whose ideals of structural logic and expression – though not his repudiation of historicism – stayed with Cuypers throughout his career. They are evident in his first major Amsterdam church, the Posthoornkerk (1860–3); but the brick polychromy and hard linearity are characteristically High Victorian, while the west front, its paired spires rising from gables, quotes medieval sources in the Low Countries and north Germany. The individualistic fusion, though, is very much Cuypers's own, as too the interior, with its double tier of galleries integral to the arcades; it attracted Beresford Hope's admiration, and may have given ideas to Pearson for St Augustine's, Kilburn (see 203). Cuypers's ingenuity in planning and medieval adaptation were aspects of gothic 'development', which he consciously pursued in the search for a nineteenth-century national architecture both historicist and modern. His solution can be seen in Amsterdam's Rijksmuseum (1877–85) and Central Station (1882–9), which are frank in their use of industrially produced material, including iron, and High Victorian in their polychromy and eclecticism,

227
Louis Cloquet and Stéphane Mortier, Central Post Office, Ghent, from 1903

although only partly gothic, since many components derive from a style itself eclectic, that of the Low Countries in the seventeenth century – the great age of Dutch power. It was a manner taken up by others building in the national interest, as it were, such as the series of urban post offices, the largest by C H Peters in Amsterdam (1895–9). Cuypers's quest for 'development' tended to push beyond the Gothic Revival and made his large practice a nursery for the proto-Modernism that emerged with his assistant Hendrikus Petrus Berlage (1856–1934), whose work jettisoned the historical styles – gothic included – that Cuypers had carefully synthesized. The Revival in Holland was not all set on 'development', however. An instructive contrast is the consistently late gothic Krijtberg (1881), Amsterdam; its taut, twin-spired west front soars up from a canal-side site. The architect, Alfred Tepe (1840–1920), was German, taught in Cologne's *Bauhütte* by Statz.

The Belgian Gothic Revival absorbed ideas from its neighbours, stamping them with its own distinctive character. Cuypers built in Brussels, where he designed St Anthony of Padua (1868–72), and the national style he evolved in Amsterdam influenced the similar eclectic manner that arrived in Belgian towns. Here, regional identity often overlaid the general patriotic register, creating street architecture voluble with historicist reference, theatrically quoting features from ancient buildings that often

Gand La Poste.

stand alongside. In East Flanders, the Stadhuis, Sint-Niklaas (1875) by Pieter Van Kerkhove (1847–89) is an early example in bustling gothic. The 'Bruges Style' that Louis Dela Censerie (1838–1908) concocted for that famous town is fruitier – as witness his rebuildings and restorations around the Market Square (from 1887) – while Ghent rivalled such urban showmanship with the Central Post Office (from 1903), by Louis Cloquet (1849–1920) and Stéphane Mortier, confected in frilly gothic and early Renaissance (227). The Post Office had to assert itself, and its paradoxically modern purpose, amid some of the most renowned medieval gothic in Europe. Just down the street, Viollet himself had advised on the fittings of St Bavo's Cathedral (1868), and restored the Stadhuis (1871). Viollet's influence in Belgium was both pervasive and ambiguous. The fantasies of Pierrefonds clearly washed over the château of Faux-les-Tombes, restored by Henri Beyaert in 1872, while Belgian parish churches of the second half of the century frequently show Viollet's impact in their thirteenth-century gothic and somewhat spartan character. But most have an axial western tower derived from regional precedent, and backed by the German Revival. Belgium's brick tradition also relates to Germany, though an open timber roof usually replaced the vaulting that both Reichensperger and Viollet prescribed.

We saw earlier the importance of Belgium's gothic ties with England. Contacts between the two countries strengthened, and High Victorianism's impact is clearer in Belgium than elsewhere in Europe. St Joseph's, Ghent (1874), by the prolific August van Asche (1826–1907) offers a full-blooded account of brick polychromy, its fine mesh of patterns closer to White than to Butterfield or Street. In the south, Eugène Carpentier (1818–86) produced the churches of Beloeil (1863–7) and Antoing (1869–70) in a very English version of Early French. Over in the east, the persistence of High Victorian influences is evident in the chunky, polychromatic churches of Louis Gife at Brasschaat (1888–90), Brecht (1890) and Kelmthout (1894–7), the steeples of the first two placed asymmetrically in the English way. Some buildings also

came direct from English architects, notably the pilgrimage church at Dadizele (from 1859), east of Courtrai (Kortrijk), designed by Edward Welby Pugin (228): stone vaulted and late thirteenth-century, it is nevertheless polychromatically red, black and buff, with an amazing crossing tower that finishes in a zigzag patterned spire containing giant statues. It was shelled to pieces in World War I; the present church is a reconstruction.

Not only astonishing, the Dadizele design is instructive too – certainly High Victorian, but with a decorative intricacy and fidelity to medieval detail characteristic of the younger Pugin, as in Cóbh Cathedral and his fine Manchester churches of All Saints', Barton-on-Irwell (1865–8), and St Francis of Assisi, Gorton (1866–72) – which was actually designed for Belgian monks. Such characteristics relate back to his father and, consequently, to Belgium's whole Revival, for Puginian gothic persisted at its creative core. There were two reasons, closely linked. First, it was strongly identified with Catholicism, which split bitterly from the Liberals over religious education, and hardened its stance following the Year of Revolutions. The second reason was that Jean-Baptiste Bethune (see Chapter 10) was fervently Catholic and devoted to the great Pugin, whose early death left him with the heavy responsibilities of discipleship. He made steady progress, working with Pierre Nicolas Croquison (1806–87) on the Sint-Kruis Church, Bruges (1852–7), and establishing a stained-glass workshop with John Hardman's advice. With E W Pugin, he designed the Kasteel van Loppem, Bruges (1858–9), giving it a distinctive Flemish character. In 1858 he moved to Ghent and expanded into metalwork, woodwork and carving, altarpieces, vestments – largely designing but also making, which even Pugin had not done. Over the next thirty years, Bethune was the great presence at the centre of the Belgian Gothic Revival, and his work the principal artistic expression of the country's Catholicism.

Bethune's output and influence were alike vast, and his gothic remained passionately close to medieval precedents. Though he

shared Viollet's structural concerns, his faith was in Catholicism not logic, and he had a feel for the richness of worship and its accoutrements lost on the atheistical Frenchman. Though he could be vigorous, there are no High Victorian torsions in his work, let alone anything so strident as 'go'. Bethune is at his most characteristic in the Vivenkapelle (1860–7) at Sint-Kruis: a monastic group arranged informally around a cruciform church, with high transepts and an English broach spire over the crossing, the interior covered in stencilled patterns and lavishly furnished. The complex convincingly realizes Pugin's

228
E W Pugin,
*Notre-Dame,
Dadizele*,
1860.
Watercolour
on paper;
122 ×
135·5 cm,
48 × 53 ³⁄₈ in.
Bisdom,
Bruges

229
**Jean-
Baptiste
Bethune,**
*Maredsous
Abbey,
Dinant*, 1880.
Oil on canvas
painting by
an unknown
artist.
Maredsous
Abbey,
Dinant

vision of a Catholic community. Among later buildings, the abbey of Maredsous (from 1872), near Dinant, is his most powerful – and, in its stern geometrical massing, one of his most High Victorian (229). Bethune designed a huge number of church fittings and furnishings, ranging from the simple, elegantly detailed candlesticks in Ghent's Sint-Salvatorskerk (1877), to the figure-packed Passion scenes of the 1864 altarpiece carved by the Blanchaert workshop, and now in Afsnee (230), or the dazzling reliquary of St Lambert (1884–96) in Liège Cathedral (231).

Such works embody the decorative intensity that was central to Belgium's Revival. Institutionalized through the Catholic craft workshops, the Sint-Lucasscholen, it reached beyond ecclesiastical architecture, recapturing the region's cultural richness during the Middle Ages. Figure painting, both murals and panel painting, became a speciality of national medievalism, spreading from churches into secular gothic, particularly civic buildings. Representative examples of an outstanding body of decorative art are provided by the complete scheme in the medieval church of Our Lady at St Trond, carried out from 1857 by Jules Helbig (1821–1906) and Edouard van Marcke (1815–84);

230
Jean-Baptiste Bethune, Reredos, carved by the Blanchaert brothers, 1864. Oak and boxwood partly gilded and polychromed; 93 × 112 cm, 36⅝ × 44 in. Now in the church of St John the Baptist, Afsnee, Belgium

231
Jean-Baptiste Bethune, Reliquary of St Lambert, 1884–96. Silver, gilded copper, enamel, pearls, precious and semi-precious stones; 93 × 200 × 60 cm, 36⅝ × 78¾ × 23⅝ in. Liège Cathedral, Belgium

the portrait sequence in the Gothic Hall of Brussels' Stadhuis, painted by the Braquenié studio (1868–80); and the historical frescos (232) carried out by the de Vriendt brothers in the Bruges Stadhuis (1895–1905).

The Gothic Revival in Belgium did not produce theorists of the international weight of Pugin or Ruskin or Viollet; it did not have the heroic focus given to German gothic by the rebuilding of Cologne; nor did it have the exceptional range of architectural talent the Revival fostered in Britain – but then neither did anywhere else. In Bethune, however, Belgium had somebody who combined the roles of gothic architect and designer, artist

en onze dappere helden binnen quamen te Brugge van Groeninghevelt 24 van hoimaend 1302 · Vlaenderen die Leu·

232
De Vriendt
brothers,
Mural,
Stadhuis,
Bruges,
1895–1905

and craftsman, in a way that not only realized the ideals of a
major strand within European medievalism, but did so at the
very heart of his national culture. For revived gothic in Belgium
was deeply engrained in the country's identity: it crossed the
divisions between French and Flemish traditions, and though
politically aligned it developed a social consciousness that went
beyond the religious battles with the Liberals. It ran far deeper
than in France or Holland or Austria, or even in Germany,
where Reichensperger's great efforts never secured a nationwide
allegiance. Only in Britain – in England particularly – with its
persistent fascination for the Middle Ages, its long history of
reinventing gothic, was the Revival broader and more deeply
set. If Pugin could have surveyed things from the end of the
nineteenth century, however, he may well have recognized in
Belgium more of his own vision of a Christian architecture than
in Britain. Because of Bethune and his position within the arts
of the Church, the Belgian Gothic Revival was the most Puginian,
perhaps the most exquisitely medievalist, of any.

13

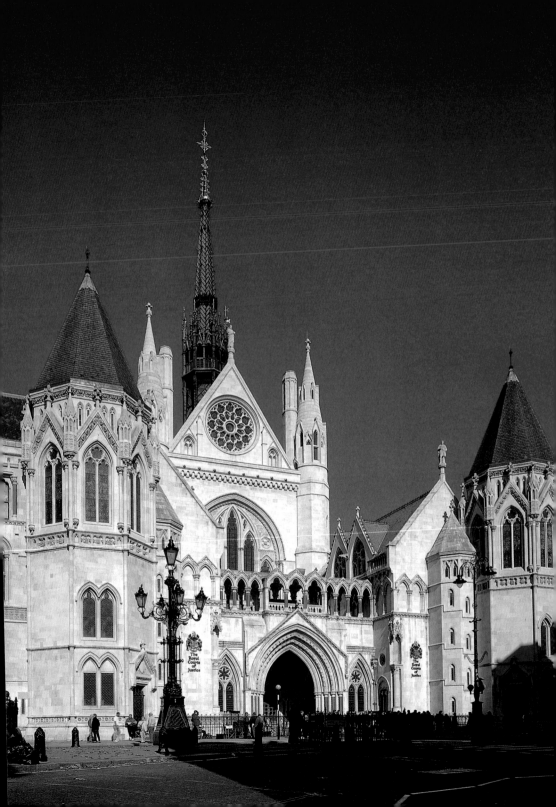

Some of High Victorian gothic's grandest architectural schemes were realized in the early 1880s. Street's London Law Courts (233) opened in 1882. Their thirteenth-century style drew on the whole ideological history in which the constitution, the law and national liberty were gothically interwoven. Architecturally, the freedom of High Victorian gothic allowed Street a maximum of functional and structural expressiveness, the Courts' elevation facing the Strand a bravura exercise in asymmetrical composition designed to be experienced sequentially as the spectator moves along the front, like the unfolding of a great narrative. It was also in 1882 that Alfred Waterhouse completed the Natural History Museum in London – stylistically Romanesque but High Victorian gothic in its bunched muscularity, in the blue and buff terracotta polychromy and, not least, in its inexhaustible decorative celebration of the natural world's variety, from common-or-garden trees to pterodactyls. In 1883 Butterfield finished Keble College, begun in 1867, a High Victorian remaking of Oxford's architectural conventions: modern red brick, banded and chequered in black and white; the quadrangle axes off-centre, its ranges asymmetrical; and a Chapel (1873–6) like no other, dominating the quad (234), the clerestory progressively enriched as it climbs high above the surrounding slate roofs, the single vaulted space of the interior vital with colour (235).

High Victorian gothic had also been advancing in the public architecture of the British Empire, with the peak coming around 1880. Canada's Parliament Buildings, Ottawa (1859–66), by Thomas Fuller (1823–98) and Chilion Jones (1835–1912), are happily cosmopolitan (236) – a German tower, French roofs, Venetian polychromy and fenestration from Ypres' Cloth Hall – the general gothic register citing Barry's Westminster. Similar in spirit is Mountfort's 1865 Council Chamber in the Provincial

233
George
Edmund
Street,
The Law
Courts,
Strand,
London,
1868–82

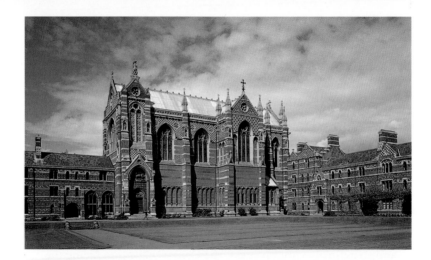

**234–235
William
Butterfield**,
Keble College
Chapel,
Oxford,
1873–6

**236 Opposite
Thomas
Fuller and
Chilion
Jones**,
Canadian
Parliament
Buildings,
Ottawa,
1859–66.
Remodelled
by John A
Pearson
and J Omer
Marchand
in 1916–24
following a fire

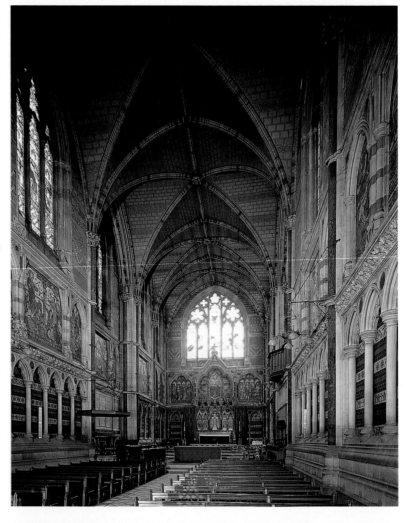

Government Buildings at Christchurch, New Zealand, with its grand arch-braced roof and spanking polychromatic tilework (237). New Zealand got other High Victorian buildings to go with it over the next few years, including the chunkily detailed Supreme Court, Auckland (1865–8) by Edward Rumsey (1824–1909), and Otago University (1878), by Maxwell Bray, who lifted Scott's design for Glasgow University and shrank it.

Unquestionably, however, High Victorian gothic's outstanding imperial creations are in Bombay. A whole set of major buildings stands south of the city centre, mostly ranked along Mayo Road. The Royal Alfred Sailors' Home (1870–6) – now the Council

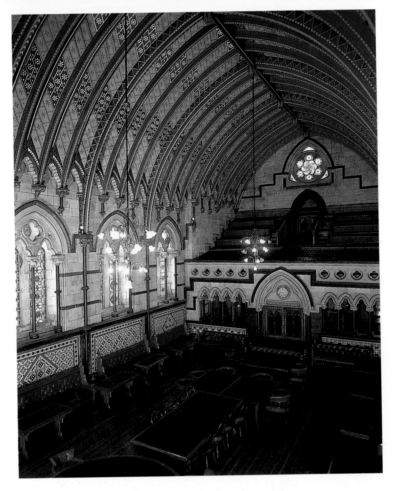

237
Benjamin
Mountfort,
Council
Chamber,
Christchurch,
New
Zealand,
1865

House – was designed by Frederick William Stevens (1848–1900)
in the mix of Indian and gothic elements that is both a character-
istic of his work and a demonstration of how High Victorian
eclecticism could blend with non-European styles. The Public
Works Office (1869–72) and the former Secretariat (1874), both
by Colonel Henry St Clair Wilson, stick to polychromatic
Venetian. Another military engineer, Colonel James Augustus
Fuller, came up with the starker gothic of the enormous High
Court (1871–9). Scott sent out designs for the University of
Bombay group, dextrously shuffling gothic and symbolic
resonances: fourteenth-century Franco-Italian for the Library
(1869–78), fifteenth-century French for the Convocation Hall
(1874), and the early fourteenth-century campanile of Florence

Cathedral, designed by Giotto and much praised by Ruskin, as the model for the Rajabai Tower (1869–78) – topped with figures by the Assistant Engineer Rao Bahadur Mahund Ramchendra. Half a mile north is Stevens's masterpiece, the Victoria Terminus (1878–87) of the Great India Peninsular Railway (238). It is a colossal building, warmly orange-red, enlivened with polychromy and inventive stone carving largely by students from the Bombay School of Art, with an internal decorative ensemble of tilework, stencilled patterns and stained glass. The design as a whole fuses indigenous architectural forms with the gothic of the imperial power in equal aesthetic measure, a stylistic inference – if no more – that East and West might meet on terms other than those of colonized and colonizer. Fittingly, and movingly, the dome over the central tower is crowned by the figure of Progress.

High Victorian gothic had proved itself in every type of building, and its influence had been global – the Empire, Europe, America. Yet to large parts of the architectural press and to a new generation of architects, the great schemes completed around 1880 looked outmoded. By the later 1860s, gothic was already being replaced in domestic architecture by the style christened 'Queen Anne', a seventeenth- and eighteenth-century compound that was a principal expression of a wider English Vernacular Revival. Part of its inspiration came, ironically, from the vernacular gothic used by Street, White and particularly Butterfield, notably in their designs for parsonages. Gothic hung on at first in the Vernacular Revival, notably in the early houses of Philip Webb (1831–1915), most famously the Red House (1859–61), Bexley Heath, London, which he designed for William Morris. After 1865, however, gothic disappeared amid the rubbed red brick and white sash windows of buildings by William Eden Nesfield (1835–88), Richard Norman Shaw (1831–1912) and – in a typically unfilial rebellion – George Gilbert Scott, Jr (1839–97). Queen Anne, and domestic design generally, became the focus for progressive architectural ideas; occasionally, progressive social ideas too. Gothic no longer offered modernity, and churches were no longer the testing ground for innovation. English architecture effectively

reverted to what had always been its main post-medieval concern, the design of the house; in doing so, it turned away from gothic.

Gothic chipped in to the picturesque kitty that made up the domestic style known as Old English, of which Norman Shaw was the master. The contribution could be major, but more often gothic dwindled into compositional odds and ends – a cusped window here, a pointed doorway there. Of longer term importance was the management of daringly asymmetrical massing, derived from gothic practice; as demonstrated, with deceptive insouciance, by Shaw in houses that range from the Wagnerian thunder of Cragside, Northumberland (1869–85) to the suburban winsomeness of The Hallams, Surrey (1894–5). Away from the architectural vanguard, gothic detailing lingered among rows of middle-class houses until the early twentieth century, as did brick polychromy, giving zip to houses in almost any style, or no style in particular. It is all a very long way from Butterfield or the Ruskinian glories of Venice.

Other building-types went down the same stylistic road. Non-denominational London Board Schools, built following William Forster's 1870 Education Act, took up with Queen Anne, its secularism a welcome change to the religious squabbling that had bedevilled educational debate throughout the century. Not everywhere adopted metropolitan ways, however: in Birmingham – perhaps surprisingly given the city's reputation for civic radicalism – the impressive local firm of William Martin (c.1828–1900) and John Henry Chamberlain (1831–83), loyal to Ruskin's ideals of a social gothic, built more than forty Board Schools between 1873 and 1898, all polychromatic, inventively asymmetrical and High Victorian in idiom. They added more Ruskinian gothic to the townscape with cultural institutions such as Birmingham Reference Library (1879) – which a grateful city flattened in the 1960s – the Birmingham and Midland Institute (1881), and local public libraries such as those at Constitution Hill (1883) and Small Heath (1893). In the old universities gothic continued to

238
Frederick
William
Stevens,
Victoria
Terminus,
Bombay,
1878–87.
Detail of
photograph
by Lala Deen
Dayal, c.1890

make a showing even under pressures of liberalization, though there were stylistic innovations. Of Cambridge's first two colleges for women, Girton (1873–87) got Tudor gothic by Waterhouse, while for Newnham (1875–93) Basil Champneys (1842–1935) chose domestic neo-Dutch, which he also used for Oxford's first women's college, Lady Margaret Hall (1881–3). When colleges for training nonconformist clergy arrived at Oxford, however, they were gothic: the Congregationalists at Mansfield College (1887–9), in Decorated and Tudorish Perpendicular by the accommodating Champneys; the Unitarians, next door at Manchester College (1891–3), by the veteran – and here rather pedestrian – architect Thomas Worthington (1826–1909) from Manchester.

For civic architecture, gothic was largely superseded during the 1870s. The Italianate Plymouth Guildhall (1870–4), designed by the local firm of James Hine (1829–1914) and Alfred Norman with metropolitan advice from Edward William Godwin (1833–86), architect of Northampton Town Hall (1860–4), is distinctive and distinguished High Victorian gothic. But even as it was being built, Francis Hames' Leicester Town Hall (1873–5) was going up in chic Queen Anne. While others followed – civic authorities not wishing to be behindhand in stylistic enlightenment – there continued to be exceptions: Bideford's river front in Devon, for example, has a jolly Tudor gothic set of 1905, comprising town hall, library and police station, by the Birmingham architect A J Dunn (c.1870–1957). This was out-of-the-way stuff for a quaint town, though there is much more of it than is generally recognized. In the cities, London particularly, classicism recaptured public architecture, though now in an imperialist Baroque that eerily anticipated the clash of empires in World War I.

Across the whole field of secular architecture, High Victorian gothic, then gothic itself, straggled away. The style that was in full array in 1870 was, by 1890, a remnant; the triumphs of the early 1880s were actually a last stand. Underlying it all were the long-term processes of cultural and intellectual secularization. Precisely because church-building had led gothic's Victorian

crusade, the style's primary semantic identification was religious, and an increasingly secular society wanted styles without a lumber of Christian meaning. Not, of course, that people suddenly stopped going to church or chapel; but religion as a social activity was increasingly compartmentalized, particularly amid the often indifferent working-class populations of the cities.

Within the boundaries of church architecture, gothic still ruled. But High Victorian gothic, the spectacular outgrowth of church-building, did not. At All Saints', Cambridge (1864–70), and St Salvador's, Dundee (1865–8), George Frederick Bodley – earlier as vigorous, French and stripy as anybody – adopted a

239
George
Frederick
Bodley,
Panel
painting,
St John's,
Tue Brook,
Liverpool,
1868–71

historically precise English Decorated, with its unforced structural expressiveness and spatial clarity, rich mouldings, fine geometrical tracery and painted patterning. Bodley took churches back to Englishness, to Pugin and to the historical authority attaching to precedent and stylistic consistency. The implications were clear: the great adventure of High Victorianism had been an aberration from the path indicated not just by Pugin but, more importantly, by English medieval gothic itself. The positive return to the fourteenth century predicated a whole set of negations, apparent at Tue Brook, Liverpool (1868–71), the church where Bodley attained his mature idiom

(239, 240). The conventional church plan and composition were deliberately self-effacing, rejecting High Victorian individualism as ostentatious; the purity of Decorated succeeded to the impurity of gothic mixing; impeccable, unemphatic detailing suggested that High Victorian boldness was merely brash; elegant proportions rebuked muscular striving, while smooth, exquisitely patterned surfaces argued the coarseness of structural colour.

At St Augustine's, Pendlebury, Manchester (1870–4), designed with Thomas Garner (1839–1906), his partner after 1869, Bodley extended his gothic register: derived from the plan of Albi Cathedral, its lofty interior, evenly lit and undivided, achieves a lucidity that is both serene and emotionally reserved. Such coolness typifies even the partnership's richest church, Holy Angels, Hoar Cross, Staffordshire (from 1872): intricate carving in stone and wood, colour and gilding – of which there is much – are all contained by a discipline that seems inevitable and thus effortless (241). The contrast with immediately contemporary churches such as Butterfield's All Saints', Babbacombe or Burges's Studley Royal (see 189 and 205), is extraordinary. The quality commentators always identify in Bodley is refinement, not meaning dainty or soft, but elegant and discriminating. This seems right, but there is also an aloofness, and a fastidiousness at times too careful of its own good taste. An essentially conservative aesthetic strategy, refinement does not go in for adventure or 'development', but perfects what is already there. It matches the larger social and cultural withdrawal of organized religion into its own sphere. Bodley reacted not just against the boisterousness of 'go', but against High Victorian gothic's love of effortful struggle, both with the stuff of architecture and with the stuff of the world. Implicitly, Bodley's aesthetic condemns any such manifestations as vulgar – to be not only avoided but feared. About his later churches, particularly, there is a fatal whiff of gentility.

Bodley set the terms for late Victorian and Edwardian church design, the last phase of the architectural Revival in Britain – gothic's autumn. A scholarly, meticulous aesthetic and a cool

240
George
Frederick
Bodley,
St John's,
Tue Brook,
Liverpool,
1868–71

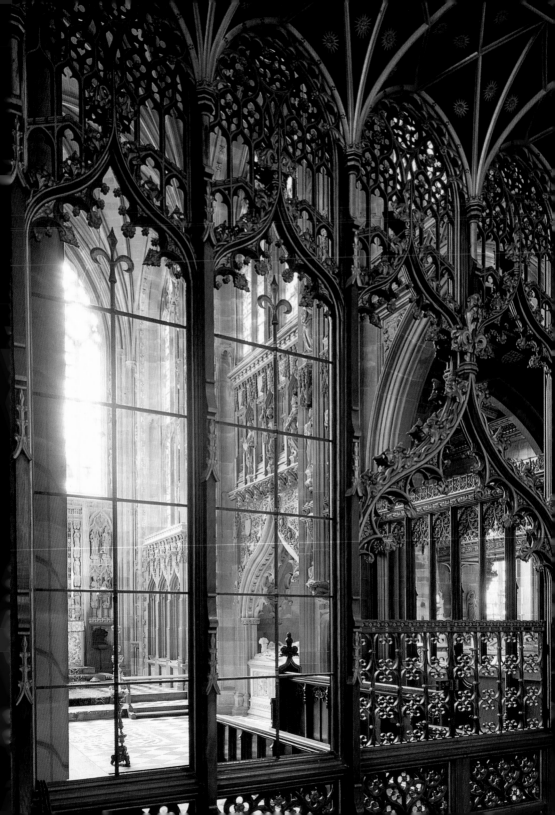

241
George
Frederick
Bodley and
Thomas
Garner,
Chancel
screen,
Holy Angels,
Hoar Cross,
Staffordshire,
from 1872

242
John Ninian
Comper,
Rood
screen,
St Cyprian's,
Clarence
Gate, London,
1902–3

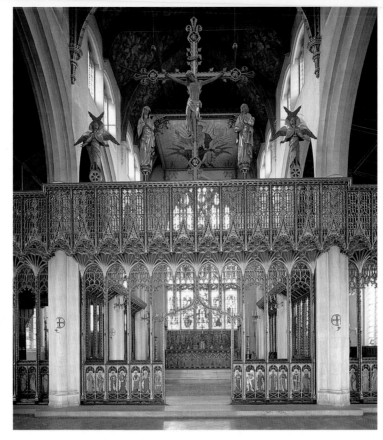

emotional tone characterize many of the period's best churches,
often those associated with the Ritualist revival of English
medieval liturgy. Two of many London examples are St Paul's,
Wimbledon Park (1888–96), by John Thomas Micklethwaite
(1843–1906), whose *Modern Parish Churches* (1874) explicitly
denounced High Victorian 'go' as vulgarity, and St Cyprian's,
Clarence Gate (1902–3), by John Ninian Comper (1864–1960), who
carried late Victorian Anglican design well into the twentieth
century. Their spatial clarity and elegant proportions provided
the setting for richly detailed furnishings, of which St Cyprian's
filigree-traceried screen is among the most exquisite (242).
Elegance extended beyond the direct Bodleyan descent. It
characterizes Pearson's Truro Cathedral (1880–1910), the only
new Anglican cathedral built in England during the nineteenth
century. Its stylistic blend is still High Victorian, its triple spires

very French, but the interior's spatial poise and rather remote perfection belong to late Victorianism. By contrast, Butterfield's near contemporary cathedral in Melbourne, Australia (1877–91), is all stripes and effort.

Increasingly, Bodley's disciples revived Perpendicular, the phase of medieval English gothic that had succeeded Decorated and had been regarded as debased ever since Pugin and the ecclesiologists. Perpendicular was more about linear elegance than structural mass, and its spacious interiors, tall arcades and large windows suited congregational worship and elaborate liturgical fittings. In late Victorian and Edwardian churches, Perpendicular became the stylistic base, sometimes to splendid effect; an outstanding example is St George's, Stockport (1892–7), by Hubert James Austin (1841–1915), of the talented Lancaster firm of Paley and Austin. Once such an article of faith as Decorated had been abandoned, however, almost anything could follow. By the late 1880s stylistic rectitude had been so far relaxed that Perpendicular turned into what is often known as Free Gothic – a mannered improvisation upon a whole range of late medieval features. Window tracery writhed into strange new patterns, arcade columns lost their capitals, weatherings on walls and buttresses became scoop-shaped. Free Gothic got one of its most accomplished treatments at Holy Trinity, Chelsea (1888–90), by John Dando Sedding (1838–91), and became the usual stylistic manner of highly successful church designers such as George Fellowes Prynne (1853–1927), particularly inventive at St Peter's, Staines (1893–4), and William Douglas Caröe (1857–1938), at his quirky best in St David's, Exeter (1896–9).

As well as internal stylistic variations, ecclesiastical gothic was affected by developments in secular architecture. The Vernacular Revival prompted some of the most attractive late Victorian churches, often by non-London architects such as Chester's John Douglas (1830–1911), whose work included delightful departures into timber framing, as at Hopwas, Staffordshire (1881; 243); or Robert Medley Fulford (1845–1910) of Exeter (244), or Charles

243
John
Douglas,
St Chad's,
Hopwas,
Staffordshire,
1881

244
Robert
Medley
Fulford,
St Peter's,
Washford
Pyne, Devon,
1882–4

Edwin Ponting (1850–1932) of Marlborough. The Arts and Crafts Movement particularly influenced fittings, though its inclination away from historical styles often meant these were not gothic at all. Sedding's Holy Trinity, Chelsea, contains an exemplary Arts and Crafts ensemble, filling the interior rather like exhibits in a design museum. For Arts and Crafts gothic, the little church at Bothenhampton, Dorset (1884–9), and the big one at Roker, Sunderland (1906–7), both by one of the movement's vanguard, Edward Prior (1852–1932), are exceptional, their bold internal structure and rough, expressive masonry recapitulating values the Vernacular Revival picked up from High Victorianism. More miscellaneous aids to inventiveness came from the essentially decorative manner of Art Nouveau, especially in the curvaceous tracery favoured by Free Gothic.

Much of the late Revival's creative ingenuity was purely formal, and it had no impact on architecture other than churches. Some of the period's most memorable architects derived their distinctiveness from sources outside the mainstream, and even outside gothic altogether. John Francis Bentley (1839–1902), always a goth, adopted Byzantine for the climactic work of his career, the Roman Catholic Cathedral of Westminster (1895–1903). Leonard Stokes (1858–1925), in All Saints' Convent, London Colney, Hertfordshire (1899–1903), was influenced by classical and Renaissance design as well as gothic. Temple Moore (1856–1920), like Viollet and the High Victorians, was inspired by the austere power of early gothic structure for his big-boned Yorkshire churches, such as St Wilfrid's, Harrogate (1904–8). Moore's pupil, Giles Gilbert Scott (1880–1960), son of G G Scott, Jr, designed the greatest building of Edwardian gothic, Liverpool Cathedral (245), begun in 1904 and not completed until the 1980s. It has much that derives from late Victorianism, Free Gothic and Arts and Crafts; but for its almost overwhelming monumentality, its cavernous spaces, we must go back to the aesthetic of the Sublime.

245
Giles
Gilbert
Scott,
Liverpool
Anglican
Cathedral,
from 1904

Late Victorian gothic's undoubted inventiveness was inward-looking. Not because architects or patrons were careless of the

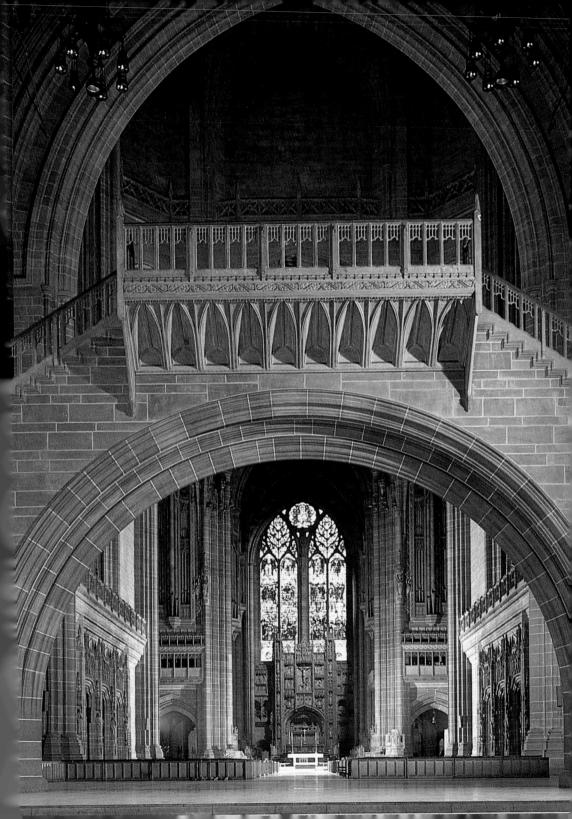

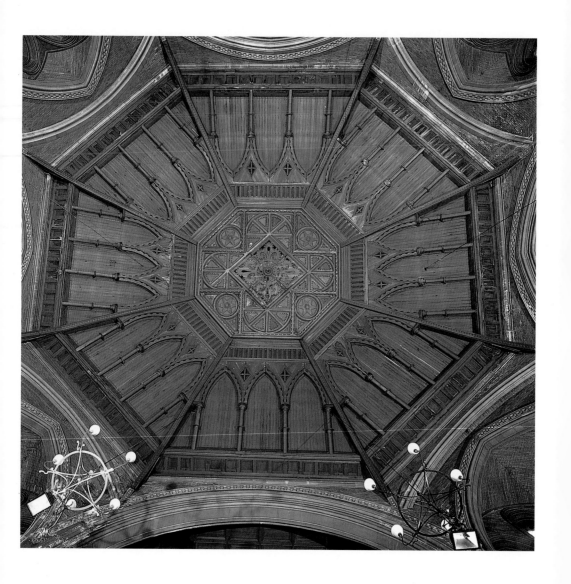

wider mission to which Pugin and Ruskin had directed the style, but because gothic's identification with organized religion steadily distanced it from the shaping forces of an increasingly secular society. When the architects of the newly established London County Council set out in the early 1890s to tackle crying social needs such as housing, they did not use gothic. In such a context, the refinement of the churches erected by Bodley and his successors has the look of defensiveness. High Victorian gothic's more robust values, vulgar or not, survived in nonconformist church architecture, outside Anglicanism's code of artistic conduct. James Cubitt's Union Chapel, Islington (1886–9; 246), a great gothic octagon with a powerfully composed tower, or some of the buildings of John Salman (1849–1934), for example the massively grouped Congregational church and schools erected not far away in London's Highbury Quadrant (1880–2), are unabashedly muscular. But by the early 1900s, nonconformity – never exclusively committed to gothic anyway – was turning to non-gothic styles. When Lanchester and Rickards designed the Wesleyan Central Hall (1905–11), on an ideologically loaded site opposite Westminster Abbey, they chose heavyweight Baroque.

246
James
Cubitt,
Union Chapel,
Islington,
London,
1886–9

The Gothic Revival was coming under more direct attack too. In 1877, when George Gilbert Scott's plans for restoring Tewkesbury Abbey were announced, William Morris launched a frontal assault on all restorations – 'those acts of barbarism', to quote his letter to *The Times*. His terms, and those of the Society for the Protection of Ancient Buildings that he founded, were the same as Ruskin's in *Seven Lamps* some thirty years before: to restore an old building was to destroy it. Instead of conjectural recreations, and gothic of the 'best' period, all ancient fabric should be preserved, its very texture cherished, and if repairs were needed they should not mimic old work. The Society's True Principles – supported, among others, by architects of the Bodley descent such as Micklethwaite and the younger Scott – were already changing architectural attitudes by the turn of the century. Now, of course, they are basic to modern conservation practice.

Restoring medieval buildings had gone hand in hand with new gothic design since the eighteenth century. Outlawing restoration not only denied Victorian gothic one of its sources, but in large measure rejected the Revival's creative validity. Further, the absolute value given to historic fabric, and thus to preservation, inevitably set the past apart, scored a line between now and then. It severed the complex continuities that the Revival had woven between past and present, medieval and modern. This was certainly part of Morris's intention. Ruskin's disciple, he read in medieval art and architecture the signs of a unified society whose members were creatively free. By contrast, the nineteenth-century Revival depended upon capitalist methods and relations of production, the system that had enslaved Britain's industrial workforce. To believe Ruskin and, more urgently, to believe what he was by now reading in Marx, Morris had to divorce the medieval gothic he loved from the modern gothic whose capitalist basis he loathed. Preserving the past, fixing it as the unalterable evidence of a once happier human state, was the spur to revolutionizing the present. Essentially, Morris confronted the Gothic Revival with its own contradictions; the past really *had* been uncoupled from the present, the medieval from the modern, and the agency that had brought it about was capitalism.

Morris's thinking on restoration informed his championship of the Arts and Crafts Movement. Emerging in the 1870s, loosely organized subsequently around guilds and annual exhibitions, the Movement had parallels with the *Bauhütte* ideal (see Chapter 10). It particularly opposed what was seen as the dominance of standardized production in contemporary architecture and applied arts. Great Gothic Revival practices such as Scott's, and the various firms of ecclesiastical furnishers and decorators were particular targets – an honourable exception being made of Morris's company, though it operated in ways very similar to all the others. Co-operative enterprises were favoured as a means of re-establishing (restoring?) the lost creative community – that dream ironically so dear to the Revival itself. Socialistically inclined, Arts and Crafts practice scrapped the Division of

Labour on which capitalist production relied, and made design inseparable from handicraft. In obedience to 'The Nature of Gothic', the work of the hand was to be a direct, unique expression of the imagination of the individual worker. Copying the things of the past, even adopting an historical style, was tantamount to sustaining slavery. The Gothic Revival, of course, had spent its whole disreputable life copying the medieval past and building in its style. To Morris's frustration, however, the typical 'worker' liberated by Arts and Crafts was middle-class and amateur. Proletarian craftsmen had neither the economic security nor the leisure to work for uncertain wages, no matter how high-minded the goal.

Culturally and ideologically, the Revival's strength was being sapped; also economically. The long agricultural depression that began in the mid-1870s eroded the power of landowners, first the local squirearchy, eventually the magnates. Around 1910 the break-up of the great estates began, and by the 1920s more land had changed hands in Britain than at any time since the Dissolution of the Monasteries. From the seventeenth century, of course, medievalism, gothic and landowning had been bound together ideologically; gentry and aristocracy had contributed heavily to the Anglican church-building that led the Victorian Revival – and eventually came largely to comprise it. The eclipse of the landed interest crucially affected not only the Revival's political and cultural standing but also its economic base. Over the same period, British industry began to suffer from increasing foreign competition; to contemporaries, the Workshop of the World seemed to hum less effectively than before. A long-term shift began from industrial capitalism into finance capitalism as the engine of the economy. Commentators have often pointed out unease, a kind of queasiness, behind the imperial self-confidence of dominant culture in the late Victorian and Edwardian decades. The introspection and defensiveness of the period's Anglican churches are analogous. In many ways, High Victorian gothic expressed the intense productive effort of nineteenth-century industry. The style made human labour, the

struggle against intractable materials, manifest; and, whatever Ruskin or Morris may have said, High Victorian gothic made it heroic. The apparent faltering of that effort in the late nineteenth-century economy, the uncertainty edging into the industrial enterprise, reflects in the aesthetics of the late Revival.

In 1881 Henry Vaughan (1846–1917), a pupil of Bodley's, settled in Boston, where he designed the Chapel of the Sisters of St Margaret (1881–2), and specialized in Oxbridge-type chapels for major schools. Vaughan's collegiate gothic overlaid and eventually ousted the Ruskinian manner Americans had adopted for cultural and educational institutions. High Victorianism survives into the 1890s with the buildings Henry Ives Cobb (1859–1931) designed for the University of Chicago – particularly the robust and hard-edged Anatomy Building (1897). However, Cobb's replacement in 1901 by Charles Coolidge (1858–1936) of the Boston firm Shepley, Rutan and Coolidge, introduced a Vaughan-like Oxbridge Perpendicular for Hutchinson Commons and Mitchell Tower (1903) – deliberately evocative of Magdalen College, Oxford – and for later buildings such as the Harper Memorial Library (1912). The stylistic trajectory of women's colleges, provided far in advance of what was happening in Britain, was rather different. Although the neoclassicism of Napoleon III's Paris, knowingly cosmopolitan, was preferred initially – as at Vassar (1861–5) – a desire to be seen as equal to men's colleges, architecturally as well as educationally, dictated the adoption of Ruskinian gothic in the first buildings for Smith College (1875) by the Boston partnership of Robert S Peabody (1845–1917) and John G Stearns (1843–1917). With growing confidence, however, came a determination to give women's higher education a distinct architectural identity. As in English women's colleges, style started to shift into late and post-medieval periods. This is particularly clear in the development of Bryn Mawr under the presidency of Minnie Carey Thomas, who employed the firm of Cope and Stewardson to design the Denbigh, Pembroke and Rockefeller Halls in the 1890s, all in a relatively informal mix of Jacobean and Tudor gothic. Even so,

aspirational gothic hung on: when Wellesley rebuilt following a fire in 1915 the central feature was a mighty tower designed by Coolidge, who had introduced Vaughan's gothic to Chicago.

In American church building some of the characteristics of High Victorian gothic passed into the hybrid of Romanesque and Byzantine that was the personal style of Henry Hobson Richardson (1838–86), most famously in Trinity Church, Boston (1872–7). 'Richardsonian Romanesque' enjoyed a relatively brief popularity, cut short by its originator's early death. What replaced it came, once again, from England, and through the influence of Henry Vaughan. In the late 1880s he worked with Ralph Adams Cram (1863–1942), whom he initiated into the Bodleyan aesthetic. Cram was Anglo-Catholic, a passionate medievalist, with a Puginian faith in the inseparability of architecture and religion, and a Ruskinian belief that gothic was the art of the people. His books, particularly *Church Building* (1899) and *The Gothic Quest* (1907), are an epilogue to the Revival's great literary tradition. In 1891 Cram went into partnership with Bertram Grosvenor Goodhue (1869–1924), a specialist in gothic decoration and fittings. Their first church, Ashmont, Boston (1891–2), announced the basics from which their whole, prodigious output would grow. The robust west tower and a certain stubbiness in the proportions suggest a lingering High Victorianism. But the impact of late Victorian gothic is unmistakable: correct Perpendicular details, a tall clerestory above passage aisles, columns without capitals, the interior space lucidly balanced.

Cram and Goodhue's gothic achieved maturity and national celebrity in 1902, when they won the competition for designing West Point Military Academy. The chapel (1902–10), is a highly successful restatement of late Victorian gothic themes (247) – the nave derived from Albi and Pendlebury, rib-vaulting, segmental arches into the aisles, freely varied Perpendicular tracery. The exterior is monumentally managed, its profile as close-cropped as a West Point cadet. Cram and Goodhue reworked the chapel's format for several of the impressive churches they designed in the

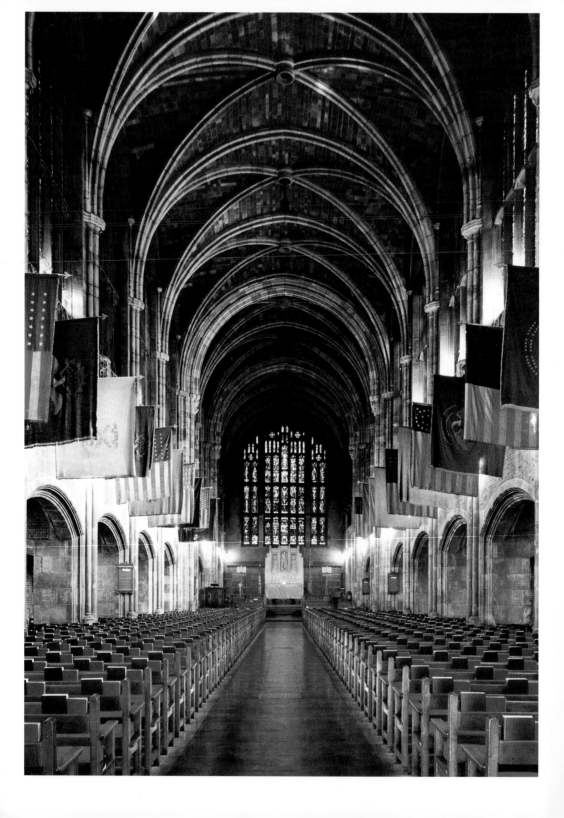

years before World War I, among them the Dutch Reform South Church, New York, and the First Baptist Church, Pittsburgh, both in an expansive Perpendicular, and St Thomas's, New York (1906–13), largely Goodhue's work and influenced by late medieval French gothic. Meanwhile, in 1906–7, Bodley himself, partnering Vaughan, designed Washington Cathedral (248), conceived as a National Monument to go with the others in the capital. Vast, vaulted, flying buttressed, it is nevertheless correct English Decorated, and very English in plan. Not to be outdone, New York called in Cram to recast the eclectic design with which the building of St John's Cathedral had started in 1893. Cram's immense scheme (1911) was largely French; with a crossing tower, two western towers and two further steeples rocketing somewhere in between, it was also more than a little mad. The vertiginous nave has actually been built, to go along with a group of earlier chapels. Between the 1890s and 1920, all the major American denominations were involved in a building programme extensively based on late Victorian and Edwardian gothic. Some of what resulted was mechanical, but the overall achievement was remarkable: the world's last great wave of gothic church-building. Fittingly so, for it marked America's coming together as a nation and emergence as a global power – one that

247
Ralph Adams Cram and Bertram Grosvenor Goodhue, Chapel, West Point Military Academy, New York, 1902–10

248
George Frederick Bodley and Henry Vaughan, Washington Cathedral, Washington, DC, from 1907

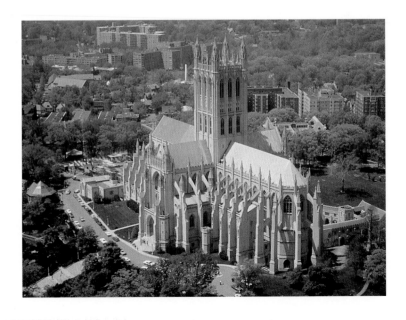

would lead the way into an age that had little to do with the medievalism invoked by all those churches.

Late Victorian gothic found no other takers outside the British Empire. Within it there were more churches and cathedrals to be built. Colonial architects, by now in established practices, adopted and adapted styles from home: Herbert Baker (1862–1946), better known as a classicist, settled in South Africa in 1892, designing Cape Town Cathedral (from 1901) in Early French leavened with English Decorated. Where the European talent thought necessary was not locally available, British-based architects were commissioned: Temple Moore did an Early English number, with thick walls and tiny windows against the heat, for Nairobi Cathedral, Kenya (1914–17).

In the Austrian Empire, however, indigenous folk had their own gothic traditions. As the imperial throne was forced to grant greater autonomy to the Empire's different nationalities, restoring medieval buildings and building new gothic to match became ways of asserting independent cultural identities – especially against the Neoclassical and Baroque styles Vienna favoured. The nature of the Revivals that resulted has only started to become apparent to those in the West since the break-up of the Soviet bloc. Many of the architects involved were trained by Friedrich von Schmidt (see Chapter 12). From the 1850s, Czech nationalists supported the restoration of St Vitus' Cathedral, Prague, where Josef Kranner (1801–71) and Schmidt's pupil Josef Mocker (1835–99) ran a building lodge on the lines of Cologne. Similarly in Hungary, granted self-determination in 1867, Budapest became a focus for gothic building in the cause of national identity. The Revival there was led by Imre Steindl (1839–1902), Frigyes Schulek (1841–1919) and Ferenc Schulz, all three trained by Schmidt, the action opening with Schulek's restoration of the great church of Saint Mathias, and culminating with Steindl's Hungarian Parliament Buildings (1883–1904), stretched along the Danube (249). They form a magical group, the polygonal dome of the central block and the corner spires of

249
Imre
Steindl,
Parliament
Buildings,
Budapest,
Hungary,
1883–1904

the legislative chambers rising behind an endlessly arcaded
frontage onto the river. The reference to Barry's Westminster
is potent, and Steindl's plan, with a main spine linking and
balancing the two houses across a central point, quotes from
his. Here is nothing less than the gothic of constitutional liberty,
in the national capital beside the national river.

In Germany, where gothic had for so long spoken about being a
nation, the completion of Cologne Cathedral (250) in 1880 virtu-
ally marked the end of the Revival. With Bismarck engaged in a
'culture-war' against Catholics, Reichensperger refused to attend

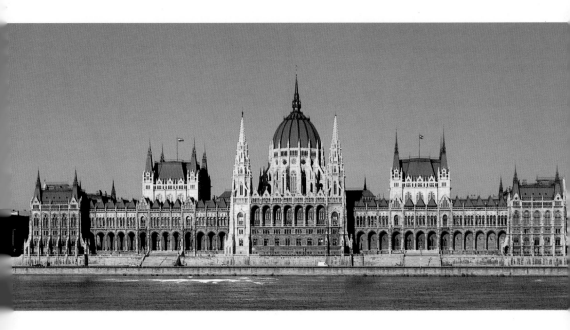

the consecration ceremony. Having found gothic useful at various
points on the way to unification, the German Empire under
Prussia adopted a different architectural rhetoric: Beaux-Arts
classicism, done with an imperial Roman swagger. In the after-
math of the Franco-Prussian War, the French Gothic Revival
seems simply to have ceased, though the restoration programme
of the Commission des Monuments Historiques kept going as a
settled part of the architectural establishment. Viollet spent his
last few years after the *Entretiens* engaged in the politics of the
new Republic, and in writing educational books about building.

WESTANSICHT Der DOM zu KOELN OSTANSICHT

Gothic churches continued to be built, and in England architects
such as Ninian Comper and Charles Nicholson (1867–1949)
kept the tradition going – often with interesting results – into
the 1930s and beyond. But as an architectural force, its ideas
resonating in the larger culture, the Gothic Revival was over.
Proto-modernist buildings had already gone up in Europe; more
avant-garde groups were trying to push things further, faster.
Most importantly, in America the skyscraper had arrived –
product of steel frame construction, the elevator and expensive
real estate. Its advocates, and proponents of Modernist architec-
ture generally, have claimed support from gothic theorists back
to Pugin, but most of all from Viollet's rationalist approach to
plan and structure. Citing Pugin for such purposes is at best
special pleading, for it ignores the religious semantic integral
to all his theory. The Viollet of the 1872 *Entretiens*, however, is a
much better candidate: the technological emphasis of his theory
obviously fits, but so also, crucially, does the complementary
indifference to the cultural meanings of historical style. Such

250
*Cologne
Cathedral,
as completed
1880, with
reminiscences
of its aspect
at previous
periods.*
Engraving in
the *Builder*,
October,
1880

indifference was sufficiently alarming for early skyscraper archi-
tects, or their clients, to deck the buildings with details pulled out
of historicism's general style-bag. But the logic of the skyscraper
– as Viollet might have argued – is precisely towards abandoning
such inherited meanings, because the building-type is the unique
product of a new technology. But also, because the skyscraper
is the iconic building of the new city and its new masters, the
great companies and corporations that run capitalism. The
point is made succinctly, and with wonderful irony, by New York's
Woolworth Building (1910–13; 251–253), designed by Cass Gilbert
(1858–1934), the upper floors pinnacled and the windows hooded
with terracotta gothic canopies because Woolworth wanted
detailing that looked like Barry's Houses of Parliament. That
would have provided one sort of meaning. In fact, the Woolworth
Building was quickly labelled 'The Cathedral of Commerce'.
Precisely: the skyscraper is the building-type of commerce,
the architectural icon of modern capitalism, and Woolworth's
gothic embellishments revealed the fact rather than masking it.

The American who first translated the *Entretiens* – the first
volume in 1875, the second in 1881 – was Henry Van Brunt, whom
we met earlier as one of the architects of Harvard's Memorial
Hall (see 216). Back in 1858, in a paper on cast iron read to the
American Institute, he had rejected architectural historicism,
emphasized the present day's 'intense intellectual activity as
regards the arts of utility', and specifically attacked Ruskin's
medievalist notions about the creative freedom of the individual
worker: 'poetic and romantic', but 'of another age'. Rather than
'individualities' in the productive process, Van Brunt looked
forward to a new age made up of 'aggregates', and demanded
'a *representative architecture*' for that age. By 'aggregates' he
meant what the twentieth century has called 'mass society', the
latter day form of the characteristic capitalist structure Tönnies
labelled *Gesellschaft* (see Chapter 5). Van Brunt's enthusiasm
was not unusual. The American writer Edward Bellamy also
anticipated the age of 'aggregates' with pleasure, and knew how
they would be organized and constructively directed. In his very

251–253
**Cass
Gilbert**,
Woolworth
Building,
New York,
1910–13,
photographed
*c.*1913
Above left
Detail of the
exterior
Below left
Detail of the
entrance hall

popular novel *Looking Backward 2000–1887* (1888), he depicted
a future state – supposedly in being as I write these words –
which is industrial and commercial, and in which everything
is administered, and everybody catered for, by the efficient
centralized bureaucracy of the Big Trust, nothing less than
corporate capitalism turned into the organizational principle
of a whole world. The skyscraper, which Van Brunt and others
showed to be a valid product of Viollet's gothic-based theories,
is the definitive architecture of the Big Trust.

In England, William Morris read *Looking Backward* and
detested it. He countered with his own futuristic novel, *News
from Nowhere* (1890), subtitled *A Utopian Romance*. It imagines
England after the revolutionary overthrow of capitalism as a
loose federation of collectives, industry abolished, religion
abandoned, money redundant. An England in which there are
no masters, but everyone is a craftsman or craftswoman
working for the pleasure of work's creativity, and the buildings,
clothes and artefacts, though dependent on no historical style,
are closest in spirit to those of the fourteenth century. It is
Ruskin read through Marx, or perhaps, Marx filtered through
Ruskin. Morris's Nowhere is the visionary gothic world, and it
is pitched against the enemy: against the capitalists and the
architecture of their bright new technologies, against the
abstraction of Viollet's gothic, against the very buildings of the
Gothic Revival. In Nowhere the Gothic Revival consumes itself
in order dramatically to recover gothic as a site of alternativism
and resistance. And Morris knew very well that the gothic
tradition he called upon was not only artistic and architectural
but also intensely political. It was the old gothic history of liberty,
the epic of the ancient gothic folk fighting the imperialism of
their oppressors. In *Commonweal*, the socialist journal he
edited, in the year of *Nowhere*, Morris wrote, 'we shall be
our own Goths, and at whatever cost break up again the new
tyrannous Empire of Capitalism.'

The twentieth century has turned out a lot closer to Bellamy's corporate state than to Morris's socialist and medievalist Utopia. Van Brunt's age of 'aggregates' has arrived, from the conscript legions of two world wars to the global armies employed by international capitalism. New building technologies have created the architecture of Modernism, and revived gothic has become a residue. In Britain pointed windows stayed longest in church design; Old English finished up as 'Stockbroker Tudor'; the medievalizing quaintness of the picturesque villa was standardized for countless suburban homes, their strips of garden vindicating the immemorial land-owning rights of a free gothic people.

254
Disney World,
Orlando,
Florida

The ever-widening suburbs house many of the century's new cultural audience – relatively affluent, mobile, enjoying more leisure. Tourism has become a mass phenomenon. The cultural industry that has grown up in response has taken over primary responsibility for the medieval past and its gothic buildings – controlling physical change by legislation, managing access by charging visitors to castles, colleges, cathedrals. The principal modern function of medieval buildings is to be looked at, prize exhibits of a patrimony in part democratized and increasingly international, but also homogenized for easier consumption as spectacle or product. History is repackaged as Heritage, the open-endedness of historical sites tidied into cultural theme parks. The process has created an economic and social base for architectural conservation, an acceptance of the integrity belonging to the things of the past that is also a measure of our divorce from it. The buildings of the Middle Ages are now cared for more assiduously than at any previous time.

Against such solicitude must be set the twentieth century's appalling destructiveness, from the havoc visited on Europe's towns and cities by war to innumerable demolitions in the cause of modernization, efficiency, commercial aggrandizement, motor cars. Gothic Revival buildings have suffered badly, victims of Modernism's hostility to historicist style and to much Victorian architecture: this book has been peppered with casualties. The last thirty years have seen a change, however, partly in response to the toll of destruction: public opinion, cultural tourism, legislation have in many countries secured revived gothic within the realm of the protectable past. Cleaned and repaired, such works as the Palace of Westminster (see 117), Manchester Town Hall and the Albert Memorial (see 196) have effectively been rediscovered. In Europe's cultural inventory they join the Revival's set-piece creations and recreations: Viollet's great *coups de théâtre* at Carcassonne and Pierrefonds; whole towns such as Bruges and Ghent; Ypres, its medieval Cloth Hall and cathedral rebuilt in replica after being shelled flat in World War I; Cologne Cathedral, completed once again after extensive bomb damage in World War II. Neuschwanstein's career is particularly instructive. Though a few castellar creations post-dated it – notably the sombre granite bulk of Castle Drogo (1910–30), Devon, by Edwin Lutyens (1869–1944) – it had no architectural offspring. Ironically democratized by mass tourism, however, it has become the prototypical castle of the twentieth century's gothic imagination.

As the architectural Revival entered its last stages, literary gothic in Britain blossomed eerily: Robert Louis Stevenson's schizophrenic fable *Dr Jekyll and Mr Hyde* (1886); the antiquarian ghost stories (from 1894) of Montague Rhodes James; the insidiously unsettling novella *The Turn of the Screw* (1898) by the American émigré Henry James; and, casting the longest, blackest shadow, Bram Stoker's *Dracula* (1897). There were French parallels in Guy de Maupassant's late stories, and American, with Algernon Blackwood's tales and,

later, the macabre New England gothic of H P Lovecraft. All shared a commitment to the supernatural that disputed Western society's rationalist tradition; as, earlier, gothic sensibility's emergence challenged the Enlightenment discourse of Reason. By 1900, scientific and technological progress, the logic of the capitalist market and secular models of social development were laying claim to the present and the future. But what of the past?

In *Dracula*, which inherits much of gothic fiction's machinery as well as an aristocratic villain craving absolute power, Stoker conjures the horror of a forgotten but unresolved past, an undead history both more and less than human that refuses – literally in the Count's case – to be buried by the modern world. It is a history that, as Mary Shelley feared, produces monsters, and they are revealed by the agency of culture upon nature, rationally uncovering those things at which rationality stands appalled. Earlier, the discoveries of geology had left Tennyson haunted by 'Dragons of the prime'. As *Dracula* appeared, so too did Sigmund Freud's first works, charting for each of us a primal history of monstrous desire. The erotic surrender to the kiss of the Count is a reversion to the self's forbidden past, the repressed history of private appetite. That surrender is economic too, for the primitive and sexually charged blood that flows through *Dracula* symbolizes financial circulation – the unrestricted movement of credit that is the life-blood of finance capitalism. The global market, ostensibly the most modern product of our economic rationalism, turns out to be configured with our most primitive longings.

Literary gothic expanded extraordinarily through the course of the twentieth century, particularly in Britain and North America. Conscious reworkings of gothic's inherited fictional conventions include: the intricate narratives of *Seven Gothic Tales* (1931) by Isak Dinesen – the pen-name of Karen Blixen; *Rebecca* (1938) by Daphne du Maurier, with its haunted mansion and incumbent autocrat; Mervyn Peake's luxuriantly

grotesque *Gormenghast* trilogy (1946–59); Anne Rice's revisionist tales of the undead, *The Vampire Chronicles* (from 1986). Geographically mobile, gothic's convolution and claustrophobia typify Franz Kafka's Middle Europe, with appropriate architectural accompaniment in *The Castle* (1926), and William Faulkner's degenerative Mississippi. Feminism and postcolonialism, both committed to challenging dominant fictions, have found gothic a ready subversive vehicle: in Jean Rhys's prehistory of *Jane Eyre, Wide Sargasso Sea* (1966); in the bizarre gender comedies of Angela Carter's *The Bloody Chamber* (1979) and *Nights at the Circus* (1984); in Toni Morrison's slave narrative *Beloved* (1987). The 1990s exponents of so-called 'New Gothic', such as Patrick McGrath, have dealt in narratives of extreme subjectivity, alienation, paranoia, hallucination. With such inclusiveness, gothic has effectively moved from being a literary genre to being a category of the consciousness, one way in which we experience and shape the world.

Outdoing gothic's literary expansion has been its dissemination through the moving image – cinema, television and video. Descended from the Fantasmagorie that stirred audiences to hysteria during the French Revolution, gothic in the movies has thrived as a theatre of vicarious horror, its every technological advance – from black-and-white silents, to talkies, to technicolour, with all the camera tricks along the way – notching sensation higher. From the start, cinematic gothic has reworked the literary tradition. In Germany, immediately after World War I, Robert Wiene's *The Cabinet of Dr Caligari* (1919) brilliantly adapted the mannered distortions found in the contemporary theatrical designs of German Expressionism, fixing the visual style for the first film version of *Dracula*, F W Murnau's *Nosferatu* (1922; 255). Since then, despite all the stakes and garlic, the movies have endlessly resurrected the Count as one of a nuclear family of gothic types whose birth was literary. The classic three – or is it four? – appeared as talkies in early 1930s Hollywood: James Whale's

255
Scene from
Nosferatu,
1922

Frankenstein (1931), with Boris Karloff's deeply endearing monster (see 63); Tod Browning's *Dracula* (1931), with the sleek Bela Lugosi, gutturally Transylvanian, in the title role for the first time; and, using every latest technique of cinematography, Reuben Mamoulian's *Dr Jekyll and Mr Hyde* (1932). In 1950s Britain *The Curse of Frankenstein* (1956) and *Dracula* (1958) launched Hammer Studios' hugely successful horror movies. Among more recent versions, Werner Herzog's *Nosferatu – The Vampire* (1979) consciously pays tribute to Murnau, while Francis Coppola's *Bram Stoker's 'Dracula'* (1992) and Kenneth Branagh's *Mary Shelley's 'Frankenstein'* (1994) overtly claim literary authority. Alongside creatures culled from gothic novels, cinema has fostered its own monstrous brood: psychopaths and serial killers, from Alfred Hitchcock's pioneering *Psycho* (1960) to the 'slasher movies' epitomized with gory repetitiveness in the *Nightmare on Elm Street* series (from 1984); werewolves, zombies and suchlike revenants derived from Europe's stock of legendary nightmares; doctors and scientists, all with a family likeness to Frankenstein, among the best Hammer's Professor Quatermass – particularly in *Quatermass and the Pit* (1967), its sci-fi reworking of gothic's hobgoblin ancestry an intriguing contribution to historicism's quest for origins.

Gothic has also provided cinema with visual conventions for imaging the fearfulness of the capitalist city, focus for the anxieties of the Revival's proponents since the early nineteenth century. Borrowings and analogies are especially rich in the film that established much of the iconography, Fritz Lang's *Metropolis* (1926): the subterranean caverns containing the proletariat like the repressed forces of the Freudian subconscious, the passionate energy of revolution, and the cathedral in which reconciliation is achieved, all draw on aspects of gothic's historical semantic. Subsequently, gothic's streetscape has spread throughout the city of the movies: in the urban gloom of 1940s *film noir*; in the futuristic dystopia of Ridley Scott's *Blade Runner* (1982), its corporate

state derived from *Metropolis*, its androids descended from *Frankenstein*; in Tim Burton's *Batman* (1989), where the original comic strip's gothic debt – moody graphics, bad suits, the very name Gotham City – is extended to a final chase up a vertiginous cathedral tower that recalls Hugo's *Notre-Dame* and the mad sublimity of Beckford's Fonthill.

Beside screening gothic's nightmares, cinema has helped realize its dreams of the Middle Ages. *Ivanhoe*, for example, the defining text of Romantic chivalry, was turned into a black-and-white silent as early as 1913, became a Hollywood costume drama in 1952 (256), and the excuse for a 1958 British – and later French – television series with Roger Moore in the lead, his smile as dazzling as his armour. Robin Hood has occasioned dozens of sword-play capers; Shakespeare's Histories have had the full battlefield treatment, most stirringly in Laurence Olivier's wartime *Henry V* (1944). And there is King Arthur, from Richard Thorpe's *Knights of the Round Table* (1953; 257) and Joshua Logan's hit musical *Camelot* (1967), to incarnations influenced by the enthusiasms of Hippie culture, notably John Boorman's spaced-out *Excalibur* (1981), full of twilit Celts and special effects. Incomparably burlesquing the whole medievalist medley is *Monty Python and the Holy Grail* (1974), directed by Terry Gilliam and Terry Jones. Appearances in the movies have remade gothic buildings, both medieval and revived – none more than Neuschwanstein. All Walt Disney's castles are versions of Neuschwanstein, from *Snow White and the Seven Dwarves* (1938), to *Beauty and the Beast* (1993). The *Snow White* castle has actually been built, for example at Disney World in Florida (see 254), and the gateway's turrety profile is the logo of the Disney Corporation – a martial reminder of the saccharine empire's commercial toughness. At the grimmer end of the market, Neuschwanstein's craziness permeates the distorted castellar perspectives of *Nosferatu*, overlays the mountain top piles in which Hammer installs the Count, and seems to lurk behind the sinister silhouette of the Bates Motel in *Psycho*.

M.G.M. presents
SIR WALTER SCOTT'S 'IVANHOE' starring Robert TAYLOR . Elizabeth TAYLOR
Joan FONTAINE . George SANDERS . Emlyn WILLIAMS with Robert Douglas . Finlay Currie
Felix Aylmer . Francis de Wolff . Norman Wooland . Basil Sydney and Guy ROLFE. Directed by Richard THORPE
Produced by Pandro S. BERMAN. Screen Play by Noel LANGLEY. Adaptation by Aeneas MacKENZIE.
This Copyright advertising material is leased and not sold and is the property of Metro-Goldwyn-Mayer Pictures, Ltd. and upon completion
of the exhibition for which it has been leased it should be returned to Metro-Goldwyn-Mayer Pictures, Ltd.
Colour by Technicolor
Series A

'Knights of the Round Table' starring ROBERT TAYLOR . AVA GARDNER
IN MAGNIFICENT COLOUR MEL FERRER . ANNE CRAWFORD
AN M-G-M PICTURE with STANLEY BAKER . Felix Aylmer . Maureen Swanson
This Copyright advertising material is leased and not sold and is the property of Metro-Goldwyn-Mayer Pictures, Ltd., and upon completion of the exhibition for which it has been leased
it should be returned to Metro-Goldwyn-Mayer Pictures LtC.
Cert 'U'

During the late 1970s, gothic extended its realm beyond buildings, novels and movies. In 1978, with Punk disrupting commercial pop culture, Siouxsie Sioux (258), lead singer of the British band Siouxsie and the Banshees, called her music 'Gothic'. Defined, like Punk itself, by negatives – no Hippie wistfulness, no disco blandness, not Glam Rock, not Art Rock – Gothic was distinguished by its introspection, turning Punk's anger into self-directed angst. If not quite like Keats, 'half in love with easeful death', Gothic youth was decidedly fond of the tomb. The term was adopted quickly, as too the black garb and silver trimmings sported by the Banshees and other groups. To fans reared on television and the image saturation of later twentieth-century culture, the link to gothic's black-and-white movies was instant: in 1979 Bauhaus's threnody 'Bela Lugosi's dead' proclaimed Gothic's cinematic debt. Record sleeves and stage sets rapidly tied Gothic music to rambling castles, ruins and midnight churches. Christian symbols materialized as fashion accessories. The cumulative effect and the lugubriousness recalls 1740s Graveyard Poetry, but with a distinctive eroticism, a synthesis of love and death derived from late Romanticism and epitomized by the vampiric embrace. Led by bands like Bauhaus, Sisters of Mercy and Christian Death, as well as the perennial Siouxsie, Gothic became a subculture. Not just in Britain, but in the United States and Canada; in Germany, where Gothic's despairing accompaniment to re-unification in the early 1990s unconsciously travestied Reichensperger's stylistic programme; and in Russia in the late 1990s, against the background of a collapsed empire and an economic shambles.

Not just culturally alternative but oppositional, Gothic has proved resistant to commercial assimilation, its obsessive visual style – from black and purple make-up to funereal decor – ideologically loaded by negation and inversion. As in the eighteenth century, the things of the night repudiate the daylit realm, now more than ever determined by technological imperatives and the machinations of capitalism's global

256–257
Posters for
Hollywood
films
Above left
Ivanhoe, 1952
Below left
*Knights of the
Round Table,*
1953

market. The icons Goths appropriate from horror movies promote vampires and revenants as champions of irrationality against the commercial calculation of the mass media that produced them. Self-consuming angst and its attendant anorexic fashion parody the voracity of consumer capitalism. Uniform black rejects the multi-coloured variety of shopping malls. Free play with Christian symbols parades the redundancy of orthodox religion. Sex and death replace love and marriage. Evocations of the crypt mock notions of scientific progress or social betterment. Atavism rebuts modernity. Thought of in this way, Gothic is counter-cultural, typified by disillusion, nihilism, an ironic sense of the self as negated

258
Siouxsie Sioux

259
Nosferatu
bebé dolls,
offered for
sale on an
Internet
Web page

or endlessly manipulated by economic and social forces beyond the control of individuals or even of governments.

However Goths might fear global technologies – doubtless preferring older magic – they have taken to the Internet with a will. More than rock concerts or the cinema, the World Wide Web has become Gothic's principal location: there are tens of thousands of sites. Some cover the Gothic scene internationally or within particular countries; there are Gothic chat rooms and electronic magazines, their naïve contents often strikingly at odds with the sophistication of

the computer graphics; cult figures and bands get whole
sites; Gothic games meander through fog-bound streets
or gloomy labyrinths, not unlike that first chase through
Otranto's tunnels; merchandise ranges from vampire dolls
(259) to Dracula desk-sets. In addition there are innumerable
personal Web pages: 'Melinda Gothic Vampire' has 'pale
skin and a predatory smile'; 'I am dark and so is my soul'
announces a sixteen-year-old from New Mexico; a voice-
over invites us to a 'little vampire group based in the
southwest of England'.

The Goths' surge across the Net is gothic's latest historical
engagement with revolutionary process – in this case the so
called Information Revolution. But amid earlier upheavals –

constitutional, economic, social – gothic's semantic, however
disparate and whether for or against change, was deployed
for expressly political aims. No longer, as modern Gothic,
characteristically negative, is premised upon political
disillusion. The Internet is its perfect home. Unregulated,
unsorted, uncritical, the Web affords limitless freedom to
Gothic's every dissenting position, but the political result is
only a cumulative incoherence. Its relationship to gothic's
inheritance is heavily ironic: for the fullest articulation of
its libertarian illogic, Gothic depends on a global technology
scientifically originated, industrially produced, managed by
multi-nationals; the thousands of electronically linked Goths

constitute a parody of gothic and medievalist community, as their contact by its nature precludes any dealings face-to-face; and for community's local geography and definite places, Internet Gothic substitutes sites that exist only virtually. A century after Bellamy's *Looking Backward* and Morris's riposte in *News from Nowhere*, Goths protest against the global corporation by courtesy of the global corporation, and build their alternatives in an electronic Web that is placeless, depthless, distanceless – that is literally nowhere. It is hardly what Morris meant when he said we must all become 'our own Goths' and dismantle capitalism's 'tyrannous Empire'. Viewed pessimistically, gothic at the end of the twentieth century appears, on the one hand, as a neutered counter-culture, on the other hand as a market leader in the heritage industry – gothic's dual inheritance of radicalism and conservatism cut down to suit consumer capitalism.

But things may not be that bleak. The preservation of gothic buildings, both medieval and revived, and their popularity with a broad cultural audience, make possible a dynamic imaginative relationship between the medieval past and the present, new dreams of the Middle Ages to reignite the creative energy that has always typified the Gothic Revival. Despite its compromises and political incoherence, contemporary Gothic remains a focus for discontent, stubbornly negative against the facile brightness of commercial culture. The very complexity of the gothic semantic, the history of contended meanings this book has traced, makes it peculiarly appropriate to the diversity promoted by postmodernism. On-going arguments about citizenship, communal values, national identity and hereditary authority, all continue issues that have been bound up with notions of gothic since the Revival began. And the process of redefining radical strategies in the aftermath of the Cold War could discover again a gothic politics of primitive liberty that will reconnect the present to Germania's free gothic folk two millennia ago.

Glossary

Apse In a church, the semicircular or polygonal end of a **chancel** or chapel.

Arcade A range of arches.

Bartizan Small turret projecting from an angle at the top of a tower or wall.

Battlement A series of alternate openings and solid portions on top of a wall, characteristic of castles; also called crenellation.

Boss A block, often elaborately carved, set at the intersection of the ribs of a **vault**.

Buttress Masonry or brickwork projecting from a wall to give added strength.

Canopy Protective hood over a statue, etc.

Capital The top element of a column, usually carved or moulded.

Chalice Cup for wine in Communion Service or Mass.

Chancel The part of a church, normally the east end, containing the altar.

Classical, Classicist The art and architecture of ancient Greece and Rome, and the subsequent styles derived from them.

Clerestory The top storey of the walls of a church, containing windows.

Corbel A projecting block, often carved, supporting a horizontal member.

Crocket Ornamental projection, carved to resemble foliage, on the sloping sides of features such as **pinnacles**.

Cusp The point between the **foils** of an arch or **tracery** form.

Dripstone Moulding over an opening, designed to throw off water.

Ecclesiology The term devised by the Cambridge Camden Society for gothic church design prescribed by medieval precedent, liturgy and symbolism.

Encaustic Tile Glazed earthenware tile with the decoration burnt into the surface.

Fan-Vault Elaborate, cone-shaped **vault**, characteristic of Perpendicular gothic.

Foil The lobe or leaf shape formed by applying **cusps** to an arch or geometrical shape; a trefoil has three lobes, a quatrefoil has four, a cinquefoil has five, etc.

Flying Buttress An arched structure carrying the thrust of a **vault** from the upper part of a building to an outer wall or support.

Gable The part of a wall filling the end of a pitched roof, normally triangular.

Gargoyle Projecting water spout, often grotesquely carved.

Grotesque A carved or painted decoration representing a fantastic creature.

Lancet Narrow pointed window, typical of Early English gothic.

Lights The subordinate openings in a window divided by **mullions**.

Machicolation Defensive gallery built out from the top of a tower or castle wall.

Merlon Solid upright in a **battlement**.

Mullion Upright element dividing a window into **lights**.

Ogee An arch form comprising a double curve, convex then concave, each side.

Oratory Small domestic chapel.

Orders In **classical** architecture, the five classes of columns and their associated features: Doric, Ionic, Corinthian, Tuscan, Composite.

Oriel Window An angled structure containing windows, projecting from the upper floors of a building.

Pendant An elongated **boss**, appearing to hang from a **vault**.

Picturesque An aesthetic category devised in the eighteenth century, emphasizing the visual and imaginative pleasures of variety, irregularity and quaintness.

Pinnacle Tapering terminal feature on a **buttress, gable** etc.

Reliquary A container for saints' relics, usually highly ornamented.

Reredos Ornamental structure rising behind an altar.

Rib-Vault A **vault** in which the structural ribs are exposed.

Spandrel Flat, triangular area between two arches.

String Course Horizontal moulding projecting from a wall.

Sublime An aesthetic category devised in the eighteenth century, stressing the effects of vastness and awesome power.

Tracery The intersecting forms in the top of a window, also used to decorate surfaces.

Vault An arched roof or ceiling in masonry or brick, often copied in plaster or wood during the Gothic Revival.

Brief Biographies

William Beckford (1759–1844) English collector. Fabulously wealthy, but reclusive and disgraced by scandal, Beckford employed **Wyatt** to create the vast gothic pile of Fonthill Abbey (1796–1812), perhaps the most celebrated architectural expression of Romantic sublimity. The expense of the building and the treasures it housed almost bankrupted Beckford, who sold up and moved to Bath in 1822.

Jean-Baptiste Bethune (1821–92) Belgian designer and architect. Bethune trained as a painter, but reading **Pugin** inspired him to take up gothic architecture and design. He acquired practical experience in Bruges, where he was closely involved with the city's fervently Catholic medievalism. He set up workshops in Ghent in 1858, after which his output was prolific, from churches and monastic buildings to a huge and sumptuous array of ecclesiastical fittings, stained glass, plate and vestments. Remaining close to medieval precedent, committed to a Puginian identification of Catholicism with gothic, Bethune's work centrally influenced the whole character of the Belgian Revival.

George Frederick Bodley (1827–1907) English architect. **Scott**'s first pupil, Bodley worked in a High Victorian idiom until the 1860s, when his All Saints', Cambridge, started the English Revival's return to the Decorated gothic earlier advocated by **Pugin**. In style and decorative refinement the churches he produced with Thomas Garner (1839–1906), his partner from 1869, shaped Late Victorian gothic and profoundly influenced American church building. An expert in liturgical provision, Bodley was also closely associated with design for advanced Anglican Ritualist worship.

William Burges (1827–81) English architect. Trained in engineering as well as architecture, Burges achieved prominence when, partnering Henry Clutton (1819–93), he won the Lille Cathedral competition (1855) with a typically vigorous design in Early French. Cushioned by family affluence, he was able to devote much of his career to elaborating a sumptuously crafted gothic, particularly in metalwork, furniture and sculpture. His fantastic and inventive manner, often stylistically eclectic, was most fully realized in the visionary interiors he designed for the Marquis of Bute at Cardiff Castle (1868–81) and Castell Coch (1875–81), and in his own Tower House, Melbury Road, London (1876–81).

Edmund Burke (1729–97) Anglo-Irish author and politician. Trained as a lawyer, Burke founded the *Annual Register* (1759) and was a leading figure in British politics from the 1760s. His early work on aesthetics, *Of the Sublime and the Beautiful* (1756) helped shape attitudes to both literary and architectural gothic. The Romantic conservatism of his *Reflections on the Revolution in France* (1790), identifying economic and political revolution with the death of chivalry, shared attitudes later expressed by **Walter Scott** and deeply influenced the social thinking of nineteenth-century gothicists.

William Butterfield (1814–1900) English architect. From a lower middle-class background, trained in building as well as architecture, Butterfield became a key ecclesiological architect of the 1840s. The forceful polychromy and formal tensions of his All Saints', Margaret Street, London (1849–59) initiated the Revival's High Victorian phase. Reticent, always an outsider, Butterfield continued to develop his own, challenging aesthetic regardless of changing fashions. As well as numerous churches and their fittings, he also created a functionalist, vernacular gothic for parsonages and estate housing that greatly influenced later domestic architecture. Among major later works were Keble College (1867–83) and a series of buildings for Rugby School (1860–85).

John Carter (1748–1817) English architectural draughtsman. Supported by the Society of Antiquaries, Carter became the finest draughtsman of medieval gothic in the Romantic period; his illustrations of English cathedrals and works such as *Ancient Architecture of England* (1795–1814) formed the basis of a scholarly approach to reviving gothic. He also campaigned fiercely against the destructive restoration practices associated with **Wyatt**.

John Cosin (1594–1672) English ecclesiastic, Master of Peterhouse, Cambridge (1635), Bishop of Durham (1660). Like **Laud**, whom he supported, he adopted a classical and gothic hybrid for Peterhouse Chapel. At Durham, after the Restoration, he initiated a remarkable revival of gothic design, particularly for church woodwork.

Ralph Adams Cram (1863–1942) American architect. Influenced by reading **Pugin** and **Ruskin**, and by **Bodley**'s aesthetic, Cram became America's leading gothic architect in the early twentieth century. His partnership with Bertram Grosvenor Goodhue (1869–1924), from 1891, became nationally famous with the designs for West Point Military Academy

(1902–10). With offices in Boston and New York, the practice – subsequently Cram, Goodhue and Ferguson – produced numerous churches and several cathedrals, including Bryn Athyn, Detroit, Halifax and the unfinished St John the Divine, New York. Cram also wrote extensively on medieval gothic, in works such as *The Ruined Abbeys of Great Britain* (1905), and on the ideals of the Revival, notably in *The Gothic Quest* (1907).

Petrus Josephus Cuypers (1827–1921) Dutch architect. Trained in Belgium, Cuypers established his practice in Amsterdam, where he became Holland's principal exponent of gothic and the leader of the architectural profession nationally. Beginning with the Posthoornkerk (1860–3), he designed a number of major brick-built churches in Amsterdam, among them the Vondelkerk (1872-80) and Maria Magdalenekerk (1887), which combine structural rationalism with inventive design and planning. For secular buildings, most famously the Rijksmuseum (1877–85), Cuypers hybridized gothic and Renaissance forms to create a richly associative Dutch national style. From the 1890s his large office became a training ground for proto-modernist architects.

Alexander Jackson Davis (1803–92) American architect. Although an eclectic designer, favouring classical for public buildings, Davis's domestic architecture introduced the picturesque gothic villa into America, beginning with Glen Ellen, Baltimore (1832–3) and eventually producing country houses such as Ericstan (1855–9) and Lyndhurst (1865), both in Tarrytown, New York. His villa designs in *Rural Residences* (1838) and *Country Residences* (1841), produced with his partner Andrew Jackson Downing (1815–52), were widely imitated.

Sir William Dugdale (1605–86) English herald and antiquary. Dugdale was the dominant figure in English heraldry in his day, eventually becoming Garter King-of-Arms in 1677. His *Monasticon Anglicanum* (1655–73) is the seventeenth century's greatest work of medieval scholarship, and the accompanying engravings by Daniel King are the first visual compendium of England's medieval architecture. Dugdale's *Antiquities of Warwickshire* (1656) largely initiated the local study of the documentary and material remains of the Middle Ages, and set the pattern for English county histories until the nineteenth century.

Frank Furness (1839–1912) American architect. The son of a Unitarian minister, Furness trained in the eclectic studio of the New York architect Richard Morris Hunt (1827–95), then fought in the Civil War before starting his own practice in Philadelphia. There, he closely identified with reformers opposing civic corruption. His strenuously expressive gothic articulated their ideals, not only in cultural institutions such as the Pennsylvania Academy of the Fine Arts (1871–6), but in banks and financial buildings, churches – including Philadelphia's First Unitarian (1883–6) for his father – and houses.

Jordanes (*fl.*530–60) Gothic historian. A lawyer attached to the Ostrogothic court in Italy, Jordanes wrote *The Origins and Actions of the Getes* (551), known as the *Getica*, a laudatory account of the overthrow of the Roman Empire by the Goths. The principal source for gothic history, it was used by Protestants in northern Europe in the sixteenth and seventeenth centuries to support ideals of primitive gothic liberty.

William Kent (*c.*1685–1748) English painter, landscape gardener and architect. From humble beginnings, Kent became an historical painter and leading Palladian architect, his career promoted by the powerful Lord Burlington. Kent introduced 'natural' effects into landscaping, notably at Rousham (1737–40), where he also designed gothic garden structures, and developed a repertoire of gothic features used to remodel houses such as Esher Place (*c.*1733).

Richard Payne Knight (1750–1824) English collector and author. Knight designed the earliest **picturesque** castle at Downton, Herefordshire (1771–8) on an estate he had inherited from his industrialist grandfather. With William Gilpin and Uvedale Price, he became a leading theorist of the Picturesque, influencing **Nash**, and publishing his ideas in a long, didactic poem, *The Landscape* (1794).

Jean-Baptiste Lassus (1807–57) French architect. With **Viollet-le-Duc**, Lassus was the principal campaigner for gothic on the Commission des Monuments Français. Staunchly committed to stylistic purity, his new churches such as St Nicholas, Nantes (1843–68) and St Jean Baptiste, Belleville (1853–9) are designed in strict accordance with thirteenth-century precedents. The most important of his major restorations are Sainte Chapelle, Paris (1842–55) and Notre-Dame de Paris (1844–64), undertaken with Viollet. Lassus triumphed in the 1855 competition for Lille Cathedral, though originally placed only third, but died before work began.

William Laud (1573–1645) English ecclesiastic, Chancellor of Oxford University (1630) and Archbishop of Canterbury (1633). The buildings he commissioned, notably Canterbury Quad in Oxford (1631–6) and the church of St Katherine Cree in London (1631), mixed **classical** forms with gothic that evoked inherited medieval authority. As a close adviser of Charles I and an advocate of religious and monarchical absolutism, Laud was charged with treason by parliamentarians during the Civil War and beheaded.

Ludwig II (1845–86) King of Bavaria (1864–86). Nurtured on Teutonic myths, dreaming of absolute monarchy and obsessed with Wagner's operas, Ludwig

proved incapable of dealing with the actualities of ruling Bavaria in the period of German unification. He sought to realize his fantasies in a series of incredible architectural projects, including the sensational Alpine castle of Neuschwanstein (from 1868). The vast cost of his building activities led to his being certified insane, and he subsequently drowned himself. Neuschwanstein has significantly influenced the visual imagination of twentieth-century medievalism, particularly through cinema.

Sanderson Miller (1716–80) English antiquary and amateur architect. In 1746–7 Miller designed the first purpose-built gothic ruin, on his own estate at Radway, Warwickshire, and, in 1748, the celebrated ruined castle at Hagley, Worcestershire. He was also a pioneer of domestic gothic, most notably in the remodelling of Lacock Abbey, Wiltshire (1754).

William Morris (1834–96) English author and designer. Enamoured of the Middle Ages from boyhood, Morris became closely involved with Pre-Raphaelite medievalism at Oxford and published his first Arthurian poems in 1858. Deeply influenced by **Ruskin**, he set up Morris, Marshall, Faulkner & Co. in 1861, becoming an extraordinarily prolific designer across the whole decorative arts, and the main founder of the Arts and Crafts Movement. He also continued to write, both poetry – notably *The Earthly Paradise* (1868–70) – and prose romances. Though medievalist in inspiration, his craft practice rejected historicist styles and he vigorously opposed the architectural restorations of the Revival. Reading Marx gave Morris's loathing for industrialization a political focus and his later years were dominated by writing and campaigning for socialism.

John Nash (1752–1835) English architect. Having established himself as an architect of the **Picturesque** in Wales, where he knew the **Knight** circle, Nash moved to London in 1796, partnering **Repton** and acquiring many fashionable clients, including the future Prince Regent. Nash's fine knack of pictorial composition made him the leading designer of picturesque gothic castles, and his output in both England and Ireland was prolific. Stylistically eclectic, he produced classical designs for the major public commissions royal patronage helped him secure.

John Mason Neale (1818–66) English ecclesiastic and author. With **Webb**, Neale founded the Cambridge Camden Society in 1839, which launched the ecclesiological movement, and through the Society's publications and journal, the *Ecclesiologist* (1841–68) – much of which he and Webb wrote – influenced the whole development of the Revival. Neale's later career, particularly once the Society came under the dominant influence of Alexander James Beresford Hope (1820–87), focused on writing hymns: one eighth of *Hymns Ancient and Modern* (1860) are by him. In 1846 Neale became Warden of Sackville College,

Sussex, but his Ritualism blocked further advance in the Church of England.

Sir Roger Newdigate (1719–1806) English amateur architect. Ultra Tory in politics and religion, Newdigate was closely associated with Oxford University, which he represented as a member of parliament (1750–80). From 1746, working with various architects and craftsmen, he devoted much of his life to creating the fantastically intricate gothic interiors of his house, Arbury Hall, Warwickshire.

John Loughborough Pearson (1817–97) English architect. The son of a gentleman painter, Pearson trained with Anthony Salvin (1799–1881) before starting his own practice in London in 1843. Many of his early churches are in Yorkshire. At St Peter's, Vauxhall (1863–5), influenced by **Viollet-le-Duc**, he introduced complete stone vaulting, which became the distinguishing feature of the major churches of his later career. Pearson's mastery of gothic construction made him a leading cathedral restorer, beginning with Lincoln (1870), and is triumphantly demonstrated in his design for Truro Cathedral (1880–1910).

Augustus Welby Northmore Pugin (1812–52) English architect. Trained by his father, who had been **Nash**'s assistant, Pugin was a passionate medievalist from his youth, prodigious in his draughtsmanship, knowledge of gothic and inventiveness as a designer. In 1836 he began collaborating with Charles Barry (1795–1860) on the New Palace of Westminster – the most important public work of the age – and eventually produced much of the lavish interior decoration. A convert to Catholicism, ecclesiastical design dominated his architectural output – churches and cathedrals, fittings, stained glass, plate and vestments. His most important domestic work was Scarisbrick Hall, Lancashire (1837–45). Of Pugin's writings, *Contrasts* (1836) galvanized the Revival by its polemic against modern architecture and society, and *True Principles of Christian Architecture* (1841) campaigned for a gothic that was historically accurate, functionally based and symbolically eloquent. As a theorist and practitioner, Pugin changed the whole course of the Gothic Revival in Britain, across Europe and in America.

Ann Radcliffe (1764–1823) English author. Radcliffe became the most celebrated gothic novelist of the 1790s with *The Mysteries of Udolpho* (1794), following it with *The Italian* (1797). Her gloomy castles, satanic villains, persecuted heroines and nocturnal terrors largely defined the gothic genre, though her novels carefully explained away the apparently supernatural and concluded with virtue triumphant. After 1797 Radcliffe abandoned fiction for a life of tranquil domesticity.

August Reichensperger (1818–95) German author. A Catholic Rhinelander, trained as a lawyer, Reichensperger was a key figure in the completion of Cologne Cathedral,

and the editor of *Kölner Domblatt*. Though committed to German unification, he urged a vigorous, regionally based gothic, the product of cathedral building lodges, as a way of offsetting Prussian centralization. Reichensperger's *Die christlich-germanische Baukunst* (1845) introduced Pugin's principles into Germany, and he was closely connected to English gothicists, particularly **Scott**. He remained the dominant personality of the German Revival, though his political ambitions for gothic were never realized.

Humphry Repton (1752–1818) English landscape gardener. The first man to call himself professionally a landscape gardener, Repton developed **picturesque** landscaping and architecture in partnership with **Nash** and, later, his son John Adey Repton (1775–1860). Arguing against the extreme picturesque theory of **Knight**, he advocated landscaping that demonstrated the extent of the owner's 'appropriation'. The *Red Books*, through which he showed before-and-after effects to clients, are famous.

Thomas Rickman (1776–1841) English architect. Self-trained as an artist and architect, Rickman wrote *An Attempt to Discriminate the Styles of English Architecture* (1817), which established an authoritative chronology for medieval gothic and a nomenclature that has been used in Britain ever since. His extensive architectural practice, based on his reputation as an expert in gothic, specialized in churches, many of which show an enthusiasm for innovative construction.

John Ruskin (1819–1900) English author. His artistic precocity encouraged by wealthy and cultured parents, Ruskin achieved early fame with *Modern Painters* (from 1843), and he went on to become Victorian Britain's most important writer on art and architecture. His *Seven Lamps of Architecture* (1849) and *Stones of Venice* (1851–3) decisively shaped the stylistic character of High Victorian gothic and the ideas it articulated. Ruskin's growing concern for culture's socio-economic basis, and his hatred of commercial exploitation – expressed in works such as *Unto This Last* (1860) – led to disillusion with the Gothic Revival, which he further denounced for its restorations of medieval buildings. His attacks on capitalism and championship of individual creative liberty deeply influenced **Morris** and the Arts and Crafts Movement.

Karl Friedrich Schinkel (1781–1841) German architect and painter. A pupil of the **classicist** Friedrich Gilly (1772–1800), Schinkel was appointed in 1810 to oversee all public and royal buildings in Prussia and architectural preservation. He became a key figure in the cultural activities of the Prussian court and planned much of central Berlin. Though principally a classicist, Schinkel's substantial contribution to Romantic gothic included easel paintings and transparencies, stage sets, lithographs and designs for a patriotic cathedral, as well

as the national War Memorial (1818–21) and the Friedrich-Werder Kirche (1824–30) in Berlin.

Sir George Gilbert Scott (1811–78) English architect. After a busy early career designing workhouses, Scott was converted to gothic by **Pugin** and **ecclesiology**. He subsequently built up the largest Victorian architectural practice, training **Street** and **Bodley** among others. His Nikolaikirche, Hamburg (1845–63) and friendship with **Reichensperger** extended his influence to Germany. Scott and his office produced hundreds of churches and restorations, restored more than twenty medieval cathedrals and abbeys, and designed across the range of secular buildings, from estate housing to vast structures such as Glasgow University (1868–71) and London's Midland Grand Hotel (1868–74). Scott's abiding commitment to integrating architecture, sculpture and the decorative arts was most fully realized in the Albert Memorial (1862–76), for which he was knighted.

Sir Walter Scott (1771–1832) Scottish author and collector. An enthusiast for gothic and the Middle Ages, Scott was an established poet before beginning the long series of *The Waverley Novels* (1814–32). Several – including *Ivanhoe* (1819), *Quentin Durward* (1823) and *Tales of the Crusaders* (1825) – are medieval: widely translated, their evocative descriptions and chivalric ethos influenced the whole Revival in Europe. Scott's own house, Abbotsford (1816–23), helped prompt the revival of Scotland's late medieval architecture.

Mary Wollstonecraft Shelley (1797–1851) English author. The daughter of the early feminist Mary Wollstonecraft and the radical philosopher William Godwin, Mary married the poet Percy Bysshe Shelley in 1816. Challenged by her husband and fellow-poet Lord Byron to produce a tale of terror, she wrote *Frankenstein* (1818). One of the greatest gothic fictions, it has had a lasting influence on the western imagination through literature, visual representation and, in the twentieth century, cinema.

Bram [Abraham] Stoker (1847–1912) Anglo-Irish author. Having worked in the Irish Civil Service, Stoker moved to London in 1878 to manage the Lyceum Theatre. After numerous short stories, largely in the horror genre, his vampire novel *Dracula* (1897) was an instant best-seller, with six editions in a year: it has never been out of print since. The visual imagery of the many Dracula movies, and of countless imitators, has dominated Gothic subculture since the 1970s.

George Edmund Street (1824–81) English architect. While working for **Scott** (1844–9), Street became deeply committed to **ecclesiology**, and his acquaintance with **Webb** helped him become Oxford Diocesan Architect in 1850. His enthusiasm for European gothic played a major part in

creating the High Victorian phase of the Revival, both through his church designs and through works such as *Brick and Marble in the Middle Ages* (1855) and *Gothic Architecture in Spain* (1865). As well as their stylistic innovativeness, Street's numerous churches are marked by their expressive vigour and compositional variety; among several cathedral restorations, those of Bristol (from 1868) and Christchurch, Dublin (1871–8) are particularly impressive. Street's London Law Courts (1868–82) are among the greatest public works of the Revival.

Gaius Cornelius Tacitus (*c.*55–120) Roman historian. After holding high legal office in Rome, Tacitus accompanied the imperial legions fighting in Germany (89–93). In *Germania* he described the social and political character of the German folk, stressing their military prowess and intense love of freedom. With **Jordanes**'s *Getica*, *Germania* was used by seventeenth-century English parliamentarians to create a gothic history that supported free political institutions.

James Tyrrell (1642–1718) English political theorist and historian. Trained as a lawyer, Tyrrell suffered under James II for his support of parliamentary rights. His *Bibliotheca Politica* (1692–1702) justified James's overthrow in the Glorious Revolution (1688–9) by drawing extensively on the gothic history of free political institutions. This was evoked architecturally on Tyrrell's estate at Shotover, Oxfordshire, where he erected the Gothic Temple (1716), the first gothic garden building.

Georg Gottlob Ungewitter (1820–64) German architect. After working in Munich, Hamburg and Lübeck, Ungewitter published *Examples for Brick and Stone Work* (1849), which brought him to **Reichensperger**'s attention, and they subsequently worked closely together on a range of gothic projects. Ungewitter's book of designs for imaginary houses (1858) and his churches, inventively adapted from Reichensperger's precepts, show that his early death robbed the German Revival of one of its most individualistic exponents.

Richard Upjohn (1802–78) American architect. Born in England, Upjohn settled as an architect in New York in 1839, making his reputation with Trinity Episcopal Church (1841–6). His many subsequent churches ingeniously develop gothic principles of structure and function, in wood as well as stone. His design manual, *Upjohn's Rural Architecture* (1852), provided cheap and simple models for frontier settlements. He was the founder and first president (1857–76) of the American Institute of Architects.

Eugène-Emmanuel Viollet-le-Duc (1814–79) French architect and author. After his training with a Parisian architect, family connections helped Viollet secure a post in the recently founded Commission des Monuments Français. At Vézelay (1840), he started on the great series of restorations that dominated his career: most famously, Notre-Dame de Paris but including the cathedrals of Amiens, Carcassonne, Clermont-Ferrand, Laon and Reims, as well as consultancies outside France. During the Second Empire he also recreated the town defences of Carcassonne and the royal château of Pierrefonds. Viollet's exhaustive *Analytical Dictionary of French Architecture* (1854–68) grew out of his unsurpassed knowledge of gothic construction. His *Treatises on Architecture* (1863, 1872), which rejected historicist styles in favour of rationalist and functionalist design, became one of the founding texts of architectural Modernism.

Horace Walpole (1717–97) English collector and author. The son of Sir Robert, Britain's first prime minister, Walpole built Strawberry Hill (from 1750), the eighteenth century's most famous gothic house, to display his collection of antiquities and curios. Innovatory in its asymmetrical design, use of medieval precedents and theatricality, Strawberry attracted so many visitors Walpole eventually had to issue tickets. Complementing his architectural activities, Walpole produced various works on literature and the arts, many printed on the Strawberry Hill press, conducted a vast correspondence and wrote the first gothic novel, *The Castle of Otranto* (1764).

Benjamin Webb (1819–85) English ecclesiastic and author. In 1839 Webb was co-founder with **Neale** of the Cambridge Camden Society. Together they produced much of the contents of the *Ecclesiologist*, as well as a number of related publications, notably the 1843 translation of Durandus's *Rationale Divinorum Officiorum*. Webb's own *Sketches of Continental Ecclesiology* (1848) was influential in making European gothic available to British architects. Close friendship with Beresford Hope ensured he remained a key figure in the ecclesiological movement after Hope had taken control. Less of a zealot than Neale, Webb became vicar of the remunerative and fashionably High Church of St Andrew's, Wells Street, London in 1865.

James Wyatt (1746–1813) English architect. After training in Italy, Wyatt made his name as a neoclassicist with the London Pantheon (1772), and rapidly acquired a large, fashionable clientele. He developed a specialism in gothic, his early designs such as Lee Priory (1783) being applauded by **Walpole**, for whom he also worked. Wyatt's flair for visual drama created some of the most sensational works of Romantic gothic, including Fonthill (1796–1812) for **Beckford** and Belvoir Castle (from 1801). Employed on several cathedrals, his drastic remodellings earned him the nickname 'Destroyer'.

Key Dates

Numbers in square brackets refer to illustrations

The Gothic Revival

1510 Donato Bramante condemns medieval architecture as 'the German manner'

1550 Giorgio Vasari's *Lives* identifies 'the German manner' with the Goths

1573 François Hotman, *Franco-Gallia*

1601 Rebuilding of Orléans Cathedral begins

1605 Richard Verstegen, *A Restitution of Decayed Intelligence* [24]

1620 Rebuilding of Oriel College, Oxford (to 1642) [13, 14]

1623 Library of St John's College, Cambridge [15, 16]

1653 Staunton Harold church

1656 John Harrington, *Commonwealth of Oceana*

1659 John Jackson's fan-vault in Brasenose College Chapel, Oxford [18]

1660 John Cosin becomes Bishop of Durham (to 1672) and revives gothic locally [21, 22]

1692 James Tyrrell, *Bibliotheca Politica* (to 1704)

1716 The Gothic Temple, Shotover Park [28]

1727 Roger Morris's Clearwell Castle [39–41]

1741 James Gibbs's Temple of Liberty, Stowe [30]

1745 Roger Morris's Inverary Castle for Duke of Argyll (to 1790) [57]

1747 Sanderson Miller's Radway Tower [34]

1752 Horace Walpole begins Strawberry Hill (to 1776) [49–54]

1754 Sir Roger Newdigate begins interiors at Arbury Hall (to 1786) [46]

A Context of Events

98 Tacitus writes *Germania*

551 Jordanes writes *De origine actibusque Getarum* (the *Getica*)

1517 Martin Luther's Wittenberg theses, marking the start of the Reformation

1560 French Wars of Religion begin (to 1598)

1588 English defeat the Spanish Armada

1620 Pilgrim Fathers land in New England

1642 English Civil War begins (to 1649)

1649 Execution of Charles I; republican Commonwealth established

1660 Restoration of the British monarchy

1688 The 'Glorious Revolution' replaces James II by William III (to 1702) and Mary

1714 George I, first of the House of Hanover, succeeds to British throne (to 1727)

1715 Defeat of Jacobite rising in Scotland

1741 Beginning of intensive enclosures of common land in Britain

1745 Jacobite rising in Scotland, crushed at Culloden (1746)

The Gothic Revival	A Context of Events
1756 Edmund Burke, *Inquiry into … the Sublime and the Beautiful*	**1756** Seven Years' War (to 1763); major British gains in Canada, India, West Indies
1764 Horace Walpole, *Castle of Otranto* [65]	
1771 Richard Payne Knight's Downton Castle (to 1778) [90]	
1773 Herder and Goethe, *Von deutscher Art und Kunst*	
	1776 American Declaration of Independence
1777 Francis Hiorne's Tetbury church (to 1781) [62]	
1781 Johann Friedrich Schiller, *Die Räuber* [68]	
	1789 The storming of the Bastille begins the French Revolution
1790 The Löwenburg, Hesse (to 1799) [100]. Edmund Burke, *Reflections on the Revolution in France*	
1792 Fantasmagorie opens in Paris [69]	**1792** European war against France
1794 Ann Radcliffe, *Mysteries of Udolpho*	
1795 John Carter, *Ancient Architecture of England* (to 1814) [73] and *Cathedral Series* (to 1813)	
1796 James Wyatt's Fonthill Abbey for Beckford (to 1812) [83, 84]. Matthew Lewis, *The Monk*	
1799 John Nash's Luscombe Castle (to 1804) [91]	**1799** Napoleon Bonaparte seizes power
1801 Tullynally Castle, Co. Waterford (to *c.*1843) [98]	**1801** Act of Union merges Ireland into the United Kingdom
1804 John Sell Cotman, *Croyland Abbey* [78]	**1804** Napoleon crowned Emperor of the French
1807 John Britton, *Architectural Antiquities* (to 1814)	
1808 James and Jeffry Wyatt's Ashridge Park (to 1820) [85, 86]	
1815 Karl Schinkel, *Medieval City on a River* [80]	**1815** Napoleon's final defeat at Waterloo
1817 Thomas Rickman, *Attempt to Discriminate the Styles of Architecture* [75]. Caspar David Friedrich, *City at Moonrise* [72]	
1818 Mary Shelley, *Frankenstein* [63, 71]. Church Building Commission established	**1818** First steamship crossing of the Atlantic
1819 Walter Scott, *Ivanhoe*	**1819** 'Peterloo Massacre' in Manchester
1824 Jeffry Wyatville's remodelling of Windsor Castle (to 1840)	
	1830 Belgium becomes an independent state
1832 French Commission des Monuments Historiques created	**1832** Reform Act extends the franchise in Britain
1833 Schloss Hohenschwangau, Bavaria (to 1838) [102]	**1833** Slavery abolished in the British Empire
	1834 Henry Fox Talbot's first photograph
1835 Barry's and Pugin's New Palace of Westminster (to 1868) [117, 118, 120–3]	
1836 Pugin, *Contrasts*	
	1837 Victoria succeeds to the British throne (to 1901)

The Gothic Revival	A Context of Events
1838 Alexander Jackson Davis's Knoll, Tarrytown, New York [112], and his *Rural Residences*	**1838** Economic slump in Britain (to *c.*1843); Chartist movement begins
1839 Cambridge Camden Society founded, becomes Ecclesiological Society in 1846	
1840 Pugin's St Mary's, Warwick Bridge [138]	**1840** Victoria marries Albert of Saxe-Coburg
1841 Pugin, *True Principles of Christian Architecture*. *Ecclesiologist* begins publication (to 1868). Andrew Jackson Downing and Davis, *Cottage Residences* [113]	**1841** *Punch* begins publication
1842 Building of Cologne Cathedral begins (to 1880). *Kölner Domblatt* begins publication (to 1892)	**1842** Chartist riots; mass disturbances in Lancashire
1844 Viollet-le-Duc and Lassus's restoration of Notre-Dame, Paris (to 1864). Adolphe-Napoléon Didron launches *Annales Archéologiques* (to 1881)	
1845 George Gilbert Scott's Nikolaikirche, Hamburg (to 1863) [158]. August Reichensperger, *Die christlich-germanische Baukunst*	
1846 Didron and Reichensperger at Consecration of Pugin's St Giles', Cheadle [139, 140]. Gau's Ste-Clotilde, Paris (to 1857) [161]	**1846** The Great Famine in Ireland (to 1847)
1847 Henry Conybeare's St John the Baptist's, Bombay (to 1858) [167, 168]. Frank Wills's Fredericton Cathedral, New Brunswick [170]	
	1848 Year of Revolutions in Europe. Karl Marx and Friedrich Engels, *Communist Manifesto*
1849 William Butterfield's All Saints', Margaret Street, London (to 1859) [185–8]. John Ruskin, *Seven Lamps of Architecture*	
1851 Medieval Court at the Great Exhibition [145]. Ruskin's *The Stones of Venice* (to 1853). Richard Upjohn's St John Chrysostom's, Delafield, Wisconsin [172]	**1851** Louis Napoleon's *coup d'état* in France; he is crowned Napoleon III in 1852 (to 1870)
1852 Joseph Poelaert's Our Lady, Laken, Brussels begun [164]. Viollet begins restoration of Carcassonne [219]	
1854 Viollet's *Dictionnaire … de l'architecture française* (to 1868) [163]	**1854** Crimean War begins (to 1856)
1855 Deane and Woodward's Oxford University Museum (to 1860) [190, 191]	**1855** Electric lamp exhibited in Paris
1856 Lille Cathedral competition	
1858 Bethune establishes workshops in Ghent	**1858** First cable laid from Britain to America
1859 Street's St James the Less, Westminster [192]. Fuller and Jones's Canadian Parliament Buildings, Ottawa (to 1866) [236]	**1859** Charles Darwin, *Origin of Species*
	1861 American Civil War begins (to 1865)
1862 Scott's Albert Memorial (to 1872) [196–9]. Viollet's restoration of Pierrefonds (to 1870) [220, 221]	**1862** Otto von Bismarck becomes President of the Prussian cabinet

The Gothic Revival	A Context of Events
1863 Peter B Wight's National Academy of Design, New York (to 1865) [215]. Viollet, *Entretiens*, vol. 1 (1872, vol. 2)	**1863** First underground railway opens in London
1864 George Frederick Bodley's All Saints', Cambridge (to 1870)	
1866 Scott's Midland Grand Hotel (to 1877) [173, 195]	**1866** Prussia defeats Austria and Bavaria in The Seven Weeks' War
1868 Alfred Waterhouse's Manchester Town Hall (to 1877). Ludwig II's Neuschwanstein begun (to 1886) [225, 226]	
1869 William Burges begins work on Cardiff Castle (to 1881) [206]. Friedrich von Schmidt's Vienna Rathaus (to 1883) [223]	**1869** Suez Canal opens; majority share purchased by Britain 1875. American Pacific railway opens
1870 John Loughborough Pearson's St Augustine's, Kilburn (to 1878) [203]	**1870** France routed in Franco-Prussian War (to 1871)
1871 Frank Furness's Pennsylvania Academy of the Fine Arts (to 1876) [217]	**1871** Wilhelm I crowned Emperor of a united Germany
1873 Butterfield's Keble College Chapel (to 1876) [234, 235]	
1878 Frederick William Stevens's Victoria Terminus, Bombay (to 1887) [238]	
1882 Street's London Law Courts open [233]	
1883 Imre Steindl's Hungarian Parliament Buildings, Budapest (to 1904) [249]	
1886 Robert Louis Stevenson, *Dr Jekyll and Mr Hyde*	**1886** First steel skeleton skyscraper built in Chicago
1890 William Morris, *News from Nowhere*	
1897 Bram Stoker, *Dracula*	
	1901 Death of Queen Victoria
1902 Cram and Goodhue's West Point Military Academy (to 1910) [247]	
1903 Cloquet and Mortier's Post Office, Ghent	**1903** First aeroplane flight by the Wright brothers
1904 Giles Gilbert Scott's Liverpool Cathedral begun [245]	
1910 Cass Gilbert's Woolworth Building, New York (to 1913) [251–3]	
	1914 World War I begins (to 1918)
1922 F W Murnau's movie *Nosferatu* [255]	
1931 James Whale's movie *Frankenstein* [63] Tod Browning's movie *Dracula*	
	1939 World War II begins (to 1945)
1955 Disneyland, California opens	
1967 Joshua Logan's musical *Camelot*	
1978 Siouxsie Sioux [258] describes her music as 'Gothic'	
1989 Tim Burton's movie *Batman*	**1989** Introduction of World Wide Web
	1990 Reunification of Germany

NORWAY

Uppsala •
Stockholm •

SWEDEN

North Sea

DENMARK

Baltic Sea

• Dublin

ENGLAND

• Hamburg

• London

NETHERLANDS

• Amsterdam

• Hanover

• Kassel

• Berlin

GERMANY

Bruges •

Ghent •

Dadizele •

Abbeville •

Amiens •

Pierrefonds •

Caen •

Rouen •

Antwerp •

Brussels •

BELGIUM

Lille •

Liège •

Dinant •

• Cologne

• Remagen

• Stolzenfels

LUXEMBOURG

GUERNSEY

Reims •

Paris •

• Prague

CZECH REPUBLIC

Nantes •

Orléans •

Blois •

Chartres •

Aillant-sur-Tholon •

Vézelay •

• Strasbourg

Munich •

• Linz

FRANCE

Hohenschwangau •

• Neuschwanstein

• Vienna

Atlantic
Ocean

Basle •

• Budapest

Clermont-Ferrand •

SWITZERLAND

Geneva •

AUSTRIA

HUNGARY

Roquetaillade •

• Milan

SLOVENIA

CROATIA

• Venice

Albi •

Carcassonne •

ITALY

BOSNIA-
HERZEGOVINA

Mediterranean Sea

• Florence

• Siena

• Rome

0 250 500 miles

0 250 500 kilometres

ONTARIO

QUEBEC

NEW
BRUNSWICK

NOVA
SCOTIA

Fredericton

C A N A D A

MAINE

Montreal

Ottawa

VERMONT

NEW HAMPSHIRE

WISCONSIN

MICHIGAN

Schenectady

Albany

Smith College

MASSACHUSETTS
Boston

Wellesley College

NEW YORK

RHODE ISLAND

Rhinebeck

Vassar College

Delafield

West Point

CONNECTICUT

Tarrytown

PENNSYLVANIA

New York

NEW JERSEY

Chicago

OHIO

Oberlin College

Philadelphia

Burlington

Bryn Mawr College

Pittsburgh

Baltimore

ILLINOIS

INDIANA

Kenyon College

WEST
VIRGINIA

DELAWARE

Washington, DC

MARYLAND

U S A

VIRGINIA

KENTUCKY

MISSOURI

NORTH
CAROLINA

TENNESSEE

SOUTH
CAROLINA

Atlantic Ocean

MISSISSIPPI

ALABAMA

GEORGIA

Orlando

FLORIDA

C U B A

0 500 miles

0 500 kilometres

Further Reading

General Works

There are no studies of the Gothic Revival that cover its entire historical span or geographical range: with the exceptions of Aldrich, Frankl and Germann, those listed here concentrate on Britain. Other general works are included for their coverage of broad cultural and architectural issues relevant to the Revival. For individual buildings in Britain readers should go to the county volumes of *The Buildings of England* (Harmondsworth, 1951–74) edited by Nikolaus Pevsner, and their subsequent revisions, and to the volumes of *The Buildings of Scotland* (Harmondsworth, from 1978), *The Buildings of Wales* (Harmondsworth, from 1979) and *The Buildings of Ireland* (Harmondsworth, from 1979).

Megan Aldrich, *Gothic Revival* (London, 1994)

E S de Beer, 'Gothic: Origin and Diffusion of the Term; the Idea of Style in Architecture', *Journal of the Warburg and Courtauld Institutes*, 11 (1948), pp.143–62

Martin S Briggs, *Goths and Vandals. A Study of the Destruction, Neglect and Preservation of Historical Buildings in England* (London, 1952)

Kenneth Clark, *The Gothic Revival. An Essay in the History of Taste* (London, 1928, repr. Harmondsworth, 1964)

Howard Colvin, *A Biographical Dictionary of British Architects 1600–1840* (London, 1978)

Charles L Eastlake, *A History of the Gothic Revival* (1872), ed. J Mordaunt Crook (Leicester, 1970)

Jane Fawcett (ed.), *The Future of the Past. Attitudes to Conservation 1147–1974* (London, 1976)

Peter Frankl, *The Gothic. Literary Sources and Interpretations through Eight Centuries* (Princeton, 1960)

Charlotte Gere, *Nineteenth-Century Decoration. The Art of the Interior* (London, 1989)

Georg Germann, *Gothic Revival in Europe and Britain; Sources, Influences and Ideas*, trans. by Gerald Onn (London, 1972)

Henry-Russell Hitchcock, *Architecture: Nineteenth and Twentieth Centuries* (Harmondsworth, 1969)

Barbara Jones, *Follies and Grottoes* (2nd edn, London, 1989)

David Lowenthal, *The Past is a Foreign Country* (Cambridge, 1985)

David Watkin, *The Rise of Architectural History* (London, 1980)

Muriel Whitaker, *The Legends of King Arthur in Art* (Cambridge, 1990)

Tom Williamson and Liz Bellamy, *Property and Landscape. A Social History of Land Ownership and the English Countryside* (London, 1987)

Gothic History and Political Gothic

Kurt Johannesson, *The Renaissance of the Goths in Sixteenth-Century Sweden*, trans. by James Larson (Berkeley, 1991)

Samuel Kliger, *The Goths in England. A Study in Seventeenth- and Eighteenth-Century Thought* (Cambridge, MA, 1952)

R J Smith, *The Gothic Bequest. Medieval Institutions in British Thought, 1688–1863* (Cambridge, 1987)

Gothic in Literature and Art

Chris Baldick, *In Frankenstein's Shadow. Myth, Monstrosity and Nineteenth-Century Writing* (Oxford, 1987)

Fred Botting, *Gothic* (London, 1996)

Richard Davenport-Hines, *Gothic. 400 Years of Excess, Horror, Evil and Ruin* (London, 1998)

Kate Ferguson Ellis, *The Contested Castle. Gothic Novels and the Subversion of Domestic Ideology* (Urbana and Chicago, 1987)

Juliann E Fleenor (ed.), *The Female Gothic* (Montreal, 1983)

Joseph Grixti, *Terrors of Uncertainty. The Cultural Contexts of Horror Fiction* (London, 1989)

David Punter, *The Literature of Terror. A History of Gothic Fiction from 1765 to the Present Day* (London, 1980)

Eve Kosofsky Sedgwick, *The Coherence of Gothic Conventions* (London, 1986)

Montague Summers, *The Gothic Quest. A History of the Gothic Novel* (London, 1938, repr. New York, 1964)

Gothic and Medievalism in Britain c.1580–1715

Sir Alfred Clapham, 'The Survival of Gothic in 17th-century England', *Archaeological Journal*, 106 supplement (1952), pp.4–9

Howard Colvin, 'Gothic Survival and Gothick Revival', *Architectural Review*, 104 (1948), pp.91-8

Mark Girouard, *Robert Smythson and the Architecture of the Elizabethan Era* (London, 1966)

Stan A E Mendyk, *'Speculum Britanniae'. Regional Study, Antiquarianism, and Science in Britain to 1700* (Toronto, 1989)

Stuart Piggott, *Ruins in a Landscape. Essays in Antiquarianism* (Edinburgh, 1976)

The Gothic Revival in Britain 1715–c.1840

Malcolm Andrews, *The Search for the Picturesque. Landscape Aesthetics and Tourism in Britain, 1760–1800* (Aldershot, 1989)

S Calloway, M Snodin and C Wainwright, *Horace Walpole and Strawberry Hill* (Richmond, 1980)

George Carter, Patrick Goode and Kedrun Laurie, *Humphry Repton, Landscape Gardener 1752–1818* (exh. cat., Sainsbury Centre for Visual Arts, Norwich, 1983)

Thomas Cocke, *The Ingenious Mr Essex, Architect* (exh. cat., Fitzwilliam Museum, Cambridge, 1984)

J Mordaunt Crook, 'John Britton and the Genesis of the Gothic Revival', in John Summerson (ed.), *Concerning Architecture* (London, 1968)

—, *John Carter and the Mind of the Gothic Revival* (London, 1995)

Terence Davis, *The Gothick Taste* (Newton Abbot and London, 1974)

Brian Fothergill, *Beckford of Fonthill* (London, 1979)

J M Frew, 'An Aspect of the Early Gothic Revival: The Transformation of Medievalist Research 1770–1800', *Journal of the Warburg and Courtauld Institutes*, 43 (1980), pp.174-85

Christopher Hussey, *The Picturesque. Studies in a Point of View* (London, 1927, repr. London, 1967)

—, *English Country Houses: Early Georgian 1715–1760* (London, 1955), *Mid-Georgian 1760–1800* (London, 1956), *Late Georgian 1800–1840* (London, 1958)

David Jacques, *Georgian Gardens. The Reign of Nature* (London, 1983)

Ian G Lindsay and Mary Cosh, *Inverary and the Dukes of Argyll* (Edinburgh, 1973)

W S Lewis, *Horace Walpole* (New York, 1961)

Derek Lindstrum, *Sir Jeffry Wyatville, Architect to the King* (Oxford, 1972)

James Macaulay, *The Gothic Revival 1745–1845* (Glasgow and London, 1975)

Michael McCarthy, *The Origins of the Gothic Revival* (New Haven and London, 1987)

Samuel Holt Monk, *The Sublime. A Study of Critical Theories in XVIII-Century England* (Ann Arbor, 1960)

Tim Mowl, *Horace Walpole. The Great Outsider* (London, 1996)

Janet Myles, *L N Cottingham 1787–1847. Architect of the Gothic Revival* (London, 1996)

Michael Port, *Six Hundred New Churches. A Study of the Church Building Commission, 1818–56* (London, 1961)

John Martin Robinson, *The Wyatts, an Architectural Dynasty* (Oxford, 1979)

Jack Simmons (ed.), *English County Historians* (Wakefield, 1978)

D Simpson (ed.), *Gothick, 1720–1840* (exh. cat., Brighton Art Gallery and Museums, 1975)

John Summerson, *The Life and Work of John Nash, Architect* (London, 1980)

Clive Wainwright, *The Romantic Interior. The British Collector at Home, 1750–1850* (New Haven and London, 1989)

Tom Williamson, *Polite Landscapes. Gardens and Society in Eighteenth-Century England* (Stroud, 1995)

Michael Wilson, *William Kent. Architect, Designer, Painter and Gardener, 1685–1748* (London, 1984)

The Gothic Revival in Britain, c.1840–1914

Victorian Church Art (exh. cat., Victoria and Albert Museum, London, 1971)

Jill Allibone, *Anthony Salvin. Pioneer of Gothic Revival Architecture* (Cambridge, 1988)

Peter F Anson, *Fashions in Church Furnishings 1840–1940* (London, 1960)

Paul Atterbury (ed.), *A W N Pugin. Master of Gothic Revival* (New Haven and London, 1995)

Paul Atterbury and Clive Wainwright (eds), *Pugin. A Gothic Passion* (exh. cat., Victoria and Albert Museum, London, 1994)

Margaret Belcher, *A W N Pugin. An Annotated Critical Bibliography* (London, 1987)

Eve Blau, *Ruskinian Gothic. The Architecture of Deane and Woodward, 1845–1861* (Princeton, 1982)

Geoffrey K Brandwood, *Temple Moore. An Architect of the Late Gothic Revival* (Stamford, 1997)

Chris Brooks, *Signs for the Times. Symbolic Realism in the Mid-Victorian World* (London, 1984)

Chris Brooks and Andrew Saint (eds), *The Victorian Church. Architecture and Society* (Manchester, 1995)

Michael W Brooks, *John Ruskin and Victorian Architecture* (New Brunswick, NJ, 1987 and London, 1989)

David B Brownlee, *The Law Courts, The Architecture of George Edmund Street* (Cambridge, MA, 1984)

Basil F L Clarke, *Church Builders of the Nineteenth Century. A Study of the Gothic Revival in England* (London, 1938, revised edn Newton Abbot, 1969)

David Cole, *The Work of Sir Gilbert Scott* (London, 1980)

Alan Crawford and Colin Cunningham (eds), *William Morris and Architecture* (Society of Architectural Historians of Great Britain, 1996)

J Mordaunt Crook, *William Burges and the High Victorian Dream* (London, 1981)

Colin Cunningham, *Alfred Waterhouse* (London, 1994)

James Stevens Curl, *Victorian Churches* (London, 1995)

Charles Dellheim, *The Face of the Past. The Preservation of the Medieval Inheritance in Victorian England* (Cambridge, 1982)

H J Dyos and Michael Wolff (eds), *The Victorian City. Images and Realities*, 2 vols (London, 1973)

Jennifer Freeman, *W D Caröe. His Architectural Achievement* (Manchester, 1990)

Mark Girouard, *The Victorian Country House* (New Haven and London, 1979)

—, *The Return to Camelot. Chivalry and the Victorian Gentleman* (New Haven and London, 1981)

Martin Harrison, *Victorian Stained Glass* (London, 1980)

Henry-Russell Hitchcock, *Early Victorian Architecture in Britain*, 2 vols (London, 1954)

Peter Howell and Ian Sutton, *The Faber Guide to Victorian Churches* (London, 1989)

Edward Hubbard, *The Work of John Douglas* (London, 1991)

John Dixon Hunt, *The Wider Sea. A Life of John Ruskin* (New York, 1982)

Simon Jervis, *High Victorian Design* (Woodbridge, 1983)

Debra N Mancoff, *The Return of King Arthur. The Legend through Victorian Eyes* (London, 1995)

G E Mingay (ed.), *The Victorian Countryside*, 2 vols (London, 1981)

Stefan Muthesius, *The High Victorian Movement in Architecture 1850–1870* (London, 1972)

Linda Parry (ed.), *William Morris* (exh. cat., Victoria and Albert Museum, London, 1996)

Anthony J Pass, *Thomas Worthington. Victorian Architecture and Social Purpose* (Manchester, 1988)

Nikolaus Pevsner, *Ruskin and Viollet-le-Duc: Englishness and Frenchness in the Appreciation of Gothic Architecture* (London, 1969)

—, *Some Architectural Writers of the Nineteenth Century* (Oxford, 1972)

M H Port (ed.), *The Houses of Parliament* (New Haven and London, 1976)

Christine Poulson, *The Quest for the Grail. Arthurian Legend in British Art 1840–1920* (Manchester, 1999)

Anthony Quiney, *John Loughborough Pearson* (New Haven and London, 1979)

Benedict Read, *Victorian Sculpture* (New Haven and London, 1982)

Andrew Saint, *Richard Norman Shaw* (New Haven and London, 1976)

Alastair Service (ed.), *Edwardian Architecture and its Origins* (London, 1975)

Mary Schoeser, *The Watts Book of Embroidery. English Church Embroidery 1833–1953* (London, 1998)

George Gilbert Scott, *Personal and Professional Recollections* (1879), ed. Gavin Stamp (Stamford, 1995)

Phoebe Stanton, *Pugin* (London, 1971)

Anthony Symondson, *Sir Ninian Comper, the last Gothic Revivalist* (London, 1988)

Paul Thompson, *William Butterfield* (London, 1971)

Stefan Tschudi-Madsen, *Restoration and Anti-Restoration. A Study in English Restoration Philosophy* (Oslo, 1976)

Michael Trappes-Lomax, *Pugin. A Medieval Victorian* (London, 1932)

Alexandra Wedgwood, *A W N Pugin and the Pugin Family* (London, 1985)

James F White, *The Cambridge Movement* (Cambridge, 1962)

The Gothic Revival in Continental Europe

Wilfrid Blunt, *The Dream King. Ludwig II of Bavaria* (New York, 1970)

Jean van Cleven (ed.), *Neogotiek in België* (Tielt, 1994)

Eugène-Emmanuel Viollet-le-Duc, 1814–1879 (Architectural Design Profile, London, 1980)

Bruno Foucart (ed.), *Viollet-le-Duc* (exh. cat., Grand Palais, Paris, 1980)

M F Hearn (ed.), *The Architectural Theory of Viollet-le-Duc. Readings and Commentary* (Cambridge, MA, 1990)

Heinrich Kreisel, *The Castles of Ludwig II of Bavaria* (Darmstadt, n.d.)

Jean-Michel Leniaud, *Jean-Baptiste Lassus ou le temps retrouvé des cathédrals* (Geneva, 1980)

Michael J Lewis, *The Politics of the German Gothic Revival. August Reichensperger* (Cambridge, MA, 1993)

Claude Mignot, *Architecture of the Nineteenth Century in Europe* (New York, 1984)

Ulrike Planner-Steiner, *Friedrich von Schmidt* (Wiesbaden, 1978)

W D Robson-Scott, *The Literary Background of the Gothic Revival in Germany* (London, 1965)

Michael Snodin (ed.), *Karl Friedrich Schinkel. A Universal Man* (exh. cat., Victoria and Albert Museum, London, 1991)

Eugène-Emmanuel Viollet-le-Duc, *The Foundations of Architecture. Selections from the Dictionnaire raisonné*, intro. by Barry Bergdoll, trans. by Kenneth D Whitehead (New York, 1990)

Renate Wagner-Rieger, *Wiens Architektur im 19. Jahrhundert* (Vienna, 1971)

Hans Vogts, *Vincenz Statz (1818–1898)* (Mönchengladbach, 1960)

The Gothic Revival in the United States

American Churches, 2 vols (The American Architect, New York, 1915)

Helen Lefkowitz Horowitz, *Alma Mater. Design and Experience in the Women's Colleges from Their Nineteenth-Century Beginnings to the 1930s* (New York, 1985)

Alma deC McArdle and Deirdre Bartlett McArdle, *Carpenter Gothic: Nineteenth-Century Ornamented Houses of New England* (New York, 1978)

James O'Gorman, *The Architecture of Frank Furness* (Philadelphia, 1973)

Amelia Peck (ed.), *Andrew Jackson Davis, American Architect 1803–1892* (exh. cat., Metropolitan Museum of Art, New York, 1992)

William H Pierson, Jr, *American Buildings and Their Architects, Technology and the Picturesque. The Corporate and Early Gothic Styles* (New York, 1978)

Phoebe Stanton, *The Gothic Revival and American Church Architecture, an Episode in Taste, 1840–1856* (Baltimore, 1968)

George E Thomas, Michael J Lewis and Jeffrey A Cohen, *Frank Furness. The Complete Works* (Princeton, 1996)

Andrew Wayne, *American Gothic. Its Origins, Its Trials, Its Triumphs* (New York, 1975)

The Gothic Revival in the British Empire

With the exception of Clarke, the following all deal with the Revival as part of general architectural history.

Basil F L Clarke, *Anglican Cathedrals outside the British Isles* (London, 1958)

Philip Davies, *Splendours of the Raj. British Architecture in India, 1660–1947* (London, 1985)

Robert Fermor-Hesketh (ed.), *Architecture of the British Empire* (London, 1986)

J M Freeland, *Architecture of Australia* (Melbourne, 1968)

R H Hubbard, *The Development of Canadian Art* (Ottawa, 1963)

C Lucas, *Colonial Architecture* (Melbourne, 1978)

Thomas R Metcalf, *An Imperial Vision. Indian Architecture and Britain's Raj* (London, 1989)

Peter Shaw, *New Zealand Architecture. From Polynesian Beginnings to 1990* (Auckland, 1991)

J Stacpoole and P Beaver, *New Zealand Art and Architecture, 1820–1970* (Wellington, 1970)

Twentieth-Century Gothic

S Prawer, *Caligari's Children. The Film as Tale of Terror* (Oxford, 1980)

Victor Sage and Allan Lloyd Smith, *Modern Gothic. A Reader* (Manchester, 1996)

A Tudor, *Monsters and Mad Scientists. A Cultural History of the Horror Movie* (Oxford, 1989)

James B Twitchell, *Dreadful Pleasures. An Anatomy of Modern Horror* (Oxford, 1986)

Index

Numbers in **bold** refer to illustrations

Acknowledgements

This book comes from many years of thinking and writing about gothic and its revival, and of visiting gothic buildings of every shape and date. In the process I have built up an edifice of contacts, acquaintances and friendships as diverse, rewarding and – sometimes – as eccentric as any structure dreamed up by a gothic architect. My sincere thanks to everybody who is part of the structure. I owe a special debt to all the people I know in the Victorian Society, their enthusiasm and commitment a constant stimulus, and their erudition a frequent source of wonder. For their help in many ways I want to thank Peter Howell, Andrew Saint, Teresa Sladen, Robert Thorne, Clive Wainwright and, for his particular assistance with several aspects of the book, Geoff Brandwood. I also owe a lot to the School of English at Exeter University, both to colleagues and to students: my special thanks for their ideas and their support go to Inga Bryden, Jim Cheshire, Simon Cooke, Richard Crangle, Peter Faulkner, Regenia Gagnier and Nick Groom – source of much advice and arcane information. For help with particular issues covered by the book I am grateful to Greg Harper, Mária Kemény, John Redmill, Roger Robinson and, for his amazingly sure-footed guidance through the gothic corridors of the Internet, to Rob Robertson. To Liz and Ivor Lloyd my gratitude for enabling me to keep things in proportion by sometimes allowing them to go out of focus.

Through the whole course of writing the book I have been much cheered by the enthusiasm and support of the editorial and picture-research staff at Phaidon: warm thanks to Pat Barylski, Giulia Hetherington and Zoë Stollery. And my especial thanks to Julia MacKenzie: I could not have wished for a better editor.

Finally, this book and its author owe a great deal to three people. To Martin Cherry and Jo Cox, with both of whom, over the years, I have discussed endless ideas and visited countless buildings; and to Su Jarwood, whose encouragement has been unflagging and whose passion for the arts is an inspiration. With affection and gratitude, this book is dedicated to the three of them.

For Jo, Martin and Su
companions in gothic ways

Photographic Credits

AA Photo Library, Basingstoke: 98, photo Tony Souter 226; photo Alistair Adams, Abbey Photography, Liverpool: 240; AKG London: 100; AlphaStock, Manchester: 92, 236; Arcaid, London: photo David Churchill 51, photo Mark Fiennes 38, photo Lucinda Lambton 37; Ashmolean Museum, Oxford: 179, 180–1, 213; Axiom Photographic Agency, London: photo James Morris 33, photo Peter Wilson 208; Bastin & Evrard sprl, Brussels: 164–5; Benoy K Behl, Mumbai: 168; Berenholtz Photography, New York: 252–3; John Bethell, St Albans: 120–3; Bethunianum, National Centre for the Study of 19th Century Art, Ghent: 229, photo Bart Cloet 230, photo Hugo Maertens 228; Bildarchiv Preussischer Kulturbesitz, Berlin: photo Jorg P Anders 79, 80; photo Bob Booth, Lichfield: 243; Bridgeman Art Library, London: 45, 106, 176; photo David Briggs, Ulverston: 88; British Architectural Library, RIBA, London: 42, 59, 85, 94, 167, 250; British Library, London: 70, 113, 157, 184, 224, 238; British Museum, London: 66–7, 78, 175; Bruges Tourist Board: 232; Chris Brooks: 23, 60, 129, 149, 177, 200, 210–11, 239, 244; Photographie Bulloz, Paris: 11; Caisse Nationale des Monuments Historiques et des Sites, Paris: 220; Martin Charles, Isleworth: 121, 124, 185–8, 190, 203, 241; Collections, London: photo John D Beldom 207, photo Yuri Lewinski 18, photos McQuillan & Brown 139, 206; photo Val Corbett, Penrith: 87; Country Life Picture Library, London: photo British Museum 29; photo David Crispin, Plymouth: 104; courtesy of the Diocesan Synod of Fredericton, NB: photo Roger Smith 170; photo Roger Dovey, St Austell: 151; Edifice, London: photo Lewis 110; courtesy Elvetham Hall Conference Centre, Hartley Wintney: 201; English Heritage, London: 173, 195, photo John Critchley 205; Esto Photographics Inc, Mamaroneck, NY: photo Wayne Andrews 218; Mark Fiennes, Clare: frontispiece, 99, 111, 115, 197–9, 214, 217; photo George Garbutt 119; Robert Hallmann, Benfleet: 196; Harvard University, Cambridge, MA: 216; photo Adrian Harvey, Winchester: 154; photo Thomas Helms, Schwerin: 68; Clive Hicks, London: 3–6; Ray Hillstrom, Chicago: Photri-Microstock 248, photo Stan Ries 171; Angelo Hornak, London: 2, 13–17, 19, 20, 32, 39, 40–1, 48–9, 62, 192, 204, 242, 246; photo Ralph Hoult, Ramsgate: 131; Hulton Getty Picture Collection, London: 148, 158; J Allan Cash Photo Library, London: 89, 219, 223; A F Kersting, London: 9, 28, 30, 35, 44, 46, 76, 57, 61, 86, 108, 116, 117, 130, 150, 152, 189, 191, 193, 233, 234, 235; Kölnisches Stadtmuseum, Cologne: photo Rheinisches Bildarchiv: 156; KPM-Archiv (Land Berlin),

Schloss Charlottenburg: 101; courtesy Rev D Graham Leitch, Barclay Church, Edinburgh: 202; courtesy of the Lewis Walpole Library, Yale University, Farmington, CT: 65; photo Joris Luyten, Antwerp: 166; by kind permission of the Marquess of Tavistock and the Trustees of the Bedford Estate: 105; Mary Evans Picture Library, London: 69, 71, 90; Metropolitan Museum of Art, New York: Harris Brisbane Dick Fund (1924) 112; photo Graham Miller, London: 138, 140, 143–4; Mountain High Maps, © 1995 Digital Wisdom Inc: pp.432–4; Musée des Beaux-Arts, Lyon: photo Studio Basset 81; Museum Oskar Reinhart am Stadtgarten, Winterthur: 72; National Academy, New York: 215; National Monuments Record/RCHM, Swindon: 212; Board of Trustees of the National Museums and Galleries on Merseyside, Liverpool: 82; National Trust, London: 43; Eric Oxendorf, Milwaukee: 172; Palace of Westminster, London: 127; Paul Mellon Centre for British Art Studies, London: 53; Photosource, Wellington, New Zealand: 169, 273; Photothèque des Musées de la Ville de Paris: photo Andreani 161; Pitkin Unichrome, Andover: photo Newbery Smith Photography 133; Punch Ltd, London: 153; Redferns, London: photo Ebet Roberts 258; RMN, Paris: photo Arnaudet 76; Ronald Grant Archive, London: 63, 255–7; Royal Academy of Arts, London: 36; Royal Collection, Windsor, copyright Her Majesty Queen Elizabeth II: 96; Skyscan Photolibrary, Cheltenham: 93, 95, photo Pitkin Unichrome 12; Society of Antiquaries of London: 24, 73, 84, 107; Spectrum Colour Library, London: 102, 225, 249, 254; photo Barry Stacey, Kirkby Stephen: 58; Städelsches Kunstinstitut, Frankfurt am Main: 1; Stapleton Collection, London: 91, 145; Tate Gallery, London: 77, 178; photo Keith Taylor, Cameracraft, Spennymoor: 22; Ticktock Publishing, Tonbridge: 47; Travel Ink, Goring-on-Thames: photo David Toase 109; Trésor de la Cathédrale de Liège: 231; Universiteit Gent, Seminarie Geschiedenis van de Bouwkunst: 103; V&A Picture Library, London: 83, 128, 146, 159, 160, 222, photo Pip Barnard 54, anonymous loan to the V&A Museum reproduced as colour plate 598 in *Eighteenth Century Gold Boxes of Europe* by A Kenneth Snowman, London 1966, and Antique Collectors Club 1990, photo D P P Naish 97; on loan to the V&A Museum from the Parish Church of St Paul, Brighton 209; View, London: photo William Fife 132; reproduced by permission of the Trustees of the Wallace Collection, London: 174; West Point Military Academy, NY: US Army photo 247; Woodmansterne, Watford: 21, 194, 245; Jean-Pierre Zénobel, Paris: 10

Phaidon Press Limited
Regent's Wharf
All Saints Street
London N1 9PA

First published 1999
© 1999 Phaidon Press Limited

ISBN 0 7148 3480 7

A CIP catalogue record for this book is
available from the British Library.

All rights reserved. No part of this
publication may be reproduced, stored
in a retrieval system or transmitted, in
any form or by any means, electronic,
mechanical, photocopying, recording or
otherwise, without the prior permission
of Phaidon Press Limited.

Typeset in Plantin

Printed in Singapore

Cover illustration A W N Pugin and John
Hardman, Reliquary, c.1850 (see pp.244–7)

8031